Black Acting Methods

Black Acting Methods offers a range of alternatives to the Euro-American per-
formance styles that many actors find themselves working with. These
approaches are rooted in a critical framework that allows Afrocentric sensibil-
ities and experiences to excite and invigorate approaches to performative
scholarship. A wealth of contributions from directors, scholars, and acting
practitioners of color address Afrocentric processes and aesthetics, and
responses from key figures in Black American theatre illuminate their
methods.

This ground-breaking collection is an essential resource for teachers, stu-
dents, actors and directors seeking to reclaim, reaffirm or even redefine the
role and contributions of Black culture in theatre arts.

Sharrell D. Luckett is Assistant Professor of Theatre and Performance
Studies Scholarship at Muhlenberg College.

Tia M. Shaffer is Fine Arts Chair and Theatre Director at South Atlanta
High School in Atlanta Public Schools.

Black Acting Methods

Critical approaches

Sharrell D. Luckett with
Tia M. Shaffer

Routledge
Taylor & Francis Group
LONDON AND NEW YORK

First published 2017
by Routledge
2 Park Square, Milton Park, Abingdon, Oxon OX14 4RN

and by Routledge
711 Third Avenue, New York, NY 10017

Routledge is an imprint of the Taylor & Francis Group, an informa business

© 2017 Sharrell D. Luckett and Tia M. Shaffer

British Library Cataloguing-in-Publication Data
A catalogue record for this book is available from the British Library

Library of Congress Cataloguing-in-Publication Data
A catalog record for this book has been requested

ISBN: 978-1-138-90763-8 (hbk)
ISBN: 978-1-138-90762-1 (pbk)
ISBN: 978-1-315-69498-6 (ebk)

Typeset in Bembo
by Wearset Ltd, Boldon, Tyne and Wear

For Eboni,
Our fiercely talented, gorgeous Black friend whose White director of her MFA program told her during her exit interview:

"I must admit, I didn't know how to teach you."

Contents

Figures

Contributors

Sharrell D. Luckett, Ph.D., is Assistant Professor of Theatre and Perform-ance Studies Scholarship at Muhlenberg College. Her literary and embod-ied interdisciplinary scholarship is situated in performance theory, Black studies and Women's studies. In addition to her being an award-winning director, professor and producer, Dr. Luckett's research has appeared in several publications, including *Theatre Topics, Journal of Cultural Studies <=> Critical Methodologies, Journal of American Drama and Theatre, Depar-tures in Critical Qualitative Research* and *Continuum: Journal of African Diaspora Drama, Theatre, and Performance*. Her forthcoming book, *YoungGiftedandFat: Size, Sexuality & Privilege*, engages with her experience as a transweight performer. Luckett's solo show, *YoungGiftedandFAT*, is on a rolling pre-miere and was recently staged Off-Broadway. An alum of the doctoral program in Theatre at the University of Missouri-Columbia, Luckett is also a proud invitee of the Performance Encounters series at Cornell Uni-versity, Northwestern University's Mellon Program in Black Feminist Per-formance, and a Fellow of the esteemed Lincoln Center Directors Lab. www.sdluckett.com

Tia M. Shaffer, Ed.D., is Fine Arts Chair and Theatre Director at South Atlanta High School in Atlanta Public Schools. She also serves as Dir-ector for Youth and Children's Ministries at Zion Hill Baptist Church in Atlanta, GA. Her educational background includes a BA in Journ-alism from Georgia State University (Atlanta, GA), Theatre Educator Certification from Columbus State University (Columbus, GA), Master of Arts in Christian Education from The Interdenominational Theologi-cal Center Morehouse School of Religion (Atlanta, GA) and Ed.D. in Educational Leadership from Liberty University (Lynchburg, VA). Shaf-fer's educational and literary work focuses on the transformative power of theatre arts in the lives of participants and viewers. As a public school educator, Shaffer utilizes theatre as a tool to instill confidence, to teach cultural identity and to evoke creativity in students. As a Christian leader, she also implements theatre arts to foster spiritual formation in

youth. Her dissertation, titled *Former Students' Perceptions of How Theatre Impacted Life Skills and Psychological Needs*, investigated ways in which theatre affected the lives of African American high school students. Shaffer is also a contributing author in an anthology titled *Running the Long Race in Gifted Education: Narratives and Interviews from Culturally Diverse Gifted Adults*. In 2012, Shaffer was awarded a grant from the National Endowment for the Arts to study the music, culture and people of the Mississippi Delta. As a playwright and director, Shaffer takes pride in creating plays that cater to the diverse identities and talents of the actors she serves in public schools and the church. Some of her plays include *Family, Faith and Love*; *Second Chance*; *We Still Together*; *The Minstrel Show: Then and Now*; *Unfrozen: Keeping Christ in Christmas* and a host of others. As an educator who has worked in public schools that lack resources and Fine Arts programs, Shaffer specializes in training first-time actors and providing authentic performance experiences for young thespians and audiences.

Daniel Banks, Ph.D., is a director and choreographer who serves as Chair of Performing Arts at the Institute of American Indian Arts in Santa Fe, NM. He directed the African premiere of August Wilson's *Jitney* at the National Theatre of Uganda. Banks is on the founding board of the Hip Hop Education Center at NYU and is Associate Director of Theatre Without Borders. He is also editor of the critical anthology *Say Word! Voices from Hip Hop Theater*. Banks's writings can be found in *Classical World, American Theatre* and other publications.

Lisa Biggs, Ph.D., a native Chicagoan, serves as Assistant Professor in the Residential College in Arts and Humanities at Michigan State University, where she teaches courses in theatre and performance studies. She has appeared in productions at the Kennedy Center, Arena Stage, Woolly Mammoth Theatre, Chicago Theatre Company, African Continuum Theatre, Baltimore Theatre Project, Brooklyn Arts Exchange and many more. She is the author of several experimental theatre/dance works, including *butterfly belongings*, *Memory is a Body of Water* (with co-author Tanisha Christie), *Blackbirds* and *Where Spirit Rides*.

Justin Emeka is Associate Professor of Theatre and Africana Studies at Oberlin College where he teaches directing, acting and Capoeira Angola. Emeka received his MFA in Directing from the University of Washington and is a member of the Stage Directors and Choreographers Society, as well as Actors Equity Association. A few of his directing credits include: *A Midsummer Night's Dream* and *Romeo and Juliet* at the Classical Theatre of Harlem; Dominique Morrisseau's *Detroit '67* and Al Letson Jr.'s *Julius X* at the Karamu House in Cleveland.

Kashi Johnson is Associate Professor of Theatre at Lehigh University and an accomplished actress, director and playwright. She received an MFA from the University of Pittsburgh. Her directing credits include *God of Carnage*, *The Piano Lesson*, *Flyin' West* and many others. She has given video recorded talks for TEDx and season 3 of BlackademicsTV on her cutting-edge Hip Hop theatre course: "Act Like You Know." She is the recipient of numerous awards for teaching and service at Lehigh University, including the Stabler Award for Excellence in Teaching.

Rhodessa Jones is Co-Artistic Director of Cultural Odyssey, the acclaimed San Francisco performance company. She was recently appointed Visiting Professor at the University of California, Berkeley to teach the Black Theatre Workshop entitled *Performance: An African American Perspective*. She is also founder and director of the award-winning Medea Project: Theatre for Incarcerated Women and HIV Circle. Some of her scholarly highlights include "Deep in the Night" in the *Journal of Medical Humanities* and *Staging Migrations toward an American West: From Ida B. Wells to Rhodessa Jones* by Marta Effinger-Crichlow.

Aku Kadogo serves on faculty in the Dance and Drama Department at Spelman College. She is an international director, choreographer and educator who made her career debut in the original Broadway classic of *For colored girls who have considered suicide/when the rainbow is enuf* by Ntozake Shange. She is an arts advisor to Tyree Guyton and the Heidelberg Project and a member of Mike Ellison's *Afroflow* creative team. She has directed numerous plays that include *Joe Turner's Come and Gone*, *In the Red and Brown Water* and many more.

Tawnya Pettiford-Wates, Ph.D., is Associate Professor of Graduate Pedagogy in Acting and Directing at Virginia Commonwealth University, received her education from the Central School of Drama, Speech and Film in London, Carnegie-Mellon University and the Union Institute. She appeared with the New York Shakespeare Festival's Broadway production of *For colored girls who have considered suicide/when the rainbow is enuf*. Pettiford-Wates has a new book under development, which interrogates professional arts training and institutions for theatre artists as ivory towers of privilege, racial oppression and mis-education.

Clinnesha D. Sibley serves as Assistant Professor in the Department of Theatre and Dance at the College of Charleston. She received her MFA in Playwriting from the University of Arkansas. Her award-winning plays include *Thorns*, *Uprooted* and *Gray*. Her anthology, *King Me: Three Plays Inspired by the Life and Legacy of Dr. Martin Luther King, Jr.*, was published by the University of Arkansas Press. She has published in various journals, including *Black Masks Magazine*, which featured her play *Memory: A Tribute to Maya Angelou and Ruby Dee*.

Daphnie Sicre is a full-time Assistant Professor in the Speech, Communications and Theatre Arts Department at Borough of Manhattan Community College, CUNY, where she teaches courses in theatre, social justice and advanced public speaking. She also teaches Arts and Social Justice at Marymount Manhattan College. Focusing on Afro-Latina performance, she will complete her Ph.D. at New York University in Educational Theatre in the fall of 2016. Her New York City directing credits include: *Dying is an Art* and *Olympic Dreams* at the Sheen Center for the 365 NYC Women's Project Festival.

Cristal Chanelle Truscott, Ph.D., is a playwright, director, ensemble artist, educator and scholar who serves as Founder/Artistic Director of Progress Theatre, a touring ensemble using theatre to encourage social consciousness, cross-community dialogue and cultural awareness. She completed her Master of Arts and Doctoral degrees in NYU's Department of Performance Studies with a research focus on representations of spiritual diversity in African American theatre before 1950. She is a recipient of national grants, including the Doris Duke Impact Artist Award, NEFA National Theatre Project grant and two National Performance Network Creation Fund grants.

Distinguished practitioners

Judyie Al-Bilali has taught at NYU's Steinhardt School and City University of New York's Applied Theatre Master's Program. In Cape Town, South Africa, she founded Brown Paper Studio, an applied theatre process that is offered as a service learning course at UMass Amherst where she is Professor of Theatre for Social Transformation. Al-Bilali is the author of several plays, including a memoir, *For the Feeling: Love & Transformation from New York to Cape Town.*

Tim Bond holds a BFA in Drama from Howard University and an MFA in Directing from the University of Washington School of Drama, where he is now a Professor of Acting and Directing. He served as Producing Artistic Director of Syracuse Stage and directed 15 productions between 2007 through 2016. Bond also served as Associate Artistic Director of the Oregon Shakespeare Festival, where he directed 12 productions, which included *Blues for an Alabama Sky* and *Les Blancs.*

Walter Dallas, a three-time Grammy award-winning writer and director of over 40 years, is considered an icon in African American theatre. He has directed over 30 world premieres and was a favorite director of August Wilson and James Baldwin. He is a graduate of Morehouse College and the Yale School of Drama.

Sheldon Epps has been Artistic Director of the renowned Pasadena Play-house since 1997. He also served as Associate Artistic Director of the Old Globe Theatre for four years. Epps has directed numerous plays and musicals at many of the country's major theatres, including the Roundabout, Manhattan Theatre Club, the Guthrie, Playwrights Horizons, Seattle Repertory Theatre, Arena Stage and the Goodman Theatre.

Shirley Jo Finney is an actress with many television and film credits. She is best known for her portrayal in the historic title role of Wilma Rudolph, the first female three-time gold medalist, in the made-for-TV bio picture *Wilma*. She has also worn her director's hat in some of the most respected regional theatre houses across the country, including the McCarter Theatre, the Pasadena Playhouse, the Goodman Theatre, and the Alabama Shakespeare Festival.

Kamilah Forbes is the Artistic Director of the Hip Hop Theater Festival. Forbes has produced several works for both television and theatre, most notably, four seasons of the Peabody Award winning series *Russell Simmons Presents Def Poetry* on HBO. As a playwright, Forbes penned "A Rhyme Deferred," a work noted as one of the first examples of the hip-hop genre.

Nataki Garrett, Los Angeles-based director, writer, producer and educator, is the Associate Artistic Director of CalArts Center for New Performance (CNP) as well as the Associate Dean and Co-Head of Undergraduate Acting for CalArts School of Theater. Garrett has directed across the United States, Rwanda and Europe. She is a member of the Stage Directors and Choreographers Society. For more details about Garrett's work, visit www.natakigarrett.com and www.blankthedog.com.

Anita Gonzalez, Ph.D., is Professor of Theatre and Drama at the University of Michigan. She heads the Global Theatre and Ethnic Studies minor in SMTD and LS&A. Gonzalez's most recent book is a co-edited anthology with Tommy DeFrantz, *Black Performance Theory* (Duke University Press, 2014), which theorizes Black performance in the new millennium. Currently, Gonzalez is a member of the Executive Committee of the University of Michigan Press.

Paul Carter Harrison is an award-winning playwright, director, dramaturg and theatre theorist whose work has been published and produced in both Europe and the United States. He has had a long artistic association with the Negro Ensemble Company, which produced his signature Obie Award play, *The Great Macdaddy*. A recipient of a Rockefeller Foundation Fellowship for American Playwriting, a National Endowment of the Arts Playwrights Fellowship and two Meet-the-Composer/ Reader's Digest Commissions, Harrison is also the author of *The Drama of Nommo*. His theoretical essays have had a seminal influence in the exploration of ritual stylizations for many contemporary practitioners of Black theatre. As co-editor, he has collected a volume of essays, *Black Theatre*:

Ritual Performance in the African Diaspora, that has amplified the aesthetics of Black theatre practice. Having retired from a 27-year service to Columbia College Chicago in 2002, Harrison currently resides in Panama while serving as Visiting Artist/Scholar at Emory University, where he guides a research project on Critical Vocabulary for African Diasporic Expressivity.

Ron Himes, Director, is the Henry E. Hampton, Jr. Artist-in-Residence at Washington University in St. Louis and Founder and Producing Director of the Saint Louis Black Rep, which he established in 1976. He has produced and directed more than 100 plays at the Black Rep, including August Wilson's *The Piano Lesson* and the Black Rep's own *I Remember Harlem II*.

Robbie McCauley is an OBIE Award playwright for *Sally's Rape* and an internationally recognized performance artist and director. Her acting credits include *For colored girls who have considered suicide/when the rainbow is enuf* on Broadway, and *Fences* at the Tyrone Guthrie in Minnesota. McCauley's directing credits include Adrienne Kennedy's *Sleep Deprivation Chamber* at Penumbra Theatre Company in Minnesota and many others.

Kym Moore is Associate Professor of Acting and Directing in the Department of Theatre Arts and Performance Studies at Brown University. She is also Co-Founder and Artistic Director of the AntiGravity Theatre Project in Providence, RI. One of her recent most notable directing credits is *Hype Hero* by Dominic Taylor (Eugene O'Neill National Playwrights Conference). For more information, visit Kym Moore's websites: www.kymmoore.com and www.theantigravityproject.wordpress.com.

Seret Scott is on the Executive Board of the Stage Directors and Choreographers Union. She has attained Off-Broadway and regional directing credits around the country, as well as numerous credits with San Diego's Old Globe Theatre, where she is an Associate Artist. She has workshopped new plays for Sundance Lab, O'Neill Theatre Center, New Harmony, Roundabout Theatre, Pacific Playwrights and New Dramatists.

Tommie "Tonea" Stewart, Ph.D., is Professor of Theatre and Dean of the College of Visual and Performing Arts at Alabama State University. Stewart is also a professional actress, play director and a national museum exhibit director. Stewart has staged more than 80 productions. Additionally, she received an NAACP Image Award nominee for her role in the film adaptation of John Grisham's *A Time to Kill*.

Talvin Wilks is a playwright, director and dramaturg. His plays include *Tod, the Boy, Tod*, *The Trial of Uncle S&M*, *Bread of Heaven*, *An American Triptych* and the 2015 world premiere of *Jimmy and Lorraine*. Acclaimed directorial projects include *UDU* by Sekou Sundiata, *The Love Space Demands* by Ntozake Shange, *No Black Male Show* by Carl Hancock Rux, *The Ballad of Emmett Till* by Ifa Bayeza and the OBIE Award winning *The Shaneequa Chronicles* by Stephanie Berry.

Foreword
The Blessing

Molefi Kete Asante

As a matter of fact Professors Sharrell D. Luckett and Tia M. Shaffer have presented us with a profoundly well written and powerfully brilliant anthology about African American/Black approaches to acting. *Black Acting Methods: Critical Approaches* is an enjoyable and readable book. We have always needed such an anthology and in this work they have succeeded where others have never traveled. They have become the deans of the field because they created the niche that was filled with the most precious understandings of the various ways actors and directors may approach process and product in the field of acting. Of course, the key to their work is the Afrocentric nature of the approach. This was not to be a book written about Black actors by those who have little or no appreciation for the intuitions, nuances and styles of the African American people. Consequently the authors of the chapters are not tip-toeing or walking on fire; their feet are firmly on the ground and they have reached deep into the souls of Black folks to bring forth revelatory ideas that are timeless and priceless. Who could have raised the kinds of questions raised in these authentic essays without Afrocentricity? Thus, what constitutes the key to this project is the belief that African Americans and other Africans constitute societies and communities and that the constituent elements of all aesthetics in a society are related to origin, history, experiences, customs and ideas. Societies and culture go together. Here we have Luckett and Shaffer like artistic magicians, choreographers or directors, providing the template for a host of the best writers on the subject. It is appropriate that they are not looking to the Greeks, Homer or any of the crew that came after him, for direction. They wanted their authors to riff off their own history and culture and this is what has produced such a provocative book.

Over the past 30 years, Afrocentricity has exploded on the international scene as a major theoretical and critical tool for understanding African and African American phenomena. The idea that Black people should be seen and see ourselves as agents and not as marginal to our narrative is a dynamite conclusion because it relocates African people to the center of our history. In a manner different from Eurocentrism, which imposes itself as a universalism, Afrocentricity says that African people should examine all forms of knowledge

and experiences from the standpoint of Africans being the makers, creators, inventors and actors in our own narrative. There are no Afrocentrists who seek an imposition on other cultures as if Afrocentricity is a universal view. On the other hand, positioning this anthology within an Afrocentric framework is the most logical way for us to understand, appreciate, criticize and augment the artistic and aesthetic ideas of African American actors. In effect, Afrocentricity brings a paradigm shift forward as an alternative to Eurocentric critiques of Black actors.

It is with a strong emotional attachment that I salute the editors and the authors for presenting what our actors have always asked for in their work: methods and ideas that are useful for explaining what it is that they do. I remember the master playwright Charles Fuller once saying to me that Black playwrights did not have enough Black critics to assess their plays. Without this type of knowing criticism, it is likely that the White critics would see and not see or think they know and not really know the inside working of the actors' intense inner contradictions, expressions or methods of delivery. We are a world people and our growing repertoire of literature and actors carrying out the wishes of the writers and directors will become even more important in years to come. Luckett and Shaffer have made their work our work and they have achieved the highest aim of the professional life: to create the rubric that defines what comes next.

<div align="right">Molefi Kete Asante, author of The Dramatic Genius of Charles Fuller,
and founder of Afrocentricity</div>

Acknowledgments

God, for bestowing us with talents and tenacity to see this project to fruition. We seek to praise you in all the work that we do.

Sharrell: Jamia, I look up to you and your many accomplishments. You have always been my Valedictorian. Jay, thank you for being the perfect big brother and to Uncle Luckett, Aunt Gloria, and all of my family in Florida, thank you for being pillars of strength.

Tia: Much gratitude is due to Evans and Nita Shaffer for their unwavering support of all my educational, professional and personal endeavors. Likewise, I am grateful for an understanding and loving daughter, Eden, for bearing with me during countless nights and weekends in which I often recited, "Mommy has work to do." I am thankful for my friend and colleague Sharrell Luckett for the opportunity to share the journey of editing this anthology. I would also like to acknowledge Freddie Hendricks, whose legacy and influence inspired this great work.

Sharrell: Tia, I have always admired your talent and I am happy to call you a friend first. Through all of the conversations, vegan wraps and caramel cakes we are still here and maintaining.

Ben Piggott, thank you for spending time with me a couple of years ago and believing in and supporting the vision for this project. Thank you Kate Edwards and the staff at Routledge Publishing for believing in this work.

Sharrell and Tia: Bryant Keith Alexander, Shirlene Holmes, J. Michael Kinsey, Daniel Banks, Rahbi Hines, Esther Terry, Debi Barber, Cheryl Black, Jeffrey Dickerson, Heather Carver, Guy Thorne, A. Wade Boykin, and Kym Moore: We are indebted to you for your generosity, feedback and encouragement during this process. The many emails, conversations and connections proved so helpful.

Molefi Kete Asante, you are an exemplar and pioneer of Afrocentric scholarship. Thank you for supporting us and for sharing in this significant work.

To the contributors and practitioners who graced us with their presence and talents in this book, the work that you have compiled is a blessing, and we are eternally grateful to share a space with you.

Freddie, you are one of the main reasons as to why this book exists. Thank you for taking me (Sharrell) by the hand in 9th grade, and ushering me into the theatre to watch you teach and direct. God works in mysterious ways. I was singled out for all the right reasons. Thank you Freddie for taking me (Tia), a potential-filled caterpillar and nurturing me into a butterfly capable of soaring into the stratosphere. Love you always.

Dawn Axam, you always told us we could dance and gave us the training that we needed to "believe" that we could choreograph, and we do! Dr. Doris Derby, you provided a space for TheaRadical and championed our efforts even after graduation. Dr. Shirlene Holmes, you modeled for us a Black woman who is fearlessly opinionated, highly educated, chicly fashionable and revered all at the same time. We are so grateful to have studied with all of you and honored to call you mentors. Much love.

And to our many students, all over the world now; salute! Continue to shine!

Introduction

The Affirmation

Sharrell D. Luckett and Tia M. Shaffer

> I hope that now you can trace your cultural ancestors all the way back to
> the people who could fly.
>
> (Glenda Dicker/sun[1])

The nature of pedagogy is grounded in the questions of what to teach, why
to teach it, and then how to teach it. The answers to these questions reveal a
complicity of intentions, a foregrounding of particular histories to perpetuate
particular realities at the expense of other realities and futures. *Black Acting
Methods: Critical Approaches* is a book designed to respond to these questions
relative to Black/African ritual, processes, and methodologies to acting;
grounded in theories of Afrocentricity with historical roots in African cos-
mologies. This book posits an African-centered origin to theatre and theatre
making that broadens the theatrical canon and provides a culturally-specific
contribution to performance pedagogy.

In a perfect world, we would like to believe that our acting classrooms
contain culturally diverse theories and approaches to replicating humanity,
various species, and inanimateness. Yet, this is not the case, as most acting
classes in the United States of America operate within a Eurocentric theoret-
ical framework of performance, while ushering actors through the explora-
tion of emotionality and embodied renaissances. Often times, in the majority
of U.S. acting classrooms, just like in other subject areas, White-ness overtly
and covertly pervades the texts and linguistic structures, and those who do
not share a White lineage or hue are de-centered, misaligned, and exiled from
a theatre history that they rightfully co-constructed. For instance, though
there are multiple theories on the origins of theatre, the one that places the
origins of theatre in Africa is rarely told, and the one that is most taught
begins with the Greeks. However, long before the Greeks, wall paintings and
drawings in African caves suggest that humans participated in spiritual rituals
that were theatrical in nature. The shamans (actors) dressed in religious cloth-
ing (costumes) and enacted rituals (scripts) to the tribal members (audience).
It was also common for men to share stories of their hunting adventures.

Additionally, tribal members engaged in dancing and singing in religious ceremonies to the gods. Egyptian (African) Passion Plays performed along the banks of the Nile River were some of the first recorded plays, dating back to 2000 BC.[2] It has even been suggested by Carlton and Barbara Molette that the advent of stage decorations can be traced back to ancient Africa.[3] Further, many acting spaces do not point out that the most common formations and activities in acting classes are in fact ideologies borne of African thought and ways of understanding the world, such as the formation of the circle, improvisation, ensemble (community) building, vulnerability, and the combination of acting, dance, and song, i.e., musical theatre. Armed with this history, let us imagine that the same folks who constructed the pyramids and created math and science also, while in the preparation phases for the African religious rites and rituals, deployed theories about performance, such as how to approach character building, how to connect with their audience, and how to be fully present in each moment. Yet, affirmations signaling the extensive contributions of Africans and African Americans to Western acting theory have been systematically excluded from many of our textbooks. For us, this gap is the vein of thought where *Black Acting Methods: Critical Approaches* is birthed and lives.

Black acting methods are defined as rituals, processes, and techniques rooted in an Afrocentric centripetal paradigm where Black theory and Black modes of expression are the nucleus that informs how one interacts with various texts, literary and embodied, and how one interprets and (re)presents imaginary circumstances. To this effect, *Black Acting Methods* seeks to: (1) honor and rightfully identify Blacks as central co-creators of acting and directing theory by filling the perceived void of Black acting theorists, (2) uplift, honor, and provide culturally relevant frameworks for Black people who are pursuing careers in acting, (3) provide diverse methodologies for actors and teachers of all races and cultures to utilize, and (4) highlight performance practitioners' labor in social justice issues and activism. We call for more critical spaces in acting classrooms for students to have the privilege to engage with methods and techniques borne of Black lineage and culture. Further, as a direct response to Africans being co-constructors of acting theory and participants in the earliest forms of theatre, it would make sense for acting and directing practitioners to collectively turn our attention to *Black Acting Methods* as a means to un-earth, celebrate, and critically engage with artistic performance practices ontologically and empirically grounded in Black thought. Thus, *Black Acting Methods* is indeed a text for all actors, simultaneously paying homage to Black pedagogy while highlighting the need for more culturally and racially diverse perspectives in acting classrooms.

Though acting and directing are often listed as separate fields, they operate as artistic siblings, as directors have to understand acting to work with actors, and actors often direct themselves. To this point, acting and directing at times are interchangeable. So in this book, we speak simultaneously to actors and

directors because at times both share similar if not equal responsibilities in the teaching and doing of acting.

It is most appropriate for Molefi Kete Asante to provide the foreword/ blessing as he is often cited as the "Father of Afrocentricity." Asante defines Afrocentricity as "a paradigmatic intellectual perspective that privileges African agency within the context of African history and culture transcontinentally and trans-generationally."[4] Thus, Afrocentricity argues for the centering of Blackness and Blacks in their education.[5] This centering is critical to identity building and for the express purpose of Blacks to exact agency in their own history. Yet this has not been the case for Blacks in acting; as in the majority of U.S. acting classrooms and awards ceremonies, Black contributions and successes are either conveniently absent, appropriated and expropriated by culture vultures, relegated to one section of African American theatre, or wrapped into a short month. Supporting points are deftly made in Cristal Chanelle Truscott and Tawnya Pettiford-Wates's offerings. Together, we are invested and vigilant in responding to nuances and scripts that perpetually alter and/or eliminate Black history and values. So, just like the students, majority Black, who are participating in nationwide protests over racial disparities and inequities on college campuses, demanding teachers who look like them and who are profoundly invested in their diverse interests and success, we are taking ownership of our stake in acting theory in higher education as we re-center Blackness.[6]

Pedagogues, such as Paul Carter Harrison, Barbara Ann Teer, Amiri Baraka and several contributors in this book, have long discussed the need to center Black students in their own acting education. So do not look for us to link Black acting methods to European acting practitioners in this introduction, though you will find those connections in some of the chapters. In true Afrocentric form, we are privileging Black thought, space, and time. And in this space, in this moment, the focus is on critical approaches to acting grounded in rich Africanist ideals. By critical we not only mean well thought out, practiced, and prescribed methodologies rooted in Afrocentric thought, but also critical in that these approaches collectively evidence an inveterate need to highlight the reciprocal relationship of art and activism. Asante points out, "The Afrocentric paradigm is a revolutionary shift in thinking proposed as a *constructural* adjustment to Black disorientation, decenteredness, and lack of agency."[7] Here, Black acting methods, rituals, and/or processes are centered and deployed as theory and practice foregrounded in the fertile lineage of Black ancestry.

Methods, rituals, and processes are not mutually exclusive, though they can be categorized as separate at times. In reference to Black acting methods, ritual signifies a connection between the material world and the spiritual world. Rituals are recursive patterns and actions embedded in acting spaces that enact processes and methods, often moving toward product, which is never fixed. Harry Elam also offers, "As both symbolic mediation and

signifying practice, ritual intends to affect the flow of history and the alloca-
tion of power in the universe."[8] By processes, we mean a certain set of steps,
non-linear, that are taken to allow the cast to arrive at a place where the fluc-
tuating product is deemed ready for presentation by the director or actor.
Methods are defined here as certain steps or rituals to "get at" something.
Thus, processes and rituals may or may not be interchangeable in one's work,
may be coined as a method when one feels their process and/or rituals are
unique, and can share their steps with others. In this way, the work covered
in this book are methods, with processes and rituals found within them, and
these methods may be utilized by doers, makers, and teachers of performance.

In an obscure documentary titled "Our Father Who Art in Blackness"
Amiri Baraka spoke to the necessity of Blacks from all walks of life to join
together to advance Black liberation, as he offered:

> As long as you think "Black" is some kind of single ideological persua-
> sion you're gonna clash, but when you find out that it is actually a united
> front and you are gonna have to struggle with people [Blacks of the
> diaspora] then that's when you can make some motion because a united
> front is what we need.[9]

Fittingly, during our journey with this anthology we discovered, like many
Black scholars have, that identifying as Black or African American can
mean different things for different folks. So while all of the methods
anthologized are situated firmly in Afrocentricity, all of the contributors do
not identify as Black/African American. Within our diasporic alliance,
however, we all share phenotypic, embodied similarities of what it means
to "look Black" in the U.S., with a range of histories, hues, and hair types,
and a mastery of code switching. As such, we share similar lived experi-
ences of the joys, successes, and traumatic experiences of people who have
been labeled Black, and for the majority of us the U.S. is our primary
home. To this effect, the scope of this anthology is both pragmatic and
personal. While we recognize that there are many people worldwide that
have Africanist ways of approaching acting, it would be difficult to include
them in one book. So we focus on work primarily being done in the U.S.
because we have a firm grasp on what is taking place in many acting spaces
and places through conversations with our high school and university stu-
dents, conversations with working actors, and the lived experience of being
actors and teachers. The scope is also personal in a sense in that we (Shar-
rell and Tia) were both born in Atlanta, GA, and both identify as African
American/Black, being decendants of West Africans who were enslaved in
the U.S. In this way, it was natural to use African American and Black
interchangeably in this book, as many of the contributors do as well. Both
labels encompass people of African descent who may or may not be the
offspring of enslaved Africans in the U.S.

In almost every major academic work on Black expression, scholars such as Zora Neale Hurston and W.E.B. Du Bois have theorized on Blackness, highlighting the construction of, protean quality, and unfixed location of Blackness. These ruminations have unequivocally extended into what defines the Black aesthetic and what constitutes a Black person. While "adjectives lay on top of adjectives" as Black folks "theorize the theory" out of Blackness where it rightfully so becomes the color of the "Black" crayon, these theoretical contributions are not yet able to effectively challenge the lived experience of being labeled phenotypically Black in the field of acting. For actors who are perceived as Black, White supremacy often controls and dictates what representations are allowed visibility, and because of this phenomenon "Black" actors are often pigeon-holed within a limited barometer of what is perceived to be Blackness. The perception and expectations of Blackness in the field of acting is that there is a skin variation of dark to light skinned, a kinky gorgeous coil of various textures is expected, sometimes altered by a wig, lace-front, or a sew-in, and we are expected to have vocal and movement genius with features of African and European ancestry combined in various ways. Period. While these expectations are at once beautiful and rife with problems, they are the expectations that Black actors often work within, and know all too well, from "ghetto to boojie." Still, historically folks who are Black and who look Black find ways to wield their agency and refute or at times delete these expectations all together. Hence, Blackness is uniquely complex to actors who look Black, as they must navigate expectations, identities, perceptions, and stereotypes, while embracing all of its intricacies. Truth is, *we all mixed*. And though race is constructed, that discourse has never seemed to help the conversation on ending oppression and advancing the oppressed. So get in where you fit in beautiful Black people (broadly constructed and diasporic).

And finally, we will continue to employ the word "race" throughout this text to acknowledge those who understand race to be a central factor in how they experience the world and who experience constructed racial stereotypes in casting choices that are exacted in the entertainment industry.

Organization of the offerings

Proudly existing in the same ancestral realm as Theatre of Being (Frank Silvera), Teer Technology of the Soul (Barbara Ann Teer), and the Theatrical Jazz Aesthetic, in that these performative frameworks signal a profound commitment to humanity, self-actualization, and freedom, this anthology proves conceptually unique because compiled for the first time are acting methods that orbit and privilege African thought, and are identifiably planted in Afrocentricity and the African American/Black aesthetic.[10]

We chose to call our chapters "Offerings" because this term is more appropriate to our alignment with Black/African customs and culture, as the notion of giving is innately ingrained in the "fiber of our being."

For the purpose of thematically linking pedagogical methods, we draw upon the work of education scholar A. Wade Boykin. In 1986, Boykin published a chapter which succinctly outlined what he believed to be central components of African American culture, deeply influenced by West African culture. He asserted that emotion, cyclical time, and oral culture are highly valued, and indicated that it is possible to be individualistic while maintaining a communal existence. Boykin identified nine interrelated dimensions of connections that he believes impacts African Americans' expressive behavior, as he suggested that these dimensions should be deployed when educating Black students, albeit we do not use them here to undermine the diversity prevalent in Black culture. The dimensions, sans hierarchy, are spirituality, harmony, movement, verve, affect, communalism, expressive individualism, oral tradition, and social time perspective.[11] In line with one of our goals to provide culturally relevant frameworks for Black actors, we were not surprised to find that many of the tenets Boykin cites are found in all of the offerings, with spirituality and communalism recurring as significant themes. Though we do not delineate the offerings by these tenets, we feel it important to identify them as the reader will come to find them in various ways in the practitioners' work.

This anthology includes ten offerings that highlight theatre practitioners who employ(ed) Afrocentric perspectives in performance spaces and classrooms. These offerings span the gamut of providing founding facts about theatre practitioners to describing acting exercises that can and should be practiced in the classroom. However, this anthology is not so much a "how-to" guide, as it is an evidentiary document and historical archive that Black perspectives on acting exist, are being documented, and deserve monograph length studies which seek to further detail and solidify the practitioner's methodology. The offerings, written either by the progenitor of the work or by scholars who study the work, seek to begin a conversation for theatre lovers and acting teachers on how to make this history and practice of racially and culturally diverse entryways into acting more readily available to theatre students, and to signal the importance of this type of material, all providing a historical lineage of the impetus of the work and the fertile ground from which it sprang. Thus, *Black Acting Methods* serves as a vehicle to begin dissemination of culturally diverse methods, processes, and rituals that we hope will be utilized by actors, acting teachers, and directors. We position this work to be a part of the past, present, and future in and outside of the Academy, as we join a rich lineage of theatre practitioners who have made bold strides in chronicling and preserving Black theatrical history in literary, mediated, and embodied forms, such as Glenda Dicker/sun, Harry Elam, Paul Carter Harrison, Carlton and Barbara Molette, Kathy Perkins, Sandra Richards, Lundeana Thomas, Harvey Young, and Woodie King Jr., to name a few.

Though each of the methods have overlapping themes and values, we separated them into three categories: (1) methods that expressly focus on social

activism with underserved populations, (2) methods and strategies that seek to help Black actors and non-White actors embody material written for White actors or historically played by Whites, and (3) methods grounded in Afro-centricity that exact a culturally pluralistic, global orientation. To this effect, "Methods of social activism" features four practitioners who produce(d) work with strong social activist and social justice viewpoints. "Methods of inter-vention" includes two chapters that re-imagine what it means for Blacks to encounter traditional White texts in acting classrooms and on the stage, and also features a chapter on directing new plays for the theatre with an Afro-centric perspective. Finally, "Methods of cultural plurality" features the work of practitioners who ground their methods in Afrocentricity, while also acknowledging the global dynamism existing in multiple cultures, and how cultures create art that is in strong conversation with one another. These cul-tural artistic connections often define new terrain in the arts, such as Hip Hop Theatre.

As Daniel Banks discusses in offering eight, though acting curriculums in the U.S. acknowledge a few methods outside of the Eurocentric canon, such as the work of Tadashi Suzuki and Richard Schechner's Indian-influenced Rasaboxes,[12] educational institutions have not fully embraced the notion that there are varied and culturally diverse ways we can and should teach students to embody characters, analyze dramatic scripts, work without scripts, and engage with(in) performance theory. Even when Black American acting teachers Susan Batson and Baron Kelly published their books on acting, their thoughts were firmly rooted in a Eurocentric thought-stream of embodiment. Batson's book, *Truth: Personas, Needs, and Flaws in the Art of Building Actors and Creating Characters* (2007),[13] expounds upon how she helps actors authentically portray characters; and Kelly's book, *An Actor's Task: Engaging the Senses* (2015),[14] provides a plethora of exercises for the novice to advanced actor. Though Batson and Kelly's work are excellent additions to the acting canon, they center White practitioners as agents in acting theory. For instance, while Batson acknowledges that theatre began in Africa, she credits a re-birth of the actor to the Greeks and pronounces all actors as "children of Thespis of Icarus."[15] What is interesting though is that, as she works to pay homage to classical Greek theatre, she inadvertently describes how the Greeks "broke" the circle with their audiencing, yet she begins with a discussion of the circle and her work with the circle, evidencing the appropriation of the circle in Eurocentric acting methods. And while Baron Kelly's book offers a wealth of useful exercises, his offering rests upon the teachings of Stanislavski and Chekhov as he provides an overview of their contributions to acting before launching into his book of exercises. So while both Batson and Kelly's books are groundbreaking because they are among the first Black practitioners to author books on acting, their approaches are rooted in Eurocentricity. With this how can all actors possibly present an authentic representation of human-ity through a racially monolithic thought-stream? Further, what does it mean

for "colored" bodies to engage with emotions and circumstances tampered with, finessed, and/or extrapolated by the oppressor? August Wilson ostensibly commented on this conundrum in theatre when he proffered:

> We cannot share a single value system if that value system consists of the values of white Americans based on their European ancestors. We reject that as Cultural Imperialism. We need a value system that includes our contributions as Africans in America.[16]

Thus, *Black Acting Methods: Critical Approaches* is invariably a response to Wilson's call.

Methods of social activism

> Not everything that is faced can be changed, but nothing can be changed until it is faced.
>
> (James Baldwin)

> I'm sick and tired of being sick and tired.
>
> (Fannie Lou Hamer)

There is much work to be done to continue the success and celebration of Black culture and Black peoples. It is true that the Black existence in the United States is equally one of joy and pain. Since our ancestors arrived on these shores we have upheld values of family, love, and triumph, while at the same time combated atrocities and injustices imposed upon us in response to our success and survival. Art has long served as a central medium to empower our people and address issues within and outside of our communities. More often than not Blacks have attended to serious matters with their artistic sensibilities, wielding art as agency. And still today this legacy continues as Black artists who are otherwise silenced in the margins find voice to speak about social issues within the pages of their plays or within the lyrics of their songs. In this way, this section highlights the work of practitioners who tackle(d) social justice topics with underserved populations such as women in the penal system and Black youth. Three of the four offerings in this section are associated with theatre companies: the Freddie Hendricks Youth Ensemble of Atlanta, Progress Theatre, and the Medea Project, respectively.

In the first offering, Sharrell D. Luckett and Tia M. Shaffer begin the conversation of social activism with a thorough exploration of three tenets of the "Hendricks Method," inclusive of reflections from the Freddie Hendricks Youth Ensemble of Atlanta alumni, most of whom are theatre professionals. Both authors, former students and current practitioners of the Hendricks Method, provide a vivid picture of how Freddie Hendricks, a director and actor, trained young African American actors who were regarded as "at-risk"

and/or underserved due to socioeconomic factors. Hendricks founded the Freddie Hendricks Youth Ensemble of Atlanta (YEA), now aptly known as the Youth Ensemble of Atlanta. Under his artistic direction, YEA devised over seven full-length musicals that address social justice topics, such as crime amongst Black youth, apartheid, and the HIV/AIDS epidemic, within an Afrocentric framework.

Next, Cristal Chanelle Truscott outlines "SoulWork," a method she created and developed as founder of Progress Theatre. "SoulWork" is a philosophy and comprehensive methodology for creating theatre based on African American performance traditions and aesthetics. This chapter provides a blueprint for how "SoulWork" employs a cappella musicals, also called "Neo-Spirituals," to communicate the urgency of survival, identity, and autonomy for African Americans. Furthermore, this offering discusses the beginning of Progress Theatre, and connects "SoulWork" to the history, legacy, and rigors of cultural institution training, calling for diverse acting pedagogy that serves the need for students of color to be artistically challenged.

Within the pages of the third offering, Rhodessa Jones, the multi-faceted performer, teacher, and writer, whose life and legacy point toward empowering incarcerated women, shares "Nudging the memory: creating performance with the Medea Project: Theatre for Incarcerated Women." Jones discusses the founding of the Medea Project and outlines the uplifting trajectory of her performance-making program specifically for women inside penal institutions. She also instructs readers on specific exercises that can be utilized in the theatre classroom and/or programs with incarcerated populations.

Lisa Biggs, theatre and performance studies professor, introduces readers to theatre director Rebecca Rice's innovative, improvisational methods in "Art saves lives: Rebecca Rice and the performance of Black feminist improv for social change." Here Biggs, who served as a co-facilitator of Living Stage Theatre's Crossing the River program, led by Rebecca Rice, recalls how Rice used improvisational methods steeped in Black feminist thought to empower women recovering from addictions. In offering this case study, Biggs seeks to broaden discussions about Black acting techniques with examples grounded in feminism, communal, and improvisational art practices.

Methods of intervention

> I ain't never found no place for me to fit. Seem like all I do is start over. It ain't nothing to find no starting place in the world. You just start from where you find yourself.
>
> (August Wilson: *Joe Turner's Come and Gone*)

We (Tia and Sharrell) know a "thing or two" about interventions. We were both born and reared in Atlanta, or what is affectionately known as the "Black Mecca." Instilled in us is a strong sense of Black pride and propensity

for higher education. After being trained together under the tutelage of acting teacher Freddie Hendricks at Tri-Cities High School for the Visual and Performing Arts, a predominantly Black institution, we both enrolled at Georgia State University (GSU), seeking to nurture our artistic impulses and further our education (Intervention #1). Because we did not sense a warm welcome into GSU's mostly White chartered theatre club and did not care to perform in plays written by Whites—and only a few Black students were cast in the theatre program's productions—we further intervened.

At the behest of a classmate, Chiwuzo Ife Okwumabua, and under the mentorship of acclaimed African American playwright Dr. Shirlene Holmes, we re-chartered the Black Student Theatre Ensemble (Intervention #2) and performed under the moniker of TheaRadical (Intervention #3). We were automatically distinct because of our Blackness, but with our new name our primary goal was to produce plays and musicals on our own terms. TheaRadical quickly became a popular entity on campus and a space for Black artists to commune together. After producing *Don't Bother Me, I Can't Cope* (1999) by Micki Grant and *Shakin' the Mess Outta Misery* (2000) by Shay Youngblood, TheaRadical began the rehearsal process for Rodgers and Hammerstein's *Cinderella* (2001). Sharrell was the director, and Tia was Cinderella! To our dismay, we discovered we could no longer perform *Cinderella* because we could not afford the royalties; and besides, we knew we could just write our own version (Intervention #4). Having trained in what is now known as the "Hendricks Method" we were certainly equipped to accomplish this feat.

Sharrell wrote the book and Ife (Chiwuzo) wrote the majority of the lyrics and melody, while Justin Ellington, now a Broadway composer, provided the scoring, as he plays piano by ear. Ronnie Campbell, now a Broadway Stage Manager, served as our Stage Manager. The product evolved into a Black, non-urbanized Cinderella, who had no fairy godmother but, instead, summoned her connection with her deceased parents (ancestors). And just before walking off into the sunset with her Black Prince Charming, she excuses him from the room for a moment so that she can give her evil stepmother a "piece of her mind." (Interventions #5–#10). Our *!?Cinderella?!* made history at GSU, as we were an all-Black cast performing to a two-week sold-out run. Word on the street was that GSU hadn't had a sold-out show since the 1960s.

As Black artists, we are intervening in theatre more often than not. Be it unhinging stereotypes, writing our own works, and founding our own theatres so we can have self-actualized roles, or working to merge our Black identities with that of White characters or words from non-Black playwrights. We are perpetually intervening. Thus, it is no surprise that several theatre scholars wrote about their interventions in this anthology. Such interventions are critical for all actors of color, as they often play roles that are historically written and embodied by Whites. Subsequently, actors and directors are primarily taught to analyze plays using one Eurocentric dramatic form, as if

plays cannot have alternate structures. To this effect, "Methods of intervention" features offerings from Justin Emeka, Tawnya Pettiford-Wates, and Clinnesha Sibley. Their approaches highlight the pivotal role that cultural rooting plays in the rehearsal room, and the importance of establishing cultural context when working with actors and playwrights.

As U.S. theatres continue the necessary task of culturally diversifying, Black actors are being offered more roles that have been traditionally portrayed by Whites, calling for theatre practitioners to seek out techniques to help non-White actors embody these roles with an understanding and conviction that culture and race is not lost within this process. For instance, Shakespeare productions are sites where Black bodies are inhabiting roles more frequently, whether or not the cultural nuance is changed or even considered in the vision of the production. Thus, these chapters all call for explicit cultural connection in rehearsal and performance spaces when working with Black and non-White actors on European texts.

In the fifth offering, "Seeing Shakespeare through brown eyes," Justin Emeka addresses the reality of actors portraying roles not traditionally written for their culture or race, lending specific attention to Shakespeare's plays. With an eye-opening account of his personal experience as a cast member in *Our Town*, Emeka seeks to explicate the need for cultural conversations during the rehearsal process while putting the idea of color-blind casting to rest.[17] Emeka also thoughtfully prescribes steps to help Black actors reimagine themselves portraying Shakespearean roles, and offers strategies to ingest and portray Euro-classical material.

Calling for "transformative processes to evolve with the academy," Tawnya Pettiford-Wates offers "Ritual Poetic Drama within the African Continuum: the journey from Shakespeare to Shange." Here, Pettiford-Wates engages in a critical discourse on how traditional acting classrooms have alienated students of color, as she espouses the importance of culturally relevant materials in the academy. Her methodology, "Ritual Poetic Drama within the African Continuum," is a holistic, Afrocentric process in acting geared towards community building and acknowledging cultural specificities when developing an actor's tools. She offers practices and exercises directors might apply when directing African American actors in academia.

With "Remembering, rewriting, and re-imagining: Afrocentric approaches to directing new work for the theatre," Clinnesha Sibley provides a unique course of action for directors who are working to develop new plays by Black playwrights. We included Sibley's work in the anthology to explicate the fact that the role of the actor, director, and playwright are interrelated, as each role affects the efficacy of other artistic parties involved. To this effect, Sibley rightfully centers the voice of the playwright who seeks collaboration from the director and actor to aid in cultural staging and representation of their liking. Topics presented include interdisciplinary approaches to preliminary director/playwright conversations, rewriting exercises that do not diminish or

eliminate all things African, and discussion techniques that help actors authentically examine the codes and cross-cultural psychology of their characters.

Methods of cultural plurality

> ...a "black play" can be seen as one that invites everybody to the table ... with this definition ... the Work will make the Change.
>
> (Suzan-Lori Parks[18])

Being that humanity sprung from the loins of a Black person, we are all, in various ways, Black. Black culture historically has served as a locus of unity, power, and healing, often bridging ethnicities together. We are a people of community, and this is evidenced in our inclusive nature. Likewise, this section features methods/processes where participants from various ethnicities and heritages are co-constructors, facilitators, and participants in techniques and knowledge rooted in a Black/Africana perspective. The authors and their work are global, as they share about Hip Hop pedagogy, work with the Indigenous peoples of Australia, and remix Theatre of the Oppressed with Hip Hop Theatre. These offerings signal the transforming impact and lasting impression that Black peoples have on the universe, as they point toward what we might look to in the future of acting, directing, and performing arts pedagogy. In a society where historically marginalized ethnic groups are swiftly becoming the majority, these chapters speak to ways in which we might work together, as practitioners striving for spaces of freedom, artistic pluralism, and diverse ways of engaging how one might go about creating work for traditional and non-traditional performance spaces.

In the eighth offering, Daniel Banks presents a dynamic discourse titled "The Hip Hop Theatre Initiative: We the *Griot*." The major part of the chapter describes the pedagogy/creative methodology and elements of creating devised Hip Hop Theatre. Additionally, Banks shares his success with the Hip Hop Theatre Initiative (HHTI), its global impact, and provides exercises to employ and build upon in the classroom. This chapter signals the pluralism unique to Hip Hop and Hip Hop Theatre.

"Kadogo Mojo: global crossings in the theatre" highlights Aku Kadogo's directing process and working style with actors, which is influenced by anthropology, dance, poetry, language, music, theatre, and encounters with various cultures, including Korean and Australian. Kadogo has merged her Afrocentrism, which is ruled by inclusion, with customs and practices gathered from the Aboriginal peoples of Australia in her work with the National Aboriginal and Islanders Skills Development Association (NAISDA) Dance College founded by African American dancer Carole Johnson. Kadogo, like several of the contributors, is a trans-global artist, as she connects Black American theatre with the works of Indigenous performance styles.

Finally, in "#UnyieldingTruth: employing culturally relevant pedagogy" the respective African American and Latina identities of Kashi Johnson and Daphnie Sicre converge to address their impetus for teaching theatre, and more specifically, their focus on teaching African American and Afro-Latino students. Kashi Johnson highlights her use of African American Hip Hop pedagogy to engage acting students, while Sicre shares how she remixes Boal's Theatre of the Oppressed with Hip Hop pedagogy.

Reflections from distinguished practitioners

We acknowledge that there are numerous Black directors blazing trails in the Ivory Tower as well as in regional theatres, on/off Broadway, in the churches, and on the streets, and in true communal fashion, we invited a select few of these dynamic practitioners to join the conversation on Black acting methods. With the eleventh and twelfth offerings, distinguished theatre professionals present a glimpse into the rituals, processes, and/or methods employed in their work. They also provide words of wisdom to actors, paying special attention to Black actors. Featured are Judyie Al-Bilali, Tim Bond, Walter Dallas, Sheldon Epps, Shirley Jo Finney, Kamilah Forbes, Nataki Garrett, Anita Gonzalez, Paul Carter Harrison, Ron Himes, Robbie McCauley, Kym Moore, Seret Scott, Tommie "Tonea" Stewart, and Talvin Wilks. We are honored to include their voices and perspectives on race and cultural diversity in the acting classroom, in the rehearsal spaces, and on the stages.

How to use this anthology

Inspired by our mamas, Shirlene Holmes, Dawn Axam and Doris Derby, to name a few, we (Sharrell and Tia) join the ranks of Black women who have vision, operate with(in) faith, and work to use our education to forge fissures of freedom. With our natural, pro-Black, at times Hip Hop feminist ways, we are here to add some flavor and soul to the mix. Ultimately, we anthologize to save acting classrooms from operating as one of the most culturally segregated places in the United States and to acknowledge that there are many ways for acting students to convey their "truth" of a character or "truth" of self in traditional and non-traditional performance spaces. We anthologize for the actors who continuously engage with "othered" material in classes, material never meant for them. We anthologize for the actors who astonishingly are able to lose their "color" in many productions, or the actor who is the queen/king of a re-envisioned tale, or the actor who is often cast as an anthropomorphic organism. We write for all actors who are robbed of having a culturally diverse education, for we can all benefit from the "warmth of other suns." Finally, we seek to empower all acting students, while at the same time rightfully centering Black students as co-creators in the theoretical underpinnings of what it means to perform.

Though this list is not exhaustive, we imagine this compendium could serve as: a central text for all acting programs, a central text for acting program faculty and directors who serve Black actors, a main textbook in courses on acting theories, a supplemental text in all acting classrooms, for all levels, and a resource to identify a multitude of prolific Black directors and scholars who are available for directing and teaching opportunities at acting studios and in acting programs, be it guest or long-term. Finally, supplemental interviews to this anthology will be published with another entity. Please visit www.sdluckett.com to obtain information about these interviews, which feature more voices from acclaimed Black actors, playwrights and directors, such as Trazana Beverley, John Shévin Foster, Bill Harris, Eugene Lee, Ron Simons, and more. Enjoy.

Notes

1 Glenda Dicker/sun, *African American Theater: A Cultural Companion* (Cambridge: Polity Press, 2008), 192.
2 For further reading on this history see: Nilgun Andolu-Okur, *Contemporary African American Theater: Afrocentricity in the Works of Larry Neal, Amiri Baraka, and Charles Fuller* (New York: Garland Publishing, 1997), xi–xxxiii.
3 Ibid., xix.
4 Molefi Kete Asante, *An Afrocentric Manifesto* (Cambridge: Polity Press, 2007), 2.
5 Molefi K. Asante and Ama Mazama, amongst other scholars, have published widely on Afrocentricity. See any of their works for a further understanding on this school of thought.
6 www.thedemands.org.
7 Molefi Kete Asante, "Afrocentricity," last modified April 13, 2009, www.asante. net/articles/1/afrocentricity/.
8 Harry Elam, *Taking It to the Streets: The Social Protest Theater of Luis Valdez and Amiri Baraka* (Ann Arbor: University of Michigan Press, 1997), 13.
9 "Our Father Who Art in Blackness," YouTube video, posted by "siraj6449," November 16, 2009, www.youtube.com/watch?v=P-JN1fBst54.
10 For further readings about Theatre of Being, Teer Technology of the Soul, and the Theatrical Jazz Aesthetic, please see these sources: Tommie Harris, "The Acting Theories and Techniques of Frank Silvera in his Theatre of Being," Ph.D. diss., Florida State University, 1989, WorldCat (28981061); Lundeana Thomas, "Barbara Ann Teer: From Holistic Training to Liberating Rituals," in *Black Theatre: Ritual Performance in the African Diaspora*, eds. Paul Carter Harrison, Victor Leo Walker, and Gus Edwards (Philadelphia: Temple University Press, 2002), 345–377; Omi Osun Joni L. Jones, Lisa L. Moore and Sharon Bridgforth, eds. *Experiments in a Jazz Aesthetic* (Austin: University of Texas Press, 2010); Omi Osun Joni L. Jones, *Theatrical Jazz: Performance, Áse, and the Power of the Present Moment* (Columbus: Ohio State University Press, 2015).
11 A. Wade Boykin, "The Triple Quandary and the Schooling of Afro-American Children," in *The School Achievement of Minority Children: New Perspectives*, ed. Ulric Neisser (Hillsdale: LEA, 1986), 57–92.
12 www.rasaboxes.org.
13 Susan Batson, *Truth: Personas, Needs, and Flaws in the Art of Building Actors and Creating Characters* (New York: Rugged Land, 2007).

14 Baron Kelly, *An Actor's Task: Engaging the Senses* (Indianapolis: Focal Press, 2015).
15 Batson, 9.
16 August Wilson, "National Black Theater Festival, 1997," *Callaloo* 20, no. 3 (1997): 483–492.
17 For further reading: Daniel Banks, "The Welcome Table: Casting for an Integrated Society," *Theatre Topics* 23, no. 1 (2013): 1–18.
18 Kevin J. Wetmore Jr., "It's an Oberammergau Thing: An Interview with Suzan-Lori Parks," in *Suzan-Lori Parks: A Casebook*, eds. Kevin J. Wetmore Jr. and Alycia Smith-Howard (London: Routledge Publishing, 2007), 139.

Methods of social activism

The Hendricks Method

Sharrell D. Luckett and Tia M. Shaffer

> What Freddie has done is nothing short of having created a new theatre method.
>
> (Jahi Kearse, Broadway actor[1])

For over 25 years, the Freddie Hendricks Youth Ensemble of Atlanta (YEA), a free professional acting company primarily consisting of African American/ Black teens, has devised socially relevant and politically charged musicals with youth employing the Hendricks Method. Since its inception, YEA has been supported and endorsed by major celebrity figures, such as Jane Fonda, Woody Harrelson, Bill Nunn, and Kenny Leon, and has showcased its work in South Africa, China, Holland, and Belgium. YEA received highest honors as a theatre maker when it was recognized by former First Lady Laura Bush with the Coming Up Taller Award, and awarded a coveted grant from the National Endowment for the Arts.[2]

The artistic feats of YEA members and alumni are extraordinary and progressive, considering that they work in a field in which roles for Blacks are limited and often detrimentally stereotypical. The Freddie Hendricks Youth Ensemble of Atlanta is the artistic home of Broadway and film actors, musicians, designers, and scholars. Featured here are some lifetime members' accomplishments. Kenan Thompson starred in Nickelodeon's "Kenan & Kel," as well as Fat Albert, and now works as a member of Saturday Night Live. Saycon Sengbloh appears regularly on Broadway. For her work in *Eclipsed*, alongside Lupita Nyong'o, Sengbloh was nominated for a Tony Award, and won a Drama Desk Award. Sahr Ngaujah starred as Fela Kuti in *FELA!* on Broadway, and received a Tony Nomination for his portrayal. Featured on the Real Housewives of ATL, Kandi Burress is also a former member of recording group Xscape. Composer, pianist, and nephew of Duke Ellington, Justin Ellington worked on Broadway's premiere of *Other Desert Cities*, and guest lectured at Princeton University. Juel D. Lane dances with Camille A. Brown & Dancers, and before that he danced with Ronald K. Brown/EVIDENCE dance company. Atlanta Ballet commissioned Lane as

the first independent Black choreographer from Atlanta to choreograph "Moments of Dis" on the company. Bringing her theatrical background to pop culture, celebrity make up artist and creative Day Byrd created the signature look of pop icon Nicki Minaj. Kelly Jenrette recently co-starred alongside John Stamos in his sitcom, "Grandfathered," on Fox. Charity Purvis Jordan co-starred as Viola Lee Jackson in the Academy Award nominated film Selma, and is Executive Producer and star of "Mommy Uncensored" which aired on Earvin "Magic" Johnson's network, Aspire TV. J. Michael Kinsey is a 2× Audelco Award Nominee and a doctoral student at Cornell University. RAHBI, a recording artist, was featured on VH1's "Make a Band Famous" and has performed with the likes of Erykah Badu and Janelle Monáe. Ronnie Campbell works as a Stage Manager on Broadway and internationally. Jahi Kearse performed on Broadway in *Baby It's You* and *Holler If Ya Hear Me*. Wanita Woodgett aka. D. Woods is a former member of P. Diddy's multiplatinum singing group Danity Kane. Duain Richmond starred as Fela in the world tour of *FELA!* Sharisa Whatley appears regularly with the St. Louis Black Repertory Company and was an original cast member of Tarell Alvin McCraney's *In the Red & Brown Water*. Theryn Knight founded MeiteKnight Design, a company that specializes in lighting and production design for celebrities. Neal Ghant, Christine Horn, Enoch King, Maiesha McQueen and others are leading performers in regional theatres throughout the U.S. In addition to these phenoms, scores more of "Freddie's babies" have appeared in a host of television shows, films, and global stages. YEA members have earned degrees from New York University, Carnegie Mellon University, University of North Carolina School of the Arts, Howard University, Cincinnati Conservatory of Music, Spelman College and University of the Arts to name a few. They have also attended Yale University, The Juilliard School and Cornell University. Further, many lifetime members have flourishing careers as theatre teachers and administrators. Yet, despite the members' achievements and impact on the theatrical community, scant attention has been paid to the ensemble or its founder in the academic theatre community.

Hence, in accord with the subject matter of this anthology, we turn our focus to the driving force and performance methodology behind the success of YEA artists: African American acting teacher and director Freddie Hendricks and the Hendricks Method. In this offering we succinctly discuss Hendricks's background, outline three of several tenets of the Hendricks Method: Devising, Spirituality, and the Hyper-Ego, and provide a brief overview of his repertoire with the Freddie Hendricks Youth Ensemble of Atlanta.

The Hendricks Method, developed while working with Black youth, is an amalgamation of empowered authorship, musical bravado, spirituality, ensemble building, activism, effusive reverence of Black culture, and devising, often sans script. In line with Afrocentricity, the methodology is purposefully infused with verbal and physical acts of positivity, such as uplifting speeches, pats on the back,

Figure 1.1 Freddie Hendricks (photo by Otis Gould).

or compliments about appearance and talent. This type of positivity is critical for minorities, as they encounter a certain set of experiences that include discrimination and prejudices at a very young age. Though the method has been and can certainly continue being used with actors of other races and cultures, its principles center Black acting students as centric-subjects in their lived experience of being a vessel and conduit of emotionality and being.

> Young people were crying out for help! [The vision] was definitely a spiritual experience; a sea of children crying out to be saved. They didn't say from what.
> My guess is the social ills of the world.
>
> (Freddie Hendricks[3])

Freddie Hendricks grew up in the era of the civil rights movement. He was born in Rome, GA in 1954, the same year that the landmark decision of *Brown vs. Board of Education* ensured equal opportunities in education for all U.S. students. Like many other African Americans, Hendricks experienced the positive effects of Black liberation and the Black Arts Movement. After graduating from Kendrick High School in Columbus, GA, he pursued acting at Lincoln Memorial University in Tennessee, earning a Bachelor of Arts degree in Theatre in 1976. He then sought work as a performer in major

cities, such as New York, Los Angeles, and Philadelphia. Eventually he decided to relocate to Atlanta and continue his acting career with such entities as Jomandi Productions and the Proposition Theatre.[4]

Upon moving to Atlanta, Hendricks was hired to teach drama to under-privileged middle and high school students in Morris Brown College's Upward Bound program, which is funded by the U.S. Department of Education. The program's main focus is geared toward mathematics and science education; however, they provide elective instruction in the arts as well.[5] From 1988–1989 Hendricks worked with the Upward Bound students, and program attendee Johnell Easter became the first member of what would become YEA. Easter writes candidly of his early work with Hendricks:

> Freddie began to take me under his wing and give me one-on-one acting lessons. After about a year of us hanging out, seeing theatre and meeting all of the great actors of the city, Freddie decided that he wanted to start a youth theatre company, with me being the initial member. This is essentially my first encounter with YEA, although that name hadn't yet been established. We were in the beginning stages of the company. During this developmental period we were actually called "Artistic Attitudes."[6]

In 1990 the Freddie Hendricks Youth Ensemble of Atlanta (YEA) was officially incorporated by Hendricks and his close friends, one of whom was Debi Barber. Barber and Hendricks met when Hendricks auditioned for Jomandi Productions. YEA was led by a team of theatre professionals that included Hendricks as Artistic Director, Barber as Managing Director, Charles Bullock as Choreographer, and S. Renee Clark as Music Director. In the same year, Barber accepted a job as the Audience Development Director at 7 Stages, a non-profit 501(c)(3)[7] theatre company with its own facilities, and whose mission has been to develop new plays and methods of collaboration since its founding.[8] When Barber observed the absence of summer programming, she suggested to Del Hamilton, the Artistic Director of 7 Stages at that time, that YEA utilize the theatre. Hamilton acquiesced, allowing YEA to produce a show at 7 Stages in the summer of 1991. He relished their work and invited the ensemble to be a part of the regular season, agreeing to include YEA as an affiliate of 7 Stages Theatre. This agreement was pivotal, in that it allowed YEA to exist as a tax-exempt organization and apply for grants and tax deductible donations even though they were not yet officially a 501(c)(3) organization.[9]

In 1993 Hendricks landed a second job as Drama Director at Tri-Cities High School for the Visual and Performing Arts in East Point, GA, serving a predominantly African American population.[10] With this new assignment, Hendricks now had access to a vast pool of talented and economically diverse African American/Black teens who were serious about studying acting. This

access to talent, along with solid leadership, caused YEA to experience rapid growth, as many Tri-Cities performing arts students joined YEA. Tia (as a Tri-Cities student and YEA member) and Sharrell (as a Tri-Cities student) trained with Hendricks in an acting methodology that is now known as the Hendricks Method. Tia performed as a lead in several of Tri-Cities' and YEA productions, while Sharrell mainly served in ensemble roles at Tri-Cities, and unintentionally blossomed as a theatre director by observing Hendricks.

As we (Sharrell and Tia) evolved into acting teachers and theatre directors, we found success emulating Hendricks's techniques in our classrooms, which compelled us to investigate his methodology in our graduate studies. Our research resulted in formal and impromptu interviews with Freddie Hendricks, YEA members, Tri-Cities alumni, and community stakeholders during parties, in cars, and even backstage on Broadway. Tia's dissertation, *Former Students' Perceptions of How Theatre Impacted Life Skills and Psychological Needs*,[11] includes substantial information about Hendricks's work with students, while Sharrell presented several papers on Hendricks's work during her doctoral studies. In 2014 Sharrell enlisted him to direct the world premiere of her one-woman show, *YoungGiftedandFAT*, in metro Los Angeles. Therefore, it is fitting for us to work together to introduce the Hendricks Method. Through our lived experiences, dissertating, and reminiscing with YEA members we began to understand how a large number of young and mid-adult Black actors and designers who trained with Hendricks found unanimous success in an industry that is often marginalizing. We also gained clarity in regards to practices and processes utilized in Hendricks's training methodology. With this, we impart the knowledge in this chapter through empirical data and experiential epistemologies.

As a concise, albeit thorough introduction to the Hendricks Method, we will expound upon three key tenets: Devising, Spirituality, and the Hyper-Ego. This triad is situated at the "seat of the soul" of the Hendricks Method, and signals what is to come in the upcoming monograph which introduces the entirety of the Hendricks Method and what it means to work in the Hendricks aesthetic. We begin with Devising in order to provide immediate insight into the way Hendricks works and to cite brief examples of the products created from his devising techniques. We then move to Spirituality, as this tenet is at the crux of his method. Finally, we suggest that Black actors must develop a "Hyper-Ego" because of their lived experience in the U.S., and we provide an example of Hendricks imparting such an ego in a young child. We end the chapter with an overview of the seven full-length musicals devised under Hendricks's artistic leadership with the Freddie Hendricks Youth Ensemble of Atlanta.

Devising: politics and the pot

I had just joined YEA and was very excited about being a part of the show. I went home and wrote a script and brought it into rehearsal the

next day. They skimmed it and then tossed it to the side. And it was like [the script] was the most foreign thing ever.

(J. Michael Kinsey, Audelco Award nominee[12])

Devising is a theatrical process in which the actor(s) create their own script or performance based on an idea, picture, theme, object, or some other form of inspiration. Within the Hendricks continuum, devising by nature is political, demands authorship from participants, and cultivates a collaborative, communal space, sans a written script. A survivor of child abuse and a witness to the pervasive attempt to exterminate his people, Hendricks sought out and found solace in the arts and understood early on that Black art is almost always inherently political. This particular politic was evident in his devising process. What makes Hendricks's devising unique is that he and YEA would often create full-length musicals with fragments of a written script. In his devising space, Hendricks believes that writing should be embodied and remain embodied, for when one writes, the script becomes dead; hence actors are always working to "bring the script to life." Hendricks's devising process is unique to Afrocentric values that signify the importance of orality and memory in Black communities. Thus, Hendricks has an "on your feet" approach where one takes notes in their mind, keeping the material fully embodied from conception to presentation. To that effect, full scripts for the majority of YEA's devised musicals have never existed. The ensemble members and design teams worked primarily off of embodied scripts, memory, and repetition. Under Hendricks's guidance, seven full-length musicals emerged, and one recurring Christmas holiday themed show: *Rhymes & Reasons* (1990), *Soweto, Soweto, Soweto: A Township is Calling* (1992), *School House Rocks* (1995), *Times* (1997), *Psalm 13* (1998), *B.L.A.C.K. – Better Left a Colored Kid* (1999), *Jekonni's Song* (2002) and the annual *Urban Holiday Soup*.

It always blew my mind that Freddie's ideology was all about self-created projects and teaching us how to put entire musicals together from scratch! It was truly amazing to be around people that talented at such a young age! And the singers, my God, so amazing! Freddie was a genius at finding and cultivating talent!"

(Kenan Thompson, Saturday Night Live[13])

Hendricks's role in the devising process with YEA was one of careful guidance. Based on what he, the artistic team, and the ensemble identified as an important social and political issue for youth at the time, Hendricks proposed a topic for the show. Hendricks compares his process of theatre to making soup, in which there are a number of different ingredients combined to form one meal. In Hendricks's world, everybody is a playwright, all voices matter, and ideas are thrown into an imaginary "pot of soup." He offered, "I brought in the subject we discussed and created. I usually

brought in an outline to fill in. The soup was my creation where all ideas were [welcomed]."[14] Vocal and instrumental music is integral to his devising process, and is arguably the starting point of his process. Thus, several YEA members were musicians, able to play by ear, and astute at creating harmonies. In this way, members had to practice non-conventional and conventional writing structure and songwriting structure in rehearsals. Hendricks also places great emphasis on researching the show topics. Company members were given home-work assignments related to the theme of the show which required them to compile statistics, books, and articles that would inform their artistic contributions.

At each rehearsal the members performed or presented their creations to the entire group, and Hendricks put their creations in the "pot of soup." Hendricks would then function as a kind of editor as he offered suggestions to the youth on how to improve their work. Through this feedback process, the members learned how to synthesize information and to develop original material into embodied scripts and songs. The entire company, along with the artistic staff, would decide which devised pieces would be performed in the show.

An ideal example of the ensemble's dedication to research and activism is the 1992 crafting of YEA's most notable production: *Soweto, Soweto, Soweto: A Township is Calling* (*Soweto*). In *Soweto*, YEA set out to highlight apartheid in South Africa, a legal system of racial segregation which paralleled the Jim Crow laws in the U.S. that were imposed on African American citizens. At age 15, YEA member Sharisa Whatley wrote a rap that evinces a clear example of how ensemble members synthesized and embodied their research:

> Soweto, Soweto, a township is calling/this city screams for peace for all the bodies that have fallen/the whole city is red 'cause justice is polluted/100 people are dead and a thousand more are wounded/apartheid is a poison slowly seeping in the skin/Soweto has affected all the people there within/Afrikaans was the language provided to hide it/racism, the virus supplied just to divide us/we're going through the same struggle in a different sector/we lost Emmett Till/they lost a boy named Hector/we tend not to care about foreign affairs/what's yours is mine/what's ours is theirs/so let's use our brains as a round tip/Soweto, that's a tormented township/fighting for freedom is Sharisa Whatley. I won't eat, I won't sleep till South Africa is free.[15]

Whatley uses vivid metaphors, such as her describing a red city screaming for peace. During an interview, Whatley stated that red symbolizes the blood shed by all the victims of the uprising. The end of her rap is also a prime example of how the Hendricks Method nurtures an authentically strong connection with the topic, for she has the wherewithal to end the rap, not as a character, but as herself fighting for equality, signaling a merging of her identity with the character's. Both clearly have real investments in ending the injustices in South Africa.

Chiwuzo Ife Okwumabua, a second-generation Nigerian in America, and a young actress at the time, created a still coveted solo role in *Soweto*. Here she describes how her particular song was devised:

> Originally [the song] was a spoken line and when Freddie was audition-ing for the part he was going "down the line" and gave everybody the line to say. They were playing the drums. Everybody was singing. It was still being performed as a line and then because I was familiar with the sound of Africa and the melodies, when I performed the line I decided to sing it and then from there Freddie started to work on the piece at that very moment, and he just kept having me say the line and sing it over and over again and kept saying "more, go there, more." And that's where the "oh yeah yeah yeah" part came from and "it sounds so beautiful." Through a lot of repetition new things were being added. And from there it became a musical number. It went from one line to a whole per-formance piece section.[16]

Finally, the fact that YEA devised productions speaks to Hendricks's being aware that one of the primary needs for marginalized actors/artists is the space to create their own work. Hendricks was aware that his Black actors would become fatigued with the lack of positive roles and the ubiquitous absence of their positive existence in mainstream entertainment, thus he ushered them through the process of learning how to create their own work so that self-created performances would be second nature. When one can't find a role, why not create one and produce it for oneself?

While we believe all actors should be trained in devising, devising and ensemble work is especially critical for Black actors so that they may have autonomy over their images, dialogue, and representation, and therefore devising is a critical component of training within the Hendricks Method.

Spirituality

> Freddie believes that when we embrace our gifts we are giving God praise. When we execute the creative task at hand, we collectively say amen or áse, or we are praised with an ajabu.
>
> (Rahbi Hines, recording artist[17])

In our Afrocentric imaginations, let's envision a village of elders taking their youth through a Rites of Passage journey, a process that denotes a change from passiveness to becoming active members of the community.[18] The elders and youth are singing, dancing, paying homage to the ancestors and learning lessons about life and contemplating ways to better their communities. Such rituals would closely resemble the practices of "Elder" Freddie Hendricks and the village of adults who nurtured YEA performers, and also encouraged

them to be aware of the ills in their communities and how to combat them with the arts. At the beginning of this chapter, we featured a quote from Hendricks regarding a vision that impelled him to "save the children." Every so often, Hendricks would tell the story of his vision, as a *griot* would in an African village. No matter how many times he told this story, it captivated the listeners. He recalls being wide awake in broad daylight in his home as a vision came to him. He saw the hands of children desperately reaching out to him imploring, "Save me, save me!" Visions are typically viewed as divine messages from God. In line with Afrocentric spirituality, Hendricks received a command from the deity about his mission, which was to save the children. Thus, Hendricks's Rites of Passage, grounded in spirituality, evoked civil responsibility, activism, and politics. Just as religious communities often engage in missions to feed the homeless, to clothe the naked, and to be good samaritans, Hendricks teaches that missions to help others can be accomplished using a spiritually rooted, artistic framework. In this way, spirituality is the nucleus of Hendricks's Method. It is the force that puts power behind the messages, the songs, the dances, and the organization itself.

Spirituality involves the supernatural, the precedence of mind over matter, consciousness of the spirit, and emphasis on the immaterial. Spirituality resides at the crux of African culture. In fact, there are over 3,000 African tribes, each having their own religious systems. African civilizations practice religion as a means of coming in contact with the gods and becoming one with their communities and the universe at large. Though their practices and beliefs might differ, there is one commonality, which is the belief that all of life is sacred. To this effect, spirituality brings oneness to the ensemble when creating, rehearsing, and performing. Of course, the belief is that the Spirit will always lead in the right direction. The Spirit is also a sustainer and comforter in the life of many Black artists when facing challenges in the industry. It is that same Afrocentric spirituality that causes Black artists to remember who they are and where they come from. Such grounding enables one to honor self-identity that is rooted in cultural identity. One with a spiritual/Afrocentric foundation is likely to choose theatrical endeavors that empower and uplift the community. Thus, for many people of African descent, it is almost impossible to isolate spirituality from other areas of life. African religious philosopher Mbiti notes:

> Wherever the African is, there is his [or her] religion: [s]he carries it to the fields where [s]he is sowing seeds or harvesting a new crop … or to attend a funeral ceremony; and if [s]he is educated, [s]he takes religion with him [her] to the examination room at school or in the university.[19]

Likewise, the Hendricks Method, being rooted in Afrocentrism, carries spirituality to the theatre. Next are some examples of how spirituality surfaced and informed Hendricks's work with YEA, as his devising process almost always produced spiritual or even biblical messages.

In 1998, I (Tia) was the lead character in *Psalm 13*, a production sponsored by Jane Fonda in her campaign to bring awareness to the teen pregnancy epidemic. The play title is taken from Psalm 13, a passage of Scripture in the Bible that laments:

> How long, Lord? Will you forget me forever? How long will you hide your face from me? How long must I wrestle with my thoughts and day after day have sorrow in my heart? How long will my enemy triumph over me? Look on me and answer, Lord my God. Give light to my eyes, or I will sleep in death, and my enemy will say, "I have overcome him," and my foes will rejoice when I fall.
>
> But I trust in your unfailing love; my heart rejoices in your salvation. I will sing the Lord's praise, for he has been good to me.

Further, "I Am Waiting," a song from *Psalm 13*, written by choreographer Charles Bullock, speaks of a heavy laden pregnant teen waiting for God to provide a solution to her problem. Some of the lyrics are, "I am waiting on a word from you Lord, a sign to let me know that everything's alright. Cause I don't know what to do until I hear from you."

Times (1997), a raw and unadulterated musical that brings awareness to HIV/AIDS, explicitly draws a parallel between the biblical character Job and individuals who are living with HIV/AIDS. One of the songs, "Like Job," references Matthew 5:11: "Blessed are ye, when men shall revile you, and persecute you, and shall say all manner of evil against you falsely, for my sake." Some of the lyrics are, "Like Job, living with leprosy, got no friends no family, but I got to keep the faith, but I got to keep the faith one more day."

Finally, in *Soweto*, YEA members boldly ask, "Why did God create a human being?" Such a question is asked by actors enacting roles of youth living through apartheid in South Africa. Their pain is so intense that it causes them to question how God could permit such a mundane existence. These are but a few examples of how the African concept of acknowledging, reverencing, and seeking God are ever-present in the work devised under Hendricks's leadership.

Spirituality and the circle

> Let the circle go unbroken, for it is the circle that connects us all, and keeps the energy flowing so that it sees no end.
>
> (Tia M. Shaffer)

The circle, which is a fortress in African thought, is a symbol of unity, inclusiveness, centering, and completion. For Hendricks, the circle encompasses all of the aforementioned concepts and more. The circle is the space where participants shared ideas while collaborating, rehearsing, and creating. As an

example, there was a "vibe" circle in which YEA stood together in solidarity, lending their unique sounds and rhythms into a bowl of sonic soup. In this sense, the circle was synonymous to a pot, as discussed earlier. Members provided the ingredients, and Hendricks was the chief chef, ensuring that all the ingredients yielded a masterful, culinary delight. Revisiting the concept of inclusiveness, everyone in the circle had something to offer, and all were expected to be on one accord, focusing their physical and creative energies into the center of the circle.

Then there is the prayer circle, which is one of the most ritualistic parts of Hendricks's rehearsal process. Each rehearsal ended with all members of the YEA family standing together, holding hands, making prayer requests, and supplicating the Creator. Those who prayed would often request protection and guidance through life, while also giving thanks for all things. Though members of YEA had divergent beliefs (i.e., Christianity, Islam, Agnosticism, etc.), the circle became a place of convergence where people of all faiths could focus in on the spiritual power of a universal God that could not be bound to man-made religions.

Finally, in African culture, there is the "circle of life" that coheres all members of the community: those unborn, those living in the earthly realm, and those ancestors who have transitioned to the celestial sphere. In honoring the ancestors, YEA members would occasionally do a communal pouring of libation that comprised of participants calling the names of ancestors while pouring water into a plant. As YEA surrounded the plant, all paid reverence to those on whose shoulders they stood, as they understood each part of their lives as sacred. Like Hendricks, other directors can certainly benefit from incorporating spirituality in their process and product, unashamedly invoking spirituality on the stage and in the classroom.

(Birthing) the Hyper-Ego

Most directors are about the piece. Freddie is about the person.

(Enoch King, actor[20])

Freddie planted a seed in so many of us that has given us a distinct walk and talk ... a *way* about us that people instantly know: *Oh, that's one of Freddie's kids.*

(Kelly Jenrette, actress[21])

That *way* is that Hyper-Ego.

(Sharrell D. Luckett)

Tia and I had just thrown a small party at my place for YEA alumni and Freddie.[22] Sometime after 2 a.m., as many were preparing to leave, Eden, Tia's then five-year-old daughter, sat near the foyer. In true Hendricks Method

fashion, Freddie knelt down close to Eden, for he knew it was not too early to instill in her a confidence like no other. I quickly turned on my recorder.

> Freddie: Fear, that's not a friend of yours. (He lifts Eden's chin up, and she is fixated on him.) And you always want to be around friends. Don't ever be afraid. If you don't get anything from tonight, know that! Fear is not a friend of yours. You know why? This is what's going to happen, Eden. In school, you know what? Other kids are going to come up to you in school and they're going to say, *Oh, that Eden, she blah, blah, blah* (mimics a negative gossiper). *Oh that Eden, she think she blah, blah*, and you say, "Yes. Yes, I'm great." (Eden appears to be in a trance.) Why? You say, because my mom told me I'm great. My grandmother, my grandfather told me I'm great. (His shoulders rise as he inflates with passion.) FREDDIE HENDRICKS told me I'm great. Because YOU are great. Don't you ever forget that. Ever. Ever!

Because Hendricks dealt primarily with Black actors in their adolescent years, we believe he felt it critical to instill in them what we term a "Hyper-Ego." Hyper-Egos are larger than regular egos. A hyper-egotistical performer feels like she can learn and accomplish any and everything of what is being asked of her in a production.

The Hyper-Ego involves a sense of fearlessness; it makes actors feel as if they can defy gravity. Perhaps this is a by-product of Hendricks's teaching that "can't" should not be a part of their vocabulary. Eboni Witcher, a Tri-Cities alumni and lifetime YEA member posits:

> [We were] not afraid to try anything ... I'm not afraid to go anywhere. And I think YEA and Tri-Cities gave me the courage of expression, like I'm not afraid to—to try to express myself as freely as possible, you know?... The sky is the limit. Like I'll go to the sky and I will paint it, you know. Why not? You know. Why not?[23]

YEA alum and former Juilliard student Amari Cheatom recalls how Hendricks instilled a Hyper-Ego in such a way that he feels limitless:

> I am more than being an actor, I'm an artist. And so that's kind of where I'm at now, like because I do—I do a lot of—I do different things. So I'm kind of at a place where I'm trying not to just be defined by one aspect of my artistry.[24]

YEA alum Dashill Smith speaks more on the notion of limitlessness:

> Through the [YEA] work ethic ... if you put work into something ... I feel like I can do it, you know, like even when it comes—when it comes

to performing, when it comes to just any task, you know, household stuff or just anything, working on cars, like you know … I've got this. I can—I can do this![25]

How one goes about building the Hyper-Ego is tricky, albeit attainable. Plainly put, developing a Hyper-Ego is getting someone to believe they are "the sh*t," even when they might not be at that moment. The idea is that, upon believing that he is amazing, the actor will begin to embody or "try on" amazing, perfecting a future for him to walk into. And no one can convince him that he isn't already phenomenal, and attractive. Yes, one of Hendricks's tactics in building the Hyper-Ego is to also compliment his actors on their phenotypical and intellectual qualities. He was often overheard using positive adjectives, such as bright, intelligent, beautiful, witty, amazing, and great in reference to his students. Minorities need this type of affirmation. They need to hear that they are beautiful or handsome. Because minorities experience the effects of racism, prejudice, and oppression in their daily lives, building self-confidence is integral to their success. Thus Hendricks doled out compliments on a regular basis, so much so that we started and learned that it was OK to sing praises about someone else. Instead of developing extreme jealously for the pretty girl, we developed extreme appreciation for the pretty girl. Further, we would often hear Hendricks tell students with clearly weak and squeaky voices they could sing. To our surprise, they began to believe it and continued to sing, and after a few months (or years) a strong, on-pitch voice would often emerge.

Ultimately, when enacting the Hendricks Method, one must cultivate actors' Hyper-Egos and nurture them. When that Hyper-Ego is in full swing, actors begin to confidently challenge reality, asking, "In whose reality are they unable or ineffective at completing what is being asked of them?" Thus, those who have trained in the Hendricks Method will say they possess a myriad of talents if asked, such as writing, dancing, singing, juggling, skating, or even playing a musical instrument. Hendricks teaches his protégés to let the casting agent decide whether or not their skill set matches what they need. In this way, actors should rarely rule themselves out of job opportunities because they feel that "they can't." "Can't" is limiting. Rather, Hendricks provided strong examples of ways for students to claim their unique talents, as he would often structure scenes, or even one time an entire show, to highlight an actor's assets.

For instance, *Times*, the piece about HIV/AIDS devised in 1997, is a prime example of how Hendricks tailored material to suit a specific talent of a company member, developing and nurturing his Hyper-Ego. During the devising of *Times*, an exceptional dancer by the name of Juel D. Lane consistently created dance solos to place in the "pot of soup." Hendricks was so inspired by Lane's talent that he made Lane the lead in the musical, requiring him to convey emotions through dancing the entire show. Thus, the lead character in *Times* evolved into a non-speaking role, and was suited for a male modern dancer, speaking only one word at the end of the show: "Live!"

Figure 1.2 Juel D. Lane and the cast of *Times*, Freddie Hendricks Youth Ensemble of Atlanta, 2004 (photo by Corey Washington).

Lane went on to become a dancer in Ronald K. Brown/EVIDENCE, and in 2012 became the first independent Black choreographer from Atlanta to be commissioned to set a piece on the Atlanta Ballet. The next year, Lane was featured in Dance Magazine's "25 to Watch" issue. He currently dances with Bessie Award Winner and Broadway choreographer Camille A. Brown, was selected to set a piece with Alvin Ailey's New Directions Choreography Lab, and is heavily involved with dance on film as an expressive medium.

In our work with students of various races, we (Sharrell and Tia) have found ourselves, like Hendricks, being invested in the well-being of the whole student and birthing Hyper-Egos. We say "you can" when the students feel like "they can't." We often refer to them as being amazing and point out their good qualities because we understand that this type of affirmation is instrumental in an industry where most of the roles are achieved by the way one looks, how one sounds and, of course, who one knows. And the latter, the social capital needed to achieve abundant success is not always available to Black students, so Hendricks practitioners must find ways to fully nurture the "ego capital." If actors truly believe in themselves, validation from others can become unnecessary. To this end, Hendricks Method trainees are equipped with spirit-hood, tools to create art on their own terms, and a Hyper-Ego that is recognizable and undeniable.

Repertoire devised with the Hendricks Method

> Freddie took scores of young people, developed their talent, and created some of the most innovative theatre the world has ever seen.
>
> (Amari Cheatom, actor[26])

> Greatness is inevitable when focus marries passion, and the desire is just as strong as the need.
>
> (Freddie Hendricks)

Employing the Hendricks Method, YEA devised and performed seven full-length, aesthetically enviable musicals, which we will briefly outline in this section. Performed in 1990, YEA's first full-length musical, *Rhymes and Reasons*, tackles child abuse. Next is *Soweto, Soweto, Soweto: A Township is Calling* (1992), which won the Overall Best Play award at the Windybrow Arts Festival in Johannesburg, South Africa in 2000. After performing *Soweto*, the ensemble remained entrenched in the ideas of Black empowerment. Many of the members found a sense of identity and started to shape who they were as individuals. This maturation was evident in their decisions to cut off their chemically straightened hair, in favor of afros and locs. Thus, the ensemble sent a strong message to their classmates and family by liberating themselves from the chemical effects of the perm. Their message was one of discovering self-identity. With their new-found enlightenment, YEA also re-discovered the importance of education and felt that their learning was being jeopardized by school violence. They were now positioned to devise material that spoke to something they were all experiencing: the consequences of ignorance. In 1995 *School House Rocks* unveiled the issue of crime amongst Black youth. YEA suggested that there was a war amongst the youth by utilizing army fatigue as costumes. The answer to the war was clearly education, as the set for *School House Rocks* is one large staircase that represents life-size books, emphasizing YEA's belief that knowledge is power. In 1997, the ensemble presented *Times*, a piece about HIV/AIDS, and in 1998 *Psalm 13* was developed to address and combat teen pregnancy. *B.L.A.C.K. (Better Left a Colored Kid)*, produced in 1999, addresses the lack of self-love and respect perceived to be prevalent in the African American youth community. Though both *Psalm 13* and *B.L.A.C.K.* recognize progression and change as essential parts of life, they implore African Americans to investigate who "dropped the ball" in caring for their youth and highlight ways to intervene in order to save the youth.

Hendricks's last devised musical with YEA, *Jekonni's Song*, is the most profound example of how the members deal with life's issues through the arts. This musical was inspired by the tragic death of Debi Barber's 18-year-old son, Jekonni Barber, who had joined YEA at age six. Jekonni's growth and participation in YEA was charted by many members, as he was the youngest member for quite some time. As he approached adulthood, his artistic

development was lauded. Jekonni had recently created his business cards for his acting career that pictured an illustration of an angel giving a "thumbs up" sign. Shortly after graduating high school, his life was claimed in an automobile accident. YEA coped with his death in the most powerful way they knew how: through devising theatre. *Jekonni's Song* is about unconditional love. Sharing tears, heart ache, and joy, YEA created three stories in which characters encounter obstacles and rely on unconditional love to solve their problems. *Jekonni's Song* was performed in 2002 at the Alliance Theatre, Atlanta's Tony Award winning theatre company, then under the leadership of Kenny Leon. At the end of each show, the entire cast raised their hands in the air with the "thumbs up" sign. The audience returned this silent gesture of love for Jekonni and love for themselves. Till this day, YEA members and alumni will give a "thumbs up" during their curtain call, keeping Jekonni's memory and message of love alive.

> Just simply being a teacher and mentor to so many people that continually contribute to theatre makes Freddie a huge influence on the entire world of theatre.
>
> (Justin Ellington, Broadway composer[27])

In 2005, a key organizational shift proved that Freddie Hendricks's vision and Debi Barber and Charles Bullock's leadership are lasting forces to be reckoned with in the arts. During this year, Hendricks resigned as Artistic Director to pursue other artistic endeavors and the Freddie Hendricks Youth Ensemble of Atlanta became known as the Youth Ensemble of Atlanta. Though Hendricks was not rich or famous, he was wealthy in spirit and believed in his vision. Hendricks and Barber's guidance and foundational impact was so strong that the company did not falter after his departure, but continued to grow in leaps and bounds. Presently, the Youth Ensemble of Atlanta operates on a budget in excess of $300,000 a year. YEA's staff consists of the Executive Director (Debi Barber), the Choreographer (Charles Bullock), the Development Director, the Management Associate, and a Board of Directors consisting of 12 members. YEA chose not to hire another Artistic Director; rather they invite guest directors to devise with the ensemble, such as esteemed African American director, Andrea Frye. The ensemble has over 70 active members ranging in ages 8–24 and offers seven programs in addition to devising theatre. These programs vary from funding for album projects to scholarship opportunities for college-bound members. YEA's work is significant and their operations and practices can be shared amongst theatre and educational entities with similar ambitions. The fact that the company provides free professional training, has toured in four continents, and produces Black artists who overwhelmingly land major roles in theatre and film suggests that YEA is a mainstay in the world of theatre.

In 2016, the Youth Ensemble of Atlanta celebrated their 26th anniversary, and our gift to Freddie Hendricks and YEA is to pay them the scholarly attention and inquiry that they deserve. As mentioned earlier, the Hendricks Method will soon be available in a full-length monograph that meticulously outlines his entire methodology, and his technique for approaching and analyzing scripted work. The Hendricks Method is set to have the influential capacity to forever augment the way acting is taught, paving the way for more directors of flavor and soul to follow.

Notes

1 This quote was collected via email in April of 2011 by then University of Missouri-Columbia student Saskia Chaskelson as part of a class unit on and subsequent project about the Freddie Hendricks Youth Ensemble of Atlanta. The class was African American Theatre with Sharrell D. Luckett as the instructor.
2 For further information about the Youth Ensemble of Atlanta, please visit www. youthensemble.org.
3 Freddie Hendricks is referencing a vision that he had in the middle of the day as a young adult in which he saw a sea of children outside of his window reaching for him and asking him to save them. This moment impassioned him to work with youth.
4 Freddie Hendricks, interviewed by Sharrell Luckett, Atlanta, GA, November 2009. Phone.
5 Upward Bound Program (accessed November 2, 2009); available from www2. ed.gov/programs/trioupbound/index.html.
6 Johnell Easter, interviewed by Sharrell Luckett, Atlanta, GA, November 2009. Email.
7 501(c)(3) is a section of the Internal Revenue Code that allows non-profit businesses to be exempt from federal taxation.
8 www.7stages.org.
9 Debi Barber, interviewed by Sharrell Luckett, Atlanta, GA, November 2009. Phone.
10 Tri-Cities is also home to half of the Grammy-winning duo Outkast (Andre Benjamin) and prolific music producer Shondrae "Bangladesh" Crawford.
11 Tia Shaffer Cowart, "Former Students' Perceptions of How Theatre Impacted Life Skills and Psychological Needs," Ph.D. diss., Liberty University, 2013.
12 J. Michael Kinsey, interviewed by Sharrell Luckett, Ithaca, NY, November 2015.
13 Kenan Thompson, telephone correspondence with Sharrell Luckett in June of 2016.
14 Freddie Hendricks, interviewed by Sharrell Luckett, Atlanta, GA, November 2009. Phone.
15 Sharisa Whatley, interviewed by Sharrell Luckett, Atlanta, GA, 2012. Phone.
16 Chiwuzo Ife Okwumabua, interviewed by Sharrell Luckett, Atlanta, GA, 2009. Phone.
17 Rahbi Hines, interviewed by Sharrell Luckett, Atlanta, GA, 2015. Phone. Áse is Yoruba for "and so it is" and ajabu is a Swahili word which means "astonishing."
18 John Mbiti, *African Religions and Philosophy, Second Edition* (Boston: Heinemann Publishers, 1990), 118.
19 Ibid., 2.
20 This quote was collected via email in April of 2011 by then University of Missouri-Columbia student Ashley Carpenter as part of a class unit on and sub-

sequent project about the Freddie Hendricks Youth Ensemble of Atlanta. The class was African American Theatre with Sharrell D. Luckett as the instructor.

21 Ibid., quote collected via email by Ashley Hayden.

22 This was an intimate party for Enoch King, Jahi Kearse, and Andre Allen, celebrating their work in "Two Trains Running" by August Wilson. The play was produced in 2013 by Kenny Leon's True Colors Theatre Company and directed by LaTanya Richardson.

23 Tia Shaffer Cowart, "Former Students' Perceptions of How Theatre Impacted Life Skills and Psychological Needs," Ed.D. diss., Liberty University, 2013, p. 124.

24 Ibid., 123.

25 Ibid., 125.

26 This quote was collected via email in April of 2011 by then University of Missouri-Columbia student Brennan Coulter as part of a class unit on and subsequent project about the Freddie Hendricks Youth Ensemble of Atlanta. The class was African American Theatre with Sharrell D. Luckett as the instructor.

27 Ibid., collected via email in April of 2011 by Lovee Bradley.

SoulWork

Cristal Chanelle Truscott

The basic thing is soul feeling. The same in blues as in spirituals. And also with gospel music. It is soul music.

(Mahalia Jackson[1])

Good theatre got soul.
Good gumbo, fried chicken and good collard greens got soul.
Soul Food.
Mahalia Jackson, James Brown, Marvin Gaye
and Nina Simone had soul.
Ella Fitzgerald, Whitney Houston, Miles Davis
and Billie Holiday had soul.
Aretha Franklin, Stevie Wonder, Bill Withers
and Wynton Marsalis got soul.
John Legend, Beyoncé, Alicia Keys and Erykah Badu got soul.
Chuck D, Nas, Mos Def/Yasiin Bey, The Roots and Kendrick Lamar got soul.
Soul Music.
Jacob Lawrence, Gordon Parks, Elizabeth Catlett, Jean Michel Basquiat had soul.
Kara Walker, Hank Willis Thomas and Carrie Mae Weems got soul.
Soul Art.
Katherine Dunham and Alvin Ailey had soul.
Bill T. Jones, Urban Bush Women and Ron K. Brown/Evidence got soul.
Soul Dance.
Soul Train.
Spike Lee, Julie Dash, and Ava DuVernay got soul.
Soul Film.
W.E.B. Du Bois and Langston Hughes had soul.
Gwendolyn Brooks and Maya Angelou had soul.
Sonia Sanchez, Nikki Giovanni and Saul Williams got soul.
Richard Wright, Earnest E. Gaines and Alex Haley had soul.
Zora Neale Hurston, Nella Larsen and Octavia E. Butler had soul.
Toni Morrison and bell hooks got soul.

Soul Writers.
Lorraine Hansberry and Alice Childress had soul.
James Baldwin and August Wilson had soul.
Ntozake Shange, Pearl Cleage, Suzan-Lori Parks and Katori Hall got soul.
Paul Robeson and Lena Horne had soul.
Ruby Dee and Ossie Davis had soul.
Audra McDonald, Viola Davis and Jeffrey Wright got soul.
Good theatre got soul.
Malcolm X/El Hajj Malik El-Shabazz and Dr. Martin Luther King, Jr. had soul.
Soul Brothers.
Fannie Lou Hamer, Rosa Parks and Barbara Jordan had soul.
Kathleen Cleaver, Assata Shakur and Angela Davis got soul.
Soul Sisters.
The Black Panthers had soul.
#BlackLivesMatter got soul . . .

The list is infinite. Examples work best because defining soul is a mind-bending, elusive exercise. The term "soul" is used and understood in African American cultural expression to describe an esoteric, aesthetic occurrence that moves someone "spiritually" in the sense that it cannot be explained through words. Rather, soul can only truly be understood intrinsically; through feeling, emotion, embodiment and expression. Dictionary definitions typically cite four main characteristics of soul: (a) the spiritual or unique/individual immaterial part of a human being; (b) a person's moral and emotional nature, the ability to feel empathy; (c) a quality of feeling deep emotion and arousing it in others, especially as revealed in an artistic performance, particularly Soul Music; and (d) all of the above as understood, created and practiced by African Americans as an essential element of Black cultural expression.[2] Research on soul can lead from Louis Armstrong's straightforward "If you have to ask, you'll never know," or Thelonious Monk's "You know it when you see it," to academia's canon of books offering a plethora of words to describe what many authors ultimately admit to being indescribable. I agree. Soul is an essence beyond words and a state never properly captured by words. As a manifestation of African American cultural production rooted in oral tradition, I'd offer that soul is not meant to be defined, but rather experienced, known and understood. Soul is experiential. Words require a finite explanation that denies the very nature of soul as endless exploration. Popularized throughout the 1950s, 1960s and 1970s by Black musicians and artists across genre, soul ultimately "became a potent signifier of solidarity within the African American community in the struggle for black power, and as such it was applied to all manner of cultural production and expression."[3] SoulWork sees itself in this tradition of "soul" as applied to theatre. SoulWork is about making theatre that got soul.

Philosophy

> Any great art is a transfer of emotion. Musically, soul is what we speak of as being transferred from the player to the listener, as in soul-to-soul. Without soul, music becomes an intellectual exercise and runs the risk of alienating the artist from the general public.
>
> (Bobby Broom[4])

SoulWork is a philosophy of theatre-making based on African American performance traditions and aesthetics that shifts actors' focus away from "me" and onto "we"; it relocates directors' ownership from "mine" to "ours" and rescues the audience relationship from "them" to "all of us." As a technique, SoulWork has specific tools, effects and, for those who want them, chronological guidelines, but its structure and implementation are not fixed. SoulWork is not an equation. To train others in SoulWork requires the same explorative presence as training in and practicing SoulWork. SoulWork is an aesthetic tool for creating space and experiences. The dream is to create an environment and occasion that neither the artist nor the community (audience) can check out of—and hopefully, won't want to. SoulWork is about making art that lingers, while creating a space that allows for a visceral experience where collective journey is an ongoing, fulfilling process of discovery and exploration. This introductory survey of SoulWork philosophies, origins and founding principles presents SoulWork as a comprehensive methodology of acting, directing, playwriting, music-making, script analysis and ensemble-building designed to create heightened levels of emotional sincerity and evoke circumstances beyond words that elicit a visceral response or, more esoterically, that elicit soul and the exchanges of soul between the artist and the audience/community.

Origins: artistic genealogy and training

> Jazz is not just "Well, man, this is what I feel like playing." It's a very structured thing that comes down from a tradition and requires a lot of thought and study.
>
> (Wynton Marsalis[5])

My artistic genealogy has a through line of soul intensely cultivated by the cultural institutions in the Black communities where I was reared in Houston, Texas. Training not only included formal instruction in church choir, dance studio, acting classes and piano lessons; but also—and perhaps most importantly—daily engagement with oral tradition and demonstrative/participatory Call and Response with family and neighbors, intersecting generations from childhood peers to elders and diverse artists within the communities. There was a network of official and unofficial apprenticeships where artistic

technique was honed and practical knowledge on how to build safe spaces where people could self-express, explore and create was studied.

These cultural spaces and institutions were an intricate system of learning craft the way a child learns language through immersion. So much so that it can feel as if all of this knowledge is innate, as if these skillsets were solely inherited via cultural and communal memory. This feeling is partly because engagement with the arts, artistic practice and/or soul wasn't an isolated experience segmented and segregated from daily life. The arts were woven into the fabric of community function, dialogue and engagement on multiple, concurrent levels: home, school, church, mosque, community center, social events, children's play, leisure, etc. Additionally, Black communities historically and contemporarily create performance practices made to serve, respond, comment and build upon intersecting socio-political moments, dialogues and shifts. So in this way, Black cultural and artistic practices and techniques— past and present—are always expanding and being renewed via the ongoing Call and Response between the individual, the community and the society. These practices and techniques are ever-evolving through interaction with and enacting of shifting social, cultural and political landscapes and dynamics that require new dialogues, techniques, strategies and responses.

Hip Hop, Neo Soul and Spoken Word are recent evidence of artistic practice birthed out of these evolutionary, continuous and simultaneous cycles of community-based Call and Response. Cultural and communal memory are real. Vestiges of the past manifest in the cultural practices of the present. But it takes work to keep, maintain, understand and access them.

For purposes of tracing the genesis of SoulWork methodology to its internal source, I often identify four catalysts that prompted me to intently excavate methodology and vocabulary from the oral traditions and immersive cultural institutions in which I was trained. One: Attending performing arts middle and high schools gave me my first experiences with artists and instructors outside of my community who, I quickly learned, problematically expected me to bring soul in certain opportune moments that suited their productions. The classroom was strictly reserved for teaching European acting methods and it was taken for granted that I had, simply by virtue of being African American, the ability—"natural" ability—to be and bring that "soulful Black thing" when requested. Two: This same expectation was present in training at the university level, but less welcomed due to the emphasis on color-blind casting where training was meant to erase cultural specificity and render actors of color "neutral" to play characters in plays written by and for White artists. I became more aware of the elitism of White Privilege that aggressively reduced the intricacy and caliber of training I'd received to "natural talent" as opposed to "work" or "craft." Denouncing this training as "natural" enabled the cultural specificity of non-White artists to be positioned in the classroom as a problem that we, for the sake of a successful career, needed to learn how to mute, except of course, when

requested. Three: Being introduced to the field of Performance Studies as an academic discipline that allowed, encouraged and required the use of performance as a *tool* for analysis and theoretical inquiry, not only as an *object* of analysis, gave me the platform to revisit my soul training through the lens of a researcher and theorist to excavate and name techniques, tools and practices unique to my soul training. Four: With the founding of my ensemble company, Progress Theatre (timing which converged with two and three), I understood the need for language and methodology to impart the skills and aesthetic of my foundational artistic training when working with my ensemble, fellow artists, students, working professionals, new actors and community artists alike—in order to create the kind of theatrical work I craved.

Ensemble intervention

> Progress Theatre switches between emotions—revealing how one can walk and fall at the same time.
>
> (Roberta Uno, Founder of New WORLD Theater[6])

I create "Neo-Spirituals"—or a capella musicals—consciously, methodologically and specifically through the lens of African American performance traditions, developed with and performed by my ensemble company, Progress Theatre. Neo-Spirituals are descendants of Negro Spirituals, Black Folklore and Slave Narratives; and simultaneously, products of contemporary Black performance aesthetics (Hip Hop, Spoken Word, R&B, The Blues, etc.). Technically, Neo-Spirituals are musicals, but this genre classification doesn't capture their "soul." Meaning: there is song, but it's not about singing; there is movement, but it's not about dance; there are characters, but it's not about acting; there is story, but it's not about crafting a linear play. The dream is to continue the legacy of performance traditions that were necessitated by the urgent need for survival, identity, dreams, autonomy, protest, peace, multiplicity and humanity.

Progress Theatre was formed in 2000. At this time, I had written the script for *PEACHES*, my first Neo-Spiritual, which spanned time to examine the stereotype of the angry Black woman from slavery to the present, and been given an independent study to develop the piece and present it as my Undergraduate Senior Project in lieu of taking the last year of studio classes at NYU's Experimental Theatre Wing (ETW). I knew how I wanted the work to feel, what I wanted the work to do and how to make it happen. I knew an ensemble/community was essential to achieving anything close to what lived in my mind. But I didn't have the words, yet. I was drawn to what theatre folks and academicians call Ensemble Theatre because of my upbringing and training in community. In the classes at ETW and then again, in my graduate work in Performance Studies at NYU, I recognized Ensemble Theatre as a context where I could find the words and space to enact my communal training and develop my aesthetic with Progress Theatre.

The founding ensemble members of Progress Theatre (PT) were all of African descent and had also been reared and trained through their geographical home communities' cultural institutions and artistic practices—from Atlanta to Baltimore to Seattle to Roosevelt, NY to Kingston, Jamaica—as I had in Houston. Of course, our experiences weren't identical. We had various strengths and strains of oral and experiential traditions. We learned a lot from each other. But, for all intents and purposes, we spoke—via our artistic and cultural practices—many dialects of the same language. So, we relished that space of "home" amidst training programs that coveted colorblindness. We'd spend our days working towards our theatre degrees at NYU's Meisner, Adler, Cap 21 and Strasberg studios. Then, in the evenings, we'd meet at ETW to dive into SoulWork training, deepening and advancing the practices that were the foundation of our artistry, often until the wee hours of the morning. We created our own studio. We didn't call it that at the time. But, looking back, I see now that it *was* the first SoulWork studio! We knew that what we were studying, cultivating and exploring was as valuable a training technique as the methods we learned in NYU studio classrooms.

Our artistry soared in the incubator of that collaborative workshop space in those early days. We were both comforted and emboldened by communicating in our native tongue. I had ideas as a director and thrived in guiding the space through techniques that would become the foundation of SoulWork. The ensemble had ideas that changed the space. I became part of the ensemble. We were a community Living in Call and Response. I called it the "leadership dance" as we rotated guiding the space based on our strengths and knowledge base. I observed and tried to find the words to explain the techniques and practices that we were enacting, exploring and building which were meant to be handed down in space, between bodies, between souls, beyond words. The articulation process was (*and is*) as tactile and robust as the oral and experiential practice. The methodology wasn't linear, per se, and trying to write about it that way proved ineffective. For example:

QUESTION: What should an artist/ensemble do first?
ANSWER: Whatever they need to do first. Whatever the moment and the people present at the moment are calling for first.

This work wasn't an equation or suited for fill-in-the-blank. Those first attempts at articulation came out in a non sequitur, a collage of investigation:

Trust. Demonstration. Experimentation. Intense dialogue and interrogation. Is freedom happening? Can we hear it? Can we see it? Can we feel it? How are we doing it? What are we doing? Do it again. It won't be exactly the same. Exactly. Do it again. Deeper. What's the word for that? Remix. Is the work eliciting an emotional response in any sort of way? Is it making us and our communities consider the show's themes in a

non-theatrical different context? Record that. Are we connecting the dots between the show and everyday life? Write down how we just discovered that. What do we have to say? Need to do? What are we giving? Receiving? Call and Response. Don't explain it. Show me.[7]

Building a working vocabulary and articulating the multiplicity of the way we created in PT space took time. Building shows took time. The rehearsal process was far longer than the standard 4–6-week typical professional theatre model, needing room to breathe. The more we did the work, the more the vocabulary came. A toolbox. A gumbo. A method that required simultaneity vs. segmentation of process. PT's process is non-linear, but also structured toward a progression of depth and an advancement of practice. With PT ensemble, I began to explore performance as an investigative tool to build vocabulary, identify practice and develop critically and theoretically relevant knowledge. Ultimately, SoulWork was developed as the primary performance technique for PT.

Founding principles of SoulWork

The "Work" in SoulWork recognizes that soul, as a practice and aesthetic, must be cultivated and developed. Soul gives art a unique quality because soul is as particular to each individual as a fingerprint. SoulWork's key principles and tools unite performers, directors and writers alike around the particularity and collectivity of collaborative creativity. And since soul can and must be cultivated, SoulWork is a technique that, through honoring the particularities of the holistic individual and the collective/communal/contextual whole, is applicable across the hybrid and fluid concepts of culture, ethnicity, geography, religion, identity, genre, modality, etc. Every human with a soul is primed to engage SoulWork. I mean:

> *Fela Kuti, Miriam Makeba and Efua Sutherland had soul.*
> *Chimamanda Ngozi Adichie, Biyi Bandele and Lupita Nyong'o got soul.*
> *African Soul.*
> *Bob Marley and Celia Cruz had soul.*
> *Sade, Jamaica Kincaid and Nalo Hopkinson got soul.*
> *African Diasporic Soul.*
> *Salma Hayek, Lin-Manuel Miranda, Meryl Streep.*
> *Sandra Oh, John Leguizamo, Bernadette Peters, Javier Bardem,*
> *Daniel Day Lewis, Idina Menzel got soul…*

SoulWork employs concepts and tools aimed to make choices on stage that are intuitive—coming from creative impulse and engagement. These introductory summaries of the four founding principles of SoulWork began solely as training grounds for actors, and have, over the years, developed into a comprehensive system of tools successfully applied to music-making, playwriting and directing.

SoulWork—Principle #1

Intention: The Call

> And that's the soulful thing about playing: you offer something to somebody. You don't know if they'll like it, but you offer it.
>
> (Wynton Marsalis[8])

Rooted in the experiences of enslaved African ancestors in the United States, African American performance traditions and aesthetics, like spirituals, storytelling, cakewalk, quilting and soul, have been historically born out of or in response to strife. The intention of Black communities through these performance traditions is directly connected to expressing, engaging, challenging, surviving and ultimately removing strife to experience the full range of one's humanity. Black cultural institutions instill the expectation of a Call to attain something for a larger purpose, for the individual and the community. In SoulWork performance practice, intention is the inroad to soul. Intention makes the work personal and SoulWork is not meant to be objective. It does not operate on principles of actor neutrality or universal characters written or developed absent of cultural, social or political contexts. SoulWork is unapologetically subjective. It leads with an acceptance of the unique creativity of the individual, their contribution to and exchange with the whole—which will make any given character, song, scene, piece what it becomes in live performance specifically because it is an expression of that person's creativity. Practitioners are expected to bring the specificities of their cultural backgrounds, as much as they are expected to bring their intellect. Before any work is done for characters, the artist must enter space with intention.

The SoulWork artist is expected to have something to say and bring to the process that which only they can give. What do you have to contribute so the collective goal can be achieved, not just your individual performance goal? SoulWork artists are expected to know why they are present, to come with contributions and to be open and flexible for discoveries. This intention is the first risk the artist must take. It is both a selfish and selfless act—at once sharing out of need and giving from service. It is both a request for and an invitation to the community/ensemble for collaboration. It is generous and empathetic. It is a new idea. They must put out a call to the community like the solo voice at the start of a chain gang who shares with the community a hope for freedom with the expectation that there will be a response that begins an exchange to guide the rest of the way.

SoulWork—Principle #2

Living in the Call and Response

> The interplay of individuality and unity is not one of uniformity and unanimity imposed from above but rather of conflict among diverse groupings that reach a dynamic consensus subject to questioning and

criticism. As with a soloist in a jazz quartet, quintet or band, individuality is promoted in order to sustain and increase the creative tension with the group—a tension that yields higher levels of performance to achieve the aim of the collective project.

(Cornel West[9])

The Response is supportive and empowering. It is mobilizing. It is the start of the Collaboration (big "C") and all of the collaborations and cycles of Call and Response that will eventually make the whole. Essential to Soul-Work training is an understanding and commitment to the nature of Call and Response in the realm of art-making that allows for the possibility of infinite discovery in the development of a work versus loyalty to a presupposed outcome. Which is to say that any SoulWork class, process or performance becomes what it is because of the who, what, why, where, when and how of those given spaces and moments. Living in the Call and Response is mandatory as it respects and invites the uniqueness of the individual, the collective, the moment, the piece, the process and the circumstances present for the work. Living in the Call and Response requires an openness and instinct that is not hindered by the logistics of intellect, but rather renders one's intellect malleable. Living in the Call and Response is deep listening and constant engagement. It allows for every person who is part of the process to uniquely contribute to the fruition of a piece. It nurtures space that is never static and where possibilities are endless, ripe for creativity. In SoulWork space, either you are calling or responding. But, there is always something to do. This communal "doing" is unifying. Living in the Call and Response forces us at all times to address what others in the space are thinking/needing/doing or saying/offering/discovering and to bring empathy to our interactions as we deal with the collaborative process of building and discovering a work. This principle of SoulWork encourages steady participation and awareness. The individual artist must never become so lost in their own "work" that they lose awareness of the presence, needs and Calls/Responses of their company/cast/ensemble or audience/community.

When I am asked if a piece I am working on is done, my passing response is that the piece is never done. It may be ready to tour, ready to meet an audience, but not done. It is a living work in constant response to its environment, an environment that changes with every tour site, every audience. I may share that I believe a piece is most complete when it is existing in front of an audience and becoming what it is because of that exchange, that live space of Call and Response and the people who are experiencing it "now." I may share that, as a result of every engagement and every audience, the piece expands and becomes something new … more. As long as a piece is being shared in the Call and Response space of live performance—how could it ever be done?

If there is time, I'll explain that while the PT ensemble has a core of artists committed to working together over time to create work, our "Ensemble" (big "E") also consists of the communities that we come from. Our Ensemble is also our society at large. Our communities and society are implicit collaborators in the work we do which we consider an ongoing Call and Response between the places we inhabit as citizens and the "stages" we share as artists. In SoulWork, we value this Call and Response as not only a philosophy, an inherent aspect of live performance or civic engagement, but also as an integral part of perform-ance practice. It's why, for example, PT holds community arts workshops, post-show dialogues and other activities as part of our developmental and touring processes. The ultimate level of Call and Response is between the ensemble and the Ensemble. Audiences are not understood as passive in SoulWork world-view. They are more than witnesses, spectators, commentators—though these are important. In SoulWork, audiences are collaborators. Either a play changes for and because of each performance or there is no real exchange and the piece has not been done.

And if I'm on a roll, I'll say I don't know what "done" means. I just know what ready means. Ready for the work of peace and progress. Ready to take on the next step, ready to meet the audience, the community, and ready to be changed yet again and to be reminded that there are as many ways of knowing, sharing, performing and experiencing the piece as there are audi-ences, spaces and communities with which to engage. I don't know done. I know ready. I ask, "Is this piece ready to become all that it is meant to become?" Over and over again. In an infinite number of ways.

SoulWork—Principle #3

Emotional Availability and the Unending Climax

> SINGING: Creating unity, easing fear, establishing moral superiority, forcing attackers to deal with demonstrators as a group rather than focus on an individual, communicating political message, setting rhythm (pickets and marches). Performance singing versus protest singing. Everyone sings, no exceptions. If you can't sing, sing louder.
>
> (Notes from a Nonviolent Training Session, 1963[10])

At the center of SoulWork is achieving what I call Emotional Availability, which allows for a state of song that is not about singing, a state of movement that is not about dance, characters that are not about acting and story that is not about a literal plot. Creating from a state of Emotional Availability con-nects and liberates emotional (breath, voice, etc.) and physical functions (action, movement, gesture, etc.) to/from intellectual analysis to explore the essence of a piece, at once spontaneously and deliberately. Often learning a song will be the introduction to Emotional Availability. The prompt and

expectation will be that everyone sings. Singers and non-singers alike. If you're in the room, you sing. Everyone. Music can so effectively catalyze solidarity and safe space within an ensemble/community for artists to take risks and be vulnerable; as it simultaneously serves to establish the culture and essence of Intention and Living in the Call and Response.

Emotional Availability creates emotional intimacy and trust between ensemble without sharing personal story or relying on personal memory. The body has lived and stored an archive of emotions, we need only find where they live in the body and access them. Breath and voice are essential. Emotional Availability is ever-changing. It doesn't grow stale like a once vivid memory. The more you live, the deeper and wider your emotional archive, constantly activating your breath, the emotional map of the body and the texture of your voice in new ways. Emotional Availability matures with you. It is not being lost in emotion. It is being present, open and allowing the body to experience what is happening around it in order to respond with emotional sincerity.

SoulWork artists embrace the idea that every emotion is appropriate for every situation and therefore diversity of emotional response is key. It is being in a state of emotional improvisation for every line, every moment. It's the unexpected or spontaneous vocal riff of a soul singer. This means that there is always something more to explore, somewhere deeper to go and a new climax to reach. Emotional Availability explores the Unending Climax.

The Unending Climax challenges the finality and linearity of "beginning, middle, end" or "rising action to climax to resolution" formulas. With the Unending Climax, one begins in a state of emotional urgency and ends with stakes higher than previously thought possible. Often in theatrical process, there is a sense of not starting too "high" for fear that we'll have nowhere else to go as we move through a piece, rendering it static or one loud mass of emoting frenzy. It's a valid area for caution. But being Emotionally Available doesn't mean randomly doing whatever one feels. It is not meant to be a self-indulgent, therapeutic exercise of releasing bottled emotions. Rather it is a very present, conscious use of intentional engaging, focused emotion as a part of the exchange of Call and Response. Emotional Availability is being aware and grounded in your emotions in order to freely and safely engage a constant state of exploration that allows for infinite ways to experience a given moment.

SoulWork—Principle #4
The Dream

> I dream a dream that dreams back at me.
>
> (Toni Morrison[11])

In R&B and Hip Hop, a remix is a song altered from its original state by appropriating aspects of its initial creative properties to make something new, improved and evolved. The remix is recognizably related to its predecessor, but

not the same. It's not a "cover" or "remake." The remix reveals new discoveries and sharper perspectives that deepen the understanding, visceral engagement and/or emotional impact on the listener. Like academic theory, the remix is at once a citation of past work, a correction and/or challenging of outdated principles and a revision or re-envisioning of a past song to impart fresher, more complete and complex meanings and experiences for the present. In this same vein, SoulWork is a remix, always reaching back to answer its ancestral call, responding to the cultural landscape of the present and calling forward to invite intervention from the next generation. SoulWork is remixing. The remix is more than altering the original state of a thing by adding, removing and/or changing pieces. The remix is a way for a community to engage in Call and Response amongst itself. It is mediation in hopes of discovering and learning something new. It is a liberatory act. The remix is an invitation for all to make a cultural product whole through diverse bodies, perspectives, interpretations, interpolations, challenges and revisionings.

Though popularized by the Hip Hop generation, the remix is a historical and traditional practice inherited from the legacies of enslaved African Americans. In Negro Spiritual performance traditions, a given song is sung various ways depending on the community and the circumstances—i.e., whether the song was to be performed in the safety of the Black Church or a Whites-only performance hall. When Spirituals were known as "field songs," during slavery and sharecropping generations, the nature of labor and/or the particularities of a day's injustices might be a deciding factor in the pace/words/harmonies of how and why a song would be sung multiple ways. For example, at the end of a long day, a song that began with resentful determination in the morning might become a wail of lament by sundown, albeit still climbing the mountain of the Unending Climax. That's SoulWork, a methodology and technique that is living, ongoing.

Today, Progress Theatre is a Houston-based, nationally and internationally touring ensemble of multi-disciplined artists committed to using theatre as anti-racism engagement to encourage social consciousness, cross-community dialogue and cultural awareness. Since 2000, PT has toured Neo-Spirituals and offered SoulWork classes on over three continents. PT performances blend traditional African Diasporic aesthetics with contemporary artistic genre, academia with popular culture and politics with social realities. We believe in the power of art and community collaboration to advance efforts toward social equality and inclusiveness. PT considers all of our initiatives as community-engaged, community-invested, community-necessitated and community collaborative. By engaging various communities onstage and off, PT strives to change the makeup of average theatregoers, encouraging diversity by creating opportunities for audiences to engage beyond their "home" communities. The dream and intention of PT's work is to explore the most compelling, honest, unflinching ways of approaching questions of humanity, and the social concerns and insights of our times inclusive of race, class,

Figure 2.1 Scene from Progress Theatre's Neo-Spiritual *The Burnin'*, written and directed by Cristal Chanelle Truscott: (L–R) Cristal Chanelle Truscott, Carlton Turner, Tiana Kaye Johnson, Rebekah Stevens, Derrick Brent II (photo by Melisa Cardona [melisacardona.com], courtesy of Progress Theatre).

generation, gender and spiritual identity—in the service of unity through diversity, cross-community healing and understanding.

SoulWork is meant to inspire empathy and invest the audience/community in the meaning of a piece not the explanation of it. SoulWork is raw with emotion, but not wild with the "natural" instinct. It is an instinctive exploration that is part of the work of all artistry. It is Work. It is open, available, generous, rebellious and dissonant. SoulWork is a space where the emotion is just as big as the intellect and gives intellect the freedom to be flexible. SoulWork aims to capture and embody the embedded spirit and purpose of a piece to engage audiences on an emotional journey that goes beyond presentation, demonstration or explanation. It is a technique that aims to get beyond the explanation of words and into the emotional core of an experience. SoulWork does not have an end. It is a holistic approach, not a metered one. It is grounded in empathy, meant to liberate one's access to creativity by a belief in the infinite possibilities of creative exploration, not tame it with absolutes and set outcomes.

So, the dream: keep working soul. SoulWork is a verb. SoulWork goes looking for soul because good theatre got soul. The dream: keep making soul, as SoulWork continues to train artists and engage communities. The dream: keep making soul. With every master class, college course, new work created, classic show mounted, site-specific work commissioned, let SoulWork be a call that goes out and comes back with more ... then goes out ... and comes back ... then, goes out ...

Notes

1 Samuel A. Floyd Jr., *The Power of Black Music: Interpreting its History from Africa to the United States* (New York: Oxford University Press, 1995), 203.
2 "Soul." *Merriam-Webster.* Accessed January 25, 2016. www.merriam-webster. com/dictionary/soul. "Soul." *Dictionary.com Unabridged.* Random House, Inc. Accessed January 25, 2016. http://dictionary.reference.com/browse/soul. "Soul in American English." *Cambridge Dictionaries Online.* Accessed January 25, 2016. http://dictionary.cambridge.org/us/dictionary/english/soul. "Soul." *Oxford Dictionaries.* Accessed January 25, 2016. www.oxforddictionaries.com/us/definition/american_english/soul.
3 Joel Rudinow, *Soul Music: Tracking the Spiritual Roots of Pop from Plato to Motown* (Michigan: The University of Michigan Press, 2010), 8.
4 Bobby Broom, "Who Took the Soul Out of Jazz?" Accessed January 3, 2016. http://bobbybroom.com/who-took-the-soul-out-of-jazz/.
5 Paul Berliner, *Thinking in Jazz: The Infinite Art of Improvisation* (Illinois: University of Chicago Press, 1994), 63.
6 Roberta Uno, "Interview," *Spotlight Magazine* (Massachusetts: University of Massachusetts at Amherst, 2001).
7 Cristal Chanelle Truscott, Personal Notes, dated November 10, 2000.
8 Wynton Marsalis, *To a Young Jazz Musician: Letters from the Road* (New York: Random House, 2005).
9 Cornel West, *Race Matters* (Massachusetts: Beacon Press, 1993), 105.
10 Permanent Exhibit at *Center for Civil & Human Rights* in Atlanta, Georgia. Viewed October 2014.
11 Toni Morrison, *A Mercy* (New York: Random House, 2009).

Nudging the memory

Creating performance with the Medea Project: Theatre for Incarcerated Women

Rhodessa Jones

> Politics don't work, religion is a bit too eclectic, but art can be the parachute that catches us, possibly saving us all.
>
> (Rhodessa Jones)

"Nudging the memory" is a response to the frequent inquiries regarding the Medea Project: Theatre for Incarcerated Women's process from students, teachers, social workers, drama and family therapists, representatives of law enforcement, and of course artists/activists throughout the world. In 1989 on the basis of material developed while conducting theatre workshops at the San Francisco County Jail I created "Big Butt Girls, Hard Headed Women," a performance piece based on the lives of incarcerated women I encountered inside the jail. During the work's creation, jail officials and I observed many issues that were specific to female inmates, such as guilt, depression, and self-loathing, which contributed to their incarceration and recidivism. Based on this observation, in 1989 I founded the Medea Project: Theatre for Incarcerated Women to explore whether an arts-based approach could help reduce the number of women returning to jail.

In this essay, I provide a brief overview of the Medea Project and its impact, introduce the creative process, provide descriptions and examples of exercises, and share an excerpt of the performance. It is my hope that this chapter will illuminate particularities of my methodology for others interested in this type of work that gives voice to the voiceless, empowers the powerless, and hopefully ennobles all of us.

The Medea Project offers guided exploration into the deepest recesses of the female psyche. The Project utilizes self-exploration techniques on an ensemble comprised of inmates, as well as community and professional actresses who stage material derived from the prisoners' own stories. The texts of the Medea Project performances are drawn from the real-life experiences of the participants. Together, the community actresses and the inmates utilize stories, songs, lies, myths, prayers, and dreams to shape the script. The ensemble uses the prisoners' language to explore a wide range of issues and attitudes that perpetuate

incarceration, including fear of others, drugs, prostitution, poverty, and single parenthood. The resulting works have not only generated new artistic forms of expression, but have also changed participants' lives. For example, before participating in the Medea Project, Angela Wilson and Felicia Scaggs were continuously in and out of jail for a number of years. During one of their last jail stays, they began to participate in the Medea Project workshop/residency process, and eventually became core members. A core member is one that establishes an ongoing involvement with the company for a number of years. Since their involvement, Angela and Felicia have never returned to jail and each have integrated back into their respective communities as productive citizens.

The Medea Project has staged over 10 full-length productions at a variety of major San Francisco theatres. The premiere Medea production, "Reality is Just Outside the Window," was staged in 1991 at Theater Artaud, a prestigious San Francisco theatre. This was the first time in San Francisco history that female inmates were permitted to perform in a two-week theatrical run outside of their jail confinement, albeit they were escorted in handcuffs to and from the jail for tech rehearsals and during the run of the show. On closing night the inmates' families were allowed to intermingle with them over food and refreshments before returning to jail.

Over the years, the Medea Project productions have generated reviews in the local press that significantly heightened the participants' sense of membership in society and self-esteem. Some quotes include:

Life changing, revolutionary, soul-searching performance.

(*The Star*, South Africa, Adrienne Siche)

Serious, thought-provoking and undeniably powerful, this is a rough 'n' tough variety show that aims to entertain as much as it enlightens.

(*The Oakland Tribune*, Chad Jones)

If the Medea Project were the standard of comparison, most theatre wouldn't even show up on the scale where relevance is measured.

(Bay Area Reporter, Wendell Ricketts)

From the outset I ascertained that increasing inmates' self-awareness is the necessary prerequisite to their breaking the cycle of incarceration and probation. The public performance enhances and enlightens the inmates' personal experience with theatre. Their self-esteem and active personal responsibility is realized and celebrated in the presence of an audience comprised of family, friends, public officials, and seasoned theatregoers. My work has set the standard for utilizing the performing arts to work with female inmates, ex-inmates, and female community participants.

Since 2008 I have collaborated with the Women's HIV Program at the University of San Francisco Medical Center (WHP) to extend my work to

include HIV positive, predominately African American women. I call this group that is now fully integrated into the Medea Project the HIV Circle. In 2014 the *Journal of the Association of Nurses in AIDS Care* published an article about my work with the Medea Project's HIV Circle titled, "An expressive therapy group disclosure intervention for HIV-positive women: a qualitative analysis." Eddy Machtinger (Director of WHP) and I (along with Sonja M. Lavin, RN, MS, Starr Hilliard, MS, Jessica E. Haberer, MD, Kristen Capito, Carol Dawson-Rose, RN, PhD, FAAN) co-authored this landmark study which represents a milestone in HIV prevention and care. Theatre Bay Area writer Jean Schiffman offered, "It's a given that Jones has changed the world for many imprisoned women, as well as, now, for these women living with HIV."

In addition, my work with the Medea Project has taken me abroad. For over seven years I have journeyed to Johannesburg, South Africa to work with female inmates in Naturena Women's Prison (popularly known as "Sun City prison"). This work was facilitated in collaboration with Roshnie Moonsammy, who is the Artistic Director of Southern African Arts Exchange, a non-profit organization that produces and manages cultural arts programming throughout the year in South Africa. In addition, I received an "Arts Envoy" appointment from the United States Bureau of Educational and Cultural Affairs to conduct my work inside the correctional facility. This unprecedented transatlantic collaboration culminated in four full-length theatre productions with the inmates. The resulting performances were entitled "Serious Fun at Sun City" and they had several incarnations over the course of seven years. These shows were directed by myself, and I was assisted by my long-time performance and business partner, Idris Ackamoor. Initially Johannesburg audiences were "bused" into this maximum-security prison to attend the show in the prison courtyard as well as at an auditorium within the prison confines. Finally, after several years of gaining the trust of correctional officials, "Serious Fun at Sun City" premiered at South Africa's State Theatre during the International Women's Festival in 2010. This was the first time in South African history that female inmates were allowed to perform at a major theatrical institution!

From San Francisco to Johannesburg, 25 years and 12 major productions later, the Medea Project is still engaged in truth-telling, self-expression, creating beauty, and teaching revolution!

Answering the call

> I am standing tall because I am riding on the shoulders of those who have come before me.
>
> (African proverb)

Theatre saved my life.

I like laughing. I like having fun. I love to travel. I love people. I love trading stories. I love children. I love beaches and long walks. I love growing

flowers. I'm growing orchids now, and understand that I know how to do it. I can lollygag for millennia, and yet at the same time like everyone else, I have work to do.

I am an African American female, the child of migrant workers, a single parent, a hippie/anarchist, and a self-made artist. Over 60 years ago, as I began my own journey into the world, I dreamed of teaching. I wanted to share my hard-earned life lessons with others, offering my experience of "living life among."

In my life I create the personal myth, and I teach personal mythology. My work with incarcerated women seeks to mine their realities and identify the mythical proportions of their lives. I am a sent spirit. Sometimes I feel like a mythical creature, only part-woman. I feel like a dragon slayer most of the time, off somewhere in my little cave on my little mountain. Then the heavens will crack and say, "you go do this."

In the autumn of 1987 I went to the city jail for the first time, asking for permission to enter and began teaching aerobics. I was unaware of how many Black women were incarcerated. I knew Black men were incarcerated but that was my first look at women—faces that looked like mine. I had no way of knowing that so many of these offenders would be persons that I would recognize, even know: women with faces that could easily be in my family, or friends of my daughter.

I began working in San Francisco's city and county jails as the number of women being arrested was rapidly increasing. African American women were the largest growing population in the penal system, with Latin American women running a close second. I have since gotten up close and personal with economic crimes, which reminds me of an oft recited quote: "If you ain't got no money, you gonna get some."

The face of the criminal had quietly gone through a sex change. No longer only the black and brown male, but his wife, mother, sister, female cousin and baby mama had been booked and sentenced too! As far as the judges were concerned, they had not witnessed the presence of so many members of America's workforce at such close proximity. The nation was made to realize that *Gone With the Wind*, *West Side Story* and *Zoot Suit* were not just images of light and shadow, but flesh, blood, and bone—in livin' color.

Nudging the memory

Thank God for my creative mind. I went in, not an aerobics teacher, yet here I was, replacing the belly dancer. I began by talking about myself—who I was. We started moving. We started to speak in the moment, letting the mind and the tongue go where they would. I started to work with these women in jail.

Some of them would just sit and look at me, asking, "Who is this person?" and "What is she doing?" I wasn't carrying a Bible. I wasn't talking about religion. I was talking about us finding a way to communicate with each

other. If we found a way to communicate with each other, we could define this community. And if we defined our community, we could find strength in that community to hold each other; find ways to get out of there.

They thought I was totally whacked, yet they loved it. They loved improvisational theatre. I remember the first time I put on Marvin Gaye's *What's Going On*. The women erupted emotionally. They started crying.

I asked, "Well, can we dance this?"

"But you don't understand, Miss Jones. This is so deep. He's talking to us, too."

I said, "Oh really? What's he saying? What's he asking us?"

It was us. It wasn't me versus them. It was us.

Conversations would bloom. They started to talk about what this madness [incarceration] was. "Why are you in and out of jail all the time?" I asked. The horror stories of people having babies and leaving them in hospitals came to light. Then there were the stories of women losing their babies to Child Protective Services due to neglect, abuse, and/or drug use. I would also look around as babies in jail would be having babies. They had the nerve to be pregnant in jail, preparing to give birth in handcuffs! I reminded them of our shared history. I said, "Do you know we are the descendants of slaves? Do you realize how many of our great, great grandparents had to find a way to let us go because we didn't belong to them? Imagine waking up in the morning and they were selling your oldest child."

Part of my work as an acting instructor on the inside was about finding a way to have that critical cultural conversation that was so coded for the Black women in that room. And like I said, it "nudged memory." Thank God too for my skill as a storyteller. They became children again. While they were listening, I insisted they participate. Everybody had to play the game. "You've gotta share. You've gotta either fill in the blanks of the story or let's build the story." This is how I gradually started creating structures and devices that would become theatre for incarcerated women. I had to build the drama to such a place where it became universal. The story became something that could be passed around and everybody could recognize it as their own.

After they learned to trust me, it was so much fun! Some days we would just play dodge ball or *Red Light, Green Light*. I gave them permission to play, to open up, to be free. My responsibility was to create a safe environment for them.

In my work there are those who get "it," and those who don't. The real test is to not come back to jail after they are released. They must work at not being a victim. The ultimate goals are not to go back to destructive relationships that led them to jail in the first place, and to honor their mothers and grandmothers in different ways because these are the women rearing their babies.

I have met some women who would confide, "You don't understand, Miss Jones, my mother was in the *life*."

I responded, "Did your mother ever go to jail?"

"No."

"Well, there is something to learn from your mother. She never went to jail and look, she built her life and yours, and now she's keeping your children. I'm not saying that it is right or wrong. I'm simply saying look at it all and claim it."

I encourage these women to claim their lives. Claim all the pieces of it. And once they claim all the pieces, then they can figure out what is disposable. There is an empowerment in facing our demons, our mistakes, and our crimes! When we can face our choices we find that the negative things we did in the past can be diminished, helping us to move forward. We can then forgive ourselves, and this can be the way to healing. It is not about placing blame but taking responsibility for our actions. Don't buy into the hype. Don't let somebody else label you and tell you who you are.

The work: art-making rooted in service

I was raised in a family where we were taught that we are responsible for the best or the worst of our community. "It takes a whole village to raise a child" is not just a politically correct sound byte, but it is very much a part of an African (Yoruba) societal ideology. Collaboration with other parties in the community—offenders and ex-offenders, those living with HIV, and those who are victims of benign neglect, as well as scholars, the jailers, students, families, and the volunteers—this is what I found to be the most successful way to infuse and enhance the dream; to enhance the vision of the art-maker.

My early work "on the inside" was made real and enriched by the collaboration between Sean Reynolds, a social worker who believes in the art of social work, and myself, the artist who believes that art saves lives. We met in 1989. Sean was already teaching/exploring self-esteem and self-awareness in the jails when I arrived. She was the first person in that seeming void of jail who showed support, understanding, and could express what I was working toward in the name of art-making as a response to jail in general and the incarceration of women specifically. We began to talk about the conditions before us—the conversations grew to include our view of the world as we had each experienced it. As two African American women working "inside," we continued to examine the lives of the incarcerated women. The conversation always came back to personal experiences, and the political situation "outside."

Nobody told her. Ignorance. That was and still is a continuing refrain that permeated all our conversations. We were inundated by the fact that poverty, disease, benign neglect, desire, rage, addictions to sex and drugs, violence, infanticide was the underlying theme of our observations of women inside our penal institutions. *Nobody told her.*

The first sessions that Sean and I conducted with the incarcerated women were based in remembrance: the first Christmas, what our mothers said, and

the advice we had been given as girls and by whom. We stressed "we" (We are We), hence building, re-building community inside. This early group work was vital to the women finding their voices and telling their stories. It still is. This collaborative process grew to include the deputies who witnessed this new way of working with women inmates, and who admitted to learning more about their captives while they stood watch during our theatre workshops. The deputies also gave Sean and me support when crisis arose in our absence with women from our group. Hence, the deputies' awareness of this community they were serving was deepened, even while working at its periphery. If a female offender grew violent and destructive, acting out in such a way that lockdown was inevitable, the deputies would remind her of her responsibility and her involvement with our group, heading off self-sabotage, which involves her willingness to sacrifice her positive participation in creating the Medea Project's latest production. Yes—service, reaching out to help an inmate, versus simply writing her up or locking her down.

San Francisco Sheriff Michael Hennessey became the Medea Project's chief collaborator. Once I could articulate the role he could play in bending the rules in jails, such as allowing for a more open, relaxed environment, which ushered in cursing and yelling, Hennessey acquiesced because he believed in the life-saving power of art. Under his watch, the art of drama— *keeping it real*—was exercised to the fullest. SF County Jail is unlike any other jail in the country with its ongoing arts and crafts programs, as well as a thriving community gardens program. All was done in the name of rehabilitation and re-entry back into the community. Philosophically, Sheriff Hennessey "got it." The Medea Project was right on time.

Planting the seeds: 1991–Theater Artaud

For the next year, Sean and I established the basis for an ongoing theatre workshop. We began to encourage storytelling based on the lives of the female offender. We gathered stories, songs, and movement. We were building a performance, planting the seeds for theatre for incarcerated women. We began to invite other inmates in to watch our work in progress. Thus began a series of presentations for local presenters, psychologists, and artists from the outside. I considered it a "test run." What is this? Will it fly? Can the offender speak, move, and sing her own home-made truth before an invited audience?

Sheriff Hennessey understood and gave permission—clearance—to those on the outside to observe. Our first audiences included Ellen Gavin from Brava for Women in the Arts, Brian Freeman from Pomo Afro Homos, dancer-choreographer-mentor-scholar Theresa Dickinson, Andrew Brown, a clinical psychologist, and Dean Beck-Stewart, then director of Theater Artaud.

Yet, not all was roses. We were not ready for prime time. Shortly after the presentation of the work in progress, the women performed for the male inmates at County Jail. Suffice it to say that pandemonium ruled the first half

of that performance. Deep-seated resentment, jealousy, shyness, competition for male attention, and sexual innuendo all played a part in a disaster that stopped the performance cold mid-way. Pulling the plug on the beat-box, I yelled, "FREEZE!"

Out of this audience of male prisoners a chorus went up, reminding the women that their work was important, and the men were waiting to hear what they had to say. Amidst the pleading for order and concentration, it was the men that reminded the women that this was their show, and they should not throw it away, not even for them. After a few moments of very pregnant silence I asked the women, "Could we proceed?" My question was met with the action of everyone moving back into their initial place so the performance could begin again.

Afterwards we returned back to the sacred circle in the women's jail to deepen the somewhat difficult discussion about the role that men play in women's lives. This is where Sean and I had our work cut out for us: Why was it more important to you to "show your ass" instead of doing the show? Why did you forget your lines, lose your concentration, and throw away whole sections of the show? The women were so invested and involved in competing for male attention and basking in the gaze of the male audience members that the performance became secondary. How did you feel when the men chided you for what you were doing? How many times have you witnessed in yourself that same form of carelessness in throwing your things away for the attention of a man? Has it been worth it? How does it figure into your incarceration today?

That disastrous first performance before the male inmates was a lesson learned that ultimately enriched the work that was to become the Medea Project's very first production. After more work with the women and with Sheriff Hennessey's permission, the Sheriff's Department engaged in a total leap of faith, allowing the Medea Project, inmates, deputies, and all involved in the work to perform outside at Theater Artaud in San Francisco. In both practical reality and the reality we presented onstage, after all we had been through to get here, all was true.

My program notes read:

> "Reality Is Just Outside the Window" is an autobiographical, multi-media performance that uses the myth of Medea to help tell the female offender's story. Medea, the betrayed lover who exacted revenge on her husband Jason by slaughtering their children; Medea, another woman who loved too much.

To be of service is both a gift and a challenge. To be of service as an artist, I often speak of being "sent" to do this work. I was sent to move among the growing population of incarcerated women in the United States. In the name of service, I have taken this journey very seriously. I have found that

everything matters, because if nothing matters, then there's nothing left to save. Because I honored my commitment to service, I have had support from unexpected quarters and felt the love of women who would have never admitted that they could love a woman, thus themselves. It has been a warm and wonderful surprise for all of us.

The great writer Leo Tolstoy once said: "Work. Just work. Don't think about the work. Don't think about the amount of work. Just work, and everything will get done in time."

Performance methodology: telling the stories, singing the songs

It matters not the medium, all artists must move!

(Louise Nevelson, sculptress)

In this section I will list the five basic steps for creating theatre in jails, prisons, and juvenile centers. These steps are central to the Medea Project: Theatre for Incarcerated Women. I have attempted to distill the process down to the five stages that are essential to art-making inside of penal institutions. The five actions are also vital to building relationships, community organizing, celebrating memory, instilling inclusion, and giving voice to the silenced. The activities of the workshop process can be adapted to take place in a variety of settings with different participant populations, including but not limited to:

- four month workshop/residency process inside a jail with female inmates and in the community with Medea core members that culminates in a major theatrical production outside of the jail;
- four–six month workshop/residency process that takes place within a variety of community settings with Medea core members, HIV positive women, and community participants culminating in a major theatrical production;
- two, three hour workshops for college or university students;
- college and university residencies that can take place between several days and/or full semesters;
- three week workshop process with Medea Project core members to prepare for a variety of benefit shows, conferences, and "one off" performances locally, nationally, and internationally.

Begin with requesting a large multipurpose room with folding chairs, open space and privacy. Have the inmates sit in a circle of chairs. A circle is always preferred; enabling each woman to come and go at will. Everyone can see each other immediately.

Step 1: planting the seeds for community

The checking in: Invite the participants to introduce themselves to the group. I have found that I can facilitate introductions by suggesting that each woman take a moment to speak her name. (How did you get your name? Who are you named after?) Very personal—each one of us has a name with a story. This can be time consuming! It is OK. Keep in mind that once the female offender is comfortable sharing her story it becomes a treasure trove of ideas for creating theatre. It is important to keep an ear open for the woman who is a storyteller and/or historian.

Step 2: the physical warm up

After the circle has heard each woman, we must get on our feet. This is about her moving, her heart beating, breathing—getting warm, feeling free! The leader should note physical strength, endurance, leadership, creativity, and fairness. Childhood games such as *Simon Says, Red Light, Green Light, Follow the Leader,* and *Duck, Duck Goose* are perfect for basic exercise. Keep track of the person who loves to play! These are the "organic performers" who will later anchor creative movement in staging the presentation.

Step 3: writing it down

After the warm up, ask each participant to "record" her responses, observations, and reactions to the sharing and the movement. This is the beginning of writing—hand to head. It is a way to identify levels of competency and cooperation. It is a way to engage the students, the scholars, and yes, the performance poets. This step plants seeds to grow the "script." This exercise will create a clearing for the singers, the actors, and the "rappers" to reveal themselves as performers in their other life before imprisonment!

Step 4: telling the story, singing the song

This is the time when the inmates/performers are encouraged to sing, dance, and recite for the group. The importance of our responsibility as "audience" must be stressed! The persons who agree to show off their talents are the "seedlings" of the ensemble that will "grow" into a production!

Step 5: standing together

Once the performers/inmates have finished sharing songs, stories, and poetry, the director should ask the group to think as a community. How can we as a group stand with the lead voice? The group is asked to contribute … to suggest ways to become part of the performance. "Let's add a club dance or a chorus of voices!" Can we create a moving prayer? (Example: "Now I lay me down to sleep"…).

The director should work to simplify the creative idea. The child's prayer is not daunting and it can be largely accessible to specific cultural groups. Watch for bilingual opportunities. Inclusion and diversity is an immediate way to educate, inform, and deepen the presentation of the ensemble!

Creating community is the essence of ensemble. The female offender is often too invested in her singularity. The Medea Project works for personal and social transformation through creative action. Women saving their own lives by engaging in theatre has been found to be ennobling and humanizing. I believe that once we start to hear, to listen, to witness, to honor and share our collective struggle, simply living becomes self-affirming!

Performance tools

As the dialogue advances in the process of the Medea Project, we work to find ways to assist each other in storytelling/retelling. I present memory and improvisational exercises, such as the "Hidden Talents Questionnaire," "Stomp, Clap, Sing," "Tell Me Yours, I'll Tell you Mine," "Hand Dancing," and "There Is a Ladder." These exercises, found below, were, and still are, juxtaposed alongside Sean Reynolds's rule: "We must agree to disagree amicably." I stress: "What's said in the group stays in the group."

Hidden Talents Questionnaire

The below "Questionnaire" helps to begin the act of re-membering—claiming our personal historicalness. Like the acclaimed French writer Sidonie-Gabrielle Colette said, "We need to look hard at those memories that pain you." The re-memory process is central to the Medea Project's creative process. The act, the art of going back through time before life hurt, exploring first memory-touch, love, loss, light, revisiting places and people who influenced you and why is important. Through the improvisational techniques of theatre, the work is about remembering what was said, who said it, when, why, and how we were influenced.

1 Name?
2 Age?
3 Hidden talents?
4 Do you write?
5 Would you like to write?
6 HOME: Last address?
7 When were you last at home?
8 When did you leave home?
9 Why did you leave home?
10 Who did you leave at home?
11 Who did you leave home with?

12 Please describe a fantasy home.
13 What is a parent?
14 Who are your parents?
15 What is parenting?
16 What was the last bit of advice you remember from a parent?
17 Are you a parent?
18 If you could do anything, or be anywhere, what would you do, where would you go? Name the place.
19 LOVE: What is love?
20 Who do you love?
21 Who loves you?
22 If love has a face, name it.
23 Describe the last time you saw love.
24 DEATH/BIRTH: How have you escaped death?
25 What is rebirth?
26 If you could turn back time, how would you change your life?

Stomp, Clap, Sing

This is an exercise that is a physical warm up, as well as imparting concentration and coordination skills, community building, and increased musical participation.

1 The participants divide into three equal groups of 3–5 members.
2 Using hand claps each group is instructed to clap to a different simple rhythm (e.g., in 4/4 time first group claps on every beat, second group claps on second and fourth beat, third group claps on first and fourth beat).
3 Repeat step 2 with stomping the feet.
4 Vocals are then added by having the first group sing a simple melody, followed by the second group singing a different and counter melody, followed by the third group singing a different and counter melody.
5 The entire ensemble then moves across the floor as a community, but remain in their respective groups.

Tell Me Yours, I'll Tell You Mine

1 Two women agree to sharing and hearing.
2 One woman agrees to tell her story while the other listens.
3 The other woman then agrees to listen to the other's story.
4 The women are then informed they must tell each other's story to the group. The director will instruct that each woman must work to make sure they honor each other's story, including the instruction to rehearse each other's story before "sharing" with the group.
5 The two women take the center stage taking turns retelling the other's story.

Hand Dancing

See top two rows of Figure 3.1.

Hand Dancing is based on American sign language. This is taught in unison. The intention of the exercise is to create a physical chorus. It is a way to "accelerate" the birth of the ensemble. I found that it is a way to impress

Hand Dancing

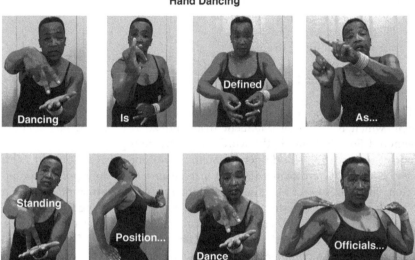

Movement Meditation

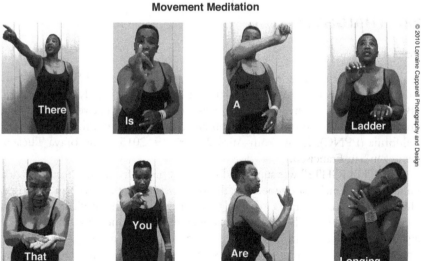

Figure 3.1 Rhodessa Jones demonstrating "Dancing Is" and "There Is a Ladder" exercises (photo by Lorraine Capparell).

upon the incarcerated woman the idea of responsibility and accountability. "Hand Dancing" is one of the Medea Project's methodologies that encourage positive group action, deepening a sense of community.

There Is a Ladder: a movement meditation

See bottom two rows of Figure 3.1.

> There is a ladder
> that you are longing to find
> that leads you
> to a higher ground.

"There Is a Ladder" is a sound and movement exercise based on a found poem which is a written statement that I utilize as a part of my teaching method. I literally "found" the words of the previous poem discarded on the floor of a print shop. Inside penal systems chaos and crisis is constant. This poem is taught as a moving prayer. Once again it calls on a positive group action. The actresses start by assembling into a very tight formation and begin to speak and move together. This exercise is used as a bilingual vocal performance that involves participants reciting words in several languages, including English, Spanish, French, and Zulu simultaneously. This sound and movement exercise combines gestures and American sign language while the words are being spoken, similar to a Greek Chorus.

"BIRTHRIGHT?"

Backstory

In celebration of the Medea Project: Theatre For Incarcerated Women's 25th Anniversary, Brava! For Women in the Arts and Cultural Odyssey presented "BIRTHRIGHT?" This production was a collaboration between the Medea Project: Theatre for Incarcerated Women and Planned Parenthood Northern California (PPNC). It ran from April 9–April 19, 2015 at the Brava Theater Center in San Francisco.

"BIRTHRIGHT?" was supported in part by grants from the Creative Work Fund, the National Endowment for the Arts, Grants for the Arts/San Francisco Hotel Tax Fund, San Francisco Art Commission, and the William and Flora Hewlett Foundation. The production was an expansion and new cultural offering in my body of work based on my original method of using "art as social activism," this time focusing on the subject of women's reproductive rights. Using skills I have honed for the past 25 years working with incarcerated and formerly incarcerated women, as well as HIV positive women of color, "BIRTHRIGHT?" pushes boundaries and examines issues affecting us all.

Women's health is at the center of a political maelstrom cloaked in religious ideology, abuse of power, and a blatant disregard for the women and families impacted by the fall out. During the creation process, the ensemble worked to unearth the questions, issues, and pros and cons of the debate surrounding women's reproductive rights.

The finished work involved a cast of 20 women who ranged from 12 to 66 years of age. There was a mixture of HIV positive women, ex-inmates, professional actresses, community members, and Medea Project core repertory company members.

"BIRTHRGHT?" utilizes multi-media, spoken word, a live sound score performed by composer/multi-instrumentalist Idris Ackamoor, extensive choreography and movement, projected text, audience participation, songs and music performed by cast members, gestural theatre, and many of the hallmarks of the Medea Project performance traditions. The show is two hours long with a 20-minute intermission. In the lobby during intermission several performers showcase pieces around the themes of the show for the audience members.

The creation of "BIRTHRIGHT?" included several years of preparation, planning, and workshops and seminars with Planned Parenthood staff and clients. For example, my staff and I facilitated eight workshops at PPNC's East Bay location to collaborate and develop material. This extraordinary series of exchanges and residency activities led to a work in progress at the City Club in downtown San Francisco for a large PPNC fundraiser. Information and feedback gleaned during the workshop series was incorporated into the workshop performance as well as into the final performance. PPNC was very instrumental in setting up, chairing, and participating in the workshop/residency process. PPNC staff contacted clients and arranged for facilities to host the meetings and residency activities. During the final stages of the collaboration PPNC also helped with the marketing, allowing us to significantly grow our audience database. In addition, PPNC staff participated in media interviews, including several radio interviews and programs. What follows is an early Medea Project spoken word/audience participation rite, and then an excerpt of "BIRTHRIGHT?"

She

Nobody told her. Now she can't believe it when it's said. Born behind the eight-ball. Life's a house of cards. Nobody told her. (*Faster*) Everything's fine, as long as there's no wind. All blown away. House. Money. Children. Love. Life. Nobody told her that the one waiting on the street corner, in the alley way, in that hotel room, is the one who loses it all. Nobody told her that nothing much is expected of her, and therefore she doesn't have to hope for much. Nobody told her.

Nobody told her. That she's getting on that train, in the car and she's caught in the traffic and what is this destination? West Highway? 57th

Street?... Nobody told her, that while doing time for prostitution trying to get enough money to feed her baby, her baby's brains are splattered on the back seat of a car in the Tenderloin. Nobody told her. Nobody told her. Nobody! Nobody told her. Nobody told her. So how could she know? Nobody told her. Nobody.

"BIRTHRIGHT?"

LIGHTS UP.

> *[Women enter from wings with dance. Dance ends with women seated on the floor with their hands and legs out. Women stand and form clump behind Angie pantomiming cradling babies in their arms as the chorus sings one verse of an original composition by Medea member Lisa Frias, "Don't Step on an Angel." Angie busts into a monologue titled "Broken" and the women stop singing words and begin to hum "Don't Step on an Angel."]*

"Broken"

Angie: Broken ... breaking heart. It still beats. Therefore I still have life. Broken. Seven years old someone touched me but I don't have the memory to tell you about that. I emulate this behavior by touching all my girlfriends during sleep overs. Breaking. Nine years old sneaking lots of my grandfather's home-made corn whiskey. Broken. Twelve years old I'm told I am adopted, which makes my brother not my brother and my father not my father and everyone knows but me. Liars. I accidentally set the house on fire. Broken. Breaking heart. Broken. Seventeen years old ran from home to California with a 50-year-old violent man. He was sure I was cheating and would come home and stick his two fingers in my body and smell them to be sure I wasn't. I almost killed him before I escaped. Breaking. Seventeen years old. Escaped to an even more violent man. He locked me in a storage shed for a week but not before he shot his dog in the head in front of his young children and me. Lots of blood and brains. Broken. Eighteen years old scooped up off a porch by a Hell's angel. Lots of repeated anal rape on the floor of the club house. Broken breaking heart. Broken. Twenty-one years old, strung out, homeless, stripper and pregnant. *[Angie begins to address women and slowly disrupt and move within clump.]* I managed to get sober until my son was three. Breaking, addicted to meth, heart sick with the needle. Broken to pieces walking away from my only child. I broke my own heart selling my precious body on the corner. Broken. Breaking heart. Not continuing breaking the chain of addiction. Cigarettes. Now that's a breaking point. Alcohol. Breaking news. Lots of shame and embarrassing moments. A broken relationship with my son so skewed, so volatile, so dangerous. I pray my son won't be killed in the

streets. I miss my mother. Heart broken. I was never the daughter my mother needed me to be. *[By the end of "Broken" Angie is in the center of the Women's Circle as Fe Fe prepares for her monologue.]*

LIGHTS TRANSITION TO CENTER SPECIAL.

Ensemble intone: "Beloved you are my sister, you are my daughter, you are me."

[Women say the chant three times, encircling Angie, placing hands on her. Women exit into wings to get chairs, except Fe Fe. Women return with chairs and scatter them across the stage. LIGHTS TRANSITION to Fe Fe as she begins her piece, "I am from," with questions to the audience.]

"I am from"

Fe Fe: Where are you from? *[FE FE engages audience members as ensemble gets in place with chairs.]* I am from ... take it as it comes. Get it how you live. Fast chicks, stay away from loose lips. I am from "girl where you get those shoes?" "How you pull that dude?" "Where you get that car?" And my so called friends hatin' from afar. I am from baby daddy's making me sick and seeing baby mamas getting clowned by their baby daddies. Love to beat on their baby mamas. I am from the sound of motorcycles rollin' up and down the street. I am from goin' to a party, everybody sippin' on Bacardi. I am from a block of players, ballers and shot callers. I am from shoot em up bang bang, everybody slang. *[There is some improv language, but the last line stays the same.]* Dead or alive. Those are the things we did to stay alive.

LIGHTS TRANSITION to "How I broke my own heart" by Kathy McWay (the newest member of Medea).

[Kathy enters through the scattered chairs and moves slowly to CENTER SPOT to begin.]

"How I broke my own heart"

Kathy: Until I thought about it I never thought I could break my own heart. Yes, I have over, and over again. The pieces started to break away. This girl lived in my house, they said she was my sister, but what is that? While growing up a sister was someone I told my secrets to, my first best friend, not a stranger. Heart broken. Years later I got pregnant and had a daughter. I got turned on to crack. I got hooked. Heart broken. I left my daughter at school alone. I was too busy getting high. I broke my own heart when I let a man do things to me that I really didn't want him to do. I was on drugs and he

was supplying. I got pregnant, had an abortion. He OD'd *[Women echo OD'd]*. Heart broken. Men say I love you when all they really want is to have a place to stay until the next thing comes along and he says I DO *[Women echo I DO]*. Heart broken. I got a call at work from my doctor saying your HIV test is positive. NO *[Women echo NO]* this cannot be. *[Tavia exits discretely SL and crosses behind fabric to SR.]* That was the last piece. This heart of mine I will put back together one piece at a time.

LIGHTS TRANSITION to Deborah's "I was a virgin."

[Another member, Tavia, moves behind Deborah's chair. Women make semi-circle of chairs. Deborah begins monologue walking around outside of semi-circle and eventually into center spot.]

"I was a virgin"

Deborah: At 13, I didn't like playing with dolls, jumping rope or having tea parties. Until then, I lived a very sheltered life. I wanted to hang out with older kids. I liked talking to my neighbor's boyfriend—a 25-year-old man that made me feel pretty. I started flirting with him. I enjoyed his attention. As I was coming home from school I ran into him. I was kind of afraid of what he wanted from me and didn't know how to react or what to do. I followed him to the basement of his mother's house. *[Deborah moves to center.]* It looked dark and cold down there. My heart was beating so fast. He told me to lay on this damp blanket and asked, "Is this your first time doing this?" I said, "I am a virgin." He pulled my panties down and opened my legs up. At first I was scared and I wanted to cry out. He told me to be quiet. Sshh *[Women say and gesture 'sshh'.]* In my mind I didn't know what to do. I was a virgin and I was raped.

LIGHTS TRANSITION to "STOP!" by Tavia.

[Tavia runs down center stairs into audience House left. Cast follows Tavia down stairs. Tavia remains in the House left aisle for the beginning of monologue.]

"Stop!"

Tavia: STOP! I need to say this. June 2002 Thurgood Marshall Elementary School in Oakland, California. *[Women start "See No Evil" gestures and slowly retreat to stage. Slowly start to sing/dance "Oh Come on Playmate".]* Everyone in the fifth grade was rehearsing for the fifth grade graduation. And I had on my pink Baby Phat jeans that my momma bought me before she left for the rehab center. I asked to go to the bathroom. I went in the stall, pulled down my pants, sat on the toilet, and started to pee. As I peed,

I heard the door open. Then, I heard it close. When I came out of the bathroom stall there was a big Black man standing in front of me. Before I could scream or before I could yell he covered my mouth, laid me out and whispered, "Shut up, bitch!" *[Women in chairs with hands raised].* I cried in silence. He stuck his penis in me. In and out. In and out. Out and in. In and out. *[Women lean over chairs.]* And when he was finished he left out. I stayed in the bathroom until school was over. And no one paid attention. At the time, I was staying with my cousin. When I got in the car, she looked at me and saw the blood on my pants and said, "Yo little ass finally started your period." I cried. I kept it all to myself. I was raped 11 days before my tenth birthday *[Women move chairs into pew position. Tavia makes her way back onstage].* Six years later, I met D. He was my first boyfriend. I made him wait three years and then I finally gave it up. I trusted him. We had sex and he stopped calling. I was devastated. Six weeks later, I was throwing up everything I ate and my period was late. So, I went to Planned Parenthood alone to take a pregnancy test. It came back positive. Scared and alone, I opted to have a medical abortion, which is an enhanced mis-carriage. The doctor at Planned Parenthood suggested I have someone with me when I miscarried so I called D, and I called and I called *[Women circle behind chairs into kneeling position]* and I called and he didn't answer. So I decided I didn't need anyone. I suffered alone. A week later I went back to Planned Parenthood and they confirmed the pregnancy was terminated. That night I tried to kill myself. Overdosing on my mother's sleeping pills

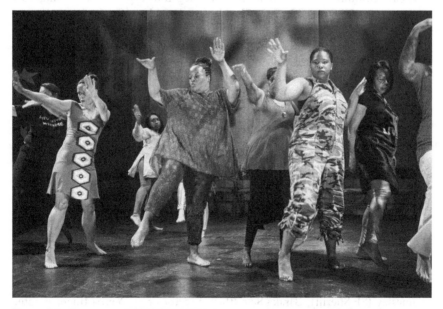

Figure 3.2 The cast of "BIRTHRIGHT." The Medea Project, 2015.

I woke up in the hospital. I never knew how precious life was *[Women stand up]* until I tried to take my own. And sometimes I still cry myself to sleep because I aborted my baby. He could have been the next Dr. King or Obama. She could have been the next Beyoncé or Rosa Parks. But I am starting to forgive myself. I'm starting to trust myself again. I'm starting to accept the fact that I broke my own heart.

And so it is

The Matrilineage

I am Rhodessa, the daughter of Estella, the granddaughter of Anna Lee, the mother of Sandra Lee, the grandmother of Chaz Nicole. Looking back over the past few decades, I have searched to make creations to save my own life. I am a teacher inside a local, national, and global culture of women.

The Medea Project: Theatre for Incarcerated Women has always believed that "she" can save her own life through the creative process. The process of art-making with female offenders for over two decades across the world has been revitalizing and transformative. Writing her way past shame and stigma, *she* is resurrected by her own words. Her voice speaking her truth! Sitting in a circle witnessing *her* journey becoming myth! Claiming her own scars as badges of courage: *I did that. I lived thru that. And I am still standing in spite of my own destructive tendencies.*

It has been more than 25 years since we began to explore truth-telling as a source for building performances inside San Francisco County jails. Everywhere I go, every time I'm asked to speak, I am constantly re-iterating: art saved my life. Theatre saved my life. The applause, the warmth, the togetherness created in the theatrical environment became a wave of energy that picked me up, held me, soothed me, and comforted me. I was home. I was loved, and I was needed, and so too were the members of the Medea Project. Our work has been lauded as an international model for personal transformation and self-empowerment. We have found throughout the world that *her* story is the same.

The Medea Project teaching methodology that I developed in the American penal system is vital and alive, even in South Africa's Sun City prison, where *she* is also broken, lost, bleeding, rageful, and betrayed by love. *She* is also eager to be heard in Turin, Italy, Anchorage, Alaska, Moscow, and the southern Caribbean in Trinidad. And yes, *she* is eager to be heard. She has blossomed in Africa as she has in San Francisco, the Carolinas, Texas, Florida, Alaska, and parts of Europe. I have learned that we must love the people. We must love the artist, and we must all work to understand the role of the artist.

The Medea Project is indebted to the support and encouragement of Mike Hennessey (SF Sheriff), Baraka Sele (then director of the Yerba Buena Center for the Arts in SF), Anna Halprin (choreographer), Fe Bongolan, (then

assistant director of the San Francisco Neighborhood Arts Program), Sean Reynolds, Evelyn C. White (author of *Alice Walker: A Life*), Idris Ackamoor (co-artistic director of Cultural Odyssey), and the artistic influences of Nina Simone, Ntozake Shange, and Alice Walker.

Looking back, I have come to understand that the work of the Medea Project is based in a woman's re-birth—her resurrection. Resurrection is the state of one who has been brought back to life. It is a difficult, transformative, yet rewarding journey. So to begin this journey, let us ponder the words of Ntozake Shange:

Let her be born, Let her be born and handled warmly.

Art saves lives

Rebecca Rice and the performance of Black feminist improv for social change

Lisa Biggs

> I realized a long time ago that if there was to be a place for me in theatre, I was going to have to make one for myself and for others by creating roles that reflected the values, dilemmas, and aspirations of the people who are seldom portrayed in positions of respect.
>
> (Rebecca Rice, actress, playwright, teacher, 1947–2002[1])

The contractions and tensions between the hyper-visibility of Black bodies and the necessity to mask the intellectual labor they at times conduct undergird Black performance practices today. Performance is the site where we make and break cultural norms, transform, and reform ourselves at the individual, interpersonal, institutional, and societal level.[2] In times of great social upheaval, Black women's activism on stage and off has been crucial for the survival of the race and the advancement of human kind. Despite the wealth of evidence of Black creative work, the contributions of Black women artists who specialize in theatre performance improvisation are far too often overlooked. Their absence paints an inaccurate portrait of the development of Black art, the discipline of theatre as a whole, and the role of performance in society.

In this essay, I recount experiences in Black feminist, improvisational theatre performance workshops led by Rebecca Rice (1947–2002) at the height of the War on Drugs, and theorize their effect. Rice was an African American theatre artist based in Washington, D.C., who worked as an artistic associate at the Living Stage Theatre Company, the community engagement "arm" of Arena Stage. From 2000–2002, she facilitated a series of improvisational theatre workshops at Living Stage with a group of Black women enrolled in a comprehensive drug and alcohol treatment program called Crossing the River. I chart Rice's artistic influences and evolution, braiding together personal recollections of my time with Rice as an assistant teaching artist to paint a portrait of her praxis. My personal account is interwoven with materials drawn from the archive as well as interviews with workshop participants and other facilitators. By gathering together these resources, I hope to

complicate the existing narrative about improv in the U.S. by revealing how this artist in the nation's capital practiced improvisation as sacred play to affirm Black women's right to respect and to a future.

About me

Six years of running between auditions and my day job as a temporary sec-retary in Chicago taught me I loved theatre, but not show business. Disap-pointed that I would have to continuously contend with the restrictive stereotypes, I began to seek out colleagues who were driven by the shared belief that the arts were essential to the human spirit and to human devel-opment. I had read about the Washington, D.C.-based Living Stage Theatre Company as an undergraduate. The ensemble worked to develop original performance works about people and issues that were relevant to the work-shop participants, most of whom were drawn from the schools and com-munity centers of the nation's capital. The ensemble of actors were not interested in making people laugh, though workshops were fun. They used improvisational theatre techniques to tell the most pressing stories articu-lated by people who never saw themselves on the main stage. Living Stage's style of theatre for social change blended aspects of Viola Spolin's improvi-sational theatre techniques with echoes of Augusto Boal's Theatre of the Oppressed, seasoned with original approaches honed from decades of working with largely poor and working class Black and Brown D.C. resi-dents. When the chance to audition for the ensemble arrived in December 1998, I took it, and was hired. Under the direction of then artistic director Oran Sandel I found a true artistic home. Everyday offered an opportunity to play any role I could imagine, create new work, and explore new artistic horizons. When Living Stage began partnering with Crossing the River, I was excited to assist. But until I met the women, I had no idea how improvisational theatre technique, taught from a Black feminist perspective, would (re)shape us all.

Improvisation: not just for laughs?

The history of theatre improvisation has been largely written as the invention and provenance of White male artists.[3] Scholars including Anthony Frost and Ralph Yarrow acknowledge unscripted play is integrated into perform-ance practices across the globe, but emphasize the history of professional American theatre improvisation originates in Europe.[4] They write that Russian theatre director Constantin Stanislavsky developed improvisation as a "rehearsal and [actor] training device" in the late 1800s–early 1900s.[5] Exiled Russian actors versed in his approach fled to New York in the 1920s and founded several influential drama schools, including the Lab and the Actor's Studio. There, actors cultivated the ability to produce "immediate"

and organic" responses to stimuli on stage as part of an emerging, modern-
ist, performance sensibility.[6] The sense of unpredictable aliveness they
learned to emit, regardless of how many times they had performed a
scripted show, captivated audiences. By the mid-twentieth century,
improvisation was being modified into a method of devising new work in
experimental theatre and dance companies across the country. Later, pro-
fessionally trained, primarily White male actors would capitalize upon the
possibilities spontaneous action offered for audience entertainment in
comedy clubs like the Second City.[7]

When African American artists are repositioned from the margin to the
center of improvisational theatre history, improvisation emerges as a critical
tool not just for art, but for Black survival. An Afrological perspective
grounded in Black peoples' experiences in diaspora understands that the
world is fundamentally unstable, unpredictable, and unfixed. In such a
volatile environment, human beings must continuously act in spontaneous
ways to meet their needs. Daily, these acts of improvisation manifest
through quotidian exchanges like playing the dozens or more spectacular
performances, such as undermining oppression. Jazz musician and scholar
George Lewis determined that an Afrological perspective animates Black
life and expressive culture. The history of jazz demonstrates that Black
artists have long been determined not only to oppose "dominant White
American culture," but to "advance" Black peoples through their music,
whose form and content disrupts Eurocentric modalities.[8] Building upon
Lewis, George Lipsitz finds:

> Afro-diasporic improvisation is an art of interruption. It teaches per-
> formers to prepare for rupture and to respond to it. It is not simply an
> aesthetic practice but rather an epistemological and ontological impera-
> tive. Improvisation entails distinct ways of knowing and ways of
> being.[9]

The kind of flexibility, responsiveness, and oppositional stance to restrictive
practices that White theatre artists came to value in their actors had long
formed the basis of Black people's understanding of, and approach to, the
world.

By the late 1960s–early 1970s as the Civil Rights and Black Power move-
ments reached their heights, however, many Black women realized that men
in their communities defined liberation narrowly as the "expanse of Black
men's agency."[10] Refusing to accept gender inequality and homophobia as the
price for racial freedom, some Black women artists began to make their own
work, explicitly embracing aspects of the women's liberation movement, espe-
cially the feminist notion that "the personal is political."[11] Lisa M. Anderson
writes that experiments with form and content gave Black feminist theatre a
distinctive style. Artists such as Ntozake Shange built performances whose

narratives, language, tone, musicality, shape, and choreography enfleshed and articulated the experiences of Black women. Black women artists put Black women's lives, bodies, stories, and knowledge center stage, revealing their thoughts, their values, and struggles with intersecting systems of oppression (i.e., race, class, gender, and sexuality). Through performance, they sought to intervene in the numerous privileged discourses that undervalued Black women's lives, intellectual work, and creativity. A determination to advance the lives and political causes of Black women in their time, in solidarity with others who faced oppression, gave birth to and continues to define Black feminist theatre.[12]

Crossing the River

In the late 1990s, a deep and abiding concern for the well-being of women and girls with histories of domestic violence, sexual assault, and substance abuse inspired Malika Saada Saar, then a Georgetown University law student, to establish Crossing the River. Crossing the River was an arts advocacy and women's leadership initiative housed at the Anacostia Mental Health Center (AMHC) in Washington, D.C. As Omi Osun Joni L. Jones writes, in rivers, the Black body—its spirit and soul—can escape the old, be buried, washed and renewed, born and reborn. Rivers' real and imagined shores can carry Black bodies to something new. The name Crossing the River invoked these waterways from the African American imaginary as "liminal" sites of "transformation and possibility" for women transitioning to new lives.[13]

AMHC offered 18–24-month, comprehensive, in- and outpatient counseling to women with histories of substance abuse, including some who were under carceral control.[14] Its rare supportive, residential setting allowed (some) mothers to keep their children as they moved from "abusive circumstances into a way of being ... strengthened by health and wholeness."[15] Saada Saar's written and spoken word workshop complemented the more conventional public health service model AMHC offered.[16] It introduced AMHC's clients to successful women who had structured their lives around evolving practices of physical and mental wellness. Tanisha Christie, Living State Artistic Assistant Director and co-facilitator of the Crossing the River workshops, recalled that Saada Saar hoped the successful Black women would serve as powerful role models for those in recovery.[17]

In the later part of the twentieth century, under the guise of a crack cocaine public health crisis, draconian War on Drug policies were implemented to undermine the growing political, social, and economic power of the poor and working classes, especially people of color. American political and cultural elites on both sides of the political spectrum advocated for tough-on-crime policies that threw millions behind bars. Frightening images of criminal Black "crack hoes," and the degenerate wards of the state that they

allegedly bore, were deployed to authorize the policy changes, and to dismantle the welfare system.[18] The violence of this symbolism, and the brutal legislation that it authorized, initiated a process that has made women the fastest growing segment of the prison population since 1980, while masking the political and economic forces that fueled their skyrocketing numbers. From 1977–2004, the women's combined state and federal incarceration numbers rose from 12,279 to 104,848; by 2000, Black women would comprise the majority of women behind bars.[19]

Community-based treatment facilities like AMHC provided a limited protective shield for those women who could access their services. After years, in some cases decades, of organizing their lives around problematic drug and alcohol use, the task of rebuilding seemed daunting. Many of the predominantly African American women that received treatment at AMHC struggled to articulate what they had experienced and to imagine an addiction-free future. When it became clear to Saada Saar that her initial, interview-focused approach required innovation, she sought out Rice, who was well known for working with women dealing with substance abuse, domestic violence, and homelessness.[20] Rice's Black feminist improvisational theatre workshops proved pivotal in the participants' self-remaking process.

Rebecca Rice

Rice was born in Tyler, Texas on July 17, 1947. As a child, she moved with her parents and sister to the Westside of Chicago, IL, where she took art classes through the local segregated Park District. In the 1950s and 1960s' Jim Crow America, African Americans organized their own amusements, and engaged in systemic campaigns to enter, occupy, and utilize public facilities, asserting a fundamental human right to mobility, public services, art, and to play.[21] One of Rice's first art teachers, Johnny Houston, an African American recreation manager, recruited her to participate in a community arts program called *Newer Still Productions* at a local city park when she was five. Houston demanded a lot and had great faith in her and the other neighborhood kids. Rice recalled:

> We worked very hard and had fun. We took dance, and voice, and acting. We were thoroughly trained and he didn't consider limitations ... Working with "Newer Still" allowed me to say to myself, "I know what I'm capable of." It gave me birth in many ways.[22]

Rice worked with Houston for over a decade, until she was nineteen. His encouragement helped her earn several college scholarships. But the call to activism propelled Rice to join the Black Panther Party and eventually move to Washington, D.C. There she began offering theatre improvisation classes at community organizations, including RAP, Inc., a program for men and

women in drug and alcohol recovery. In 1970, Rice auditioned for and became a member of the Living Stage Theatre Company, a community engagement initiative affiliated with Arena Stage. This began a fourteen-year collaboration with Living Stage's founding artistic director, Robert Alexander (1929–2008), and an evolving ensemble of dedicated performing artists, including Jennifer Nelson, Oran Sandel, Mark Novak, and Ezra Knight.[23]

Four years earlier, Zelda Fichlander, founding artistic director of Arena Stage, had invited Alexander to start an outreach and educational program, which evolved into the Living Stage. Alexander, a White director of Russian-Jewish descent cultivated an interracial acting ensemble—a rarity then and now—to make theatre in disenfranchised communities with those he called "the forgotten."[24] Susan Haedicke writes that Alexander referred to poor and working class people, Blacks and Latinos, the disabled, the incarcerated, seniors, and inner-city youth as "the forgotten people" to signal how they had been, in his words, "depoliticized."[25] Alexander believed racism had rendered these constituencies "politically and socially passive by taking away their initiative to speak and act."[26] Under his direction, Living Stage worked to reaffirm and amplify their inherent "genius."[27] Because Living Stage's approach, like other theatre for social change programs, was meant to "maximize the participants' agency," the company shied away from producing commercially viable products.[28] Intensive, self-contained performance workshops incubated and enacted social change by teaching art-making techniques and developing creative work "not *for*, but *with*" oppressed communities.[29] On a daily basis, these sessions served as vehicles through which the "forgotten" could tell their own stories and impact public discourses.[30] For some thirty-six years, Living Stage artists approached this work with an ethos that affirmed improvisational theatre could quite literally save lives. Rice agreed:

> Art saves lives, yes, it does, and I have to begin with my own self because I believe that art and Living Stage saved my life very particularly ... I believed that the only way that anything could change in this country was through violence ... [When] I met Robert Alexander, he said that you can pick up the sword or you can pick up the pen. You can pick up a gun or you can become an artist. For a long time I wasn't sure which one I wanted to be. As I transformed my anger into something that was more empowering and something that was more powerful, I discovered that I didn't need to pick up a gun. I could have a greater and more long lasting impact by becoming an artist.[31]

For fourteen years, Rice co-composed original scripts and led untold numbers of performance workshops for participants aged 3–103. The work was transformative for Rice, but over time she realized that, while Alexander provided strong direction, he also hindered some forms of expression. She explained:

> Black culture consists of more than just pain … Because of [Alexander's] perspective and lack of knowledge, we spent very little time exploring Black values and how White society can learn from them. The audiences we served reaped enormous benefits from the creative and supportive atmosphere the company established. However, I consistently carried the feeling that we were not sharing some vital information … and ran the risk of deepening their wounds.[32]

Concluding that "spirituality, sacrifice, love, common sense and a strong sense of community" were integral to her life and her work, Rice left Living Stage in 1984.[33]

With Janet Stanford, a White American theatre artist, she soon co-founded the Human Bridge Theatre based on a "common theatre language and a passion for the work."[34] They developed *This is the House*, a two-woman play about domestic violence, and toured it to women's shelters in the U.S. and U.K. From 1984–1987, opportunities to collaborate with other companies took her across the country until she chose to settle in Minnesota.[35] There she began working with two companies that would powerfully shape her future.

At the Foot of the Mountain was then the longest-running feminist theatre in the United States. Rice joined the company as it transitioned from an all-White women's collective into a multi-racial ensemble. Rice and another newly hired actress, Bernadette Hak Eun Cha, were soon promoted to co-artistic directors to steer the transformation.[36] Rice also began working with the Penumbra Theatre Company, Minnesota's longest running African American theatre company, appearing in several leading roles. Lou Bellamy, their founding artistic director, invited her to become a core member of the ensemble. Rice's leadership helped Penumbra expand its repertoire to include more Black women playwrights. Over the next ten years, they produced Rice's original plays, *Waiting in Vain* (1993) and *Everlasting Arms* (1996), alongside works by Laurie Carlos, Robbie McCauley, and many more.[37]

When she returned to D.C. in the mid-1990s, Rice had grown into a much sought-after actress, playwright, director, teacher, and anti-racism/anti-oppression trainer. An opportunity to affiliate with Arena Stage again led to main stage acting roles and a new engagement with Living Stage, now under the direction of long-time company member Oran Sandel. Lessons learned from her artistic journeys she brought home to Crossing the River. The critical, Black feminist improvisational storytelling process that formed the foundation of Rice's workshops counteracted the repressive narratives that defined these Black women's lives as shameful and worthless. They revealed to some, and affirmed to many more, the constructed nature of what passes for truth in public discourses and the instability of the myths that uphold the system. Critical to the process was the use of songs as anthems to welcome and galvanize the women to participate, and unscripted improvisational scene work developed in collaboration with them about issues that were most important to them.

Rice's process: come as you are

It was Rice's custom to begin Crossing the River workshops singing a *jam*, a short song that had been collectively composed in advance by Living Stage ensemble members through an improvisational process similar to that of jazz musicians. In a typical workshop, before the participants would enter, Rice would signal to her team of teaching artists, including me, to use the song to welcome the women into the building on the corner of 14th and T Streets, NW. The expansive white box theatre had high ceilings, sprung wood floors, and colorful set and costume pieces that shone with natural sunlight. It filled with song as the women—Black mothers of all ages, in sock feet, soft blue jeans, and oversized sweatshirts—entered in.

To start our work together, Rice began singing *Come As You Are*, a jam with lyrics by Oran Sandel and music by Zoe Alexandratos. As the women entered the space, she crooned, "It doesn't matter what you say, if it comes from your heart then it's okay." Never missing a note, Rice directed the Crossing the River women to stand shoulder to shoulder with the Living Stage teaching staff in a large circle, including me. Once everyone was in place, Rice taught the *jam*, breaking it down line by line. She sang a line then signaled to the participants to repeat it back.

REBECCA: It doesn't matter what you say
PARTICIPANTS: It doesn't matter what you say
REBECCA: If it comes from your heart then it's okay
PARTICIPANTS: If it comes from your heart then it's okay

Through a process of call-and-response, the lyrics accumulated until together we sang:

> It doesn't matter what you say, if it comes from your heart then it's okay.
> It doesn't matter what you do as long as it comes from Y-O-U.
> Come as you are, one step at a time,
> You're beautiful, you're a star, you shine.

Sound as song within the African diaspora connects people otherwise distinguished and divided by geographical location, language, culture, and experience through the act of singing and listening into a burgeoning "political public."[38] Shana Redmond demonstrates that songs like *Lift Every Voice and Sing*, *We Shall Overcome*, and South Africa's anti-apartheid *Nkosi Sikelel' iAfrica* articulated and symbolized a distinctive political position forged from the experiences of African descended people in the diaspora. As opposed to official national anthems, these songs represented counterhegemonic communities that included Black peoples as citizen-subjects. Lyrics conveyed shared experiences of "violence and racial exclusion" while voicing liberatory

visions for the future. The songs established and affirmed a community of belonging that exceeded the boundaries of the modern nation-state. Through these songs, Black peoples were repositioned as respected community members worthy of protection. Redmond concludes that because Black anthems conveyed recognizable histories of oppression while simultaneously offering up life-affirming "alternative theorizations and performances of blackness," they helped mobilize Black people to action.[39]

The lyrical invitation to "come as you are" signaled a deeply held respect for the women's histories, ideas, experiences, and fundamental humanity that eased their transition into the workshop. The song communicated Rice's belief that they belonged—at Living Stage literally, and more metaphorically, in the world at large. Teaching the song through call-and-response further established that the workshop would emerge from a Black cultural praxis that placed a high value upon embodied experience, local know-how, orality, and hands-on, deep participation. It was a powerful experience for me as a young Black woman to sing and hear the song sung, and to invite and simultaneously be invited into the artistic process. Because Rice had grown up in segregated Black communities, and long worked as a community-based theatre for social change artist, she grounded her workshops in this approach.

Claim your space, T'Angela

Rice, Saada Saar, Sandel, and co-facilitator Denise Kumani Gantt (a distinguished poet) often discussed how Crossing the River women struggled to imagine themselves as successful. Living in a world that did not value them, why should they take risks? Rice proposed that the women investigate how a person creates a meaningful life for herself using a technique called a Backward Improv. The women would develop a character that embodied their collective ideal of success. They would invent a scenario in which she was being recognized for her accomplishments. The improvisation would move her backwards through time to reveal the significant, if not always successful, moments in her life. The goal was not to draw causal relationships between events, or generate a prescription for success, but to imagine the myriad, even competing events that might contribute to a character's meaningful life journey. While the plot would focus on the character's past, the process required the women to compose the story in the moment and imagine how it might unfold in the future. It was an exercise in responding to challenges in the moment and dreaming the future for the character and themselves.

Gathered together in the Living Stage theatre one February afternoon in 2000, the women brainstormed an image of their ideal woman and settled upon a figure that I call T'Angela (pronounced Tee-Angela). T'Angela was a complex character whose name evoked superstar entertainers and a legacy of Black political activism. Today, she might be a combination of Michelle Obama and Beyoncé—an accomplished, confident, politically astute, and

beautiful Black mother who could really sing. In 2000, I recall she was part Tina Turner, part Angela Y. Davis. The name I chose for this writing, T'Angela, is meant to evoke their ideal.[40] Like Turner, it was soon revealed that T'Angela was also a survivor of domestic violence; like Davis, she had been incarcerated. Rice announced T'Angela would receive a lifetime achievement award this day. One woman volunteered to embody the role. The other women wrapped her in a brightly patterned cloth like the Statue of Liberty and stood her on a red rehearsal cube for a stage.

The women decided that T'Angela was being honored by a combined human rights and environmental justice organization at an extravagant gala. Everyone else in the room, they imagined, was seated at tables in the decadent hall in their glittery best. The improvisation would begin with her acceptance speech. She was unsure what to say. Participants shouted out possible lines, which the actress quickly synthesized into a short speech in which she thanked God, her family, and her supporters. Rebecca then said, "Freeze," meaning that everyone should stop moving and stop talking to listen for instructions.

In a Backward Improv, the flow of action moves from the present into the past in increments large or small. The exercise involves both preplanned and unanticipated elements. Participants might craft a scene a handful of seconds before or after an important event in a character's or community's life, or leap across significant stretches of time. Time can even be compressed, allowing an extended examination of a single moment. Omi Osun Joni L. Jones and Sharon Bridgforth demonstrate that in Afrological performance "*now, then* and *will be* coexist": the tension between the scripted/anticipated and the unknown/improvised brings a show to life.[41] With Crossing the River, Rice used play to compose the critical turning points in T'Angela's past that brought her to the award ceremony. She did so by blending participants' suggestions about what might have happened into a loose script filled with opportunities to improvise upon the accepted plot. Doing so allowed performers to build upon the script to reveal implied if unarticulated—even unanticipated—truths that shaped the characters' lives. The script had enough structure so they understood where the story was headed and could act with confidence within it. But playing required taking risks because the outcomes were not fully determined. One had to commit to living within the unknown, exploring unforeseen possibilities, and using the body/mind to make connections in the moment that would impact the self (actor), the character(s), and the audience.

Rice prompted them to make up what had happened right before T'Angela came on stage to deliver her speech. Thirty seconds before T'Angela accepted her award the participants decided she was standing behind the stage curtain with two of her children. Two women agreed to play these roles, and quickly donned scarfs, hats, wigs and other costume

pieces. Rice brought this scene to life just long enough to establish the names of the children and their enthusiastic support for their mother's achievements, despite what they alluded to as "all the odds," then Rice froze the action.

Another brainstorming session revealed that five minutes before this supportive family moment, T'Angela had been in her dressing room arguing with those same children, her mother, and her ex-husband-former-pimp-and-drug-dealer. She had loved him, but it was complicated. He was trying to get some money from her, and offered her drugs. The dressing room scene was soon cast and brought to life. It became a space in which to explore what one might do when faced with the very real possibility of being offered drugs by someone who knows you well, without delving into anyone's history like drama therapy, verbatim, or playback theatre. Their meaningful, often funny exchanges, explored the challenges facing families whose members have histories of problematic substance use. After weeks of working together, however, Rice wanted them to do more than repeat the message "Don't Use" advanced by AMHC. To do so, she asked the women to imagine several perhaps less predictable scenarios from T'Angela's past, including the day she was born.

Now tasked with playing T'Angela as a baby or one of her parents, the participants (and in some cases Living Stage ensemble members playing alongside them) were asked to imagine what the parent might have said to the baby T'Angela the day she was born as well as how she might have grown up, and what kind of childhood she had. A brief environment—i.e., open play session where everyone is improvising in small groups simultaneously as if in a single locale or several related places—allowed the participants to embody T'Angela as a girlchild. For this group of women who in many cases felt they never had a real childhood, the opportunity to play openly was exhilarating. A culminating creative letter writing activity provided a capstone to the workshop. The page became a space in which to commune with both past and future temporalities at once, blurring the presumed binary between where they had been and where they were going.

Rice was met with some resistance, particularly assertions early on that the women could not write or did not know how to play. Persistent coaching encouraged them to challenge the boundaries, be they imposed by society or by themselves. For some, this movement from margin to center, audience sidelines to stage, may have felt like the "longest trip of [their] life," but in that journey, Rice recognized, "[W]alls come crashing down, worlds [start] opening up."[42]

To bring the workshop to a close, the women stood together in a closing circle. Fashioned now in brightly colored patterned fabric, oversized wigs, hats of all shapes and sizes, and the occasional sport coat and tie, they asked that instead of reprising the opening song, *Come As You Are*, to conclude the afternoon with *A Rose Is Still A Rose* by Aretha Franklin. The CD was quickly located and loaded into the sound system. Only a few people really

had all the words down. But, when Franklin rounded the chorus, together we all sang:

> A rose is still a rose
> Baby girl, you're still a flower
> He can't lead you and then take you
> Make you and then break you
> Darlin', you hold the power.[43]

As Franklin's voice faded, Rice stepped forward to say, "Become yourselves." The phrase signaled it was time for the costumes to come off and for the women to return to AMHC. Her words also acknowledged the journey they had been on and the determination embedded in their chosen song, *A Rose Is Still A Rose*. After two hours focused on exploring paths to a successful life, their self-selected anthem captured our time together. The lyrics acknowledged the possibility they might again encounter love and loss again, but expressed an abiding faith that the outcomes were not fixed; they would meet these challenges differently having done this work together.

Trajectory

Rice used improvised play(s) to confront and break up the derogatory stories told about Black women that were upheld in public discourses as truth.[44] The result was an improvisational theatre that blurred the boundaries between onstage and off-, sacred and secular, real and fiction, and most importantly, between healing transformations and performance. In an era of endemic poverty, racial injustice, gender discrimination, and limited access to comprehensive health care, improvisational theatre workshops could not single-handedly change the world for the better. Yet under Rice's direction these sessions at Living Stage offered Crossing the River participants a "productive way" to think about the unanticipated "breaches" that occur in life as well as the "solutions."[45]

More than a decade later, Imani Walker, a former workshop participant, reminisced about her time with Crossing the River in a 2012 speech given for the District of Columbia Superior Court's New Directions drug intervention program (a.k.a. drug court).[46] Standing under a bright blue sky before an audience of some 150 drug court staff, men and women who had completed the voluntary program and their families, Walker reflected upon the changes she underwent during treatment. She explained, "What I know now is that courage is not absence of fear, but having fear and acting responsibly even in the face of that fear. When I think about the unknown [now] I think about infinite possibilities."[47]

Rice offered improvisational theatre workshops to Crossing the River participants to name and challenge the forces that limited their opportunities, including for some their own sense of what they could accomplish. Grounding

her approach in Black feminist theory was a determination that these forums would advance the women's "values, dilemmas and aspirations."[48] From there, Rice asked the women to engage in a whole world re-making process with themselves at the center of creation. Improvisation requires paying close attention to self and to others as well as to the larger social forces that shape every interaction between players. The intimacy of the moment-to-moment exchanges powerfully affirmed the women's presence in the world. In these exchanges, time stopped and worlds of new possibilities opened.

An expansion of the scope of the field of improvisation studies to include Black feminist artists reveals different stakes and differing outcomes for the praxis. Undergirding Black feminist improvisation is an explicit determination to use performance to undo inequality and produce a more inclusive society. This is the fundamental work of the Black feminist improviser.

Acknowledgment

My deepest thanks to Oran Sandel, Kristin Horton, Tanisha Sabine Christie, Denise Kumani Gantt, Lorna Hogan, Rosetta Kelly, Imani Walker, Terese Monberg, Austin Jackson, the George Mason University Library Special Collections librarians, and the editors for their generous support.

Notes

1 Rebecca Rice, "Losing Faith (or Gaining Perspective)," in *Reimaging America: The Arts of Social Change*, eds. Mark O'Brien and Craig Little (Philadelphia; Santa Cruz: New Society Publishers, 1990), 212.

2 D. Soyini Madison, *Critical Ethnography: Method, Ethics and Performance*, 2nd. Ed. (Thousand Oaks: Sage Publications, 2011), 188–190.

3 See Anthony Frost and Ralph Yarrow, *Improvisation in Drama*, 2nd ed. (New York: Palgrave MacMillan, 2007); Keith Johnstone, *Impro: Improvisation and the Theatre* (New York: Routledge, 1987).

4 Frost and Yarrow, *Improvisation*, 45–47.

5 Ibid., 20.

6 Ibid., 4.

7 The origin of U.S. comedy improv is popularly attributed to two White American women—Neva Leona Boyd and Viola Spolin. See Frost and Yarrow, *Improvisation*, 49–57.

8 George Lewis, "Improvised Music After 1950: Afrological and Eurological Perspectives," *Black Music Research Journal* 16, no. 1 (1996), 94.

9 George Lipsitz, "Listening to the Lambs," in *The Improvisation Studies Reader: Spontaneous Acts*, eds. Ajay Heble and Rebecca Caines (New York: Routledge, 2015), 10.

10 LaDonna L. Forsgren, "'Set Your Blackness Free': Barbara Ann Teer's Art and Activism During the Black Arts Movement," *Frontiers* 36, no. 1 (2015), 155.

11 Uri McMillan, *Embodied Avatars: Genealogies of Black Feminist Art and Performance* (New York: New York University Press, 2015), 5.

12 Lisa M. Anderson, *Black Feminism in Contemporary Drama* (Urbana; Chicago: University of Illinois Press, 2008), 11–13.

13 Omi Osun Joni L. Jones and Sharon Bridgforth, "Black Desire, Theatrical Jazz and River See," *TDR: The Drama Review* 58, no. 4 (Winter 2014), 137.

14 Some Crossing the River women were in treatment at AMHC by court order on drug or alcohol related charges or to regain custody of their children; Tanisha Sabine Christie, interview with the author on April 19, 2015, Brooklyn, NY.

15 Tammeric Itson Scurry, *Living Stage Theater Company Production Report: Annual Report*, Washington, D.C., Living Stage Theatre Company, Arena Stage, 2000–2001, 2–3.

16 Traditionally service providers treat the symptoms of illness after disease processes have already set in. Thanks to Bob Eubanks for insights gained in conversation on October 31, 2015.

17 Christie, personal interview with the author, 2015.

18 Richard Iton, *In Search of the Black Fantastic: Politics and Popular Culture in the Post-Civil Rights Era* (Oxford: Oxford University Press, 2010), 155.

19 This shift is not indicative of a rise in women's illegal activity, but modifications in the law which for the first time mandated incarceration for the nonviolent offenses women are most likely to commit. See Paula C. Johnson, *Inner Voices: Voices of African American Women in Prison* (New York; London: New York University Press, 2004), 34–39; Allen J. Beck and Jennifer C. Karberg, *Prison and Jail Inmates at Midyear 2000* (Washington, D.C.: Bureau of Justice Statistics, 2001), 5; George Hill and Paige Harrison, *Female Prisoners Under State or Federal Jurisdiction 1977–2004* (Washington, D.C.: Bureau of Justice Statistics, 2005), accessed January 23, 2016, www.bjs.gov/content/dtdata.cfm#prisoners; Paul Guerino, Paige M. Harrison, and William J. Sabol, *Prisoners in 2010* (Washington, D.C.: Bureau of Justice Statistics, 2011), accessed January 24, 2016, www.bjs.gov/index.cfm?ty=pbdetail&iid=2230.

20 For more about Rice's career, see William Cleveland, "Rebecca Rice: Building Bridges," in *Art in Other Places: Artists at Work in America's Community and Social Institutions* (Westport; London: Praeger, 1992), 259–271; Janet Stanford and Jennifer Nelson, "In Memoriam: Rebecca Rice (1947–2002)," *American Theatre* 19.6 (July/August 2002), 18; *Walk With Me: The Movie*, DVD, dir. Tanisha Christie and Ellie Walton (Brooklyn: Ayaa Arts and Media, 2011); Macelle Mahala, *Penumbra: The Premier Stage for African American Drama* (Minneapolis: University of Minnesota Press, 2013), 81–92.

21 Victoria W. Wolcott, *Race, Riots and Roller Coasters: The Struggle Over Segregated Recreation in America* (Philadelphia: University of Pennsylvania Press, 2012), 9.

22 Rice quoted in Cleveland, "Rebecca Rice," 260.

23 Robert Alexander was a professional theatre director of Russian Jewish descent from New York who had been affiliated with Julian Beck and Judith Malina's Living Theatre. For more about Living Stage and Alexander's approach, see Robert Alexander, "What Are Children Doing When They Create?," *Language Arts* 61, no. 6 (September 1984), 478–479; Susan C. Haedicke, "The Challenge of Participation: Audiences at Living Stage Theatre Company," in *Audience Participation: Essays on Inclusion in Performance*, ed. Susan Kattwinkel (Westport: Praeger, 2003), 71–87.

24 Haedicke, "Challenge," 85.

25 Ibid., 85.

26 Ibid., 85.

27 Rice quoted in Christie and Walton, *Walk With Me: The Movie*, 2011.

28 Susan C. Haedicke and Tobin Nellhaus, "Introduction," in *Performing Democracy: International Perspectives on Urban Community-Based Performance*, eds. Susan C. Haedicke and Tobin Nellhaus (Ann Arbor: University of Michigan Press, 2001), 3.

29 Haedicke, "Challenge," 71.

30 Haedicke and Nellhaus, "Introduction," 1–2.
31 Christie and Walton, *Walk With Me: The Movie*, 2011.
32 Rice, "Losing Faith," 209.
33 Ibid., 209.
34 Ibid., 211.
35 Companies included Centrifugal Force, Latinegro Youth Theatre Collective, Liz
 Lerman Alliance for Cultural Democracy, Planned Parenthood of California, Art-
 sreach Theatre Project, and Black Artists-White Artists (BAWA). For an overview
 of her professional accomplishments from 1970–1988, see Rice, *Reimaging
 America*, 206–213.
36 Charlotte Canning, *Feminist Theatres in the U.S.: Staging Women's Experience*, (New
 York: Routledge, 1996), 83–84. For more about At the Foot of the Mountain,
 see Martha Boesing, "Rushing Headlong into the Fire at the Foot of the Moun-
 tain," *Signs* 21, no. 4 (Summer 1996), 1011–1123; Jill Dolan, *The Feminist Spec-
 tator as Critic* (Ann Arbor: University of Michigan Press, 2012), 92–95; Lynne
 Greeley, "Whatever Happened to the Cultural Feminist? Martha Boesing and At
 the Foot of the Mountain," *Theatre Survey* 46, no. 1 (May 2005), 49–65.
37 Quoted in Mahala, *Penumbra*, 85.
38 Shana L. Redmond, *Anthem: Social Movements and the Sound of Solidarity in the
 African Diaspora* (New York: New York University Press, 2014), 2.
39 Redmond, *Anthem*, 2.
40 Interviews with former Living Stage ensemble members and research at the Arena
 Stage archives at George Mason University Special Collections have failed to
 identify the original name of the character.
41 Jones and Bridgforth, "Black Desire," 138–139.
42 Becky [Rebecca] Rice, "How Do You Describe a Sunset to Someone Who Has
 Never Seen One?," *Off Our Backs* 1, no. 23 (June 1971), 9.
43 Aretha Franklin, "A Rose Is Still A Rose," *A Rose Is Still A Rose* CD,
 Arista, 1998.
44 Sara Warner, "Restoryative Justice: Theatre as a Redressive Mechanism for Incar-
 cerated Women," in *Razor Wire Women: Prisoners, Activists, Scholars and Artists*,
 eds. Jodie Michelle Lawson and Ashley E. Lucas (Albany: State University of New
 York Press, 2011), 239–240.
45 Warner, "Restoryative Justice," 240–241.
46 Drug courts are an alternative judicial method of addressing crimes related to
 problematic drug and/or alcohol use. For more see the National Association of
 Drug Court Professionals (NADCP) website: www.nadcp.org.
47 Imani Walker, "Drug Court Key Note Address," for District of Columbia Supe-
 rior Court's New Directions Graduation, delivered September 20, 2012, tran-
 scribed from audiotape by author.
48 Rice, "Losing Faith," 212.

Methods of intervention

Seeing Shakespeare through brown eyes

Justin Emeka

In the United States, because of our legacy of racial inequality and White supremacy, the scope of our stage has been historically limited to one racial perspective. Great authors often regaled with the title "classic playwrights" tell a "classic" story that is exclusive to a unique cultural framework that can often be defined by "Whiteness." As the American theatre becomes more inclusive and reflective of our diverse population, it will be important for our stages to reflect the richness and specificity of the multitude of cultural traditions that define America. First and foremost, this requires a commitment to nurturing and producing work written by artists of color. Yet, also imperative is redefining approaches to casting roles in the canon of "classic" texts that were written for White actors but now, as a result of many generations of struggle and protest, may be played by actors of color.

The plays of William Shakespeare continue to represent one of the most influential bodies of work in the English-speaking theatre. Shakespeare in many ways represents the center of the Western theatre tradition and the epitome of "classical theatre." Every year, Shakespeare is the most produced playwright in America—no other playwright even comes close.[1] At some point, most students of the acting craft will confront Shakespeare's canon. Each actor in addition to mastering the text will rely on the wisdom of their own experience and imagination to create these roles. Konstantin Stanislavski considered the "embodiment of the role" an essential part of the actor's process.[2] In addition to strong vocal and speech preparation, an actor's success will largely be determined by their ability to take ownership of the language and experience Shakespeare's characters through their own eyes. For the artist of color, this can pose a unique challenge if there is not a clear discussion or agreement as to the significance of race and culture in the construction of character within the production.

This chapter will trace some of my own experiences, as an African American actor and director, that have led me to move beyond color-blind casting toward practices that encourage audiences to see race and incorporate its significance into an author's story. Loosely defined, "color-blind casting" is the practice of casting the best actors for the job without regard to race and has

emerged as a popular response to the changing complexion of American theatre. It has been in some ways a step in the right direction; but today I find that race neutrality in "classic theatre" usually implies a cultural hegemony that denies a Black actor access to their own cultural memory, one of an actor's greatest resources. Culture is an important lens that allows us to process and respond to the world, so it can be difficult to create character without the specificity of how race and culture define norms, values, and behavior in the world of a play.

In the first section of this essay I share my own theatrical background, then sketch the history of Black actors' participation in Shakespearean theatre as well as prevailing approaches to creating multi-racial theatre in the U.S.—which is often termed "color-blind" or a form of "non-traditional casting."[3] I then discuss my revelations while performing professionally in two different American "classical" productions, Thornton Wilder's *Our Town* and William Shakespeare's *King Lear*. The production of *Our Town* used a color-blind approach by a White director, while the production of *King Lear* was racially specific and featured an all-Black cast and director. I end by discussing my own approach and work as the director of *A Midsummer Night's Dream* at the Classical Theatre of Harlem, where I integrated Harlem's legacy into the production. My goal is to convey through my own experience the shortcomings and often ineffectiveness of color-blind approaches, in contrast to the great potential of examining Shakespeare and other White classic authors through a new cultural lens.

Reflections from the past

> Does any here know me?
> Who is it that can tell me who I am?
>
> (*King Lear* I, 4)

My mother was a White woman from a small town in Oregon, and my father was a Black man from a small town in Arkansas. They were married at a time when it was still against the law for them to do so in much of the country, including my father's home state. Out of concern, both my father and mother's families initially urged them not to marry; however, my parents ignored their caution. They married and ended up moving around a lot, largely in search of a place to plant roots. As we moved from place to place around the country, I always found my way to a stage. Much of my childhood was defined by my passion for performing. I was the kid in class who was never afraid to read out loud or to perform on cue. All throughout elementary, middle school, and high school I was in talent shows, musicals, comedies, and dramas. I read or performed with church choirs and community groups. Big parts or little parts—I could make myself known onstage.

One summer, I was invited to participate in a Shakespeare acting intensive for teens at a professional theatre. We spent five weeks reading text and

rehearsing scenes for a final performance. Although I learned a lot and could sense the richness of the writing, I also felt a profound distance from the process and struggled to define myself within the world of Shakespeare's texts. As the only Black actor in the program, rehearsals often left me feeling uncomfortable or uninspired, and I struggled to see myself in the scenes we worked on. As I continued theatre through high school, I felt myself becoming more disillusioned by the roles I was and was not considered for because of the shade of my skin.

As a student at Oberlin College, I majored in African American studies to broaden my perspective on history as well as my relationship to the world.[4] My studies focused on what W.E.B. Du Bois called the "double consciousness" of being Black in America. He spoke of this phenomenon as a:

> sense of always looking at one's self through the eyes of others, of measuring one's soul by the tape of a world that looks on in amused contempt and pity. One ever feels his two-ness—an American, a Negro; two souls, two thoughts, two unreconciled strivings; two warring ideals in one dark body, whose dogged strength alone keeps it from being torn asunder.[5]

I was also drawn to the Blues in my studies. More than just a genre of music, the Blues is a cultural aesthetic that informs many art forms—the artistic intersection of African sensibilities and American experience. The Blues shaped a worldview born out of the legacy of survival through the physical, mental, and spiritual bondage that Black people experienced in America.[6] Inspired by the Blues tradition, I began to recognize its fingerprints in theatre within the plays of Lorraine Hansberry, Langston Hughes, Alice Childress, Aisha Rahman, August Wilson, and Ntozake Shange. Their voices echoed the transformative power of the Blues tradition and gave me a new way to see myself. These playwrights made me realize I could not personally move forward in the theatre without looking back at what had come before me.

> The oldest hath borne most: we that are young
> Shall never see so much, nor live so long.

> (*King Lear* V, 3)

Historically through the nineteenth century, most Black actors who wanted to perform onstage largely had to do so by Blackening their faces and performing characters in minstrel shows that made a mockery of Black humanity.[7] Minstrel shows emerged in the early part of the nineteenth century as White performers grossly imitating Black peoples' songs, dances, and behavior in a way that helped justify the perpetual inhumane treatment of Black people. Yet by the end of the century, Black performers such as Bert Williams and George Walker were also building extraordinary careers by participating in these disparaging shows. In *Black Manhattan* esteemed African American

artist and scholar James Weldon Johnson noted that minstrelsy was, up to his time, the only completely original contribution America had made to the theatre.[8] In this way the American theatre was one of the early tools used to justify the dehumanization of Black people. And so from the very beginning Black people faced an uphill battle trying to be seen as anything beyond the demeaning, stereotypical characters of the minstrel show—onstage and off.

While Black actors were allowed to perform in minstrel shows, they were excluded from participating in Shakespeare's plays. Blacks were not even allowed to perform Shakespeare's Black characters well into the twentieth century. African American actor Ira Aldridge is often said to be the first Black man to perform the role of Othello, Shakespeare's most famous Black character, in London in 1826—more than 200 years after the play was written, in 1604. Ira Aldridge came to be known as one of the greatest American actors in history, yet he had to leave America to work and perform in Europe because he was Black.[9]

It would be more than 100 years before Paul Robeson would take the stage as Othello in 1942 as the first Black man to perform the role in America. Robeson's casting opened the doors for other Black tragedians, such as Canada Lee, Earl Hyman, as well as Black directors, such as Owen Dodson, who taught and directed at Howard University, one of America's premier Black colleges.[10] Though Robeson's performance in many ways redefined how the role would be cast (using a Black actor instead of White), it was the only Shakespearean role that he was ever offered. Black female participation in Shakespeare was even less encouraging since Cleopatra, his one Black female role, was rarely ever acknowledged as actually being a Black woman. For hundreds and hundreds of years, theatre companies failed to imagine a Shakespearean world where a Black woman could even exist.

From the beginning of American theatre, there were some important efforts to re-imagine Shakespeare with Black actors in White roles, yet they had little resources and were met with rejection by the White mainstream. One of the earliest efforts was the African Company in New York, one of the first Black theatre companies, which emerged in 1821 and presented Shakespeare's plays, including the infamous production of *Richard III* that closed due to violence and rioting by White audiences who felt threatened by the company.[11] The Federal Theatre Project of the 1930s and 1940s produced several productions, including *Voodoo Macbeth* in New York in 1937, which was set in Haiti with an all-Black cast, directed by Orson Welles. This production found an inspired audience even while receiving lackluster critical acclaim. In 1939, Broadway produced the short-lived musical *Swinging the Dream*, which integrated jazz with *A Midsummer Night's Dream*. This show featured the music of Benny Goodman and Count Basie, and featured Black actors in lead roles, including Louis Armstrong as Bottom. However, the integration was seen as a miserable failure as it was concluded that Swing and Shakespeare were irreconcilable; it closed in less than two weeks.[12]

Opportunities for Black actors in any roles remained scarce well into the twentieth century. In 1959, because Black actors continued to face extreme discrimination, Actors Equity Association agreed to sponsor a special show-case to encourage theatres to integrate their hiring practices. The showcase was directed by Lloyd Richards, and featured Harry Belafonte, Diahann Carroll, Ossie Davis, Lou Gossett, and Ellen Holly.[13]

Joseph Papp in many ways was the first to answer their call by directing color-blind productions of Shakespeare in the Park in the 1960s. Papp's efforts led to the creation of the Public Theatre in 1967—one of the first professional theatres to practice a "color-blind" approach to casting. Using this approach, Papp created spaces for actors of all backgrounds to perform new work as well as classic work such as Shakespeare. In the 1960s and 1970s New York's Central Park became home to such memorable performances as *King Lear* (1973) featuring James Earl Jones, Rosalind Cash, and Raul Julia; and *Coriolanus* (1979) with Gloria Foster and Morgan Freeman. Other theatres such as the Arena Stage in Washington, D.C., began to embrace color-blind casting practices in productions, such as their 1981 production of *A Midsummer Night's Dream* featuring Avery Brooks as Oberon and Kathleen Turner as Titania. These productions typically cast only one or two roles with actors of color while the cultural milieu remained largely unchanged. Eventually, color-blind casting began to raise questions in regards to the art-istic impact of Black and Brown bodies delivering a White story.

Movements like the Non-Traditional Casting Project (NTCP) of the 1980s and 1990s made another attempt to encourage the use of marginalized communities on stage. Founded by Clinton Turner Davis, Joanna Merland, and Harry Newman, the NTCP attempted to clarify and outline four dif-ferent approaches to non-traditional casting, which included: societal, cross-cultural, conceptual, and blind.[14] In 1986, the NTCP produced a two-day national symposium on "non-traditional casting," which included over 1000 actors, directors, producers, educators, and critics. In the following years they distributed a book, *Beyond Tradition*[15]; a video, *Breaking Tradition*; and con-ducted numerous forums and symposiums that challenged producers and institutions to make a commitment to diverse casting policies.

Today, all across the nation, professional theatres, as well as colleges and universities, continue to rely more heavily on various forms of color-blind or non-traditional casting as a way to be inclusive. Recent productions of note include Theatre for New Audiences' (Brooklyn, NY) production of *Tambur-laine* by Christopher Marlowe featuring John Douglass Thompson, a Black actor, as Tamburlaine; as well as the Wilma Theatre's (Philadelphia) produc-tion of *Hamlet* featuring Zainab Jah as the first Black female in the titular role. On Broadway, recent examples include the 2014 production of *Romeo and Juliet* featuring an inter-racial cast that included Condola Rashad and Orlando Bloom; as well as the 2013 Black productions of *A Trip to Bountiful* with Cicely Tyson, and *A Streetcar Named Desire* starring Nicole Ari Parker and

Blair Underwood. In 2012, the Royal Shakespeare Company toured a production of *Julius Caesar* set in Africa. "Color-blind," "non-traditional," or "experimental" practices that cast Black actors in White roles continue to gain interest and enthusiasm. As casting practices continue to evolve and mean different things for different productions, I believe it is important for actors and directors to develop clear and consistent approaches to the implications of race within a production.

The impact of race on casting today

Speaking in racial terms, I have identified three directing approaches that are often used when working with a Black actor in a role that was written for a White actor:

1 Attempt to create a race-less or color-blind reality onstage where racial distinctions bare no biological or cultural significance. An example would be casting a White family with an Asian mother, a Black father, and White child.
2 Maintain the character is still White even though the actor is not. All theatre is a game of pretend so onstage anything is possible—a woman can be cast to play a man; a man can be cast to play a child; a Black person can be cast to play a White person.
3 Change the race of the character. That is, invite the audience to recognize the character as a Black person within the world of the play and incorporate this dynamic into their understanding of the story.

In an ideal theatre, where all people participate equally, I believe there is room for all three approaches. However, I believe the first two approaches are more problematic than progressive. In my own experience, most times when White directors cast Black actors or other actors of color in White roles, they believe they are implementing the color-blind approach; when they are actually implementing the second approach—creating a White cultural experience using Black and Brown actors. I believe this type of directorial vision occurs largely as a result of an inability to discuss the implications of race and specificity of culture, as well as a dangerous assumption of what is "universal."

Topics concerning race continue to be some of the most difficult conversations to have in our country. As Americans, we still struggle to address our legacy of racial injustice and cultural inequality. Wounds from the past continue to haunt us and inform our national identity, so when the issue of race arises many choose to avoid it altogether and act like racial inequality does not even exist. Much of America's progress in racial politics is measured by the ability to effectively ignore the idea of race at all times. This is often reflected in the American theatre by the use of color-blind casting.

The practice hopes to be all-inclusive and alleviate preferential treatment based on race by not seeing or "blinding" oneself to race during the casting process. Although it was once a progressive approach because of its ability to include Black and Brown people into a largely exclusive American Theatre, actors of color who are asked to participate in "color-blind casting" are often required to deny their culture and aesthetic as a reference point for the sake of becoming race neutral or "universal." So if the race of a character that was written for a White actor is not consciously or effectively addressed with the actor of color, this practice often forces them to assume or imitate Whiteness in order to fit into the world of the play. Actors of color must mold themselves in the shape of White people under the pretense that they are "just a person."

Whose town is *Our Town*?

> Grover's Corners, Sutton County, New Hampshire, United States of America, Continent of North America, Western Hemisphere, Earth, the Solar System, the Mind of God.
>
> (*Our Town*, Act I)

One of my first color-blind experiences as an Equity actor was in a production of the classic play *Our Town* by Thornton Wilder at a Tony Award winning regional theatre. In his preface, Wilder asserts that the play offers a picture of humanity, a generic account of people's failure to perceive the true value of life[16]. In the play, the audience is introduced to two (White) families—the Gibbs and the Webbs—in a fictitious New England town named Grover's Corners near the end of the nineteenth century. When I learned the director was using a multi-racial cast filled with enormously talented actors of all shades, I was very excited and honored to be a part of it. The theatre developed a marketing campaign promoting the multi-cultural production as a way to explore the complexities of what it really means to be an "American."

On the first day of rehearsal I walked into a room filled with photos from the turn of the New England century. In the room, as customary at the commencement of a project, were designers, administrators, and actors. We were all encouraged to walk around the room and enjoy the research images. We were told the images captured and reflected the world we were creating—people, places, objects, houses, etc. Yet in the numerous (100+) pictures, there was not a single Black or Brown face. In a cast of roughly 25, over half the cast was not White—about a third of us were African Americans. Given the fact that there were African Americans in turn-of-the-century New England, I wondered if I was the only one who was a little confused about our function as Black people in this production. I waited for an appropriate moment to frame my concern.

After we finished our first read-through, everyone left except the actors and director. At that point, we sat around the table and the director began to talk more about his vision and the world of the play—never mentioning race at all. He invited us to ask questions or share any comments. For about an hour, the other actors praised the writing, the profundity of the story, and what an extraordinary opportunity it was to be in the cast. Finally, I asked, "Does race exist in Grover's Corners?" There was immediate silence in the room while the director hesitated. As a White man, he was genuinely confused by my inquiry. I continued, "Do the characters of this town recognize or reflect cultural distinctions based on race?" The rest of the cast waited attentively in anticipation of his response. Still unsure, his tone became slightly defensive and he began talking proudly about how race had nothing to do with any of his casting decisions—he only saw our tremendous talent as actors. Ignorance defined his sincerity. My question was more practical than philosophical. In a biological family that is made up of a Black father, a White mother, a Black son, and a White, blonde hair, blue-eyed daughter, as an actor, I needed to know what type of family we were referencing. At the turn of the nineteenth century in New England, a White family and Black family, even within the same economic class (and it is important to note the existence of middle-class New England African American families at the turn of the century), may have significantly different cultural nuances that define the character of the entire family. Uncertain, yet still confident, the director finally answered, "No, the characters did not see race as a distinction." He asserted that questions of race in this world would only be a distraction to what we were doing. We were simply creating one homogenous culture inspired by the culture of Thornton Wilder—one race defined by Wilder's vision and description of life in Grover's Corners. Whether the director knew it or not, he was telling the actors of color that we were all, culturally speaking, "White."

During rehearsals, I felt some actors struggling to shape a "cultural mask" to fit into Grover's Corners—even though it was a mask many of us were familiar with. It was a mask used to hide or minimize any ethnic flavor the actor naturally possessed. Behavior was shaped with comments or notes from the director that never mentioned race specifically, such as our speech could be "folksy," but not with too much "drawl"; our laughs could be "joyful" but not too "loud" or "boisterous"; our walks could be "loose" but not too "bouncy"; as we sang our parts in the choir we were instructed to sing straight, with no vibrato. The donning of this "cultural mask" was subtle but profound. A mask used to navigate being a dark body in a White space. The struggle was often relieved on break with jokes. Laughter became the armor against our uncertainty as we wore our masks on stage to fit into a world that was ultimately incapable of recognizing our full existence.

The show sold out almost every night. The largely White audiences gave us regular standing ovations. They admired us as much as themselves for

never noticing race. During talkback after talkback, comments culminated with, "It was so universal. I never even saw color." Unfortunately, I was not able to take pride in a job well done. I felt something profound was missing. Like a tree severed from its roots, I felt like I had no roots in Grover's Corners. The irony of the experience was that the production aimed to talk about the complexity of the American identity, yet left many of us feeling invisible and insignificant. An opportunity for cultural expansion was lost, further masking the honesty and diversity of American culture to its audience's admiration.

In America, if we are not racially, ethnically, or culturally specific, the White majority is assumed as "universal." One of the most profound and subtle benefits of White privilege is the ability to ignore race—the ability to not identify Whiteness even while enjoying the specificity of "White culture" or "White institutions."[17] For instance, one does not need to say *White* university to be discussing a university that is predominately White—one just calls it a university. One does not need to take a *White* history course to focus on the history of White people—she or he just takes a history class. Theatres do not address themselves as *White* theatres, even when they are run by predominately White staff and plan a season of work dedicated, with few exceptions, exclusively to examining the lives of White people. We often reference these companies as representations of American theatre. In this way, "Whiteness" is usually perpetuated in silence.

Historically, classifying people specifically as "White" or "Black" was largely an American phenomenon that was constructed over hundreds of years to promote one portion of the American population ("White") with notions of superiority and entitlement, while damning another part of the population ("Black" or "Negro") to perpetual servitude and inferiority.[18] Although race is confusing because of the inconsistencies and contradictions as to how race is actually defined (sometimes color of skin, sometimes nationality, sometimes ethnicity, sometimes heritage, sometimes religion—not to mention the complexities that emerge as a result of races "mixing"), the effects of race and racism are very real and remain a vivid reality in terms of how we relate to one another. Today, many seek to undo the negative effects of racial distinctions by not speaking of them. Yet, if we ignore race we ignore the persistence of White supremacy woven into the fabric and foundation of our collective consciousness. I am not referring so much to the White supremacy of extremists such as the Ku Klux Klan or Neo-Nazis, but the subtle and persistent notions within public and social policy that White people/culture are somehow more important, more valuable than Black people/culture. Because a contemptuous heart cannot be legislated, artists and artistic institutions have a critical function in transforming the soul of the nation. Black cultural expression, in a way, serves as a tool to counter the overt and covert assault of White cultural imperialism.

The Africanization of *King Lear*

> So we'll live,
> And pray, and sing, and tell old tales, and laugh
> And take upon the mystery of things
> As if we were God's spies.
>
> (*King Lear* V, 3)

Avery Brooks was the first person to introduce me to an idea and process he called "Africanizing" Shakespeare.[19] In 2004, he invited me to Yale Repertory Theatre to play the role of Edgar and serve as the movement coordinator for an original production of *King Lear* that was directed by African American director Hal Scott.[20] Avery had been invited to play Lear and his "Africanizing" concept was inspired by the work of world-renowned scholar Ivan van Sertima, who documented in his groundbreaking book, *They Came Before Columbus*, how Africans came to America hundreds, perhaps even thousands, of years before the arrival of Christopher Columbus. Avery's idea was that King Lear was one of the last of these early African Kings in ancient America. The ancient Olmec heads found in Mexico with uncanny African features provided the backdrop of our set. We were an all-Black cast with Black composers and choreographers.[21]

Avery's idea and vision for the production struck a deep chord in me. The process was unlike anything I had experienced in my previous work with Shakespeare. Each rehearsal we warmed up with African dance and worked to develop a unique movement vocabulary for how people moved and interacted in this world. Hearing the drums and Black tongues wrapped around Shakespeare's text everyday invited me into the world and gave me unique confidence as an actor. I had never experienced Black culture in Shakespeare. I started to recognize the iambic pentameter inside the heartbeat of the drum, and it gave me a new way to embrace the musicality of Shakespeare's verse and prose. Hearing my fellow actors deliver the text, I could hear how the iambic pentameter was a part of our natural rhythm of speech, as opposed to some foreign speech pattern that we had to imitate.

The play made sense in a way I had never experienced a "classic" text. I understood the scenes better and it became easier to commit to my dramatic actions. I suddenly felt as if Shakespeare belonged to me—I could look inside myself to find his characters. There was no longer the enormous pressure of doing it the "right" way. Shakespeare and I could both be "right" together, instead of dueling opposites, as I had believed for much of my life.

Though the production had its challenges and was by no means perfect, being involved in it liberated my imagination and gave me permission to dream for the first time inside of Shakespeare. Night after night we played to packed houses. I was reassured to know that audiences were eager and hungry for such cultural innovation. Some critics praised us, while others questioned

the audacity and validity of our artistic vision. Still, I was infinitely inspired by the idea of what we were doing and wanted to continue this "Africanizing" approach as a director.

Black Shakespeare

Where is our beautiful fire that gave light to the world?
The fire of pyramids;
The fire that burned holes through slave ships and made us breathe;
The fire that made guts into chitterlings;
The fire that took rhythms and made Jazz.

(*Catch a Fire*, poem by Sonia Sanchez)

Within the continuum of Black culture throughout the African diaspora, there is a long tradition of creating or transforming artistic forms in the new world by syncretizing African or "Black" aesthetics with European traditions. This process can be identified in music, dance, poetry, language, cuisine, fashion, and religion. The Black aesthetic is a creative fire with an unrelenting commitment to expressing itself—redefining everything it touches. As a director, this is the light that shines on every text I read and prepare to direct—so that in shaping my vision, my creative process is similar to music. In jazz, gospel, funk, hip hop, it is common for a musician to take a "classic" tune or standard and re-mix it through their own lens—their unique sensibility. This does not replace or undo the original author's intent, but rather expands its reach by locating the song within a new style and tradition. For example, jazz legend John Coltrane created his own classic version of "My Favorite Things" by using a song from Rodgers and Hammerstein's *The Sound of Music* (culturally speaking, one of the Whitest plays on Broadway). Through an integration of his own artistic talents, Coltrane created a powerful new experience while the legacy of the original song remains intact and is even re-affirmed.

Theatre, like music, is fluid not fixed. No two productions are ever the same. In this way classic theatre that has been handed down over hundreds of years functions like myths and folktales—with the ability to be re-told within a different time, a different place, a different people, and still reveal an important truth about the human experience. Many popular classics lend themselves to great risk taking, as no single production alters the importance of its legacy and production history. For example, no one production of *Hamlet* will define the past or future legacy of the play. No matter how good or bad it is, its legacy will remain intact once the production closes. The reality that Shakespeare's plays continue to be far and away the most widely produced works in the country (and perhaps the world) lends them to extraordinary interpretations.

When a production of Shakespeare is produced there is invariably enormous cultural license that takes place. We are all 400 years culturally

removed from the Elizabethan era, so no one can speak with certainty of what is or is not accurate; or what Shakespeare did or did not intend. Many White directors unapologetically embrace this fact, and take extraordinary risks when staging Shakespeare. For instance, Peter Brook's 1970 landmark production of *A Midsummer Night's Dream* at the Royal Shakespeare Company was staged in a white box set with a trapeze. And still, for all the fantastical and experimental conventions that have been praised and deemed successful in modern Shakespeare productions, audiences and critics are still essentially unaccustomed to the idea of Black culture existing within the same world as Shakespeare.

When it comes to inviting the Black aesthetic into theatre, there is still a cultural rigidity that imposes strange limitations on audiences' imaginations. I have often found it odd that theatre companies, producers, and directors are likely to think it more possible for an audience to accept the fact that a Black actor could play the blood relative of a White actor, yet not have any faith that audiences might actually accept the possibility of Black cultural traditions existing in the world of the play. In turn, we are collectively guided as to what is and is not within the realm of our own minds. There is a need for a revolutionary quality of the imagination to emerge among theatre artists and audiences that will allow us to see and embrace reflections of Black life onstage as well as off—in new works as well as old.

Though some of my heroes such as August Wilson have suggested that Black actors performing in works by White playwrights represent a form of cultural mimicry that inherently undermines efforts to create authentic Black theatre,[22] I do not believe the only way to reveal an authentic Black experience onstage is to use a script written by a Black playwright. Just as Black music is not predicated on having a Black songwriter, as John Coltrane and numerous jazz musicians regularly illustrate, Black theatre is not always defined by *what* is being done—equally important is *how* it is being done.[23] Engaging a Black aesthetic is its own methodology and Black culture can be invited to the stage through the writer, the actor, the designer, or the director.

Directing *A Midsummer Night's Dream* in Harlem

> I have had a most rare vision. I have had a dream, past the wit of man to say what dream it was...
>
> (*A Midsummer Night's Dream* IV, 1)

When I was invited to direct William Shakespeare's *A Midsummer Night's Dream* at the Classical Theatre of Harlem, though it was 2013, I was keenly aware of the fact that I was still one of the few African American directors to direct Shakespeare on a New York stage with a cast of all Black and Brown actors. Rather than be intimidated by this fact, I wanted to take advantage of

it. The artistic director wanted to use the production to institute a tradition of free Shakespeare in the Park Uptown—to give people a reason to come Uptown to celebrate the traditions of Harlem. The production was staged at the Richard Rodgers Amphitheatre in Marcus Garvey Park, near 125th St. and Malcolm X Blvd. Everything about the location of the production pointed to a figurative and literal crossroads, a cultural intersection.

I thought for a long time about the point of bringing Shakespeare Uptown. Why do it? What does Harlem have to gain? What does Harlem have to lose? Would this encourage the people of Harlem to revere Shakespeare over our own great writers? Was this a chance to show everyone that Black and Brown people can speak and perform Shakespeare, too? None of these ideas attracted me. Ultimately, I realized my artistic vision was driven by a commitment to effectively and equitably integrate cultural traditions. So often American racial and cultural integration in practice requires people of color to participate in White spaces assuming the ambition is to be just like White people. I remember hearing how my grandfather, who was a principal of a Black high school in the segregated South, lamented the desegregation of schools because he knew he would be out of a job. He was in fact correct, because most all-Black schools—most all-Black institutions with the exception of the church—were indeed shut down, having been seen as inherently inferior to their White counterparts, even though these institutions managed and maintained African American cultural capital. My father always encouraged my brothers and I to wonder what would have happened if Whites had been shipped to Black schools and taught to value Black cultural traditions and norms as equal to their own—what impact would this have had on both Black and White people? So I wanted to find a way to bring Shakespeare to Harlem, while bringing Harlem to Shakespeare; so that both traditions might work together equitably in revealing what is great in each.

Artistically, Harlem represents a mecca for Black culture—a melting pot of cultural exchange that reflects the unique identity and creative impulses of the African in America. Whether through poetry, music, dance, art, fashion, food, or religion, the Black presence in Harlem has inspired new kinds of expression, new ways of seeing, new ways of understanding, and new ways of influencing the whole world. Privileging nothing above or below, I wanted to engage the spirit of Harlem and the writing of William Shakespeare as a way for the audience to better understand something about Black life today.

A Midsummer Night's Dream is one of Shakespeare's most popular plays. It is a magical fairy tale that weaves together the world of the living with the world of the fairies to celebrate dreams, magic, love, and marriage. Originally, the play is set in the ancient city of Athens and takes place in three major locations—the palace of Duke Theseus, the woods near Athens, and the place of working men—the mechanicals. This world represents an ancient period that is loosely defined. Shakespeare reimagines history in his depiction of Athens. He imposes English cultural references that are distinctly "un-Athenian"—such as giving

Theseus the title of "Duke"; using English names for many of his characters, as well as incorporating fairy characters that come from English lore.[24] By setting his play in an ancient Greek city and endowing the characters with the contemporary qualities of his own times, Shakespeare took enormous creative and cultural license in his storytelling—presumably to create a more profound experience for his audience. This was the same impulse I wanted to use to encourage my actors and audience to take ownership of the play and see themselves at its center, as opposed to experiencing it from the cultural margins. Without changing the names, the language, or the city, I decided to use Harlem and its mythic cultural legacy as the inspiration for my depiction of ancient Athens. "Athens" would exist as an amalgam of time and culture—an elusive moment when time converges on itself—ancient and contemporary, young and old, spirit and living, city and nature, African and American.

> We will meet; and there we may rehearse
> most obscenely and courageously.
>
> (*Midsummer* I, 2)

My cast included all Black and Brown actors with diverse cultural experiences and backgrounds—many with roots in the U.S. as well as throughout the Caribbean, and Africa. I worked to create a dedicated rehearsal space that allowed the actors to fuse their own experience and cultural imagination with Shakespeare's characters. Because Shakespeare wrote different dialects for different characters, I gave my actors permission to develop their natural voice or an accent they had a personal connection with. Without changing the language, we stayed true to the traditional scansion of Shakespeare's text using accents including: Jamaican, South African, Puerto Rican, and Haitian. Their speech informed the ethnicity and attitude of the characters they shaped. The personality and musicality of the different tongues of Harlem came to life through Shakespeare's verse and prose.

We shaped their speech through traditional text work as well as experimental. One strategy for actors having difficulty embracing Shakespeare's scansion and imaging was to reference how Black tongues claim and deliver the verses of the Bible. Often viewed as intimidating or incomprehensible to the masses, Shakespeare's language is essentially the same as the language in the original King James Bible. Most everyone in the room had first- or second-hand experience with attending a Black church and hearing the musicality of how the Black preacher and/or congregation naturally delivered complex verse. Grandmothers, grandfathers, mothers, aunts, uncles, or community members regularly and naturally quote Bible passages in their own heightened voice. With this sense of ease and ownership of the text I wanted us to deliver our story.

One design challenge for almost anyone directing *Midsummer* is developing a creative and effective approach to the magical elements of the play—fairies, spells, magic herbs, shape shifting—in a way that is rooted in the reality and

imagination of the audience. Referencing books such as Robert Ferris Thompson's *Flash of the Spirit* and John Mbiti's *African Religions and Philosophy*, I found that many traditional African cultures believe that there are invisible, mystical forces and powers in the universe. These forces are neither good nor bad; they are just like other natural things operating in man's realm that may be controlled.[25] I decided the "fairies" in *Midsummer*'s forest could represent the convergence of African spiritual forces in Harlem—inspired by a wide pantheon of deities from traditional West African cosmology. Puck and the fairies' magical movements became defined by a vocabulary of West African dances in the Diaspora.

My production of *Midsummer* averaged approximately 400 people each performance, and on closing night we had an audience of over 2300 people from the neighborhood, as well as guests who made the journey Uptown to see what everyone was talking about. Critics and audiences alike applauded the production for embracing the Black aesthetic as opposed to ignoring it. The *New York Times* praised my cast for their "rare and nuanced understanding of the Elizabethan words they are called on to speak."[26] By acknowledging race and incorporating its cultural implications onstage, this production created unique possibilities for the audience to understand the text that also demanded dynamic performances from the actors allowing them to draw from their own cultural experiences.

In conclusion

Directing *Midsummer*, I learned in order for a director to effectively integrate and/or infuse particular traditions in Shakespeare, the director must be fluent in the language of Shakespeare, the craft of acting, as well as equally confident in directing the cultural history and behavior of the characters onstage. When directing Black characters, a director must understand how race informs the construction of identity, character, community, and behavior. They must have a trusted relationship with the culture represented onstage in order to maintain the actor's faith and help them create archetypes, as opposed to stereotypes. In this regard, the race of the director matters. Although it is not impossible for a White director to direct Black characters—the complexity of this dynamic should not be overlooked or ignored. It is easier said than done and many "all-Black" productions have lost their soul in the hands of "expert" White directors.

In creating theatre that reflects the complexities of our multi-racial, multi-cultural, multi-national world; race is an important dimension of our work and should be discussed during the rehearsal process. Because of race's significance and mis-assumptions of what is "universal," casting practices that attempt to ignore race can serve as regressive decisions that push away those it seeks to include. Speaking from my own experience, color-blind theatre is alienating, as it often forces people of color to function in an environment

where their culture must be left outside of the rehearsal room in order to participate. This is not to say that actors of color are not completely capable of being "artists first." However, one's artistry can never be separated from the totality of their experience and the legacy they represent. We can employ race and culture as a creative way to better understand the characters, settings, conflict, and story within a given text. In doing so, I believe we invite stronger performances from actors; revitalize texts for contemporary audiences; as well as contribute to our ability as a nation to address the complexities of race relations in our society.

Notes

1 Every October *American Theatre Magazine* lists the top produced writers of the year with the note that they never include Shakespeare in the list because he would always hold the number one spot by far.

2 Konstantin Stanislavski, *Creating a Role* (New York: Theatre Arts Books, 1961), 105.

3 Ayanna Thompson, *Passing Strange: Shakespeare, Race, and Contemporary America* (Oxford: Oxford University Press, 2011), 76–77.

4 At Oberlin College, my path to self-discovery was guided by extraordinary teachers such as bell hooks, Calvin Hernton, Ama Ata Aidoo, Wendell Logan, and guests Sonia Sanchez, Ivan van Sertima, Angela Davis, Amiri Baraka, Toni Morrison, and perhaps the most influential, TV, stage, and film actor Avery Brooks, who would become my longtime mentor and friend.

5 W.E.B. Du Bois, *Souls of Black Folks: Essays and Sketches* (New York: Fawcett Publications, Inc.), 17.

6 For further discussion, see James Cone, *The Spirituals and the Blues: An Interpretation* (New York: Seabury Press, 1972), 97–127.

7 Yuval Taylor and Jake Austen, *The Darkest America* (New York: Norton & Company, 2012), 31–56.

8 James Weldon Johnson, *Black Manhattan* (New York: Arno Press and The New York Times, 1968), 87.

9 See Errol Hill, *Shakespeare in Sable* (Amherst: University of Massachusetts Press, 1984), 17–27.

10 Ibid., 130.

11 Ibid., 11–12.

12 Ibid., 103–116.

13 Ibid., 130.

14 Angela Pao, *No Safe Space: Re-casting Race, Ethnicity, and Nationality in American Theatre* (Ann Arbor: University of Michigan Press, 2013), 4.

15 See Ana Deboo, "The Non-Traditional Casting Project Continues into the '90s," *The Drama Review* 34, no. 4 (Cambridge: The MIT Press Stable Winter, 1990): 188–191.

16 Thornton Wilder, *Three Plays* (New York: Harper & Row, 1957), 12.

17 For further discussion, see Birgit Brander Rasmussen and Eric Klinenberg, *The Making and Unmaking of Whiteness* (North Carolina: Duke University Press, 2001).

18 Lerone Bennett, Jr., *The Shaping of Black America* (Chicago: Johnson Publishing, 1975), 77.

19 I was introduced to Avery Brooks by one of my other mentors, Calvin Hernton, at Oberlin College. Avery attended Oberlin in the late 1960s and helped found a theatre group called Psuekay (Greek for "soul") to help Black students see themselves

in the world and process their experience on campus. He was the first graduate of the Mason Gross School of the Arts at Rutgers University, receiving his MFA in Acting and Directing before building an extraordinary career in theatre, TV, film, opera, and music. Avery remains one of my closest friends and strongest references.

20 In 1989 at the Folgers Theatre in Washington, D.C., Avery Brooks and Hal Scott created a groundbreaking production of *Othello* featuring Avery as Othello and Andre Braugher, a Black actor, in the role of Iago. They used race to add a complex dynamic between Othello and Iago—as two Black men trying to gain power and respect in a White world. In a similar vein, Yale Repertory Artistic Director James Bundy invited Avery to develop an innovative concept for *King Lear.*

21 In addition to Avery and I, the cast included Petronia Paley as Regan, John Douglass Thompson as Edmond, Johnny Lee Davenport as Kent, and Rosalyn Ruff as Cordelia. African American composers Anthony Davis and Eli Fountain, Jr. created the music, and Brooklyn-based choreographer Lakai Worell provided choreography.

22 August Wilson, *The Ground on Which I Stand* (New York: Theatre Communications Group, 2001).

23 For a more complete description of "Black Theatre," see the introduction in Paul Carter Harrison's *Kuntu Drama* (New York: Grove Press, 1982), 3–30.

24 Jan Blits, *The Soul of Athens* (Lanham, MD: Lexington Books, 2003), 10.

25 John Mbiti, *African Religions and Philosophies* (New Hampshire: Heinemann Educational Books Ltd., 1990), 74.

26 Anita Gates, "A Midsummer Night's Dream Gets a Harlem Spin," *New York Times,* July 16, 2013, www.nytimes.com/2013/07/17/theater/reviews/a-midsummer-nights-dream-gets-a-harlem-spin.html?_r=0.

Ritual Poetic Drama within the African Continuum

The journey from Shakespeare to Shange

Tawnya Pettiford-Wates

In the beginning...

Acting was always something I wanted to do. I was in love with Shakespeare even though I didn't always understand it. The elevated language made me feel like I was transported to another place and time. It never occurred to me that unpacking its cultural context and historic legacy would complicate both my love of the story, the drama and my place within that narrative; complexities that would literally take decades to de-construct. I loved the queens of drama like Lady Macbeth.

> Wouldst thou have that
> Which thou esteem'st the ornament of life,
> And live a coward in thine own esteem,
> Letting "I dare not" wait upon "I would,"
> Like the poor cat i' th' adage?
>
> (Lady Macbeth, from *Macbeth*, Act I, sc vii)

In 1973 I auditioned for The Juilliard School with the aforementioned Lady Macbeth monologue and I nailed it! I was accepted for admission, but chose Carnegie Mellon University to pursue my training.

"My mainstream is the one I'm standing in ... the one that feeds me and nourishes me." Those are the words my grandmother used to say to me and yet my journey through conservatory training alienated and disconnected me from the very stream that gave me my identity, the culture and customs that defined both my physical and my spiritual self.

My first Broadway audition was at the Public Theatre in 1977 for Ntozake Shange's *For colored girls who have considered suicide/when the rainbow is enuf.*[1] I almost went into cardiac arrest when I looked at the script. The entire piece was in "Black English," with no punctuation, no scenes to study and no stage directions to follow. It was not written in the standard of "the well-made-play,"[2] the standard that is held to be the best in the traditional American theatre industry for which I had been aptly trained. No. It was

poetic drama, a *choreopoem*, as defined by the playwright. Poetic drama had not been anywhere in my training.

Classic textual analysis and stage standard speech could not help me with Ntozake Shange. There was a gap. I was inadequately prepared for my first Broadway audition after attending the best schools in the United States and the United Kingdom. The traditions of Stanislavski, Chekhov and Grotowski may have prepared my physical instrument in pursuit of a professional acting career, but they did not nurture my spirit nor feed my soul. I realized these facts with a type of transparent recognition when I auditioned for *For colored girls...* The play is steeped in my cultural continuum and I found I was disconnected from both its content and context. I was missing my authentic self and the cultural and spiritual connections to my own power and potency. In this specific audition, I felt under-prepared and disconnected from my artistic being—the opposite of what my education and training had promised me. The hegemony of the conservatory training model imposed upon the student artist makes impossible the exploration and/or discovery of a pluralistic and inclusive methodology. This imposition renders the non-White student/artist deficient and under-served by the very training that is supposed to equip and prepare them for not only a highly competitive industry where success is often dependent upon a certain element of "the right place at the right time" but, one might argue, more importantly the ability to be fully grounded in the essence of self-identity and self-knowledge. Nonetheless, I got a call back, read for the director, got the job and joined the Broadway company on my way to the first national tour. The eighteen-month tour and twelve-month extension was my formal introduction to a form and methodology that would later evolve into Ritual Poetic Drama within the African Continuum.[3]

Ritual Poetic Drama within the African Continuum (RPD) is a tool for artists to access their own individual creative content, potency and power as artists. The methodology engages the artist as a creative entity rather than an imitative one. The process is designed to facilitate the artist's ability to cover their ground, to discover their authentic voice and take responsibility for the contributions they are impelled to make to their community as empowered and engaged creative artists. In creating this model with particular interest toward recognition of cultural identity and perspective as essential in performing arts training, I am engaging in a critical interrogation of arts education and the "traditional" training models within the academy.

To this effect, this chapter interrogates the way in which artists of the dramatic form have been traditionally trained, with particular attention on the challenges faced by artists of color, specifically Black artists within classic training models inside the academy. It recognizes cultural connection and context as essential to the growth, development and empowerment of the Black artist and acknowledges the deficit faced when access to and acknowledgment of those connections are thwarted or marginalized. Further, the chapter will delineate for

the reader the pedagogy and practice of RPD and rite of passage journey[4] as an alternative methodology that directly addresses the specific needs of the Black performing artist in studying the dramatic form and developing into self-actualized and empowered creative artists.

Alienated acting

As I prepared my audition for *For colored girls* ... in 1977, my lack of affinity with Shange's words, the hysteria and disconnection I felt in the moment made me confront the fact that after years of conservatory training I was missing something. Shange's text was like a foreign language to me and although I had been methodically and precisely trained as an actor, prepared for the professional arts industry, somewhere along the road I lost—myself. Panic is not uncommon for emerging young artists at an important audition. In fact it is part of the journey we all take upon stepping out on our own beyond the classroom, studio spaces, and university stages into the "real world." We take a leap forward into the great unknown trusting in the "magic if" and the "suspension of disbelief" to become the artists we are destined to be as we "test" our training and skills in the open marketplace. My problem was more disturbing and had nothing to do with fear of the unknown. A lack of connection to my own cultural continuum and a basic knowledge of my authentic self (beyond an assembled "forced" character portrayal) exposed fragility in my cultural construction and a deficiency of awareness that made me question who I was.

In my studies, the approved canon of dramatic literature did not include a Black girl, an African-descended person, like me as a part of the narratives read or spoken about in my classroom spaces. In my training, my Blackness was almost never addressed directly, as if it was no more consequential to my person than being tall or short of stature or being a blonde or a brunette. The perspectives, expressions and collective stories of people who were not a part of the dominant culture were absent from the mainstream arts culture and expression in America, and only occasionally represented as a convenient subplot, sidekick or exotic compliment. My culture seemed to be intentionally kept out of the conversation as if it were some secret identity that caused discomfort, or was an impolite or insensitive topic to bring into the discussion. The general modus operandi of my instructors was "Let's just pretend we don't notice."

Throughout the course of my studies I began to *pretend I didn't notice* as an unconscious response to the immersive process of studying stage standard speech and Western European *classic* models of theatre arts within the conservatory. I now realize and recognize my cultural heritage and racial identity as essential to the authenticity, power and passion of both my artistic self and my citizen being.

Further, I have an adversarial relationship with history and more specifically with the particular perspectives of theatre history taught within traditional

classroom spaces. It reminds me of an African proverb that says "How different
the history of the Lion and the Man would appear if it were the Lion that told
the story." *Stolen Legacy: Greek Philosophy is Stolen Egyptian Philosophy* by Dr.
George G.M. James was originally published in 1954. It was reprinted and
edited in 2001 by Dr. Molefi Kete Asante. These works address the denial of
Africa's central and primary contributions to arts and culture, science and
philosophy. It should be noted that Dr. James was originally unable to find a
publisher due to the manuscript's unrelenting and full throated challenge of
the notion that what is called "Greek philosophy" did not began with the
Greeks at all but instead must be credited to Egyptian philosophy, culture and
custom.[5] The appropriation of the African origins of arts and culture by Greek
philosophers has created the foundation of the Western European theatre tra-
dition (hidden beneath the cloak of Whiteness and White supremacy) and has
caused a disconnection from the authentic origins of the dramatic form, its
original context and purpose, and as a consequence a distortion of the form
itself. This false authentication has given Greek philosophy credit for the
foundations of the Western theatre tradition and modern drama without
acknowledgment or validation of the formative role played by its African
origins. In this way, the contributions of non-White artists and scholars have
been systematically excluded from (a) the practical form of the dramatic arts
(the play/story itself), (b) the theory or pedagogy of the dramatic form (how
to do it), and (c) the methodology and study of the form itself.

With these revelations I ask of the Black performer: Can the dramatic
artist be effectively and adequately trained to become a self-determined and
self-actualized performer, director, and/or writer empowered to pursue the
fullness of their creative potency without the knowledge of their own cul-
tural and spiritual continuum? Is this self-knowledge an essential element in
one's ability to stand fully present in the power of creative force? Can you
be your authentic self, fully embrace your cultural and spiritual continuum
and work on the Broadway stage or in the Hollywood film industry without
wearing the mask?[6]

RPD has proved effective in facilitating the process of exploring these
questions, while centering cultural awareness and exploration of racial
identity and authenticity within context as an essential component to the
artistic training of the student/artist. RPD is specifically designed from an
African-centered perspective with acknowledgment of the formative role
the African origins of the dramatic form play in the content and evolution
of Western European theatre and theatre forms. RPD is a methodology
designed to facilitate self-actualization and empowerment through an
exploration of *rite of passage journey* and the lived experiences that expose
the emotional blocks and psychological barriers we build that often inhibit
our innate creative nature from engaging in the fullness of its potency
and/or purpose. RPD asks each person to become an active and conscious
advocate and ally—to begin the process of empowerment and healing

through self-knowledge and self-discovery. Trainees are immersed in the power and impact of telling our own stories, (re)membering ourselves and finding our power and purpose as creative artists. Artists take responsibility for the impact a transformative process can have on the progression of learning, (re)membering legacy, and en-visioning the future. We must *Sankofa*: go back and retrieve what has been lost, stolen or forgotten. As an arts educator, the empowerment of young creative artists moving toward becoming self-actualized and self-identified, infused with the certainty and knowledge of their own creative power, is what I aim to do with this work.

Overview of Ritual Poetic Drama within the African Continuum (RPD)

(R)itual is an altered state of consciousness. It is relating to the universal self and the collective rhythms and experiences of the universe. The truth of the universe is life/death/transformation: the inner knowledge that after every sunset there will be a sunrise. (P)oetic is the emotional internal truth as well as the metaphoric and the dance. The Poetic lives within the symbolic in broad strokes. Its language encompasses representative, emblematic and figurative speech, sound and phrase. The complimentary duality of the metaphor and the poem and the poetry of the dance creates the poem and the dance within the RPD. (D)rama/drama in the first instance is the form and the second the content and style, the story itself. The essence of the drama is the story that is impelled to reveal itself. Life is defined by life's rhythms and cycles. There is then a perfect marriage of the inter-action of the drama (of the self) coupled with and shaped by inner knowing creating the Drama (for the society/community).

Story is the centerpiece of the ritual process, and rite of passage journey is the modality used to reveal the story. That revelation serves to enlighten and transform both the artist and the community surrounding the artist. The collective acknowledgment of the community is essential to the transformative process in RPD. Certain characteristics are foundational to the process and the community that is created by intentional adherence to its tenets:

- A search for origins
- Personal growth emphasized as intent of the process
- Risk without judgment or evaluation
- Acknowledgment of commonalities
- Bonding with the rest of the community
- Improvisation as a means to transformation
- Spirituality rather than dogmatic or didactic paradigm
- Homecoming/familiar/family encouraged as an integral part of the artist creative self: if the artist is to be complete and fully functional in his/her role within the community.

As stated earlier, most Western/European models of actor training are grounded in Greek philosophy. The Western origins of theatre traditionally claim the Greeks as their forebears without recognition or acknowledgment of Africa's primary contributions. The African dramatic continuum is not usually acknowledged or addressed in Western arts education. Therefore in order to begin training in RPD, students need to be given an opportunity to expand their knowledge and perspectives on the origins of theatre and the dramatic form. In order to accomplish this, we have employed various learning strategies, including but not limited to seminars, films, group projects, expert speakers and reading lists on the evolution of the Western form of theatre and how its origins can be traced directly back to Classical Africa (Kemet/Nubia) prior to the Greeks.

The well-made play model is a linear construct composed of: exposition, plot, conflict, climax, resolution and dénouement (conclusion). There is a rise and fall of dramatic action. The play presents a beginning, middle and end as its form. The drama or comedy functions within the idea of the "fourth-wall," the imaginary wall between the player and their audience. When compared to the RPD model, which functions within a cyclic construct of rite of passage moment, initiating event and transformational change as the outcome, there is a clear contrast. The modality here is a story that is impelled to reveal itself, the artist being the vessel that brings that story to life. For the purpose of this work, the ritual is defined as an altered state of consciousness, which the artist willingly enters. The poetic is the sound and projection of word imagery (as in poetry) giving the words musicality, rhythm and passion—the power to engage the senses with multiple interpretations. The words bring a largeness of passion and emotional content. And the drama refers to the story whose purpose is not resolution but rather revelation.

Ritual Poetic Drama within the African Continuum (RPD)—an emergent methodology

For over twenty-five years, my teaching and research has been centered on a re-connection of the dramatic artist with the African origins of the dramatic form, and theatre as a tool for social change. My classroom/studio space has helped to facilitate the process of exploration for the actor/performer as a creative artist of the dramatic form, self-actualized with an authentic voice ultimately responsible to both an artistic integrity and social responsibility to the community in which they create art. It can be argued that in their origins, the dramatic arts and the dramatic artist both had significant social impact and relevancy. In the contemporary dramatic arts industry the clarity of purpose for the individual artist is often less specific and has less to do with the artist's role as a citizen artist with a specific and defined role and purpose for the community they serve and more about being employed. Social and community responsibility is not usually at the forefront of the artist's consciousness and is not typically

inspired conversation in classic training. The commercial art industry and art as a commoditized form has taken primacy over its content and/or purpose. Something on a higher, more spiritual level has been lost in the translation over time, and what is largely responsible for that deficit may be rooted in arts education and training.

In the methodology and practice of RPD the alignment of the artist with their artistic purpose has created a potent impact both on the individual artist and on the community in which they contribute their time, talent and skill. In examining the traditional study of the arts and the classic Western training of the individual artist, I found a significant lack of consideration given to the impact of culture and/or cultural location upon students/artists within the framework of selected Western models of arts training and traditional Western European methodologies. Whether it is perception or practice, the fact is that many actors lose themselves (the spirit of who they are) somewhere on the roadside while training to become practitioners of the dramatic form. By this I mean the student/artist initially upon entering the conservatory has a passion for their art, although they may not have identified why. They have an inner knowing that they *want* to be an actor and a desire to pursue training in order to fulfill that yearning. They have an intense need to be pleasing to the aesthetic and the demands of those in a position to judge, evaluate and recommend them. This is what becomes particularly problematic for the Black student who has been trying so hard to become "qualified" by the White aesthetic that they have, whether intentionally or subconsciously, eviscerated themselves from their own cultural, spiritual and even physical context and content. When the time comes to exit the institutional training academy or conservatory and enter the "real world" of the profession Black students often find they are missing something extremely important: knowledge of themselves as artists and the ability to apply that knowledge to the creation of their art and unique artistic expression. They have become well-trained instruments of the form but lacking in spiritual content or connection. They are missing their "spirit," the essence of who they are or once were.

Therefore, the goal of my classroom/studio is to be a space of communal and holistic training, as I facilitate the process of the student becoming a self-actualized creative artist aware of their ability to impact and influence the greater community in a significant and transformational way.

RPD finds its inspiration in Nommo

In the West African nation of Mali, the Dogon people's version of the Word is the Nommo, which is understood to be the creative force that gives form to all things.[7] As I work with students in the use of RPD, the most difficult obstacle to making steady progress implementing the methodology is their inability, at times, to let go of the linear thought process. The influence of "Greek tragedy" and the legacy of the "well-made play" all hang around the

studio space like some familiar ghosts. When asked about their feelings of RPD, initially many express some amount of disorientation. They have never approached acting/training from the particular modality of RPD and rite of passage journey before, nor have they ever been given as much ownership or responsibility for their individual and collective learning process. It is amazing how insidiously Western/European cultural thought and process so permeate our own thought and culture that we seem more content and comfortable to fit into a "form" rather than explore and push beyond its boundaries— boundaries that cause so much frustration, limiting both our human and artistic potential. An example of this is the studio space. It is a communal space where all students are both learner and teacher, both participants in the journey of another and the subject of one's own journey. They are at times in the center and the entire focus of the work and at other times the facilitator and support surrounding the work. There is no specific stage but rather the entire studio operates as performance space at times and sanctuary at other times.

The RPD process challenges us to bring traditional thought patterns that define performance in terms of good and bad or audience and actor intellectually into a partnership with the physical and emotional senses; it requires the artist and the community to make a commitment, willingly and wholly immersing ourselves in the process itself. What we think is no more important than what we feel and we endeavor to allow our feelings more space to reveal themselves than our thoughts. Patricia Hill Collins reminds us that the intellect and the achievements of the intellect are highly exalted in Western culture, whereas in many indigenous African cultures there is more of a holistic reverence of the intellect as an equal and shared part of the entire person in concert and compliment with the community of which they are a part rather than the superior fragment meant to be singled out or isolated by the individual alone.[8]

Much of the student's confusion and even resistance centers around embracing the intellect as primary or superior, rather than a part or interdependent piece of the individual in connection and collaboration with the community as a whole. It is the same confusion surrounding the distinction between plot and story, the linear and the cyclic, the product/result as compared to the process/transformation. Western theatre models of the well-made play depend upon the linear model of plot rather than the African-centered model of story. In the first there is a conclusion or resolution and in the latter the most important outcome is revelation. James Baldwin illuminates the distinctions and comparisons between plot and story while illuminating the purpose of a story: "A story is impelled by the necessity to reveal itself; the aim of the story is revelation, which means that a story can have nothing—at least not deliberately—to hide."[9] Baldwin eloquently differentiates between *story*, the vehicle of RPD, from *plot*, the prescribed vehicle of the well-made play. RPD incorporates a tri-unity of practice from

a position of power in the word, the music/sound and the movement/dance. It is presentational and spiritual. There are no spectators, the audience participates in the drama much like the Black church experience. It is essential that you participate if you are going to be present.

Implementation

Using RPD in practice includes a process of community building.

- Student participants are asked why they are present.
- What do they bring to the studio/space and what would they like to take away?
- There is a discussion about the process being a departure from what is *known* and exploring the *unknown—even the unconscious*.
- There is an acknowledgment of fears and apprehension.
- We do a ceremony of recognition and acknowledgment—this is a formalized process of validating the fears expressed by putting them inside the circle. Sometimes the fears are written down and put inside a container that we can burn or seal. Sometimes they are spoken and give shape with sound and movement that others in the circle take on so that your fears are then the shared responsibility of everyone that is present. The ceremony can be done in a number of different ways. The decision is made by the facilitator and is determined by "feel" of the group or by organic impulse.
- We pour libation and call upon our ancestors, acknowledging that we do not stand alone, but on the shoulders of those that have come before us; thanking them for the gifts they have given to us that allow us to stand in this space and time; and asking them to come and be with us as we embark upon this journey.
- We all agree to be a part of this community and support one another with our respect, honesty and vulnerability. We agree to have a shared responsibility in keeping the community values. And we agree that what happens within this circle stays within the circle and no one has the right to tell another's story or disclose anything that has been shared in this sacred space without permission of the community. We then close the ceremony.

With these actions we effectively consecrate our space and dedicate ourselves to this endeavor and this process, recognizing that what we are discussing is a major paradigm shift. Each day we prepare the space by doing a floor-washing ritual, which serves as a communal activity and collective warm-up. There is always an opening and closing each day, which is led by the various family groups we have divided into as we have created our community. We do "housekeeping"[10] daily, which allows students/participants to share frustrations, confusion, anger, hurt or revelations with one another. The goal is to release and renew and not to "hold on" to stuff we need to let go. There

is a process of writing and physically sharing in a loud voice with strong emotion each time we gather together. Just as the community becomes more and more authentic as we move through the process day by day, so too does the writing gain in clarity and authenticity. A primary and guiding principle in our creative process is the West African word *Sankofa*. Literally it means to go back and fetch it. Concisely, if a man goes on a journey and he gets down the road only to discover he has forgotten something—*Sankofa*, go back and fetch it. There is no shame in forgetting. But if that same man because of his pride just continues down the road only to find at the end of his journey that the very thing he forgot is the thing he needs most—for that man, it is a shame. *Sankofa*, go back and fetch it (a Ghanaian proverb).[11]

The process of finding our authentic voice—rooted in the power of our own story—requires that we go back and fetch it. We must reclaim the things that have been taken, stolen or forgotten. At times, during our life journey, we have been paralyzed on the road, frozen at a particular place and time of traumatic experience[12] or transformative moment, and inadvertently have left something behind, a piece of our authentic self. We often (the community "we") press forward without some essential parts of ourselves, our experiences and even our content. Now, those lost, forgotten or forsaken things are what we need most to be whole creative beings fully functioning in our artistic potency. We must *Sankofa*—there is no shame. These stories are rites of passage moments and each time we reclaim one of them or a piece of them we become stronger—we reclaim ourselves, our voice, and our power. We become more whole, healthier artists.

The collective journey

We engage daily in facilitated collective meditative journeys; always writing/ sharing after each one until we are ready to begin the process of community-facilitated individual journeys. An example of this would be what we call the River Journey. The entire class lays down and closes their eyes using the relaxation techniques of tension and relaxation through the breath. The students reach a level of relaxation that allows them to visualize themselves as a bird that flies over a metaphorical land mass that is divided by a massive river. The river represents their "life's journey." They fly over the river identifying places along the way that are dry and desolate, green and fertile, rocky and dangerous and so forth. These places represent an important rite of passage, a specific event or moment in their life, where they were having a strong and precise emotion. They physicalize that emotion with sound and movement and finally text. We move to several different locations and then we retrace our journey back up the river briefly revisiting each location with sound, movement and text. We slowly come back into the room, into ourselves and into consciousness and then we get our journals, draw the map of the river and identify the places on the journey we just took. A writing prompt is

given for each location and a period of free writing takes place for each. After we have finished writing for each location, four people self-select and go to the four corners of the room and alternate reading from their journal with sound and movement while following the map they have drawn. This is an example of a communal journey where all community members are fully engaged in the journey. After we have done a series of communal and corporate journeys, we are ready for individual journeys that are facilitated by students in small groups of three to five peers/facilitators with a single student in the center of a small circle.

The individual journey

The most consistent element in the space and as a part of each and every facilitated journey is the beat of the drum. It is our baseline.

The drum connects us to our center, our beginnings, our origin and it is the internal rhythm of life as in the beat of our hearts. There is a process of self-selection as individuals step into the community circle, eyes closed. Once three to five people have stepped in to begin their personal journey, the community members begin to move to the drum's rhythms around the individuals, making smaller, more intimate circles so that each student/participant has two or three people who will be their personal facilitators, helping and

Figure 6.1 Tawnya Pettiford-Wates leading a studio class at the University KwaZulu-Natal in Durban, South Africa in the Drama and Performance Studies Department in 2013 (photo by Jade Maskel).

encouraging them, keeping them safe so that they can fully give themselves to the journey process with complete and utter abandonment, fully trusting their facilitators to take care of them throughout. We begin through a process of allowing the breath to drop in and release out and relaxation with the laying on of hands, each journeying student/artist entering into an altered state of consciousness that resembles a trance-like state. This is achieved through a prolonged period of tension-relaxation breathing and a "test" of the level and/or depth of their relaxation. In the extremely rare event that someone cannot achieve an unconscious state that is deep enough to continue, they are asked to step out and are encouraged that another opportunity will arise when they are ready.

As primary facilitator, I initiate the journey with a suggested time period within a particular age range (5–8 years or 9–12, etc.) The student/artist remembers a time during that period when they were having a rite of passage experience or significant moment. This is an experience that had a profound and transformative effect upon the individual. Through breath, sound, movement and eventually text, the individual lives in that moment in a very stylized/abstract manner. It is not a literal "acting out of the event" and cannot always be completely understood by those who are witnessing the event while facilitating the journey. The stylization is determined by the individual in an organic creative expression of whoever the person is at the center of the journey. Those community members who surround them during their journey protect the individual journeyers from harm, akin to the way midwives and doulas engage during the birth of a child. Throughout the journey the participants live in a series of three different emotional locations that are associated with the same event. They begin with the initiating "happening" or incident and move cyclically to the next moment and the next representing life/death/transformation. The entire journey usually takes from twenty to thirty minutes in length. The process is fully immersive and exhausting. After the *cool down* period, which brings the participants out of the trance state, they begin to write in their journals at an intentionally fast pace to the rhythm of the drum. All other facilitators also begin to write and after a time whoever is impelled to share in a loud voice with strong emotion does so until we close with the drum and a collective Ase' Ase'.[13]

Speaking immediately in a loud voice with strong emotion is essential. Because the stories that are impelled by this process are usually extremely cathartic covering a spectrum of emotion and are often stories that have been deeply buried within the subconscious or unconscious mind of the storyteller, it is important that they get the story *out*. It helps to "breathe" the story out ... to speak fully on one's voice. It is a strategy of facilitating the revelation and healing process. It keeps the intellect from taking over and suppressing the story before it has the ability to expose itself.

The stories that reveal themselves throughout the process bring revelation, transformation and change. They heal and empower the student/artist with

the rhythm of their own heartbeat and the power of their own voice. The following are some reflections on the process from former students.

> I will be the first to admit that at the beginning I was a bit skeptical and resistant to the work. However, my skepticism was rooted in fear. I was afraid to surrender to the work because my natural instinct was to shield my emotional baggage from the world. RPD was the first methodology I was exposed to that fully enveloped a sense of cultural identity and artistic responsibility.
>
> (Adanma Onyedike Barton, Associate Professor, Berea College)

> I just wanted to let you know how much I appreciate everything I learned in your class last year. I began the internship fully prepared and unafraid to "immerse myself"/"jump all the way into the water." The reason I'm saying all of this is to show you how imperative your class was to my work ethic and confidence as an artist. I am unafraid to take risks and put my heart into my art because of your class.
>
> (Caitlin Carbonne, BFA in Performance, 2013, Virginia Commonwealth University)

One of the most rewarding outcomes of sharing this process with students who are White, such as Caitlin, is not only engaging with them in the process of finding their authentic voice but also witnessing the evolution and rediscovery they have as self-actualized artists. Caitlin's journey through the RPD process is illuminating because what she reveals above has to do with the acknowledgment of how much working within the RPD model actually liberated her as an artist and taught her the value she holds within her own unique creative impulse. I only mention that Caitlin is a White woman because it speaks to the value of the process for students regardless of their racial identity and acknowledges that even when the system of traditional arts education is designed for White students and significantly elevates and validates them throughout, they still have issues, emotional and psychological blocks that inhibit them from being fully present in their creative force.

A pedagogical shift

My first trip to the continent of Africa was in 1994 for several weeks, touring Ghana from Accra, to Kumasi, to Cape Coast and the slave castles that line its coastal border. Although I went as a scholar and guide for the students that accompanied me, my experience was profoundly personal, emotional and psychologically transformative. Standing on the stage of the National Theatre of Ghana and speaking the text from *For colored girls* ... gave me outbursts of uncontrollable glee and was an intensely spiritual happening.

dark phrases of womanhood
of never having been a girl/half notes scattered without rhythm/
no tune/distraught laughter falling over a black girl's shoulder/
it's funny/it's hysterical/the melody-less-ness of her dance
this must be the spook house/another song with no singers/
lyrics no voices/& interrupted solos/unseen performances
are we ghouls/children of horror/the joke
don't tell nobody/don't tell a soul
...somebody/anybody
sing a black girl's song...[14]

Standing on that stage in Ghana, built by Black hands, for the expression of Black art with other Black artists and community members to whom I needed offer no explanation, comment or context, was so liberating that I wept openly. These are the same lines I spoke nearly three decades prior as the Lady in Purple on the stage of the National Theatre in Washington, D.C., performing in the New York Shakespeare Festival's 1st National Tour of *For colored girls* ... The cyclic and cosmic connections to who I was then and who I had become were not overlooked in that intensely profound moment. What I knew then, which I had always known but hadn't envisioned, was the urgent need to revise the whole of my educational and theoretical philosophy within the dramatic arts industry. What I was compelled to do was to dedicate myself to dismantling the Euro-centered arts education I had been bound to and construct a new methodology rooted in the cultural heritage of the African origins of the dramatic form and the liberation of the creative artist within. A decade later that vision would emerge as a holistic methodology called the Use of Ritual Poetic Drama Within the African Continuum (RPD).

Personal growth and benefits

The potency and impact of the use of RPD has been undeniable. From 1990 to the present, the positive outcomes have been wide ranging in scope. What has been consistent in countless reflections is that the process was transformative and empowering for the students who fully participated in and completed the course of study. RPD was illuminating for the student/artist and facilitated a process of both revelation and recognition of who they were as artists and as individuals. The use of this methodology has provided for those students/artists a level of cultural awareness and self-actualization that empowers them to continue the process of evolving into creative artists rather than imitative ones. RPD, as a methodology, facilitates and supports the artist who is courageous enough to tell their own story, devise their own performance and interrogate an arts culture that has historically championed a Eurocentric aesthetic as the highest standard of training, practice and/or

performance, and marginalized or ignored other more indigenous and cultur-
ally located perspectives and principles as effective or significant in making a
formative contribution to current and contemporary practice.

The work *works* and can be employed by all students, although it is
designed specifically to illuminate and edify the Black student/artist by
counteracting the false doctrine of superiority and primacy in Eurocentric
models of arts training and practice. Because the focus of the work is cen-
tered on facilitating the process whereby the dramatic artist is able to
connect with the essence of their creative self, the core of their artistic
genius and power, it is an effective tool and model for all artists of the dra-
matic form who have the courage to step into the circle. Here are some
reflections from some of them.

Jasmine Eileen Coles is a teaching artist, actress, singer, dancer and a proud
graduate from Virginia Commonwealth University with a BFA in Theatre
Performance:

> My very first impression of RPD Within the African Continuum was full
> of excitement and a familiar energy and essence. I had never done any
> work like it; however, there was something about the principles and
> values that felt like it belonged to me. I dove into the process with antic-
> ipation, knowing that I was on a path of discovering who I was as an
> artist. Before studying the RPD process I defined myself as an artist that
> knew how to take direction, but I did not know how to create. I met
> the most resistance in this process coming to the realization of knowing
> that my story was valuable and worthy enough to tell. Because of RPD I
> do not have a dependency on commercial theatre work for my liveli-
> hood. I am always able to create my own work. I will always use RPD as
> the inspiration for my work. I am a teaching artist in New York City and
> use it to create original work with students in high school. RPD is a
> transformative methodology that uses song, word power and dance to
> create revelation and social change.

Joseph Anthony Carlson, an actor, director, teaching artist and graduate from
Virginia Commonwealth University with an MFA in Pedagogy and a focus
in the use of RPD, explains one of the tenets of RPD, as he understands it:

> It is self-determining and/or self-defining: The process of artistic train-
> ing is deeply personal and in this methodology it is dependent upon
> one's knowledge and one's ability to validate one's self. As a person, and
> as an artist, the work I do, if it is of any quality, impacts the world; it
> impacts my community. This methodology, in recognizing our inter-
> dependence upon one another, recognizes that our acting as artists has
> consequences whether or not we choose to work for social change or
> for popular entertainment.

Afterword

Ritual Poetic Drama Within the African Continuum has emerged as a holistic powerful method in which to nurture and transform both the creative artist and the creative process. It is rooted in the inner knowing that with every sunrise there will be a sunset and that the power of theatre in performance is life, death and transformation of not only the artist but also the audience and community. The infusion of cultural pluralism and inclusion of a catholicity of thought and practice is essential, if the dramatic arts industry is to be relevant in the future beyond entertainment of elites or some commercial bottom-line. As creative artists, arts educators and scholars, we have an innate responsibility to move our industry forward by infusing cultural pluralism of thought and practice throughout arts education.

The ultimate function and purpose of RPD is to empower the dramatic artist to fully embrace their artistic purpose to become self-actualized and recognize their function as an activated artistic force responsible to both their personal artistic integrity and social responsibility. Training that is devoid of any recognition of cultural identity and cultural location is risking creating artists who are technically proficient but may be morally and socially dysfunctional or disconnected from the authentic self and their community. We must ask, "Who are we as artists and what is our purpose?"

Notes

1 The First National Tour of a Broadway show is considered a Broadway company. Tony Award winner Trazana Beverley, and several original cast members, launched that first national tour. I auditioned for and was cast in the Broadway company, and a few months later was cast in the First National touring company. At the time of my audition the cast for the national tour wasn't yet chosen.

2 The well-made play is a term used to describe logically constructed plays following the pattern of careful exposition and preparation. It is a linear model that begins with exposition to inform the audience with the same set of circumstances and conditions. The plot evolves into a series of complications and conflicts that build in rising action to a climactic point and then a resolution in which important and relevant questions are answered.

3 The Use of Ritual Poetic Drama Within the African Continuum is a methodology which emerged out of a series of studio experiments I conducted between 1989 and 1992; *Revision: Towards a Re-connection of the Dramatic Artist with the African Origins of the Dramatic Form*. The methodology embraces the African origins of the dramatic form and is grounded in African-centered practice and definition of ritual and story/drama and community.

4 Rite of passage journey/moment is a specific time, moment or event during your life's journey that has such a significant impact on your thoughts, feelings and/or perceptions of the specific time, place or event that it is transformational for you and impacts both your actions and your reactions regarding those particular circumstances, environments or people involved in the event, whether consciously or unconsciously, from that moment forward.

5 Knowledge that the African Continent gave civilization the arts and sciences, religion and philosophy is designed to produce a change in the mentality of both

White and Black people. George G.M. James, *Stolen Legacy* (San Francisco: Julian Richardson Associates Publishers, 1954 [Reprinted 1988]), 153.

6 The mask is the symbolic and metaphoric reality that Black people live with, particularly when intersecting with Whites or Whiteness. The National Black Theatre director Barbara Ann Teer stated:

> As the black experience in America is quite different from the white one, black actors are frequently asked to play roles that have nothing to do with the basic reality of their lives. This may seem to be a contradiction but Stanislavsky's "as if" theory does not always work for black actors in these times.
>
> (Lundeana Thomas, "Barbara Ann Teer: From Holistic Training to Liberating Rituals," in *Black Theatre: Ritual Performance in the African Diaspora*, eds. Paul Carter Harrison, Victor Leo Walker and Gus Edwards, Philadelphia: Temple University Press, 2002, 353)

7 "The benefits of the Nommo are received primarily through ritual: a specific, formalized activity that a people create in order to achieve a particular psychological, physical, or spiritual result for individuals and the community." Paul Carter Harrison, "Form and Transformation," in *Black Theatre: Ritual Performance in the African Diaspora* (Trenton: African World Press, 2002), 316–317.

8 Patricia Hill Collins, "Toward an Afrocentric Feminist Epistemology," in *The Use of Dialogue in Assessing Knowledge Claims*. (Reprinted from *Black Feminist Thought: Knowledge, Consciousness, and the Politics of Empowerment*, Patricia Hill Collins, 1990, by permission of the publisher, Routledge: New York and London. Footnotes and references deleted.) www.woldww.net/classes/Principles_of_Inquiry/Collins-AfrocFemEpistemology+.htm.

9 "Plot on the other hand answers all questions it pretends to pose." James Baldwin, *The Price of the Ticket: Collected Nonfiction, 1948–1985*, 2nd ed. (New York: St Martin's Press, 1985), 583.

10 "Housekeeping" is the metaphoric and symbolic cleaning out of the space on the physical plane as well as the spiritual. This could be anything from a reading or "sharing" of written work, a revelation someone had regarding a misunderstanding or irritation between two people that needs to be mediated and taken care of before we can begin our work for the day.

11 We use *Sankofa* as a literal going back to pick up something forgotten, as in beginning something like a story, scene, or moment again because you were not fully prepared to begin; in that particular moment you might say "Sankofa" and the community gives you the grace of allowing you to begin again.

12 Traumatic experiences and denial of those experiences cause psychological damage and emotional barriers for the actor. In addressing the needs of the Black performer within the context of Eurocentric educational and training models, that damage can be exacerbated exponentially. I relate the work I do in RPD using rite of passage journey to the work of African American psychologist Dr. Amos Wilson on trauma. Dr. Wilson posits that because we choose to forget a traumatic event, or we choose not to learn of a traumatic history and a history that may make us feel ashamed, does not mean that history is not controlling our behavior. See Elise Law, "Educating Black Students According to Their Own Psychology: Gary Byrd Interviews Dr. Amos Wilson (1988)." *Legal Eagles Community Newsletter Blog*, April 21, 2015. http://legaleaglesflyordie.com.

13 Ase' Ase' is a West African (Yoruba) word meaning an invisible force, a magical-sacred force of all divinity, and of all things. It is an individual and communal affirmation of calling into being.

14 Ntozake Shange, *For colored girls who have considered suicide/when the rainbow is enuf A Choreopoem* (New York: Scribner Poetry, 1997), 3.

Remembering, rewriting, and re-imagining

Afrocentric approaches to directing new work for the theatre

Clinnesha D. Sibley

On new work and artistic leadership

In the theatre profession, it is the artistic director's responsibility to serve as a visionary. The director's role is to implement the vision and to shape the aesthetics of the play. An artistic director who aims to produce at least one world premiere play per season once shared with me that, in order to produce a new play, he must (a) really care about the play and (b) highly respect the playwright. The notion of caring about the play and respecting the playwright is vital for companies who seek to engage in diversity initiatives while creating new work. In line with our conversation about Black acting methods, it is detrimental to the play process if the artistic director does not care as much about stories that aim to uplift and attract Black communities, or if the artistic director's idea of diversity means artists and audiences of color have to assimilate.

Hence, the purpose of this essay is to offer constructive steps towards re-imagining theatre by way of new play development that relies on the traditions and histories of African Americans. The strategies outlined in this essay can help a theatre director become attuned to the artistic energies of Afrocentric artists. When discussing community cohesion, Professor Ted Cantle views it as a trust factor:

> Indeed, from the outset, community cohesion attempted to develop a positive vision for diverse societies, in which people from all backgrounds would feel that they belonged and were valued, enjoyed similar life opportunities and interacted with people from different backgrounds to break down myths and stereotypes and to build trust.[1]

Theatre that is racially inclusive can certainly aid in breaking down stereotypes. However, it is not enough to place an African American in a play that was written with all White people in mind and expect to accomplish trust-building. Cultural diversity is not fully accomplished when people of color are used to sell messages about what it means to be American. While interculturalism is noteworthy, it is not enough to bring a person of color

into a story so that the character has to navigate or negotiate his or her place in a White world.[2] While there is Black presence, Whiteness is still being staged.

As audience members, we should seek personal empowerment in the theatre by holding artistic directors accountable to their mission statements. Real diversity involves people of color and Whites interacting without resistance, and without attempting to make sense of their respective worlds without regard to others' perspectives. The theatre can be productive in showing how one culture influences another if audiences demand that leaders not only be bold and empathetic, but also racially conscious. An artistic director/leader must not be a person who only makes executive decisions. Such a leader should also be a spiritual guide, affirming a people, not denying them. I will never forget having a new play of mine developed by a theatre company when the artistic director fired one of the actors because she was not as "skilled" as the others in the ensemble. I was stunned by the decision and, for the first time, felt disoriented concerning theatre—an art form in which the human spirit is truly of the essence. While natural talent is good and convenient, I argue that mere talent cannot be the sole factor in determining an actor's worth. Rather, worth should be measured by the performer's overall contribution to the experience. Every artist of color comes to the table with different backgrounds, experiences, training, and resources. Therefore, it is important to find an artistic director who can connect with the spirit of each unique and complicated individual involved and serve in a capacity where sound executive decisions are being made about the piece. He or she should have a willingness to affirm and nurture all involved, while considering how the experience will touch, transform, heal, and awaken. With this model of transformative leadership, the goal of the production is not always to yield high-quality productions. Instead, the director aims for a rites of passage in which our souls and minds are on the same wavelength.

Remembering: Afrocentric cognition

The play director may feel strongly about helping the playwright to arrive at a strong final draft of the play. Understand, however, this is not the ultimate reason you (the director) are being brought into an Afrocentric circle. When you are called upon to direct theatre of the African diaspora, you either get "it" or you understand that knowledge is power and, therefore, have potential to get "it." The "it" I am referring to is the art and science of being Black. As someone responsible for the birth of this new work, you, the director, are also responsible for the transference of cultural values, traditions, codes, and memories of Black people onto the stage.

Dr. Barbara Ann Teer, founder of the National Black Theatre in Harlem, was a pioneer in that she believed actors were not actors, but liberators. As

the director of an Afrocentric piece, referring to performers as liberators is certainly appropriate. A liberator's memory and what he or she is able to bring on stage is interrelated and is often what makes the process of acting and "becoming" such an exhilarating experience. For centuries, actors have utilized memory to recall certain emotions associated with a specific human behavior to achieve verisimilitude. When dealing with memory in Afrocentric theatre, it is first and foremost about liberation—helping the Black performer become free from systematic processes to concentrate on Blackness and the collective identity.

Brooke Kiener recalls the convening of fifty students and community members in a black box theatre in the winter of 2004 at Whitworth University Theatre for a Social Justice Institute. They were invited to speak about instances of socioeconomic discrimination they had witnessed or experienced, and she recalls the following:

> I was impressed right away by the level of engagement in the group; it seemed obvious that people needed to tell these stories, to hear and be heard. But as the night went on, I also became peripherally aware of a widening gap. As the community members became more activated, empowered by the act of speaking their truth, a resistance started to surface among some of the students who, as you might expect, tended to come from more privileged backgrounds.[3]

Kiener reminds us of the vulnerabilities associated with memory and shared experiences. The swapping of experiences when developing a new play is a surefire way to get people to open up about their beliefs and practices while engaged in memory. The challenge occurs when there is resistance or dismissiveness during the swapping of experiences due to lack of knowledge. I am reminded of a quote by Henry Louis Gates, "Blacks—in particular, black men—swap their experiences of police encounters like war stories, and there are few who don't have more than one story to tell." If such a topic comes up in a new play development circle in which there are White males involved, there may be some resistance because White males are not typically held in suspicion. Because resistance threatens our progress as Black artists, Kiener challenges us to contemplate our roles as theatre collaborators. Through collaboration, our goal is to center the perspectives of the Afrocentric/Black contributors, and to stifle resistance by evoking awareness and sensitivity. If there is a lack of knowledge and awareness, a director must be able to redirect the resistance and lay a framework in which culture is the context and the paradigm that holds Afrocentric "ideals, beliefs, stories, texts, myths and narratives in place."[4]

Resistance can also surface when vernacular challenges Eurocentrism. I remember being the only Black writer encircled around a table in a graduate playwriting class trying to explain why the phrase "making groceries" made

sense. "You don't 'make groceries,'" my White male mentor said. "You go shopping for groceries." Because the characters in my plays are directly inspired by my kinfolks and my life in the South, it is very appropriate that lines like "making groceries" are spoken by my characters. To me, these sayings are not only authentic, but eloquent—borrowed from the voices of my ancestors; yet, according to the majority, if "making groceries" were a goal my female character needed to accomplish before eleven o'clock in the morning (the hour that her favorite daytime soap, *The Young and the Restless*, came on), then my character was considered to be using the English language improperly. However, according to "White normative structure,"[5] "I need to go get groceries" is the proper line of dialogue. Now, let me add that the phrase "making groceries" has been spoken by every member of my family and probably every female grocery shopper in southwest Mississippi. I have tender memories of going to the Sunflower store in the town of McComb to help my grandmother "make groceries." My husband, who frequented the White-owned Vaccarella market with his grandmother in the same town, remembers pushing a buggy filled with enough food to last an entire month, to a register where his grandmother had a tab. The reputation of this African American woman granted her a credit line that would last until the store's closing. When the store shut down, she was personally called and told she could come and get whatever she wanted because of how much she was loved and appreciated by the store owners. My husband's memory takes him to the store aisles where he was pulled to the side by his grandmother in silent acquiescence to White customers passing by. Ultimately, I wasn't just sharing with my fellow playwrights unique phrasing among Black folks or southerners; I was divulging a history about personage, prominence, race relations, and customs—not just a way of talking, but a way of life. The notion of "making groceries," deeply embedded in my memory, held profound historical and personal significance. It is astounding how the mind stores information.

Directors and playwrights exist in-community together; therefore, they should value each other's unique experiences. Likewise, directors must trust the power of where the playwrights' memories can take a story. While the art of remembering is an individualized process, it tends to move toward the communal Afrocentric work, allowing everyone involved to develop a consensus with their sentiment or ideology. Reminiscing aside, there is the reality of crafting and understanding the parts of a play. Afrocentric cognition should be the default of the overall experience. When engaged in this form of recollection, the playwright should also be engaged in meditation as a means to foster ancestral or spiritual intuition, which links the playwright to an absent-other or another time period. When appropriate, direct the playwright to write nothing and to meditate in a private space. When his or her brain muscles have flexed, giving way to something that has cultural, social, political, or artistic significance, have the playwright write down everything that strikes a chord. Allow the playwright to speak aloud his or her thoughts,

or the accounts of actual or imaginary persons, places, or things. Remember that an expressive playwright is not arrogant, she is liberated; encourage your playwrights to give voice to memory. The impact of remembering can be powerfully integrated into a play, strictly as a form of ritual that may or may not be connected to a personal account. As an example, in Javon Johnson's play *Bones*, memory is an agent that illuminates injustice. The following dialogue takes place between a WHITE MAN and a Black man named JAKE, who have known each other for a long time:

WHITE MAN: I remember what they did to your daughter.
(*Jake stops chopping and looks to the White Man*).
WHITE MAN: Everybody remembers.
JAKE: What you want from me?
WHITE MAN: A piece of tranquility, I suppose.

After JAKE refuses several times to recall such an emotional memory. He finally surrenders:

JAKE: (*Lowers the ax*) They killed my baby. Thirteenth birthday and they took her from me. They left me one shoe. Just one. Little white shoes I got her to celebrate her life and they took that away from me and left me one. Wasn't white no more. Just red ... torn with my baby's blood on it.[6]

We see both Afrocentric cognition and memory at work in this moment from Javon Johnson's play. He uses the recollected past of both male characters to exist simultaneously in the same place.[7] Inevitably, the moment, the sharing of memory, reclaims legitimacy of the deceased.[8]

What happens in the mental workspace can anchor a play or a character in ritual, giving it purpose, a sense of being, a reason to fight, a reason to believe, a reason to lose hope, regain hope and lose it all over again. Kinship, goodness, and pain reside in the mental workspace. When unsure of the story's direction, memory re-routes the writer. The practice of commemorating memories can happen as foundational work. Perhaps when the ensemble is gathered to do work on the play, ask members of the group to share memories associated with the play's greatest issue or theme. I have heard the most authentic retorts emerge from collective memory-sharing. In this stage of development, the playwright can begin to modulate the story through Afrocentric cosmologies.

Rewriting and non-writing

Before the play is wrought, it is important for the author to understand why the story must be told in the first place. This is similar to finding the dramatic question; however, the Afrocentric dramatic question requires "a deeper level of

investment"[9] in that what is really being asked is *"what will it take for us to get free?"*[10] Ebony Noelle Golden is the founding CEO and principal strategist at Betty's Daughter Arts Collaborative, LLC. Her stance on art is "to infuse her values into the creative process." This must happen in order for her to reach audiences in the communities she is "accountable to." Because she believes devising ritual is just as essential as developing new work, Eurocentric trends get in her way when building a play's foundation and can be equally challenging for any director who is being accountable to the work of an Afrocentric playwright. Here, I am specifically concerned with whether or not it is "Afrocentrically" vital to fully abandon all trends, devices, and literary tropes that seem Eurocentric, or whether it is fitting to employ what is necessary, be it Afrocentric or Eurocentric, to realize the story. Next, Golden mentions accountability. By forfeiting the Eurocentric trends, she, in turn, becomes fully anchored in Blackness. If this is the level of freedom we should achieve in Afrocentric new play development, how bound are we to plot and structure, objectives and needs? Should we even pause to establish protagonist and antagonist? Furthermore, what is character? While we are programmed to identify the protagonist of a play, for example, I believe in Afrocentric development that the first person to be identified in the piece is the *griot* or *griotte*. A leader among the other storytellers in the play, this individual is the one who connects one member to another. Identify the *griot* or *griotte*, and you have a sense of community, an ancestral connection and a "theatricalization" of history. The *griot* or *griotte* in actuality becomes more necessary than a main character. Therefore, focus on the stories, sayings, songs, proverbs, and other cultural products of the *griotte*. Explore the play's peak emotional moment as a manifestation of one or more significant historical events preserved or shared by this *griot*. August Wilson practiced this in his work. *The Piano Lesson* is a prime example. The play's *griot*, Doaker, in act one, scene two, explains why Berniece will not sell the family's heirloom. He commences to explain the history of the carvings on the piano, therein, the history of the family:

DOAKER: Then he put on the side here all kinds of things. See that? That's when him and Mama Berniece got married. They call it jumping the broom. That's how you got married in them days. Then he got here when my daddy was born ... and here he got Mama Esther's funeral ... and down here he got Mr. Nolander taking Mama Berniece and my daddy away down to his place in Georgia. He got all kinds of things what happened with our family.

We see a "theatricalization" of this in act two, scene five, when Berniece plays the piano for the first time in years. She calls on the names of her ancestors:

BERNIECE: I want you to help me. Mama Berniece. I want you to help me. Mama Esther. I want you to help me Papa Boy Charles.

By channeling the help of her ancestors, she is able to cast out unwanted spirits that had been lurking inside of her home.

If there is no sign of a *griot* or *griotte*, invite the playwright to function as the guardian of his or her own people's history. Encourage the playwright to be a *griot* among the others in the room. Guide his or her histories so that they become realities of characters. Directors traditionally place emphasis on character development when working on a new play tinged in realism. When the experience is Afrocentric, it is just as important to focus on the history and development of a people, not just a single character. It is proven that good script analysis translates into idea conception, design, and acting work. While there are many ways to analyze a play, our questions for Black play script analyses should also be culturally specific. Consider the following questionnaire for the Afrocentric performing artist:

Afrocentric analysis

Character's name(s) (African, enslaved and/or new name/identity)— calls attention to a distorted historical legacy, such as Oya in Tarell McCraney's *In the Red and Brown Water*.

Character's African tribe and customs—celebrates the root of what sustains a people, as seen in Julie Okoh's *Edewede (The Dawn of a New Day)*.

Most valued treasure/artifact—gives context to pre-existing objects or images, such as the piano in August Wilson's *The Piano Lesson*.

Traditions, values, and religious beliefs/conversions—establishes strong kinship bonds or spiritual practices while keeping ritual alive, such as the juba ritual in August Wilson's *Joe Turner's Come and Gone* or the oral tradition as seen in Gus Edwards's *Two Old Black Guys Just Sitting Around Talking*.

Anthems—connects generations and their plights through song, as seen in Regina Taylor's *Crowns*.

Greatest threat to the people—also the greatest threat to the core values, which may accentuate a state of oppression as well as an opportunity. For example, the issue of gentrification explored in Keith Josef Adkins's *The Last Saint on Sugar Hill* and the subject matter of AIDS in Danai Gurira and Nikkole Salter's *In the Continuum*.

Hero worship—may be a war hero, man or woman of courage, civil rights activist, community, political or religious leader, or someone impactful who ultimately gives the character hope, such as Nina Simone in Keith Antar Mason's *For Black Boys Who Have Considered Homicide When the Streets Were Too Much*.

Antiheroes—explores those who are a threat to justice or misrepresent it, as seen in Kia Corthron's *Cage Rhythm* or Lynn Nottage's *Ruined.*

Environmental bonds—the connection to physical and social surroundings, emphasizing conditions and patterns of suppression, as seen in Katori Hall's *Hurt Village.*

Adversity tactics—involves characters emancipating themselves from a state of affairs, as seen in Idris Goodwin's *How We Got On* or Ben Caldwell's *Birth of a Blues.*

Along with this analysis should be a list of words, poetic phrases, and images that inspire them to live as a member of this story. Unlike other character analysis models that are need-based and sensory driven, the purpose of the Afrocentric analysis is to get the artists actively working to see the play as a sacred event in that it gives them spiritual and kinship ties, sheds a light on both the history and destiny of a people and emphasizes the need for justice. When the play does not provide the answer, the Afrocentric artist will come up with the missing analytical element on his or her own, becoming a unique carrier of social memory. In essence, all participants take on a creative and explicit role.[11] All artists have the power to explore the origin of a community and to determine the fate of that community. In his book *The Ritual Process*, Victor Turner writes about ideological communitas, which describes the external effects and inward experience of a group by examining the optimal social conditions under which they might be expected to flourish or multiply.[12]

Before the play advances far in development and becomes significantly different from its original version, it is also important that the playwright steps away from the process as a work-session and be allowed to fellowship with other artists invested in the work. Involve the designers whom we have not addressed as much. Their participation is vital, as their artistic work can capture the vastness of Afrocentricity as a holistic and complex entity or state of mind. In Afrocentric rewriting, there should be a point of non-writing to allow the playwright to become absorbed in Afrocentric spaces where bonding and sensory awareness occurs. Communing at a dinner table, attending a poetry slam, going to church, and walking through an urban community are a few examples of such spaces.

According to Jualynne E. Dodson and Cheryl Townsend Gilkes, table fellowship and meals provide context for storytelling while evoking laughter, solace, and providing a temporary release from emotional experiences.[13] Issues of concern for Black people are exposed in this space via "a communication style that is rich in allusion, metaphor, and imagery"[14]—a style that is "prolific in the use of body gestures and nonverbal nuances."[15] When people who love oral tradition are encircled around a table of food, values, histories, and

situations, valuable information can be transmitted. Comfort food triggers socializing and eases the act of conversing. Table talk might include narratives containing dramatic and comedic situations and include characters with whom everyone is familiar. A playwright can infuse her script with moments from this space.

A poetry slam is another way a playwright can engage with culture and explore the language and situations of a community. Have the playwright focus on the power of words, pauses/beats, and when and why people are compelled to snap their fingers in response to the message. How is music integrated? How is repetition utilized? What compels members of the community to engage in poetry? What type of poetic lines trigger moments of call and response? The landing of a poetic line can be associated with the lines and moments in a play where there is a consensus among audience members. The poet's desire for personal presentation, verbal artistry and commentary on life's circumstances[16] can also serve as monologue or soliloquy inspiration. Have the playwright consider the ways in which metaphor, alliteration, rhythm, and wordplay inspired Langston Hughes as both a poet and a playwright.

Movement/dance, musicality, and vocality can all be extracted from religious experiences as well. Lundeana Thomas explains this religious experience in her book *Barbara Ann Teer and the National Black Theatre: Transformational Forces in Harlem*. The chapter, "Black Cultural Resources: Pentecostal" explains:

> The climax of the Pentecostal church service is usually the minister's sermon, which is both emotional and dramatic. During the sermon, a Pentecostal minister might strike the pulpit or even jump on top of it. Nor does he remain in the pulpit or rostrum area, but he might take a microphone and go down into the congregation. He might also establish a rhythm, keeping the beat by tapping his foot or clapping his hands. His sermon is in many ways an enactment of his biblical text. Such rhythmic preaching descends from its roots in Africa, in rhythms used by the griot or storyteller.[17]

Thomas goes on to say this type of experience is what Dr. Barbara Ann Teer instilled in her students. The connection between spirituality and food; spirituality and poetry; spirituality and music—all manifested in the church experience, all anchored in Africa. The social and communal importance of the Black church—testifying, singing, humming, and praying—can inspire an atmosphere, a controlling power, or the supernatural, and the soulful responses of a people. Let's consider the play *The Mountaintop*. Playwright Katori Hall explains call and response in the stage directions: "[Camae] stands on top of one of the beds. King looks on in awe. She steadies herself. Throughout her speech, King is the congregation, egging her on with well-timed sayings like, 'Well!' 'Preach!' Or 'Make it plain!'"[18] In this moment, a bed becomes a pulpit, a maid becomes a minister, a man becomes a body of

spontaneous, spiritual believers and a room becomes a sanctuary. Everyone becomes one, inviting the audience to join the ritual.

Finally, an urban community is the space in which an Afrocentric playwright can become even more race-conscious because they retain cultural codes and atmospheric tones that can inform story and character. Taking time to participate in the life of these communities can be integral when writing from the lens of urban worldviews.

By engaging in non-writing and simply participating in cultural bonding activities, artists developing new work, director included, can establish a centeredness or collective identity. This centeredness and oneness is the Afrocentric vision that sets the Afrocentric new play development process apart from the American one that is embraced at conferences across our nation. On the other hand, what if the attempts to absorb African American culture are not embraced? For example, some were not comfortable in the neighborhood you visited, some were not fully engaged at church, you weren't moved by the poetry and your dinner experience was subpar. Be reminded that, in ritual, criticism is prohibited. If the critic inside the creator is not quiet, the opportunity to fully engage will be missed. The creators must stay centered on the shared experience. Focusing on bad feelings, rough opinions, and negative dispositions will lead to apprehension. It is this apprehension that tends to force theatre practitioners to create theatre in the normative, which is a threat to multiculturalism.

At this juncture, the playwright, having absorbed many Afrocentric experiences, returns to her script, infusing it with Neo-Africanisms, spiritual happenings and structural rebellion, placing emphasis on the poetic; actors or storytellers reactivate their analytical acumen, embracing the physical and psychological traits of a people; designers reinforce central images and areas with Afrocentric motifs, symbols, and emblems, strengthening their visual statements; then the director's performance style becomes rich with visual compositions and punctuated moments. Everyone's work becomes inspired by Afrocentric absorption. Creative impulses are in sync. "By regaining our own platforms, standing in our own cultural spaces, and believing that our way of viewing the universe is just as valid as any, we will achieve the kind of transformation"[19] Afrocentric theatre needs to withstand the test of time.

Re-imagining: a spiritual default

Developing a play should feel both reactive and proactive. Reactive in that there is some historical response, and proactive in that there is self-questioning. The result should lead to a re-fashioning of society or the self, which is a sacred event. To be devoted at this level is essentially what it means to devise ritual. If the new work you are developing or devising is realism, have the creators explore a version of the play in which time and space are abolished. Allow the playwright to think on how the story would

function in symbolic time or if time and space were abolished during a peak moment in the play. Consider the two plays mentioned previously, *Bones* and *The Mountaintop*. *Bones* is set "somewhere in the woods" and the time is left to our "discretion." In *The Mountaintop*, culminating stage directions read: "Camae begins to float away into another world. Another dimension. Her voice becoming an echo as the future continues to consume the stage."[20] While the core of your interpretation may already be established, involving yourself in the process as a member of the ensemble will shape your thinking about every other aspect of the production and possibly inspire you to rethink or re-imagine your interpretation. Actors will develop a deeper understanding of who they are and the playwright herself will begin to understand what the play is really about. Design and technical aspects of the production will be integrated in alignment with the Afrocentric ideal. Everyone's creative impulses will be informed by culture, values, and the spiritual. This calls for a re-imagining of what collaborative means. Creative collaboration, as we know, is vital to theatre. Afrocentric collaboration does many things that "traditional collaboration" does not, one major aspect being that it not only invites the spiritual, but makes spirituality a necessity. The director exercises the faith-muscle more than the brain-muscle. Designers focus on the play as an evocative experience more so than what they can create with technical resources and instruments.

Many times, as a playwright, I have prayed privately over my work and my impulses, asking an absent-other to guide me so that I know what needs to happen next, what needs to be said next, or to what place the characters should be led. Divine intervention is what I find myself seeking. Divine intervention is what all artists should seek at all times.

Collective creativity doesn't thrive on establishing the same mood and style to achieve cohesion. Rather, cohesiveness matters most during cultural absorption and fellowship. Assuming the likeness of Ebony Noelle Golden, collaborating or ensemble-building is a means of "getting people comfortable with sharing a story with one another."[21] Much like the dramatic question requires a deeper level of investment, so does the collaborative. "How are people in a creative space able to get closer to what it takes for us to be free?"[22] Raising consciousness through creative work and process impacts everyone involved, from the creators, to the performers, to the audience. The growth and development of a people and a play can hearken back to the artistic leader and the director of the play. And so, do we need a hybrid method for developing new work? Must we have a blend of Eurocentric theatrical conventions when we set out to accomplish an Afrocentric agenda? My response is no. Plays that are "modeled upon Eurocentric dramatic structure"[23] are not Afrocentric. These plays may deal with the Black experience, but they are not Afrocentric. For my thesis, I wrote the most Afrocentric play I could ever write. The earlier drafts of this play explored the life of an African American woman named Joanna, who was pursuing a Ph.D. at a

predominately White university. She was married to a White man. Her best friend was White. Essentially, Joanna's worldview was grounded in White-ness. Ironically, she dreamed of Africa. There was a character in the play, Jira, who represented true Blackness and was Joanna's alter ego. Joanna and Jira would journey together to African villages, building communities and birth-ing movements. There were nineteen drafts of this play. With each draft, the play became more and more universal. It became more and more American and the Jira character went away. No one in the play development process could help me sustain Jira and what she represented, because no one, other than me, could comprehend her. This is an example of how African Ameri-can playwrights can become under-served, and Afrocentric visions are eradi-cated when processes are not re-imagined.

Conclusion

If we consider the acceptance speeches of Tony Award recipients Anika Noni Rose, Audra McDonald, Phylicia Rashad, and James Monroe Iglehart, we will see a pattern that speaks to the spiritual sensibilities of most, if not all, African American theatre artists. Anika Noni Rose tells us the meaning of her middle name, Noni, which means "gift from God."[24] Audra McDonald thanks "all the shoulders of the strong and brave and courageous women" she stands on, giving honor to Lena Horne, Maya Angelou, Diahann Carroll, Ruby Dee, and Billie Holiday.[25] Phylicia Rashad talks about being born into a family of courageous people who helped her to realize her full potential as a human being.[26] James Monroe Iglehart literally does a praise break on stage.[27] There is no denying that when it comes to our contributions to the theatre, our work is a commemoration of our African American histories and strug-gles. For some Black artists, Afrocentricity is innate and, by way of ritual, we honor and broadcast it. The "catch-22" is that most writers, directors, and performers of Black plays enjoy the security of (White) American theatre training, companies, and success measurements. While these great benefits may give way to diversity initiatives within the American theatre canon, it often contradicts what it means to be a true Afrocentric artist.

Notes

1 Ted Cantle, *Interculturalism: The New Era of Cohesion and Diversity* (New York: Palgrave Macmillan, 2012), 92.
2 Ric Knowles, *Theatre and Interculturalism* (New York: Palgrave Macmillan, 2010), 1.
3 Brooke Kiener, "The Wizdom of Us: Reconsidering Identities and Affinities Through Theatre for Social Justice," in *Staging Social Justice: Collaborating to Create Activist Theatre*, eds. Norma Bowles and Daniel-Raymond Nadon (Carbondale: Southern Illinois University Press, 2013), 235.
4 Lundeana Marie Thomas, *Barbara Ann Teer and the National Black Theatre: Trans-formational Forces in Harlem* (New York: Garland Publishing, 1997), 161.

5 Ebony Noelle Golden (activist) in discussion with the author, February 2015.
6 Javon Johnson, "Bones," *Black Drama: Second Edition* (Chicago: Alexander Street Press [online]).
7 Alessandro Portelli, "History-Telling and Time: An Example from Kentucky," in *History and Memory in African-American Culture*, eds. Genevieve Fabre and Robert O'Meally (New York: Oxford University Press, 1994), 171.
8 Andree-Anne Kekeh, "Sherley Anne Williams Dessa Rose: History and the Disruptive Power of Memory," in *History and Memory in African-American Culture*, eds. Genevieve Fabre and Robert O'Meally (New York: Oxford University Press, 1994), 224.
9 Ebony Noelle Golden (activist) in discussion with the author, February 2015.
10 Ibid.
11 Portelli, "History-Telling," 171.
12 Victor Turner, *The Ritual Process: Structure and Anti-Structure* (New York: Aldine Transaction, 1997), 132.
13 Jualynne E. Dodson and Cheryl Townsend Gilkes, "There's Nothing like Church Food: Food and the U.S. Afro-Christian Tradition: Re-Membering Community and Feeding the Embodied S/spirit(s)," *Journal of the American Academy of Religion* 63, no. 3 (1995): 519–538.
14 Janice Hamlet, "Word! The African American Oral Tradition and its Rhetorical Impact on American Popular Culture," *Black History Bulletin* 74, no. 1 (2011): 27–31.
15 Hamlet, "Word," 27–31.
16 Ibid.
17 Thomas, *Barbara Ann Teer*, 110.
18 Katori Hall, *The Mountaintop* (York: Methuen Drama, 2011), 17.
19 Molefi Kete Asante, "Dancing Between Circles and Lines," in *The Afrocentric Idea* (Philadelphia, PA: Temple University Press, 1998).
20 Hall, *The Mountaintop*, 39.
21 Ebony Noelle Golden. Clinnesha D. Sibley. Phone interview. Arkansas and New York. February 27, 2015.
22 Ibid.
23 Thomas, *Barbara Ann Teer*, 3.
24 "Anika Noni Rose Wins 2004 Tony Award for Best Featured Actress in a Musical," YouTube video, 3:33, from an acceptance speech televised by CBS on June 6, 2004, posted by "awardscrazy," November 2, 2013, www.youtube.com/watch?v=jfFVHMFgn-E.
25 "2014 Tony Awards—Audra McDonald—Best Performance by an Actress in a Leading Role in a Play," YouTube video, 2:07, from an acceptance speech televised by CBS on June 8, 2014, posted by "The Tony Awards," June 8, 2014, www.youtube.com/watch?v=bKjXKM1a5RQ.
26 "Phylicia Rashad Wins 2004 Tony Award for Best Actress in a Play," YouTube video, 3:28, from an acceptance speech televised by CBS on June 6, 2004, posted by "awardscrazy," November 2, 2013, www.youtube.com/watch?v= OAiYPjh0A0s.
27 "2014 Tony Awards—James Monroe Iglehart—Best Actor in a Featured Role in a Musical," YouTube video,:55, from an acceptance speech televised by CBS on June 8, 2014, posted by "The Tony Awards," June 8, 2014, www.youtube.com/watch?v=fHs7p_ZxPCc.

Methods of cultural plurality

The Hip Hop Theatre Initiative
We the *Griot*

Daniel Banks

> The flesh/Of the word spoken/Is the breath of the one who spoke it.
> Each word spoken/Is a tangible piece/Of someone.
> <div align="right">(Anthony "Made" Hamilton[1])</div>

The year 2014 marked the tenth anniversary of the Hip Hop Theatre Initiative (HHTI). During its first five years in residence at New York University in the Undergraduate Drama Program, Tisch School of the Arts, HHTI produced:

- a curriculum of eight courses;[2]
- a series of workshops and lecture demonstrations;
- a full-length performance—*Re/Rites: A Devised Theatre Piece Celebrating Hip Hop Culture*;
- community action projects in New York, Pittsburgh, Ghana, Mexico, and South Africa.

HHTI also brought over thirty artists and leaders in the field to work with the students. After its first five years at NYU, almost all of the program's alumni immediately went to work in youth arts education and activism, many creating and running programs. HHTI alums continue to run programs and earn their living as teaching artists around the country, bringing social justice inspired music, theatre, and dance to thousands of youth. Many of the alums also work on New York and regional stages and appear in film and television where they use their Hip Hop and acting skills to create positive representations of Hip Hop generation youth.

As I have written elsewhere, there are many Hip Hops.[3] For the purposes of this chapter, I discuss the global, youth-driven, social justice movement and culture. This Hip Hop has its roots in peace-building activities in the economically devastated but culturally rich south and west Bronx in the early-to-mid 1970s.[4] The red-lining and planned shrinkage imposed on this geographical area produced an outpouring of creative energy, thwarting attempts to silence and

marginalize its residents. Kenyan playwright, novelist, and essayist Ngũgĩ wa Thiong'o writes, "Art is more powerful when working as an ally of the powerless than it is when allied to repression. For its essential nature is freedom, while that of the state is the restriction and regulation of freedom."[5] The Hip Hop discussed here embodies the resistant power of art described by Ngũgĩ. This is the Hip Hop from which HHTI draws its origins and inspiration.

HHTI based its theories and practices on the aesthetic/spiritual connections of Hip Hop culture to African, African diasporic, and Indigenous rituals and creative production. Central to the working methodology of HHTI are three elements of Afrocentric thought (discussed in greater detail below):

1 The mythopoetics of the ritual space;
2 The transformative power of the word, especially as it relates to a legacy of orality; and
3 The circularity of time/history/birth-death-ancestors.

In this chapter I share the origins of HHTI, how its methodology developed, and some of its workshop process. I also discuss the experience of taking this work to Ghana and South Africa and insights about Hip Hop and Hip Hop Theatre's inherent African retentions that were reinforced and disrupted during this time. Finally, I suggest future steps and implementations of Hip Hop and Hip Hop Theatre in terms of U.S. theatre and theatre training curricula.

> Until lions have their own historians, tales of hunting will glorify the hunter.
>
> (Akan proverb)

Mix-tape #1[6]: back-story

In 2004, three NYU students approached me with a dilemma. Utkarsh Ambudkar, Joby Earle, and Robbie Sublett asked if I could help them with experimentations that they had been doing on their own into the realm of Hip Hop Theatre outside their formal actor training. I had already been working closely for two years with the Hip Hop Theatre Festival in NYC, directing readings and workshops of new works and organizing and facilitating panel discussions on the aesthetics and politics of producing this then emergent genre. My students asked if I would come to their dorm after-hours to look at their work and coach them.

I made a counter-offer (although going to the dorms would have been a classic Hip Hop, counter-establishment move and not the first time a Hip Hop revolution was started in an NYU dorm[7])—I asked them if they would like to do the work for degree credit. I felt that, although working on their

own showed an entrepreneurial spirit that is core to Hip Hop's origins and survival, it also kept the important work they were doing on the margins. Many theatre programs across the country work to blend a Western or Euro-centric approach to performance with other culturally informed approaches (perhaps the most significant example being the widespread interest in Tadashi Suzuki's work. Other notable examples include Richard Schechner's Indian-influenced Rasaboxes, the inclusion of Noh or Butoh in training cur-ricula, and the use of yoga, meditation, and other mind-body approaches). Most of the millennial generation of students have grown up "under the sign" of Hip Hop, if not directly connecting to it as a culturally specific set of ethos and practices. Therefore, it seemed critical to move *this* culture into the center (borrowing from Ngũgĩ[8]) of a training program—especially since an increased number of projects in theatre and film began to call for trained actors who were equally qualified in Hip Hop genre performance practices and acting. The students agreed.

From the work I have done in residencies at universities and theatres around the country, it seems to me that theatre programs are transparent in their struggle with providing equal opportunity to students of all backgrounds and making sure these students have equal access to the field upon gradu-ation. Work options in the professional arts are, in many cases, broader than they are in certain training programs and not all programs equally prepare their students for the range of realities in the performance industries. Progress has certainly been made; but I think it is fair to say that many, if not most, programs work to balance teaching theatre history and what the faculty already know with encouraging innovation, especially in terms of season selection, casting, and the inherent aesthetics and politics of these decisions.[9] My hope was that HHTI would begin to address some of these challenges and provide a model for other programs to follow.

Hip Hop Theatre (HHT) provides another bridge for training programs. My own training in a Stanislavski approach to script analysis of objectives and actions is fundamental in all that I do, whether working in drama, dance, opera, music, or performance art. Critical to understanding and per-forming within a Hip Hop aesthetic are certain culturally specific modes of thought and ritual. Some of these Hip Hop/Afrocentric principles—such as the power of the word and thought-intention—tether with Stanislavski's techniques. In other words, Afrocentric principles and Stanislavski tech-nique are already in a reciprocal relationship and understanding certain Afrocentric principles can underscore and make the Eurocentric acting techniques more readily practicable while rehistoricizing some of the origin points of this work. As there are now more and more instructors working in higher education fluent in both Afrocentrism and a Stanislavski-based approach, it is increasingly possible at a pedagogical level to connect the dots and make these crucial connections legible to Hip Hop generation stu-dents. Thus began a journey of creating a Hip Hop Theatre curriculum

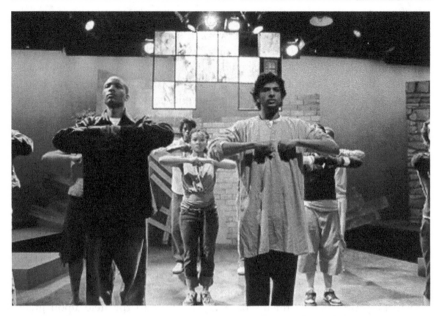

Figure 8.1 The company of *Re/Rites: A Devised Theatre Piece Celebrating Hip Hop Culture* at New York University (photo by Kitty Leech).

within an undergraduate theatre training program. We already had a Devised Theatre Practicum rubric, so Hip Hop Theatre became the focus of one section of that course.

> The foundations of an aesthetic can be found in the culture of a society.
>
> (Kariamu Welsh Asante[10])

"Devised Theatre Practicum: Hip Hop and Spoken Word Theatre" had an academic counterpart, "Hip Hop Theatre: Routes and Branches." In this course we looked at: (1) the origin of Hip Hop culture as a social justice movement; (2) the Afrocentric origins of Hip Hop culture and Hip Hop Theatre; and (3) Hip Hop Theatre literature and its unique intersection of aesthetics and politics.[11]

After teaching this work for several semesters, the department offered us a slot in its Mainstage season and, rather than producing an extant play (of which there were many excellent options[12]), we proposed building on the "Devised Theatre Practicum" by creating a new, student-generated Hip Hop Theatre piece. Over the course of five months, over fifty students worked on *Re/Rites* in performance, production, and design roles, mentored by eight guest artists. I offered a simultaneous course with the rehearsal period during

which the students researched and presented on world ritual theatres.[13] The premise was that Hip Hop Theatre is the ritual theatre of Hip Hop culture, so it was important for the team to understand how ritual theatres grew out of and sustained other world cultures.

> Hiphoppas are judged by the content of their character and skill, not by the color of their skin, their choice of religion, or social status. Since the early days of our cultural existence, our moral pillars have been peace, love, unity, and happiness.
>
> (KRS-One[14])

First breakbeat[15]

The three Afro-diasporic principles/practices from which HHTI draws its inspiration and practice—ritual, word, and time—are not discreet or divisible. They interrelate, playing off of and informing one another:

Word, sound, and movement fuel ritual.
Rituals invoke and embody the ancestors.
Word and ritual expand an understanding of time.
Time inhabits a reciprocal relationship with the word's spiritual power.

The ritual utterer of words conjures time; they know how to stop and start time through the histories they impart and also through the (re)creation of those histories.[16] Not only does word have the potential to alter time; but time, throughout human history, alters the power and efficacy of words.

The emcee in Hip Hop culture carries the legacy of the *griot* or *djeli*, the carrier of culture, who serves as the embodied memory of a culture. Playwright, theorist, and one of the central proponents of an Afrocentric model of understanding Black theatre Paul Carter Harrison writes, "Word-force, spoken or gesticulated, is essential for ritualistic illumination."[17] The ritual leader sets in motion the Nommo force, "the creative force that gives form to all things."[18] According to Harrison, it is "the power of the *word*, that Nommo force, which manipulates all forms of raw life and conjures images that not only represent his biological place in Time and Space, but his spiritual existence as well."[19] Thus the actor, in the role of ritual leader in a ritually derived theatre practice, is the "activator" of spiritual energy.

Barbara Ann Teer, founder of the National Black Theatre in Harlem, similarly referred to the actors in her company as "liberators."[20] Looking at this progression in an African diasporic context, the actor of/in an African (Indigenous) influenced performance participates in the liberation of a people and

culture still healing itself from the transgenerational trauma of forced reloca-
tion and a system of enslavement.

THE ELEMENTS/REFINITIONS—*according to KRS-One*
DJ'ing
Rapping/MC'ing (emcee-ing)
Breaking/B-boying/B-girling
Graffiti/Writing/Burning/Bombin'/Tagging
Beat Boxing
Street Fashion
Street Entrepreneurialism
Street Knowledge
Street Language[21]

Beverly J. Robinson in "The Sense of Self in Ritualizing Performance
Spaces" discusses:

> Ritualizing spaces where rhythms, dance, songs, storytelling, humor, and
> masking are used reflect the ambitions and intelligence of people who have
> created their own theatre history. These people may have been displaced
> from their homeland, but they have not lost their self-knowledge.[22]

Robinson describes a resilient function of performance. This type of perform-
ance ensures the survival of a culture, of a language, and therefore of a people.

Harrison similarly situates African diasporic performance as necessary for
survival:

> Black Theatre must generate a transformative ritual style of work
> informed by the expressive strategies located in the continuum of African
> memory throughout the Diaspora. At its expressive core is a spiritual
> connection between shadow and light, ancestors and the living. Most
> importantly, whatever value it might have as entertainment, the inven-
> tive process of Black Theatre must illuminate the collective ethos of the
> black experience in a manner that binds, cleanses, and heals.[23]

Some practitioners focus their definition of Hip Hop Theatre according to
content (does it tell stories of the Hip Hop generations?) or form (does it
include the performative "elements" of Hip Hop culture?). I believe that Hip
Hop Theatre, at its origin, was born out of the struggle to own both form
and content. However, now that the pioneers have paved the way, some
artists and producers recognize the commercial potential of incorporating rap,
"graffiti," and commercial dance forms into a musical or theatre piece and
invoke the genre Hip Hop Theatre to describe their work. But often the

purveyors of this work have little understanding of the history or the present day realities of the culture—much less its "ethos" or core values. So I began to think about what *really* differentiates a play or musical with rap, for example, from Hip Hop Theatre.

A culture's *ritual* theatre serves a dual function. On the one hand, this act of self-representation emboldens members of the culture. The act of telling and retelling a culture's history creates cultural vibrations of belonging that not only informs the young about their origins, but also creates a harmonic resonance with individual and collective DNA. This performative assertion and exploration of identity maintain the interrelated wellness of the individual and their communities.

Culturally based ritual theatre also promotes cross-cultural coexistence. An audience member who is not from a particular culture has the opportunity to dwell within that culture for a period of time, encounter its cultural psychology and ethos, and experience its mythopoetics, origin stories, and ways of knowing the world. This first-hand immersive experience offers people from the outside both a window into that culture and, more importantly, a somatic or embodied real-time relationship to the culture.

As explained above, HHTI understands Hip Hop Theatre to be the ritual theatre of Hip Hop culture. And our methodology considers how an understanding of this genealogy of performance works not only for participants of African heritage, but for an entire planet transformed by the global trauma of colonialism and the ensuing system of human and economic exploitation set into motion. Moreover, as Hip Hop has absorbed (as any culture does) other cultural influences, from Asian martial arts to *capoeira* to Caribbean toasting to the power of public art, what emerges is a polyvalent narrative of resistance against hegemonic and dehumanizing leadership and practices, as described in the above passage by KRS-One (see p. 144).

Consider the parallels between this well-known passage of Griot Mamadou Kouyaté in *Sundiata: An Epic of Old Mali* and the following monologue from *Hieroglyphic Graffiti*, an unpublished play by Chadwick A. Boseman:

I am a griot. It is I, Djeli Mamadou Kouyaté, son of Bintou Kouyaté and Djeli Kedian Kouyaté, master in art of eloquence. Since time immemorial [...] we are vessels of speech, we are the repositories which harbour secrets many centuries old. The art of eloquence has no secrets for us; without us the names of kings would vanish into oblivion, we are the memory of mankind; by the spoken word we bring to life the deeds and exploits of kings for younger generations. I derive my knowledge from my father Djeli Kedian, who also got it from his father; history holds no mystery for us [...] I teach kings the history of their ancestors so that the lives of the ancients might serve them as an example, for the world is old, but the future springs from the past. My word is pure and free from all untruth; it is the word of my father; it is the word of my father's father.[24]

In the above passage, Djeli Kouyaté situates his role as transhistorical—an understanding of time as living and generative. Time for Kouyaté is not a passive marker or description—it is of vital necessity to his people.

In *Hieroglyphic Grafitti*, Boseman remixes the Isis, Osiris, and Horus story of ancient Kemet. In Boseman's version, Horus is a young artist whose medium is aerosol art. He describes what drives him:

> If you had something important that you wanted to say and you just wanted the world to know you're here, you just wanted to wake people up, break the monotony of their everyday lives, what's better than signin' a wall … especially when you're the first one to tap that wall open, make it speak. People are going about their everyday lives, ridin' the train, ridin' to work, walkin' to school and it's like, "Who had the audacity to hit this? When did they hit this? How did they hit it?" It's the mystery behind it that gets you. And you have no choice but to read it cause it's all in your face.[25]

Emcees document alternative histories to the mainstream media and history books.

(Baba Israel[26])

Here, Horus is a modern-day visual *griot*. As in Baba Israel's quotation, he is "documenting history" as he sees it, telling the stories of his generation, asking people to learn his version of history. The wall is his stage.

Hip Hop, as an Afrocentric art form and culture, has inherited the understanding of the metaphysical power of both the word and the "sign." In his play, by remixing and re-versioning the ancient myth of Isis and Osiris, Boseman demonstrates that Hip Hop not only celebrates but also continues to learn from its African and Indigenous roots. Taking the emcee as a contemporary *djeli* and the actor in Hip Hop Theatre as an extension of the emcee, HHTI asks what is the *role* and *responsibility* of Hip Hop Theatre to its audience?

Overall, the oral artist is to a large extent the prime organizer of the cultural universe of the society in which he functions.

(Samuel Osei Boadu[27])

The intent of offering the simultaneous "Ritual Theatre" course with the creation of *Re/Rites* was that the focus on this topic would influence the students in creating a new performance work whose purpose was to serve as ritual for its various audiences. The course succeeded in this regard, in that the students were able to experiment with various aesthetic aspects of ritual

theatre, including: non-linearity, attention to place, integration of sound and body with text, intergenerational and ancestral relationships, connecting their passion and emotion to something beyond the psychological, and using their "airtime" as performance makers to communicate something that had cultural significance to them and their peers as young, current generation Hip Hop heads. They became the *griots* of their immediate communities.

> It is understood that the artist is a conduit and therefore not responsible for the greatness of the work. This does not mean that the artist is irresponsible, in fact, the responsibility is awesome … The artist is considered "chosen" and the rejection of this role is often considered sacrilegious.
>
> (Kariamu Welsh Asante[28])

Mix-tape #2: beyond the classroom

After performing *Re/Rites* to sold-out houses for two weeks, HHTI was invited to bring the piece to the Pittsburgh Project, a not-for-profit organization that works with historically underserved and marginalized populations.[29] We were asked to perform for their youth and give a workshop afterward. I was unable to travel with the student performer-facilitators because of another work commitment; but, prior to their residency, we planned how to lead an HHTI workshop with youth and we also stayed in communication during the workshop about how to address certain challenges that they encountered. This experience impassioned the HHTI participants, many of whom had previously worked with youth in other contexts, and they asked for more training to be able to lead Hip Hop Theatre workshops. Similarly, the students wanted to learn how to facilitate the post-show dialogues about the work and the political and aesthetic intersections of Hip Hop Theatre. Undergraduate Drama already had a Minor in Applied Theatre (on whose committee I served), so this experience provided an organic way to expand HHTI's pedagogy beyond professional acting training. Becoming an engaged community leader, both through facilitating arts workshops and dialogue, spoke to the HHTI participants' desires to make a difference in the world using their art and provided opportunities beyond commercial performance to support themselves doing what they loved. I understood that both of these pillars needed to be part of HHTI. And this expanded mission was the natural extension of the idea of training contemporary *djelis* or *griots*. These two areas of skill-building formally entered the HHTI curriculum in concert with the existing performance training and making.

The following year (2006) Awam Amkpa, NYU professor and academic director of the NYU-in-Ghana program, invited HHTI to spend a semester in Ghana. I taught two courses at University of Ghana-Legon attended by NYU students, University of Ghana Drama Department students, and

two students from other U.S. universities. We remixed the NYU curric-
ulum with one course looking at the history of both U.S. and Ghanaian
Hip Hop movements and how these had translated into theatre in both
countries. The second course introduced making Hip Hop and Hiplife
Theatre from contemporary cultural contexts and leading this work in
community-based settings.[30] This class organically grew into three service
learning projects—two in the then United Nations High Commission for
Refugees Buduburam refugee camp and one with an after-school and
weekend arts and academic program that brought together youth from dif-
ferent economic backgrounds, ranging from orphans and street youth to
the children of diplomats.[31]

Reggie Rockstone, Ghanaian Hip Hop icon and creator of the term
"Hiplife," is oft-quoted as saying, "What is African? Hip Hop is African!"[32]
Nevertheless, despite his high-profile in the capital city, Accra, most of the Uni-
versity of Ghana students from the Theatre Arts program on the first day of class
were somewhat incredulous that the HHTI students and I saw a connection
between Hip Hop and Ghana. From their perspective, Hip Hop was something
that the U.S. exported to Ghana that had altered their traditional society (and
not necessarily in a positive way).[33] This world-view was disarming for the
NYU students, as they had been dutifully exploring the African retentions in
Hip Hop. It was also a wake-up call that the Afrocentrism that they had learned
either at home, in their communities, and/or at school was a diasporic idea with
which not all of the people they met in Ghana would necessarily concur.

However, between the first and the second week, the Ghanaian students
began talking with peers from outside their discipline who were avid Hip
Hop fans and the U.S. students began to experience more of the complexities
of their own presence in Ghana. In that second class, both groups of students
were able to share more deeply their experiences with acculturation shaped
by colonialism on either side of the Atlantic and the beliefs that they had
inherited and/or held around Afrocentrism and the Diaspora. The discussion
during this week's class more organically evoked what Halifu Osumare in *The
Hiplife in Ghana: West African Indigenization of Hip-Hop* calls the "arc" of
"mutual cultural inspiration."[34] Osumare describes a musical genealogy of
"African approaches to rhythm and call-and-response performance styles rein-
vented in the diaspora and then reformulated back in the motherland."[35] Sim-
ilarly, the Ghanaian students explained to the class the roles of drums and
rhythm, the orality of the *okeame* (praise-singer/historian), and a history of
political poetry and song in Ghanaian society.

It was useful for the NYU students to observe their Ghanaian peers' thought
processes. What seemed to be a fairly standard process of post-colonial historic-
ity and genealogy for the NYU students was not the optic through which the
Ghanaian students initially encountered our conversations about Hip Hop.
Only I was old enough to remember how Hip Hop in the U.S. was treated by
national leaders in the 1990s, such as Tipper Gore and C. Delores Tucker, who

led the charge against the culture as something that was eroding "traditional values" (mostly in response to the genre of so-called "gangsta" rap).

However, once the Ghanaian students also began to think of Hip Hop in terms of an African continuum (including African heritage people in the Americas as part of that continuum), not only did their interest in Hip Hop and Hip Hop Theatre grow, but so did their excitement in connecting with their U.S.-based peers. (It bears mentioning that two of the NYU students in these classes were second-generation Nigerian American. It is possible that having them in the class helped materialize the notion of diaspora and diasporic performance.)

Osumare describes the mobius-like relationship of U.S. Hip Hop to African and African diasporic aesthetics and cultural traditions:

> If hip-hop performance patterns are African in nature, did the culture originate in the South Bronx or on the continent? Many African hip-hopers argue for hip-hop as a received U.S. aesthetic, the source of which was *already* present traditionally among the West African Ashanti, Ewe, and Dagomba in Ghana; the Wolof in Senegal and the Yoruba in Nigeria or the Central African Bakongo, Bakuba, or Bateke.[36]

Osumare uses Tope Omoniyi's term, "the Boomerang hypothesis," and describes "rap as 'a long-standing African oral tradition that was only transplanted to North America through the middle passage.'" She explains, "According to *this* argument, hip hop aesthetics has only 'boomeranged' back to the African continent from its diaspora."[37] Finally, Osumare cites two Ghanaian Hip Hop artists on their understanding of their role in this cultural production: "Lord Kenya's perception of his hiplife music ... that it is 'not something I borrowed ... [but] ... something indigenous,'" which "resonates with Daara J's similar sentiments: '...but this music is ours. It is a part of our culture.'"[38] My students were not the only ones puzzling over the cyclical and simultaneous telescopic relationship of Hip Hop to the African continent.

Immediately following the semester in Ghana, I spent six weeks in South Africa directing a workshop of Zakiyyah Alexander's Hip Hop play *Blurring Shine* at the Market Theatre Lab in Johannesburg, organizing a Hip Hop Theatre Lab at the Market for local actors, poets, rappers, dancers, and critics, and facilitating workshops in Johannesburg and Cape Town and surrounding townships. The actors and artists with whom I worked at the Market and in Cape Town through Artscape[39] already held this belief about the circularity of influences. Significantly, there is a long history of political Hip Hop in South Africa—the Universal Zulu Nation opened a chapter in Cape Flats in the late 1980s/early 1990s.[40] When I began rehearsing *Blurring Shine*, the cast and crew's starting point was of Hip Hop as an activist culture with its roots in African aesthetics and philosophy. And while some of the youth at the Sibikwa Community Theatre in the East Rand, where I invited members of the Market Hip Hop Theatre Lab to co-facilitate a

three-day workshop with me, did not immediately identify themselves as "Hip Hop" because of the commercial music genre associated with the same name, as soon as we began discussing cultural and political values, they realized the broader implications of the culture.[41] As was happening in Ghana, at least in terms of the music, South Africa took the U.S.'s Hip Hop modes of production and "indigenized" them, creating multiple forms of music and dance.

> The man who beats the drum doesn't know how far the sound goes.
>
> (Akan proverb)

When we returned to NYU after the semester in Ghana and the project in South Africa, I recognized that HHTI work needed to happen in a more intensive environment if we were going to focus on performance and leadership training in equal measure. So rather than teach separate classes, I offered students the opportunity to dedicate all their elective time in one semester to a double class-load that would meet twice each week for an extended class period. We called this the "Hip Hop Theatre Lab," modeled after the experience at the Market Theatre, and what had previously been spread over two semesters now became one intensive program, forming a kind of unofficial "mini-studio" within the Undergraduate Drama studio-based curriculum. The original goal of moving Hip Hop Theatre to the center of training was becoming a reality.

HHTI Core Faculty (at NYU): Toni Blackman, DJ Center, Jerry Gant, Rha Goddess, Baba Israel, Marc Bamuthi Joseph, Kwikstep and Rokafella, Yuri Lane, and Will Power.

Special guests: Claudia Alick, Piper Anderson, Chadwick Boseman, Sharon Bridgforth, Ayodele Casel, Henry Chalfant, Kristoffer Diaz, Martha Diaz, DJ Reborn, Kamilah Forbes, reg e gaines, Marcella Runnell Hall, Rennie Harris, Rickerby Hinds, Danny Hoch, Angela Kariotis, Mildred Ruiz, Steve Sapp, Baraka Sele, Ben Snyder, Nilaja Sun, and Clyde Valentin.

This group became the second HHTI cohort. The following year I offered a course specifically in classroom methodology, "Actor-Teacher Practicum: Hip Hop Theatre in and out of the Classroom." I was also in the process of creating a Hip Hop Theatre criticism course when a new chair arrived and academic priorities shifted. As a result, I left NYU to focus on DNA-WORKS, the arts and service organization I co-founded and currently

co-direct with dancer, educator, and activist Adam McKinney, and HHTI became one of our programs. Since that time, HHTI has continued to work around the world, in such locations as Azerbaijan, Hungary, Israel, Italy, Palestine, and Serbia, as well as in New Mexico, where we work with educators and leaders to reach underserved youth through an ensemble process that reframes pedagogy and community leadership.

Mix-tape #3: pedagogy

HHTI has led workshops that span a few hours or several weeks. These workshops have been in the context of: a professional theatre training program, such as at California Institute of the Arts, the Market Theatre Lab in South Africa, and the La MaMa International Directors Symposium in Spoletto, Italy; community-based organizations, such as the Guga S'thebe community center in Langa township outside Cape Town, South Africa, and through the New Mexico Community Foundation in Santa Fe and Española; work with teens and younger youth, such as at the Roma and Friends Camp in Balatonlelle, Hungary, and the American Corner with Arab Israeli youth in Acco, Israel; and at professional and student organizational meetings, such as the Black Theatre Network conference, the Southeastern Theatre Conference, and the Kennedy Center American College Theater Festival (KCACTF). HHTI workshops have also been community-generating events at universities with students, faculty, staff, and local artists and leaders all in the room, such as at West Virginia State University and Rhodes College.

The workshops can play out in multiple ways depending on whether the focus is devised theatre or moving more towards self-expression and community building. In the former, we work in short form compositions; in the latter the workshop usually results in the creation of one or more sung "hooks" (refrains) that can be introduced to build community and as a connector for other forms of self-expression, such as poetry/rap or storytelling. Examples of these include "Liberian brother, Liberian sister, let's come together and form a better future" (Buduburam refugee camp, Ghana, 2006) and "Peace, strength, determination and love" (Roma and Friends camp, Hungary, 2011).

We always attempt to lift up youth leadership by working with one or more assistants, either alumni of our programs or local participants with a Hip Hop performance and/or community leadership background. The intent is to decentralize my role as leader. Our hope is that this person will step into more active leadership in their community, inspired and emboldened by the workshop experience. This almost always happens.

In one version of the workshop, "We the *Griot*," we pose the questions: "What would your intentions, words, and actions look like if you accepted that you were the carrier of *your* culture? How would you interact differently with your community? What power would your speech hold?" The playwright

Suzan-Lori Parks writes, "Words are spells in our mouths."[42] Traditionally, *griots* know this power, own it, and harness it to ensure the survival of their people and communities. We ask participants to consider how their lives and the lives of the people around them might be different if they understood they had this power and chose to activate it.

I have notated below some of the exercises HHTI uses so the reader can follow the devised theatre progression. There are multiple variations or versions of an exercise, depending on length of time and the "feel" of the room. As facilitator, my workshop notes will generally look similar—an overall progression with many possible directions. It is crucial to take the pulse of the room and sculpt the workshop to the actual participants. When time is limited, I offer participants several options to see what direction they would prefer to move in—for example, more writing, or singing, or discussion about direct application of the work in their communities.

A note about HHTI philosophy: we eschew notions of "helping" or "empowering." We do not subscribe to the theory that HHTI or our work "gives" people power or voice—based on the experience of seeing how people respond to the work, it is clear that all people have innate power and potential to share their own stories. However, in many cases, that power and "voice" have been so suppressed, ignored, and/or made invisible that some people in these situations experience a hopelessness that impedes self-efficacy. Therefore, these workshops are designed to "clear a space" for people to rediscover or strengthen their connections to their own unique purposes and power. I have also discovered that people in situations of severe physical and psychological oppression often need a model of what such a radical shift in role looks and feels like. As with Augusto Boal's "rehearsal for the revolution," an arts workshop can offer a productive environment in which participants reconnect with their own senses of self and creativity.[43] Engaging a group in workshop planning for their own community can often be the first step in this process.

The workshop is often framed in some way around Hip Hop aesthetics. As described above, this system of aesthetics is an outgrowth of certain key African diasporic and Indigenous thought systems. Therefore, at some point, we discuss sampling, remixing/versioning, and other DJ techniques, all of which involve fissures and sutures of time. In a sufficiently long workshop, we consciously weave these aesthetics into the performance compositions.

Sample HHTI workshop

The workshop has three primary phases:

 I Warmup
 II Skill-building
 III Composition and group critique

I Warmup

Arriving. The first step is for all of us to get into the same "time zone," notice who is in our cipher, and *breathe together*. Sometimes this is quite literally done by "gazing" at one another in silence, studying the faces of everyone in the circle. Other exercises include:

- **Shout-out**: Who is in the cipher? Students? Teachers? Staff? Actors? Visual artists? Parents? Community members? The shout-out is a Hip Hop ritual, most familiar to concert-goers and community organizers. This approach ensures that everyone is heard and everyone's identity is accounted for from the beginning.
- **"What is Hip Hop to you?"**: Another exercise to engage community knowledge. This can be done through a shout-out "popcorn" style, passing the metaphorical mic around the cipher, or through a "Wall Write."

> For a Wall Write, there are large swaths of paper already on the wall when participants enter with a prompt posted at the top. Participants are asked to take a marker and write, draw, doodle, tag, or otherwise represent themselves on the wall-paper. This is done in silence and then they read one another's writings when they have finished their own. They can move around the paper and respond in writing to what others have written. People organize themselves at the wall physically, organically. The room usually settles into a kind of calm space with people working well together.
>
> When the time is up, we discuss what we notice about what the workshop community has written.

- **Name game**: There are many variations to this exercise. The one we use most often involves a participant saying their name, a quality they bring to the room when at their best (such as "fun" or "passion"), and a gesture that represents that quality. The group then repeats the name, quality, and gesture. Person #2 says theirs; the group repeats P2's, then says P1's again, and so on, repeating all the names/qualities/gestures backwards around the circle after each new one is added.
 - When everyone has finished, we add on different variations, depending on the energy/time:
 - Reverse the order of the circle and do the whole circle in the other direction.
 - Have everyone physically change places in the circle, choose a new starting point, and go around the circle naming/gesturing in this new order.

♦ Go back to original positions and do the gestures three times in
silence, increasingly connecting the gestures so that they all
become one dance. We call this "Name Dance." The idea is for
people to find the transitions between the individual gestures so
that they become woven into one fluid movement. (This exer-
cise was introduced by Adam McKinney.)

*Pedagogical suggestion: I encourage facilitators to create their own variations based
on these elements and what seems to be working. At this point in the workshop, it is
more effective to find something that is working and build on that than to look for
something that is not working and "rehearse" the group on this "deficit." Again, we
use a resource-based approach to community building, noticing what strengths the com-
munity already begins to display (I avoid the term "assets," although that is also used
to describe this approach). Using this strength or resource-based approach situates the
facilitator from the beginning as someone holding a space for the community's success,
not "training" or "developing" the community, all words with hierarchical and colonial
undertones.*

• **Ask the participants** to suggest and lead theatre games, songs, chil-
dren's rhymes, word and rhythm exercises, call-and-responses, raps, and
tongue-twisters. One excellent example is "Shabooya, Roll Call," a
rhythmic, rhyming game that is useful in discussing African diasporic aes-
thetics. It includes call-and-response between an individual and chorus,
self-naming, syncopation, and rhyming. The process creates a community
narrative, again focusing on community resources/strengths/likes (exam-
ples of this song can be found on YouTube[44]).

*For groups where rhyming is not a practiced skill, participants can free-associate in
rhythm, make a sound instead of speaking, or do a gesture or dance phrase. For
example, in Hungary we asked the youth to repeat, "I like...," "I like..." If
someone freezes, it is OK—the group just needs to keep the rhythm no matter what
is happening. By keeping a steady rhythm, each person will find a way to contribute.*

• **Physical/vocal warmup**: This can be something simple like head
circles, neck and face self-massage, and/or a gentle roll down the spine to
articulate each vertebra. (Please note—physical exercises should only be
led by people with a background in physical work who understand safety
for a group of people with physically varied needs and experiences.) In a
multi-day workshop, once participants are acquainted and we have a
sense of people's energies and levels of experience, we invite workshop
members who have specific knowledge or experience (such as yoga,
Feldenkrais, Gyrotonic, theatre movement) to lead a few *gentle* exercises,
reminding them to keep it simple and accessible to people of all abilities.

• **Intro to HH culture and HHTI approach**: I find that showing slides
of the burnt-out buildings and lots in the South and West Bronx in the
1970s immediately and viscerally sets the stage for the conversation of the
origins of Hip Hop as resistant culture.

- **Spatial exercises in preparation for composition work**: some of our favorites include "Grandmother's Footsteps," "Enemy/Defender," "Triangles" (choosing secret partners and creating an equilateral triangle between you and your two secret partners, while everyone else is trying to do it!);[45] Jacques LeCoq's plateau balancing chorus exercise; and "Flocking" exercises. Explanations of many of these exercises can be found on the web.
- **"Sample cipher"**: in a circle, participants are asked to share a hook from a song that communicates something close to their hearts. If the group does not know the hook, the sharer teaches it. We sing each hook together a few times. The sharer "passes the mic" to someone else in the cipher.

II Skill-building

In thinking about creating compositions with participants of all levels and experience (in terms of performance and/or Hip Hop), we offer people at least an introduction to the skills that make up a Hip Hop aesthetic. The somatic power of many of Hip Hop's elements communicate something about the origins and longevity of the culture. For a shorter workshop, basic skills that can be easily introduced include Human Beatboxing, Rhyming, and the beginning of a Hip Hop dance movement vocabulary. Whenever possible we ask a community artist or workshop participant to lead this session.

In a longer workshop or semester course, it is possible to go into greater depth with skills such as DJ'ing (in all the HHTI courses, students spent a good amount of time behind the turntables) and "Writing" (a.k.a., using aerosol art as a jumping-off point to think about what can be accomplished visually/graphically in performance; asking, for example, what the significance is of a "tag" vs. a mural and how that difference might influence performance aesthetics and composition).

Several key faculty in HHTI helped introduce these elements. In terms of skill-building, our core faculty included Baba Israel and Yuri Lane for Beatboxing; Kwikstep and Rokafella and Marc Bamuthi Joseph for dance/movement; and Toni Blackman and Rha Goddess for lyricism.

III Composition and group critique—fragments and collisions

Hip Hop aesthetics

To demonstrate some of the fundamental aesthetics in Hip Hop creative production, I introduce principles from DJ'ing, notably: samples; remixing or versioning; break-beats; scratching and other time manipulation; and song as history lesson. Some notable examples include: samples of Ofra Haza in Eric B and Rakim's "Paid in Full," as well as Rebel Diaz sampling the SNCC Freedom Singers' versioning of the Appalachian work protest song "Which Side Are You On" in a song of the same title. The Fugees's "Killing Me

Softly" is a familiar and popular remix. The Incredible Bongo Band is always good for extended break-beats. And the numerous versions of songs titled "Where I'm From" from around the world indicate the political stance of Hip Hop music as a declaration of being and belonging.

I use the process of generating fragments and "colliding" them, i.e., at first randomly juxtaposing or overlapping them as we experiment with order and form. Eventually the collisions become more and more considered; but at first I ask the performers to take leaps of faith with material to encourage poetic abstraction and non-linearity. This process creates a space for participants to listen to instinct and connect with the work on an intuitive/spiritual level, being guided by other forms of cognition.

In the editing phase, the collision "clusters" are ordered, which invokes a conversation about multiple notions of structure—proposing that linearity, often associated with Eurocentrism, is not the only valid structure. An Indigenous thought system that understands existence as cyclical and multidimensional will have a different relationship to time/space than will what is often taught as the so-called "hero's" journey. This "fragments and collisions" approach speaks to the world-view of the Hip Hop generations who have grown up on fast-moving, non-linear media that is saturated by samples, back-spins, remixes, and extended break-beats; it also challenges the audience to assume an active role in meaning-making—the imagery and juxtapositions engage the viewer in a metaphysical call-and-response as they are similarly invited to connect to the work on an intuitive/spiritual level.

Generating material from improvisation

- In a longer workshop, after an introduction to beatboxing, we work on a sound and movement composition. We begin by discussing the Elements of Composition:

 - I ask the group what they think makes for a "dynamic composition" and scribe on a flipchart or white board. If they are not all theatre artists, I will ask them to respond from the perspective of any genre.
 - After getting the group's response, I emphasize the elements that make for a dynamic performance composition that we will be primarily working with: Time; Use of Space, i.e., staging (horizontal) and levels (vertical); Sound/silence; and Tension/surprise. There can be more—again, depending on the group and their interests/experience/cultural approach we may include others.
 - Sound and Movement Composition—the participants have a limited amount of time (usually about fifteen minutes) to create a *dynamic*

composition using only sound and movement. They do not need to think about story, but are encouraged to determine a theme or emotion. It is helpful if they consider Hip Hop aesthetics. If they are mostly sitting and talking in the first five minutes of composition time, I ask the devisers to dare to get on their feet and start taking risks. After the time is up, we return to a cipher. I ask each group where they want the audience to be. People generally show their work group by group from where they are in the cipher, as often in the first composition they have not yet considered this; but it plants the seed to consider this performer–audience physical relationship for a later composition.

- **Processing**: Depending on how large the workshop is, we either process the compositions after each showing or at the end. I ask the group "What did you see?" (If they fall into the habit of saying "I liked" or "I didn't like," I bring them back to "I saw..." For certain groups, however, it can be useful to stretch people's ability to listen to dissenting views and "I liked/didn't like" can be added later.)

Part One (remixing Will Power's exercise)- Sounds of the Neighborhood:

- Walk around. Explore the room. Notice places in the room you have not noticed before. Notice how you are walking. How is your body moving? Are you "holding" yourself anywhere? What characteristics or character does your body already carry?
- Choose a sound from your "neighborhood," wherever that may be, current or past, or imagined in the future (see the following text box).
- Begin to reproduce that sound vocally.
- Add your body to the sound. Find the physicality of that sound.
- Allow that physicality to grow into a character. How does the character move? How does the character interact with objects in the room? What speed does the character move? Can the character move at other speeds?
- Begin to notice the other beings in the room. Start small—how do you interact with other beings? First, sense the other beings, then sight, then sound. Would your character greet another being? If so, how?

The HHTI methodology is to foreground "choice" in this exercise as different groups will have different relationships to the notion of neighborhood or home. Especially in groups that have experienced severe or sustained trauma, it is important that the participants choose what material they want to work on. The goal of this workshop is not clinical, although it is HHTI's belief that expressing oneself and having the opportunity to be creative can have positive therapeutic benefits. I am always aware of this dynamic and also conscientious to keep the work that we do closer to

questions of sociology and ontology. Clearly the participants bring their own needs and desires with them; but we work carefully to guide the exercises in the direction of self-expression and leadership.

Even in situations when a participant chooses to bring an emotionally charged incident or story into the space, the opportunity to share it and then bring it to the cipher has served as a powerful jumping-off point for the group's coalescing as an ensemble. Also, in this work, we choose not to reenact violence or traumatic material. We find this to be potentially retraumatizing for the performers as well as audiences. Whereas certain therapeutic styles of work have developed methodologies for this type of performance work, for our process, we find that by investing in the theatricality and metaphor of live performance, there is always an alternative, a more abstracted method of multi-dimensional storytelling that keeps with our goals and values.

Part Two (Daniel Banks, borrowing from and remixing Monica Pagneux):

- ○ Continuing to move and, making the sounds of your character, come into a cipher (circle).
- ○ Keep the sounds going at a low level, perhaps cycling them so there is auditory space (i.e., making your repetitions less frequent).
- ○ One person enters the center of the circle, moving and sounding their character.
- ○ Through eye contact, that person invites someone else into the center.
- ○ The two begin to dialogue, using their sounds. The chorus holds the ostinato of the collective soundscape quietly and consistently to support the "scene" in the middle. *Facilitator may need to side-coach if the chorus gets too loud or soft.*
- ○ Let the "scene" play itself out. Encourage the actors in the middle of the circle to have a specific scenario in mind—they may be using abstract sounds, but they are communicating clear thoughts with each other. *Facilitator may need to side-coach so that the actors in the middle take turns making sound. Sometimes, with abstract sounds, less experienced performers will just sound on top of each other.*
- ○ The first person in the circle exits when they feel the scene is over. The person remaining invites someone new in. In other words, A invites B. When A exits, B invites C, and so on. The new dialogue using sound begins. This process of *exit and invitation* continues until everyone has been in the circle once.
- ○ When the final person exits the cipher, the facilitator, who has been part of the cipher too (at least in terms of being in the circle and making a sound) becomes conductor. Facilitator raises the sounds gradually to very loud (without people hurting themselves vocally), then starts to

lower it gradually until it is just a whisper … and then no sound. Facilitator quietly asks the participants in the cipher to continue to feel the sound and movement in their stillness. This stillness is held for a minute or two and then the facilitator thanks them, and the cipher is complete.

o We generally process the exercise here before taking a short break and coming back to Part 3 of "Sounds of the Neighborhood" (if, in fact, we go on to that section—I often use the break to gauge in which direction the workshop will continue).

(Sound and movement composition may alternatively be done at this point.)

Part Three (Will Power):

o Divide the group in two. Have one-half of the group stand along one wall (or diagonal if the space is not very long) and the other sit as audience against the opposite wall (or diagonal).

o Ask for a volunteer to go first. Ask this actor to start moving like their character across the room and stop in the middle of the room. They will then say (from the perspective of the character and fill in the blank) "My name is_____. I am coming from_____. I am going to_____" and continue moving "downstage" towards the audience until they reach them. Then they let their character go and join the audience.

A few facilitation hints that may be helpful:

◆ *It is sometimes useful to encourage the participants to think abstractly.*

◆ *If they drop the character as soon as they speak, encourage them to speak in character, somehow integrating the character's sound into the character's voice.*

◆ *If they drop the character when they have finished speaking, encourage them to complete the physical trajectory in character.*

o We sometimes process after the first group so that the second group can learn something about the exercise before they try it.

Generating Material from Writing:

o After "Sounds of the Neighborhood," I determine whether to keep going along that theme or move towards a more direct exploration of what is happening in the participants' lives. If the former, everyone gets in a circle with a journal and begins to write:

Option A (riffing on Will Power):
o Four lines based on their characters.
o In the four lines, they need to include (in the first person, as the character):

◆ description of time of day;

- description of place (using multiple senses);
- description of their character;
- something the character has accomplished, wants to accomplish, or failed to accomplish.

 o We go around and share the writing. Often people will have left out one of these elements. If there is time, they go back to writing and complete/edit their four lines and share again if they have something new.

Option B:

 o We move into a Sharing Circle. Standing in the cipher, participants answer a prompt as much as they feel comfortable. They can pass when it is their turn and we come back around to them. Possible prompts:

 - What's most "up" or present for you in your life? What keeps you up at night? What are you thinking about when you get up in the morning? *(I will generally go first or ask an HHTI member to go first to set a courageous tone. As described above, choice is key here. No one is forced to share anything they do not want to. This is material for self-scripting, not self-processing, although clearly there may be some overlap between the two.)* Another possible prompt is, "What is your greatest joy/greatest challenge so far in your life (or right now in your life)?"
 - Sometimes a recurrent theme will have already emerged in the workshop at this point, often something around community well-being, or a recent event in the community. If it seems appropriate and it is a direction that all participants want to explore, we work with that (for example, in the refugee camp in Ghana, the themes education and discrimination emerged). Or I will leave the prompt open-ended so that they can address whatever topic they like.

 o After everyone has shared, there is time for individual free-writing based on what was shared. Make it clear that *this writing is private* and they will not need to share this writing with anyone else, although they will be continuing to work with it. I generally give 10–15 minutes for this, depending on how engaged participants are in the exercise.
 o Participants are then asked to construct a four-line poem or passage from their free-write that they feel comfortable sharing in the circle.
 o They share their four lines.

Collisions, Compositions, and Critique:

- Participants form their own small groups (three or five people) based on affinity with what was previously read and/or shared. *I rarely find that it is too "sticky" to do this or that someone is left out. I will sometimes match-make if the thematic affinity is not immediately clear or suggest matches if there are some outliers in the group in terms of subject matter or style. I primarily look to match people who will collaborate well together.*

- They now have small group time to create mini-compositions as an ensemble. Once again, they are asked to identify and explore a theme. Each person in the group takes a role; for example, in a three-person group, one person each is responsible for paying attention to:
 - ◦ words;
 - ◦ sound;
 - ◦ movement/space.

 In a five-person group, time and tension—or Hip Hop aesthetics—can be added. This individual is not directing; they are just keeping that plate spinning, making sure the group is thinking about this dynamic—for example, asking everyone to share a meaningful song/melody, or a favorite dance move.
- The groups have 20 minutes to complete this composition. Anything from the workshop is fair game. I encourage them to start by colliding fragments just to see what happens. I let them know it is a work-in-progress and ask them to take big risks. I remind them that abstraction is worth exploring. Again, I keep an eye on how much seated discussion is happening, encouraging the actors to "dive in." Once their time is up, I invite them back to show the work-in-progress, again first asking where in the room they want their audience. This is important so that the performers begin to conceptualize their relationship with the audience and consider the audience experience in viewing their work. This time it is usually somewhere specific in the room with a specific audience configuration.
- The group feedback process is much the same. First I ask the performers, "What was the theme you were exploring?" and then the viewers: "What did you see?" The idea is to give critique about how well the group's goals were realized—not to create an open court for re-directing the piece.[46]
- In an ideal workshop, there is time to go back and edit based on the feedback: Was the theme clear? Did they succeed in addressing the three or five elements of composition on which they focused (for example, spatial levels are not always addressed; often sound is hinted at, but could be more fully developed)? After hearing the collective feedback, I will summarize and narrow their revision task and give them 10–15 minutes to work. They then come back and show again. Groups can accomplish quite a bit in a short revision time when they collaborate well.

> In communities negotiating a particular conflict or sociological issue, these short compositions are often later performed at community gatherings and functions, and successfully stimulate community dialogue.

Wrap-up:

- After the second showing, we generally do a final check-in on the composition process and the workshop as a whole. Some closing activities include:

 - an appreciation circle;
 - going around the circle asking, "What is one thing you are taking away from the workshop?";
 - a final sound and movement/dance cipher;
 - a conversation about leadership and how individuals may or may not use this work going forward in their communities;
 - an *ashé* circle (brought by HHTI member Archie Ekong). The invoking of *ashé*, a Yoruba word that will be familiar to many readers, signifies the sealing of a speech act—the utterance of *ashé* makes something so in the Nommo-verse, reminding each of us of the power of our speech. It is an aligning of our spirits and our thoughts around the power of art and community to unite and to heal.

> In an *ashé* circle, participants turn their right shoulders into the circle and reach their right hands to the center, touching finger tips, and curving the hands with the finger tips pointing back towards themselves, so the middle of the circle looks like a Nautilus shell. Then each person speaks individually (or all at once) something they are claiming in their lives for their art or their leadership and we all say "ASHÉ" and reach our hands up until the fingertips separate.

In a devised theatre process or a semester-long course, I break up the devising into three sections: one-third of the time is spent community-building, skill-building, and generating fragments; one-third is spent colliding fragments, not trying to make particular sense of the collisions until after we see what they produce; and the final third is spent editing and refining.

Other possible workshop activities include:

- Asking participants to read scenes from HHT plays (the choral prologues to *Deep/Azure* by Chadwick Boseman and *Goddess City* by Abiola Abrams and Antoy Grant are particularly valuable in discussing Hip Hop Theatre aesthetics).[47]
- Showing video clips of HHT productions (most often I show selections from Will Power's *Flow*; a clip from Aya de Leon's *Thieves in the Temple: The Reclaiming of Hip Hop*; and a clip from *Re/Rites*. Also useful are Yuri Lane's *From Tel Aviv to Ramallah*, Rennie Harris/Puremovement's *Rome and Jewels*; and Universes's *Slanguage*.[48])

- A discussion of Hip Hop pedagogy and how creating a space reflective of Hip Hop's ethos alters the learning environment.[49]

As described above, the goal is that participants/students take leadership and ultimately lead the workshops themselves. This is how we worked in the Buduburam refugee camp in Ghana, as well as at Sibikwa Community Theatre (as mentioned above), and with other youth collaborators.

And the beat goes on and on (as does the cipher)

The first documented use of the term Hip Hop Theatre is in the U.K. in the early 1990s; and it appeared in print in the U.S. in 1999.[50] But folks were making Hip Hop Theatre before that and still are. Practitioners in the field wrestle with the question, "Is all Hip Hop Theatre being called Hip Hop Theatre?" As a form of community expression that some of us have attempted to define through such organizations as the Hip Hop Theatre Festival (founded in 2000) and the Hip Hop Theatre Initiative, there are nevertheless artists across the country—and the world—doing their thing and making work that speaks to the current youth generation. Many of the originators of the form are now older and in positions of leadership within the performing arts industries, bringing their sensibilities to mainstream stages and institutions, with film, television, and Broadway appearances or academic positions, and producing credits. Many practitioners work in both commercial/academic and activist/community settings.

Nevertheless, Hip Hop Theatre as a youth voice and resistant form is still strong on the grassroots level and generates energy and activism. For example, in 2013–14 educators and community leaders in northern New Mexico, where I then lived, gathered for a series of workshops and brainstorming sessions over six months on how to bring this approach into their work. Also at the 2014 KCACTF in Boise, ID, a group of students from California took part in a HHTI workshop that I led. Soon after the festival they began writing a Hip Hop Theatre piece, within a year had performed it at their school, and in 2016 returned to KCACTF with the full production. HHTI receives weekly hits from people on our "Global Cipher" Facebook page looking for a community with which to connect. And, similarly in the related area of Hip Hop Education and Pedagogy, the Hip Hop Education Center wrapped a three-year project of public think-tanks in 2013 that attracted over 500 artist/educator/activists from around the world to discuss how to include the creative, performative elements of Hip Hop in classrooms striving to maximize student success.

As long as young people have something they want to tell the world—like the middle school and junior high school Roma youth and non-Roma allies in Hungary who sang, "Wake, wake, wake up the world/Peace, peace, peace for the world/Wake, wake, wake up the world/And save the world"—Hip Hop

Theatre will remain the voice of the current generations. These are the generations that still connect to the mystical power of the word and the vision for a future with less oppression of people, animals, and the environment—in other words, respect for the planet, itself, and all its inhabitants. For these young people, the cipher remains a source of political and ritual/spiritual power and belonging. In the words of a group of women completing a short composition in the Sibikwa workshop, "I've got the mic in my hands. I am the mic."

My recommendations? Keep passing the mic to young people. Overall, those of us in educational and community leadership could do a better job of trusting them and of being allies to them. They are already changing the world at younger and younger ages than ever imagined. Hip Hop and Hip Hop Theatre have proven themselves as legitimate disciplines through artistic production and scholarship, not to mention commercial success. The plays by Abiola Abrams and Antoy Grant, Zakiyyah Alexander, Chadwick Boseman, Eisa Davis, Aya de Leon, Yuri Lane, Kristoffer Diaz, Rha Goddess, Idris Goodwin, Rickerby Hinds, Danny Hoch, Will Power, Ben Snyder, Universes, and so many more could fill syllabi for many years in understanding history, cultural production, the "arc of mutual cultural inspiration," and the revolutionary power in this epic, global cultural movement. Hip Hop has pushed technology, reframed entrepreneurialism, demanded conversations about cultural exploitation, and created pedagogical innovations that reach back to ancient Indigenous African rituals, the philosophical writings of Gramsci and Freire, and far ahead into the future. Hip Hop quite simply cannot be ignored for educational and cultural institutions to stay relevant. Stand in a cipher, and you will understand what I mean.

Notes

1 Jeff Chang, ed., *Total Chaos: The Art and Aesthetics of Hip Hop* (New York: Basic Civitas, 2006), 10.
2 These courses included: "Topics in Performance Studies: Hip Hop Theatre Routes and Branches"; "Devised Theatre Practicum: Hip Hop and Spoken Word Theatre"; "Theatrical Genres: Ritual Theatre"; "Actor Teacher Practicum: Hip Hop Theatre in and out of the Classroom"; "Hip Hop Theatre and Hip Life Theatre"; "Hip Hop Theatre, Hip Life Theatre, and Community Action"; "Hip Hop Theater Lab"; and "Hip Hop Theatre Criticism" (developed but not actually offered). I also co-facilitated "Sampling Hip Hop: Popular Culture as a Pedagogical Tool" with Prof. Kyra Gaunt from the Music Dept. Offered by the Faculty Resource Network, this was a week-long workshop with and for university professors and educators from around the country focusing on strategies for incorporating Hip Hop materials into college and high school curricula from various disciplines. Our focus was on the values and methodologies embodied in Hip Hop culture in order to think about alternative pedagogical models and contexts.
3 Daniel Banks, ed., *Say Word! Voices from Hip Hop Theater* (Ann Arbor, MI: University of Michigan, 2011), v.

4 For more information about this period, see Jeff Chang, *Can't Stop, Won't Stop: A History of the Hip-Hop Generation* (New York: St. Martin's, 2005).

5 Ngũgĩ wa Thiong'o, *Penpoints, Gunpoints, and Dreams: Towards a Critical Theory of the Arts and the State in Africa* (Oxford: Clarendon, 1998), 33.

6 A mix-tape is a collection of songs put together by its creator. It is essentially an individual's own DJ set. In the days of cassette tapes, it was often made by using a dual-cassette player, connecting one player to another, or simply recording low-tech without cables while something played on the radio or on another device. In the early days of Hip Hop, young entrepreneurs sold their own collections/tapes. It is a precursor to the digital playlist. It is also a way that Hip Hop heads created their own genealogies of musical influences—great care is/was taken in what is included, in what order, by which artists, and which styles are "cited."

7 In the early 1980s, Rick Rubin and Russell Simmons founded Def Jam records out of Rubin's NYU dorm room.

8 Ngũgĩ wa Thiong'o, *Moving the Center* (London: Heinemann, 1993).

9 See Daniel Banks, "The Welcome Table: Casting for an Integrated Society," *Theatre Topics* 23, no. 1 (2013): 1–18.

10 Kariamu Welsh Asante, "Commonalities in African Dance: An Aesthetic Foundation," in *African Culture: The Rhythms of Unity*, eds. Molefi Kete Asante and Kariamu Welsh Asante (Trenton, New Jersey: Africa World Press, 1990), 72.

11 Kevin Kuhlke, Chair of Undergraduate Drama at the time, gets credit not only for the title of this course, but for urging me to teach it and to continue expanding the opportunities for students to explore this work. HHTI would not exist were it not for his visionary leadership and mentorship.

12 See Kim Euell and Robert Alexander, eds., *Plays from the Boom Box Galaxy: Anthology for the Hip Hop Generation* (New York: Theatre Communications Group, 2007) and Banks, *Say Word!*.

13 A big shout-out to Dr. Amma Ghartey-Tagoe who assisted me on this course.

14 KRS-One, *Ruminations* (New York: Welcome Rain, 2003), 181.

15 A breakbeat is a rhythmic section of a song that the DJ as innovator, remixer, archivist, time manipulator, and composer extracts from that song and plays on a loop, extending the duration of that rhythmic section. The DJ is essentially creating a new composition out of an element of a previous one.

16. More and more I find myself facilitating in rooms with individuals who identify as gender queer, gender non-confirming, or on the gender spectrum. Until recently, I alternated "she" and "he," "her" and "him," "hers" and "his" in academic writing. However, this formulation only reinscribes gender binaries and marginalizes participants who do not identify with these terms. In this chapter, I use "they," "their," and "them" for both singular and plural as it is one of the more accepted ways to allow for a spectrum of identification. I ask readers to support this grammatical intervention and the attempt to create a welcoming space for all, even though for some the adoption of plural usage may at first feel awkward. Given that Hip Hop is about creating spaces for self-expression for all people, especially those who are and have been historically marginalized, it would not be commensurate with Hip Hop ethos to create a linguistically exclusionary space.

17 Paul Carter Harrison, "Form and Transformation: Immanence of the Soul in the Performance Modes of Black Church and Black Music," in *Black Theatre: Ritual Performance in the African Diaspora*, eds. Paul Carter Harrison, Victor Leo Walker, and Gus Edwards (Philadelphia: Temple University Press, 2002), 324.

18 Harrison, "Form and Transformation," 316.

19 Paul Carter Harrison, *The Drama of Nommo: Black Theater in the African Continuum* (New York: Grove, 1972), xiv.

20 Lundeana M. Thomas, "Barbara Ann Teer: From Holistic Training to Liberating Rituals," in *Black Theatre: Ritual Performance in the African Diaspora*, eds. Paul Carter Harrison, Victor Leo Walker, and Gus Edwards (Philadelphia: Temple University Press, 2002), 361.

21 More recently, Hip Hop Education and Hip Hop Theatre are often cited as tenth and eleventh elements.

22 Beverly J. Robinson, "The Sense of Self in Ritualizing New Performance Spaces for Survival," in *Black Theatre: Ritual Performance in the African Diaspora*, eds. Paul Carter Harrison, Victor Leo Walker, and Gus Edwards (Philadelphia: Temple University Press, 2002), 341–2.

23 Paul Carter Harrison, "Praise/Word," in *Black Theatre: Ritual Performance in the African Diaspora*, eds. Paul Carter Harrison, Victor Leo Walker, and Gus Edwards (Philadelphia: Temple University Press, 2002), 4–5.

24 D.T. Niane, *Sundiata: An Epic of Old Mali* (Essex, England: Pearson/Longman, 2001), 1.

25 Chadwick Boseman, *Hieroglyphic Graffiti* (Unpublished Manuscript, 2000), 14.

26 Baba Israel, *Remixing the Ritual: Hip Hop Theatre Aesthetics and Practice* (New York: Baba Israel, 2008), 20.

27 Samuel Osei Boadu, "African Oral Artistry and the New Social Order," in *African Culture: The Rhythms of Unity*, eds. Molefi Kete Asante and Kariamu Welsh Asante (Trenton, New Jersey: Africa World Press, 1990), 84.

28 K.W. Asante, "Commonalities in African Dance," 73–4.

29 Saleem Ghubril, the father of cast member Christina Ghubril, is founder of the Pittsburgh Project.

30 Hiplife is a Ghanaian form of Hip Hop, often performed in traditional languages employing traditional rhythms. See Halifu Osumare, *The Hiplife in Ghana: West African Indigenization of Hip-Hop* (New York: Palgrave, 2012) for more about the origins and aesthetics of Ghanaian Hiplife and its relationship to Hip Hop.

31 For more information about these individual projects, see Daniel Banks, "Youth Leading Youth: Hip Hop and Hiplife Theatre in Ghana and South Africa," in *Acting Together on the World Stage: Performance and the Creative Transformation of Conflict*, Vol. 2, eds. Cynthia Cohen, Roberta Gutierrez Varea, and Polly O. Walker (Oakland, CA: New Village Press, 2011), 43–72.

32 Reggie Rockstone, interview with the author (Legon, Ghana, 2006).

33 During her research that began at about the same time we left, Halifu Osumare experienced a similar response by some Ghanaian youth, who "view[ed] … hip-hop as foreign and deleterious to traditional values of discrete ethnic groups" (Osumare, *The Hiplife in Ghana*, 3).

34 Osumare, *The Hiplife in Ghana*, 3.

35 Ibid., 1.

36 Ibid., 33.

37 Ibid.

38 Ibid.

39 Artscape is one of Capetown's premiere performance venues that regularly presents and produces Hip Hop programming, including Hip Hop Theatre.

40 Emile Jansen, *My Hip Hop Is African and Proud* (Cape Town: Cape Flats Uprising, 2005) and Emile Jansen, e-mail correspondence with the author (New York, March 29, 2008).

41 See, for example, the interview with participant Leboxa Kolani: www.youtube.com/watch?v=S62bb1GlYiM.

42 Suzan-Lori Parks, *The America Play and Other Works* (New York: Theatre Communications Group, 1995), 11.

43 Augusto Boal, *Theatre of the Oppressed* (New York: Theatre Communications Group. 1985), 126.

44 To get a sense of the melody, Spike Lee's movie *Get on the Bus* has a version of "Shabooya, Roll Call" that is close to the version we use—www.youtube.com/watch?v=3iuMfmc7zAM.

45 I learned this exercise from Kevin Kuhlke at NYU.

46 I have been deeply influenced by Liz Lerman's "Critical Response Process" in developing our own protocols (http://danceexchange.org/projects/critical-response-process).

47 In Banks, *Say Word!*.

48 There are HHT video clips on YouTube and the Hemispheric Institute's web-site—http://hemisphericinstitute.org. While at NYU I created a collection of Hip Hop Theatre performances at the Bobst Library, where the above-mentioned videos are available.

49 This is also the subject of a full workshop, "Hip Hop as Pedagogy."

50 Banks, *Say Word!*, 1.

Kadogo Mojo

Global crossings in the theatre

Aku Kadogo

> Na'im Akbar proposed that the energy system of Black personality is
> rhythm. Rhythm is flow, flow is interconnecting. It is the desire/striving
> to unite the Self with the Universe, the striving for unity between the Self
> and Nature.
>
> (Kobi K.K. Kambon[1])

What does it mean to be Afrocentric? Is it a bone deep memory? Is it learned
and cultivated as life reveals itself? Is it the laying on of hands from a beloved
community that thrives inside one's heart and memory? Is it encountering
myriad peoples and cultures of the world, then sharing ideas and rituals that
sustain us all? For me Afrocentricity includes all of the above and more.

The pursuit of a life in theatre took me to places I never quite imagined.
The theatre captivated me but not in the sense of remaining confined within
four walls and a proscenium arch. Whether I was performing on a Broadway
stage, sitting beneath the Milky Way witnessing ceremonial dance in Australia
or viewing a puppet show in a busy Indonesian intersection, I have been
touched with an insatiable curiosity for those transcendent moments we
define as a theatre experience. As a maker and a spectator I want to be out-
doors, indoors; using spaces big or small, in the mainstream, alternative or
underground; collaborating with artists across the spectrum or playing my
own song. I love being in a room full of strangers having a shared experience.
In that room I want to laugh together, shed tears together, and breathe a sigh
of relief as one. This is the theatre experience I crave and endeavor to create.

I approach this essay by quilting together a range of eclectic experiences
that inform my work. I refer to the metaphor of quilting to acknowledge our
ancestors who came to these American shores and were able to create a cul-
tural tapestry so rich in spite of the adverse circumstances they endured.
Segregation and exclusion is still an issue we combat today in the academy, in
the theatre, in Hollywood and in our cities. I put seemingly disparate experi-
ences and elements together to formulate a method of directing, in which I
detail my work with actors.

I open this essay defining a seminal mid-career work that was a major turning point in what has proven to be an unwieldy yet exciting life's journey. Combining anthropology, dance, poetry, music, theatre, travel and cultural encounters I have developed my own brand of a working style: *Kadogo Mojo*. I've spent a lifetime in pursuit of the hidden treasures of my own culture, which in some instances can only be recouped from stories passed on to me as once was done in the hand-down oral traditions. I've endeavored to incorporate this found knowledge in my art practice, which at its foundation is Afrocentric but informed by extensive global travel. I've gathered customs and practices I admire from the many I have encountered along this path. Thus, I will also share some of the highlights of my artistic work and the way Afrocentrism has played a part in the development of those works.

Devising *Ochre & Dust*

The symbols are a form of visual language in which ancestral renewal of life is celebrated and its continuance ensured. The arts all express—indeed, establish—the relationship of the people to their ancestors and to their tribal lands through stories of ancestral travel across the landscape (Jennifer Isaacs).[2]

Aerial view

I'm in Anangu desert country, smack dab in the middle of Australia. Anangu means the people of the Western Desert in Pitjantjatjara (Pit-jan-jat-jara) language. The night sky offers up an astonishing light show, complete with shooting stars and meteors. No street lamps to be found; just the light of flickering campfires and the shimmer of the Milky Way. *Inma*,[3] or ceremony, is taking place on the dancing ground where the epic stories of law and culture are sung, danced, painted, and whispered. Desert paintings by Indigenous people from the center of Australia often depict water holes, food sources and other places of sustenance from an aerial point of view.

The above description could have been a diary entry of mine when I first travelled to Tjukurla, Western Australia. I was invited to a women's ceremony in 1994. It was a special honor to be an outsider welcomed into the sacred space of this women's knowledge sharing ritual. It was there that I had an epiphany. There was a woman sitting majestically in the desert sand during the ceremony. Her face was the most ancient face I had ever seen in my life. Viewing her face was like time travelling into the past and future all at once. I glimpsed the future and knew I wanted to create a theatre work in homage to that moment and these extraordinary and generous women in this powerful landscape. For two years from 1998 I travelled into the central Australian desert to spend time with and interview two Anangu senior law women, Mrs. Nellie Patterson and Mrs. Nura Ward, in their traditional

homeland. I gathered personal stories, songs and dances, hunted for bush tucker (food) as well as witnessed the harsh conditions they lived in and the life skills they practiced to survive in their day-to-day lives. Mrs. Patterson and Mrs. Ward graciously consented to participate and perform in my devised project based on my experience with them. Commissioned for the Perth and Adelaide International Arts Festivals, I titled the work *Ochre & Dust* (2000).

I met Mrs. Ward in 1984 at the National Aboriginal and Islanders Skills Development Association, now NAISDA Dance College, founded by African American dancer Carole Johnson.

NAISDA Dance College is dedicated to teaching modern and traditional Aboriginal and Torres Strait Islander dances to Indigenous students from urban and rural Australia. I was the Course Coordinator and one of the principal teachers there until 1990. As part of our ongoing traditional Indigenous pedagogy, we had Traditional Owners[4] (TOs) come from their communities to share language, dance and culture with NAISDA students. Then, once a year, our students would, travel to the tutors' remote area to experience cultural practices connected to daily life. Exposure to ritualized storytelling, a cycle of songs and dances related to sacred and non-sacred sites, handed on from generation to generation, has stimulated my imagination over the years and contributed to the knowledge base I draw upon for inspiration.

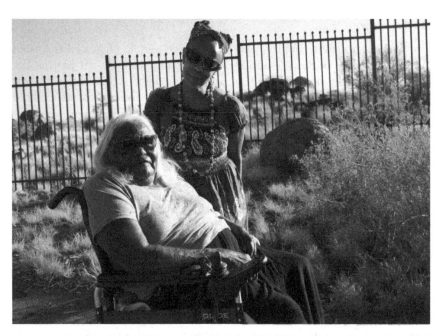

Figure 9.1 Nura Ward with Aku Kadogo, Ernabella, South Australia, 2013 (photo by Juno Gemes; *with respect to Aboriginal and Torres Strait Islander people as imagery is of a deceased person).

This system of education whereby TOs of a specific region would come to Sydney to share their songs and dances was ground breaking at the time. In return, our students went on location to see the songs and dances as they are performed in the storytelling cycle. This type of pedagogical exchange remains one of the most innovative and inclusive teaching techniques I have been exposed to and participated in. The Anangu have a saying in Pitjantjatjara: "Ngapartji Ngapartji" (*I teach you, you teach me*).

At the school, once we began choreographing we didn't have to adhere to a standardized formula of theatre making since there were not any preconceived ideas about collaborating with Indigenous people. The collaborations were exhilarating. The TOs watched carefully as we grappled to make new and meaningful dances based on their traditional style fusing it with contemporary movement. We were afforded the luxury of experimenting; making new works, new cycles, fusing dance styles and mixing traditional language with pidgin and English. Creating from what was, to define what is, we developed an exciting contemporary art form. Over the years I've had constant exposure to Indigenous people who still, in spite of merciless colonization, have a connection to the sun, moon, stars, their traditions, language and homelands.

When I set out to devise *Ochre & Dust*, I wanted to see and hear people we don't often see on Western stages. I wanted to hear the Pitjantjatjara language, which is struggling to survive, yet continues to thrive in central Australia. Included in the work were stories of survival, particularly of those who had lived through the Maralinga nuclear tests that had been conducted by the British from 1956 to 1963. Anangu had been forced from one of their homelands and scattered throughout South Australia. Then the landmark handback of Uluru (Ayers Rock) from the Australian government to the custodianship of Anangu Traditional Owners happened in 1985. Mrs. Ward and Mrs. Patterson shared stories of both these events as well as tales of cruel displacement and Anangu's unswerving resiliency. This resilience encompasses the tjukurpa[5] that is handed on from generation to generation along with an encompassing knowledge of the land.

Besides the two storytellers, I also collaborated with photographer Heidrun Lohr and Indigenous Batdjala artist Fiona Foley, whose sand installation with screens provided our story ground in *Ochre & Dust*. We created a low tech, multi-media performance. Most importantly I wanted to bring people to the stage that we do not commonly see or hear in the Western theatre setting.

Ochre & Dust was a seminal turning point for me. The women were natural, engaging storytellers. I was adamant that their language, songs and stories were not viewed as "how marvelously" they were coping with harsh, unjust circumstances. I wanted to celebrate their ability to maintain family life in spite of the constant challenge of coping with the circus of government agents coming onto their lands. Simultaneously the women still seemed to find time to fortify and maintain their cultural practices through ceremony

and the handing down of sacred knowledge. I devised a work that unfurled like the winding desert roads I spent traveling to develop it. We presented a story of cultures clashing from a perspective that gave voice to a small group of Anangu senior Law women who had something important to say.

> A person who walks through a ritual and ends up feeling charged and invigorated is a blessed recipient of healing waves of energy that no one can see but everyone can benefit from.
>
> (Malidoma Patrice Somé[6])

The ceremony in Tjukurla was my first true experience of participating in a sacred ritual practiced miles away from the built environment. I truly grasped the meaning of dance as connected to a people's belief. I made a connection with myself and lost African traditions that were emerging and coming to inform my life. This experience offered a confirmation. True, I experienced this on the Australian continent with Indigenous people of this land, but as Somé points out, "We are talking about the weaving of individual persons and gifts into a community that interacts with the forces of the natural

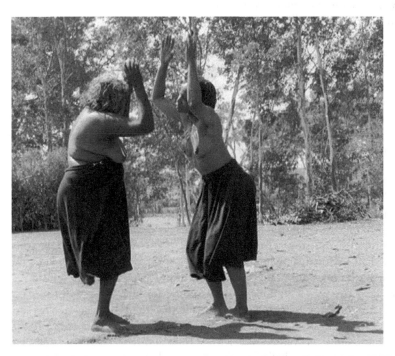

Figure 9.2 Nura Ward with Aku Kadogo, Ernabella, South Australia, 1999 (photo by Heidrun Lohr; *with respect to Aboriginal and Torres Strait Islander people as imagery is of a deceased person).

world."[7] My time in the Australian desert offered me a wellspring of know-ledge that I draw upon today. The first thing I charge my actors to under-stand is the ground they walk on. That ground, and the place and the experiences that occurred on that ground, should inform the work.

Artist as Anthropologist

The dynamic African Spirituality of communalism-collectivism, merging or uniting into holistic synthesis, is the driving energy of the African personality.

(Kobi K.K. Kambon[8])

I am a director/choreographer/performer. Whether it be a text-based play, a musical, an opera, or an improvised spontaneous event, the approach I take in my work is through the lens of an interdisciplinary practitioner. I incorp-orate music, movement, sound, text, and other inspirations in my process. Depending on where I'm working I must also consider the available cultural information and protocols. I have travelled extensively, worked internation-ally, across languages and all of this influences me. My Afrocentered-ness is that I include it all; INCLUSION. Malidoma Somé offers that "Community is important because there is an understanding that human beings are collec-tively oriented."[9] We are stronger and healthier in a collective environment. I endeavor to practice the spirit of collectivism in the creation of my works, offering participants responsibility for their character development and ownership in the process and outcome.

The theatre I set out to create, whether it is with professionals or in train-ing institutions, involves:

- intersections between language and culture
- exploration of history, memory and place
- devised ensemble work
- chanting, improvised dancing, free word association
- active reflecting
- deep listening
- physical theatre that includes gymnastics and martial arts
- collaboration with artists from varied backgrounds
- community engagement.

I am kinetic. I use my hands when I speak; I dance when I lecture; I jump up and down to illustrate a point. This is *the director* my actors encounter when they walk into a room. I bring with me memories, anecdotes, visual stimuli, obscure music sources and random tales of personal folklore. This is my way of conjuring up a production. "Stardust,"[10] as I refer to it, represents the nothingness of the beginning to the realized production, which is an immersive event. I encourage actors to share stories of them-

selves around the themes we are working on. All are asked to contribute to the "brain trust" we are creating.

My anthropological interest in theatre can be traced back to a series of events that took place when I attended New York University. Katherine Dunham was a renowned choreographer, dancer and anthropologist. Her lexicon gave the world a defined movement vocabulary for African and Caribbean dances. Mentored by Pearl Reynolds in the Dunham technique, I was exposed to the idea of dance having a deeper meaning beyond just movement. With the Dunham dance training, I began to understand dance's intrinsic cultural link to the way a group of people live.

The tour de force was meeting Ntozake Shange, who embraced this music and dance in her poetry. In the 1970s, New York was exploding with multi-cultural influences in the music, theatre and poetry scene, featuring concerts of Sun Ra, the Art Ensemble of Chicago and Don Cherry, to name a few. This excitement was captured when Shange and company burst onto the New York theatre scene offering *For colored girls who have considered suicide/ when the rainbow is enuf* (1976). I became a part of the original company that took her words from the lofts of NYC to Broadway. Coining the term *chore-opoem*, Shange offered a definition to an African American aesthetic that was prevalent not only in her works but could also be found in the works of Barbara Ann Teer, Melvin Van Peebles and Amiri Baraka.

The *For colored girls...* experience in the 1970s opened a floodgate of ideas. One was to ensure that in my creative life I would seek out writers/musi-cians/artists documenting our times. There are so many stories to tell and I want to tell them with the artists of my era. I remain true to that. The other is that I return to the choreopoem form often. It is spacious, making room for non-linear interpretations, bending time frames and utilizing imaginative visual possibilities. This space includes gesture and physicality to make poetic statements embracing laughter, tears, the street, the clubs, hip hop, the church, multiple languages, the past, the now, and the future.

> Eliminate the competitive aspect of most commercial theatre. This goal was accomplished through an essential black medium: the black family structure.
>
> (Barbara Ann Teer[11])

Working towards eliminating the competitive aspect in theatre, I create a space where actors can be vulnerable. Emphasizing "collective heart, col-lective brain," it's important that I establish an atmosphere where self-questioning, examination and exploration can take place. This must happen very early in the process. I do this by asking actors to reveal something per-sonal about themselves. The stories may or may not have anything to do with their characters but it gets the actor thinking about a meeting place between their own life and the character's life they are bringing forth.

Rehearsal process

In this section I am going to discuss my rehearsal process, which shifts from project to project with the basic tenets remaining the same for all situations. There is always kinesthetic work to discover through the body, such as how the character responds and behaves. The act of playing and improvisation is a key to spontaneity. I endeavor to create an atmosphere whereby the actor can access that place where truthful sensitivity dwells. There is also my call and response methodology, which is: I put forth ideas for actors to explore and then come back to me with their interpretations, creating an atmosphere for the company to lend to the development of the work.

The first rehearsal is an opportunity to get on our feet, sing, call and respond to one another with vocals and movement. Watching actors walk, run and freeze gives me an idea of their "truthful" way of using their bodies. I question the actors frequently to make sure they have archived certain feelings and movements that have been exposed. I want the actors to analyze where an impulse might have come from, how they got there, and store it in their memory bank.

I often refer to having spent many years watching dancers from remote Indigenous communities in Australia. When these Indigenous dancers take on the persona of a brolga, or a wallaby, they "become" that entity. Spirit comes to life and it inhabits the entire body, including the eyes, the fingers and the way the foot touches the ground. This truth telling in the body is culturally embedded. My question is how to even begin touching that kind of honesty in performance. I must look for ways to help actors reach that "pure" space of emotion and find that coded ancestral information inside themselves.

Another question I grapple with in my process is how to portray the presence of spirit in my work and its importance in our daily lives? Duro Lapido's Travelling Yoruba Theatre came to New York in the early 1970s with *Oba Koso*. The call and response singing was familiar; the forceful drumming was familiar; the dancing, twirling, bouncing, upside down Igunnokos were not. The presence of these mercurial, constantly in motion creatures, in brightly colored fabric cylinders, whose stature could be two feet small or eight feet tall were ever present entities on the stage, never leaving. This theatre experience has indelibly remained in my mind and my heart. The Igunnokos embodied the unknowable and un-namable. They also represented magic. These deities of fertility and good health were always on the stage as a reminder to remember the ancestors, remember to be grateful, and remember to honor a higher power. Performance training must be rigorous and demanding as well as sacred. At some point in the process I want my actors to explore the mystical and sacred qualities that might be present in a work.

Improvisation as liberation

> The use of music must be understood. Music goes more deeply into the spirit than words; music is a living creature, a human intellectual and emotional creation with a readily apparent spirituality that transcends the visible world of its creators. It is not bound by our physicality. Music is a profound speaking, moving, raising, perception, and teaching, the old folks said.
>
> (Amiri Baraka[12])

Improvisation is central to my process. To improvise is to sense the other performers you are in the space with, to know when to blend into one another's tempo, to match the dynamic of each person in the scene and know when to answer the call to serve your own impulses. Liberating the actors away from an external demonstration of a character and guiding them to an internal comprehension of the emotional landscape of the character they inhabit is key to what I am looking for. I tapped into this awareness through watching and feeling live music performances and ceremonial dance. At these live performances the audience/spectators elevate seemingly altogether and the atmosphere intensifies when the performer can stretch out into a zone that defies description.

As rehearsals go along I try to determine what the rhythm of the work is. Where are the highs and lows? Do we need to slow down or speed up a scene to make it better understood? Does the piece need music to punctuate the emotional intensity? Will stillness make this scene stronger? What experiences or surprises can I offer the audience that differ from passive film and television viewing while affirming the uniqueness of a live theatrical event? Searching for that immediacy makes the theatre a place of thought and transcendence.

Other languages; other codes

Working on the African American canon for the past ten years has afforded me the opportunity to delve into my ancestral roots. However, I have spent a great deal of time working out of the United States and collaborating with people from all around the world. I bring with me a solid cultural base of who I am combined with a large dose of gathered information and practices.

From my earliest days as Course Coordinator at NAISDA Dance College I worked with people whose first language was not English. These experiences impelled me to develop a way of deep listening. This often entails paying attention to hearing what people have to say without interrupting with superfluous questions and interjections. Developing this listening ability is an asset when devising works and also serves as a powerful teaching tool. This proved to be an invaluable asset when I moved to South Korea.

In 2011 I was invited to join the Music/Theatre faculty at Yongin University located just outside of Seoul. I took a leave from Wayne State University and accepted the invitation, which ultimately led to my teaching and living in South Korea for several years, before returning to Australia, and then being awarded a visiting professorship at Spelman College.

In South Korea was the first time I worked with a translator on a daily basis in the classroom. My ability to pay close attention to how things were being said and to observe how people used their bodies when speaking became keenly developed. It was exciting to be in a situation so new and different. I had the willingness to be open like a child and to slowly take in all the nuances going on around me. Eager to find those similarities in our cultures I had to initially create an extraordinary experience that would serve as a gateway to our creative turf.

One of the shared cultural experiences I offered was a workshop with my colleague Mohamed Bangoura (Bangourake) from Guinea. Koreans have a drumming and dance tradition so I invited Bangourake to conduct an African drum/dance/song workshop in my first semester at Yongin. This was my way of bringing us all together, finding a commonality, and having a shared cultural experience that proved to be a great ice-breaker and unifying for all involved. Once again music and dance served as a cultural connector.

Back to the source

I was born and reared in Detroit, Michigan. I lived in an African American community that was thriving with new-found mobility, money and bustling with Black creativity, from Berry Gordy's Motown to Woodie King and David Rambeau's Concept East Theater. The intellectually stimulating home life that my parents provided instilled a life-long sense of curiosity and an abiding connection to and celebration of African American cultural practices. The Detroit of my childhood was vibrant and full of dedicated hard working, loving people. The spirit of "each one teach one" manifests in my work because of that loving community.

Understanding the necessity of "giving back" I returned to Detroit in 2006 to take up the position as Director of the Black Theatre Program at Wayne State University (WSU). Thirty years of living away from Detroit I found a city broken down and its citizens in a state of malaise. I observed that there was a remarkable absence of joy in much of the entertainment. This is not to say that I want joy all the time but there certainly appeared to be an imbalance in the offerings.

Choreopoem as creative catalyst

The fact that we are an interdisciplinary culture/that we understand more than verbal communication/lays a weight on afro-american writers that

few others are lucky enough to have been born into. We can use with some skill virtually all our physical senses/as writers committed to bringing the world as we remember it/imagine it/& know it to be to the stage/we must use everything we've got.

(Ntozake Shange[13])

A choreopoem can be described as utilizing music, song, dance, movement, poetry and ritual, as it "emphasizes action, collective participation, and celebration."[14] I rely on telling a story in more than one form. This distinctive African American theatre form that draws on the poetry of the church, jazz improvisation, the spontaneity of ring shouting, scat singing and improvised creativity is a form that I have worked on from Australia to Korea and across the USA. It is a form that I love and one that bends and shapes itself according to the project. The following works, which I have had the opportunity to direct, are good representations of the choreopoem at work: *The Adventures of a Black Girl in Search of God* (2005) by Djanet Sears, *Flow* (2011) by Will Power, both presented at WSU, and *Booker T and Them* (2013) by Bill Harris, presented at the Charles H. Wright Museum of African American History for Art X Detroit.

Sears's *Adventures of a Black Girl...* calls for a chorus that morphs from onlooking ancestors into flora and fauna or everyday objects. Together with the cast we developed a specific physical language. In my director's notes I defined the work as magic/realism. The ancestors/chorus provided a soundtrack that ranged from crickets at dusk to a hallelujah choir. Sears based this work on her influences from travel in Africa.[15] Very much inspired by her trip to the continent, her theatre includes masquerading, movement sequences of celebration or mourning, and good storytelling.

Centricity is also a very important tenet in my work. Asante defines centricity as "the process of locating a student within the context of his or her own cultural reference in order to be able to relate to other cultural perspectives."[16] I believe every actor/student who enters into my realm possesses a history worth sharing. Valuing a person in such a way has guaranteed a lessening of fear and doubt for the actor/student when approaching tasks that might seem daunting at first; such as utilizing one's voice or body in an unfamiliar way.

A clear example came when directing Sears's play. A student actor expressed an interest in music and composition and asked if he could contribute to the soundtrack of the play. He didn't have a proven track record of composing, only his desire to do so. Rather than challenge him on his technical prowess, I asked who were his influences? He offered Thelonious Monk, Jimi Hendrix and Bobby McFerrin. Impressive! That he had come forward made me want to encourage him to pursue his interest in composition. When the time came to present his first sample of work, he nervously approached me. Then he shared a quartet of voices evoking a rich tapestry of

the emotions portrayed in the scene. Aha! He comprehended where I was going in the work. My trust paid off and our relationship elevated to a collaborative status. We were able to enter into a dialogue where we could discuss what might be needed for the coming scenes. If something didn't work he welcomed the criticism and created a better solution for the given task. We were able to advance our relationship from just mentor–student to collaborators. I valued what he might bring to the situation and he flourished with the opportunity. Kambon describes this as contribution to the community (collective uplifting).[17] I had enough trust to give permission for his creativity to shine through for the greater good of the work. He delivered a beautiful soundtrack that enhanced the production. This contribution by a company member disrupted that notion of individual hierarchy, rather us collaborating instilled the spirit of collective contribution.

Original works

Booker T & Them by Bill Harris

> Dance that must be in it. But not as the dance we know now. The common dance. The every-minute, moment-to-moment dance that everything actually is. I want the movement of the players to take on the rhythm of the music without "leaving" the dramatic context. The dance must be heightened movement.
>
> (Amiri Baraka[18])

I am committed to bringing original works to the stage. It means that I am experimenting with form constantly. I improvise, like a jazz musician or a quilter, utilizing the available resources and creating with the tools or text at hand.

So much of our history has been intentionally hidden from us. I believe it is important to speak the name of ancestors every chance we get. I welcomed the opportunity to create a choreopoem based on one of our important African American leaders: Booker T. Washington. I had been in conversation with my fellow colleague and award-winning playwright Bill Harris and we were both eager to begin a working relationship with each other. In Harris's *Booker T & Them* I was confronted with the conundrum of extracting a performance text from his Blues Bio-poem/novel. The work fluidly moved around in time and space, evoking a burgeoning America of the early twentieth century. There were also references to Washington's meetings with the boisterous President Theodore Roosevelt. I concentrated on Washington's accomplishments and his struggle with the Jim Crow laws[19] that he constantly faced. Harris portrayed Washington as a John Henry[20] figure in a race against himself and the unfair segregation laws of the south. My attraction to Harrison's prose/poem blues novel was the wry and lyrical, yet action packed

depiction of early twentieth century Jim Crow America. The text evoked a circus atmosphere. Once again the actors played multiple characters, opening the show as circus barkers and eventually morphing into Booker T. Washington and Jim Crow.

This novel was filled with action that easily lent itself to visual and aural interpretation. The actors were asked to dissect each scene and bring a physical interpretation to the text. We then collaborated with two musicians—a drummer and a tuba player—creating sound elements that reflected the characters' and Washington's struggle. Though not a traditional script, and thanks to the author's generosity towards my ability to edit, I was able to create a choreopoem featuring excerpts of Harris's words. *Booker T and Them* was performed in 2013 for a festival in Detroit celebrating Bill Harris's tenure as a Kresge Eminent Artist, which is awarded by the Kresge Arts in Detroit Advisory Council. The actors ran a marathon of a performance from the minute they made their entrance to their final bow.

Disruption as a tool: Singing for that Country (2004)

My attraction to Tyree Guyton's Heidelberg Project is the disruptive nature of his work. The Heidelberg Project is a 30-year-old outdoor art installation in Detroit, Michigan. Upon discovering this work I immediately wanted to know the person who created it. Tyree Guyton, who is primarily described as a painter and sculptor, is a modern-day medicine man in my estimation. Through his art he forced a community to confront its blighted condition by transforming vacant houses into works of art.

This artwork is confrontational for all who view it. One is forced to contend with it whether you are for or against it. Tyree stepped out into the streets one day and took matters into his own hands: forcing neighbors to think about what had happened to their neighborhood. So rather than his community passively accepting that they had been discarded by the powers that be, Guyton's art mobilized his community.

I was interested in working with an artist who confronted his audience in such a manner. Thus, I created *Singing for that Country*, a project that involved community engagement through art and performance. This was a cross-cultural project bringing Guyton and myself into a multicultural community in South Sydney that was inhabited by Indigenous and non-English speaking immigrants. Although we had the sanction of the City of Sydney and local youth arts groups I wanted once again to disrupt the acceptance of gentrification using art as the catalyst. We lifted our voices up together to bring attention to the idea that we might have to find a way to get along with each other, no matter our economic circumstances. To that end I conducted workshops where people painted found objects such as shoes and tires. These would eventually be incorporated into the public installation. In several of the local schools we created chants around the theme of "if my shoes could talk."

On the opening day in Sydney Park, there were performances by local community groups and various artists who lived in that neighborhood. It was a mammoth task to garner the enthusiasm of the disaffected youth of the area. In some instances I attained participation and in some instances I didn't do so well. Did art stop the gentrification? No. But it demonstrated that we could be resoundingly heard if we joined forces together. The visual component of the project remained in the park for ten days.

My collaborative relationship with Tyree Guyton is ongoing.

Salt City: An Afrofuturistic Choreopoem by Jessica Care Moore

Assemble counter mythologies.

(Kodwo Eshun[21])

Afrofuturism is the intersection between black culture, technology, liberation and the imagination, with some mysticism thrown in too; it can be expressed through art, literature, music. It's a way of bridging the future and the past and essentially helping to reimagine the experience of people of color.

(Ytasha Womack[22])

I am constantly looking to deepen my research into African American cultural practices. When poet/playwright/performance artist Jessica Care Moore presented me with the story of a curious Black girl who visioned herself into the future while facing extinction by gentrification, I was enthralled. This work offered an opportunity to explore another African American cultural aesthetic: Afrofuturism. I began developing Moore's *Salt City: An Afrofuturistic Choreopoem* in 2015 as part of my residency at Spelman College. Spelman College is a historically Black women's liberal arts college in Atlanta, Georgia. Taking the cast on a journey into the world of Afrofuturism continued the exploration of our African-centered past as it connects to our living times. Afrofuturism bridges many aspects of our cultural past, present and the imagined future melding Afrocentricity with music, non-Western cosmologies and urban myths.

Presented as the culminating event of my year as Distinguished Visiting Scholar for the Arts I especially wanted to include an original work as part of what I believe twenty-first-century training for theatre practitioners should and must be. I advocate for creating art that responds to the now, and continues to honor the richness of our cultural heritage that is not just surviving but thriving.

In preparing this Afrofuturistic choreopoem, I spent hours on Skype and email with Moore, sifting through text and developing ideas for scenes.

Moore and I were inspired by the salt mines that spread from lower Michigan to Ohio. We included the music of Mike Banks and Jeff Mills, techno music producers from Detroit, furthering the Black aesthetic of our futuristic adult fairy-tale of love, curiosity, malaise and gentrification. The audience response was a combination of delight and curiosity. There was also fascination with the imagery of salt crystals and mines, and intrigue with the concept of a strong, young Black girl on the precipice of womanhood taking on her community and forging into the future. And certainly there was a "funky good time" with the house music.

Salt City is still unfolding. Jessica Care Moore and I continue to research and develop the "fairy tale" that will be a part of our modern-day myth making. We are currently in the second developmental phase of the work.

Conclusion

Malidoma Somé maintains that we are healthier as a community when we are less isolated and not operating solely as an individual.[23] The spirit of collectivism is very energizing. I attempt to bring this spirit of collectivism into every project that I lead.

I encourage all who come before me to tell their story: speak it, dance it, sing it, paint it, animate it. The writers and artists I collaborate with are dedicated to the creation and proliferation of our own modern-day myths, our own stories. Globally, we are looking squarely at the mass displacement of people through urban development and gentrification. Accompanying that comes a loss of the collective memory, that essential handing down of stories that should encourage the next generation to honor those who have come before us. Afrocentricity plays a big part in my artistry; honoring the ancestors, utilizing poly forms to create vivid staged experiences, collective knowledge sharing to make strong the spirit of communal ownership, and affirmation of all who come before me to acknowledge that we are nothing alone and everything with each other. I seek out the places we gather to tell stories and collectively remember. I am committed to live performance. I look for that place where we can share an emotional connection together. I am driven to create a theatre that addresses modern myths, dreams and social awareness.

From stepping on the stage in *For colored girls...* to creating a fairy tale for adults, I continue to push the boundaries of what theatre performance is: a continuous gathering of rhythm, memory codes, landscapes, languages, cultures, music, sounds, inclusion and SPIRIT!

Notes

1 Kobi K.K. Kambon, *African/Black Psychology in the American Context: An African-Centered Approach* (Tallahassee: Nubian Press, 1998), 301.
2 Jennifer Isaacs, *Arts of the Dreaming; Australia's Living Heritage* (Sydney: Lansdowne, 1984), 208.

3 Ara Irititja Project, *Inma* traditional dancing and song (www.irititja.com/sharing_knowledge/glossary.html, 2011).

4 Aboriginal or Torres Strait Islander people consider the lands and waters they have traditional affiliation of and responsibility for as their "country." Senior people in the community, who are responsible for their traditional land and waters, are referred to as "Traditional Owners." *Protocol for Acknowledgement of Traditional Owners and Welcome to Country* (www.arrowenergy.com.au/__data/assets/pdf_file/0015/2193/Acknowledgement-to-Country-Protocol.pdf 2012).

5 Ara Irititja Project, *Tjukurpa* (www.irititja.com/sharing_knowledge/glossary.html, 2011).

6 Malidoma Patrice Somé, *The Healing Wisdom of Africa* (New York: Tacher Putnam, 1998), 23.

7 Ibid., 22.

8 Kambon, *African/Black Psychology*, 307.

9 Malidoma Patrice Somé, *Healing*, 22.

10 Neil Degrasse Tyson, *We Are Stardust*. Lecture delivered at Beyond Belief Symposium, 2006.

11 Lundeana M. Thomas, "Barbara Ann Teer: From Holistic Training to Liberating Rituals," in *Black Theater: Ritual Performance in the African Diaspora*, eds. Paul Carter Harrison, Victor Leo Walker II and Gus Edwards (Philadelphia: Temple University Press, 2002), 350.

12 Amiri Baraka, "Bopera Theory," in *Black Theater: Ritual Performance in the African Diaspora*, eds. Paul Carter Harrison, Victor Leo Walker II and Gus Edwards (Philadelphia: Temple University Press, 2002), 378.

13 Ntozake Shange, "Unrecovered Losses/Black Theater Traditions," in *Lost in Language & Sound or How I Found my Way to the Arts* (New York: St. Martin's Press, 2011), 16.

14 Phillip Effiong, *Ntozake Shange's Choreopoem: Reinventing a Heritage of Poetry and Dance* (www.philip-effiong.com/Shange-Choreopoem.pdf).

15 Ric Knowles, ed. *Afrika, Solo* (Toronto: Playwrights Canada Press, 2011), v.

16 Molefi Kete Asante, *An Afrocentric Manifesto* (Malden: Polity Press, 2007), 79.

17 Kambon, *African/Black Psychology*.

18 Amiri Baraka, "Bopera Theory," 378.

19 Jim Crow was the name of the racial caste system which operated primarily but not exclusively in southern and border states, between 1877 and the mid-1960s. Jim Crow was more than a series of rigid anti-Black laws. It was a way of life. Under Jim Crow, African Americans were relegated to the status of second-class citizens. Jim Crow Museum of Racist Memorabilia www.ferris.edu/jimcrow/what.htm.

20 S.E. Schlosser, *John Henry: The Steel Driving Man* (http://americanfolklore.net/folklore/2010/07/john_henry.html, 2014).

21 Kodwo Eshun, *More Brilliant than the Sun*. (London: Quartet Books, 1998), 158. Eshun is commenting on the possible effects that Sun Ra's artistry engenders.

22 Ytasha Womack, "Afrofuturism takes flight from Sun Ra to Janelle Monáe," *Guardian* (www.theguardian.com/music/2014/jul/24/space-is-the-place-flying-lotus-janelle-monae-afrofuturism, 2014).

23 Malidoma Patrice Somé, *Healing*.

#UnyieldingTruth

Employing culturally relevant pedagogy

Kashi Johnson and Daphnie Sicre

With the advent of social media, the imperceptible struggles of Black students at predominantly White institutions (PWI) are more apparent than ever. The "BeingBlackatUniversityofMichigan" Twitter hashtag and the "I, Too, Am Harvard" Tumblr blog have spawned similar movements both nationally and abroad. The message is clear: Black students are tired of being ignored, devalued and alienated. These campaigns underscore the need for a consistent, productive pedagogical space where Black students can release their frustrations, speak up and celebrate their identity at the university level.

We (Johnson and Sicre) are college theatre professors and directors who have experienced similar frustrations both as students and as faculty. As a result, we share a common bond that celebrates and critically engages artistic performance practices dedicated to uplifting Black students. We have a common interest in creating an inclusive, productive pedagogical space that applies ensemble/communal theatre principles. While our classes consist of a diverse student population, for the purposes of this chapter we will focus on our work with Black students and share the ways we have combined theatrical performance with the unlimited potential of Hip Hop's creative self-expression and Theatre of the Oppressed (TO) performance techniques to engage and empower Black students.

Merging aesthetics firmly rooted in the African continuum with the pedagogical wisdom of Brazilian educator and philosopher Paulo Freire, we have devised new teaching methodologies and performance modalities building upon inclusive and thoroughly non-traditional performance techniques found in Hip Hop Theatre (HHT) and TO. We build upon Freire's ideas,[1] where students are not seen as blank slates, but instead they are recognized as individuals who have just as much to share within themselves, fostering a climate where communal learning can occur. We utilize our communal classroom communities to resolve problems where our Black students are not only challenged to connect with social justice issues but tasked with finding ways to incorporate these concerns into their writings and performances. Although we engage in actual classroom content differently, we specialize in remixing pre-existing acting approaches with Hip Hop aesthetics and TO methods.

JOHNSON: I branched off from the traditional Eurocentric celebrated acting approaches in the creation of my HHT course, *Act Like You Know*,[2] where accepted performance assignments like scene work, character study and content-less dialogue are replaced with ol' skool tributes, rap lip syncs and original spoken word assignments.

SICRE: I trained with Augusto Boal in Brazil and now I remix TO techniques with HHT, resulting in powerful social justice inspired performances that empower Black students to speak their truth, celebrate their identity and become critical change agents in society.

The foundation

SICRE: When Johnson and I met, I was set to stage-manage *A Raisin in the Sun* by Lorraine Hansberry, in which Johnson was starring at Lehigh University. Although I had already graduated, I stayed one more year to complete a third major in History after having completed a Bachelor of Arts in Theatre and Journalism in 1998. As a student, I participated in productions of *Dutchman* by Amiri Baraka, *Spunk* by Zora Neale Hurston and *Fences* by August Wilson. After our brief encounter in *A Raisin in the Sun* in 1999, I went on to teach history, and later theatre, in Miami, FL, before pursuing my Ph.D. in Educational Theatre at New York University.

JOHNSON: I graduated in 1994 with my Bachelor's degree in Theatre from Lehigh and returned years later as a visiting professor and artist-in-residence. I joined the faculty in a tenure-track position in 1999 where I have since directed several Black plays, including *Flyin' West* by Pearl Cleage, *The Colored Museum* by George C. Wolfe, and *Joe Turner's Come and Gone* and *The Piano Lesson* by August Wilson. We both agree that Lehigh's commitment to producing Black theatre and hiring faculty of color is impressive and sets a precedent for others to follow.

The need for the work

SICRE: While Johnson directed Black plays at Lehigh, I began directing Black works at a high school in Miami, FL. My students were predominantly Black, and I quickly realized I needed to tailor my curriculum towards work that catered to their lives and diverse experiences. My rationale was that students would become better actors once they were able to see similarities between their own lives and the historical accounts found in plays. A perfect example proved to be *The Death of the Black Jesus* by David Barr III, a play set during a present-day TV show where three former radical Black Panther-esque '60s members known as the Black Jesus portray the lives of the former top leaders of the Black Panthers. When I began directing this play, my students did not know who the

Black Panthers were. We spent three weeks researching the Black Panther Party in order to better understand the characters and historical facts needed to discover the parallels between the Black Panthers and the characters in the play. Many of my students were unaware of critical racial movements within their own history. I also started preparing my students for auditions by having them read Black plays such as *A Raisin in the Sun* and several other plays by August Wilson. Having been fortunate enough to participate in *Fences*, *Spunk* and other Black productions at Lehigh, I had a foundation in Black theatre that I could share with my students.

Today, I teach full-time at Borough of Manhattan Community College (BMCC) in the Department of Speech, Communications and Theatre. BMCC is a predominantly Black and Latino community college in New York City. Even here, I see similarities to my students in Miami: a basic lack of knowledge about Black history, little exposure to theatre in general and virtually no knowledge of Black theatre overall.

JOHNSON: As a faculty member supportive of Black theatre, it is important that a decent amount of the plays we select to produce at Lehigh, and that I direct, inform and empower Black students while simultaneously appealing to students of different backgrounds. When we select a season, we ask the questions: What types of plays should we expose students to during their time with us? Or, are there enough Black students in acting classes, or active in the department at this particular time to mount a Black play? On occasion, the answers to these questions have led to concerted efforts to recruit Black students to audition for roles in order to ensure that Black theatre remains a vibrant part of what Lehigh does. I feel fortunate to be a member of a department that values diversity, and reflects its commitment by showcasing existing and emerging Black playwrights. By striving to bring a wider range of voices and experiences to the classroom and stage, a bridge of understanding is created, performing the vital, necessary work that only art can do.

When I was a Lehigh undergraduate, there were racial tensions and flare-ups. Today, the tensions are still present and flare-ups occasionally occur. Over the past 16 years, as a faculty member I have seen Black students bring their concerns to the attention of the administration by way of silent protests, marches, sit-ins and walkouts. I watched students become increasingly frustrated with a school culture that marginalized their identity, while promoting a culture of homogeneity. Because the Black students know they count and do matter, they continue to demand more student and faculty diversity, point out inequities and file grievances in the hope of changing the campus culture. Recognizing and relating to the toxic campus climate, I decided to do something about it. As a theatre professor, I felt inspired to address diversity issues. I created the course *Act Like You Know*, a college theatre course where Hip Hop

aesthetics are employed to tackle issues of identity and social justice. In it, students are empowered to find their voice by creating and performing their own original work. As a Black woman, and someone who demands authenticity from my students, I recognize that I must also walk in truth. I acknowledge the silent connection I share with most of my Black students based on the fact that we are all navigating a PWI environment. In this regard, I do not shield students from my unique experiences as one of the few Black faculty on campus; instead, I share personal situations in which students can see themselves and draw strength and motivation.

SICRE: Interestingly, I had comparable experiences at another school where I teach part-time, Marymount Manhattan College, an institution like Lehigh, where the student population is predominately White. There I created a course called *The Arts and Social Justice*, where students are exposed to performance and issues of identity, race, class and concerns that hit close to home. Black and Latino students have often approached me after class sharing, "You're the first professor of color I've had and I've been here three and a half years," or "Thank goodness I get to have a class with you, because I have no other professor who looks like me!" It is shocking when I hear I am the only professor of color they have ever had but more so that I am one of the only professors on campus tackling issues of cultural diversity and inclusion in the classroom. But regardless of where I teach, I realize students want their voices to be heard, especially marginalized students. They want to not only contribute to the conversation, but through performance, they want to leave their mark.

JOHNSON: Essentially, I believe that theatre provides a unique opportunity for transformation and it is my job to continue to open doors of access for my Black students. They can see their work on-stage, realize the importance of their voices and recognize the value of their stories by studying well-known Black playwrights.

SICRE: Likewise, in teaching my Black students, I enjoy contemplating, who of them might be the next August Wilson. It is exciting to know I help shape, motivate and propel my students into doing this work, pushing them not to stop or give up on themselves.

Hip Hop performance

JOHNSON: Through *Act Like You Know*, I was able to amplify Black students' voices on Lehigh's campus, tackle social justice issues, and enable them to create their own original work. According to Daniel Banks, "Hip Hop theatre addresses ethnicity, class, culture, gender, sexuality and generation—it is a theatre of issues that confronts not just young people but the whole world."[3] In my class, Hip Hop is the thing that they *do* in order to tell the story, share the message and ultimately declare, "I am here and what I have to say matters!" Hip Hop is the lure that inspires students to

interview and audition for the class and the Trojan horse that ushers them into the world of the performer. The four foundational elements of Hip Hop are the DJ, break-dancing, graffiti arts and emceeing.[4] These elements open the portal to Hip Hop culture, as I ask them to walk down a few performance corridors, and see what they discover. What really grounds my passion for Hip Hop is the fact that it is a culture born out of necessity, giving voice to the voiceless. I draw on the history of empowerment by teaching students about the kids who created their own parties in the park when they could not get into nightclubs, such as the work of Afrika Bambaataa, founder of the Zulu Nation, an organization that transformed gang activity into Hip Hop culture, replacing weapons with break dancing, graffiti and deejaying battles.[5]

SICRE: I also teach Hip Hop aesthetics by studying revolutionary Hip Hop music that galvanized social change in performance, asking students to write and perform original spoken word poetry and exploring graffiti as a street art cultural phenomenon.

JOHNSON, SICRE: Through the application of Hip Hop Theatre activities and assignments, we have devised a portal for Black students to access the familiar and make their presence known by writing and performing their own work. Since our students were born, Hip Hop has been the dominant form of global youth culture, and created a natural bridge where we can meet them in the middle. Many Black students feel Hip Hop is their culture, and they can talk about it with confidence because this is where they come from. The classroom becomes a gathering place for a full circle experience, where teacher and student are both blown away by the talent and knowledge the other possesses through the intergenerational exchange of ideas. Learning spaces like these open doors for marginalized students to bring their own personal knowledge to the discussion, and to lead the conversation into critical thinking and explorations on race and identity.[6] Students can confidently engage HHT pedagogy because it often represents where they come from and what they are familiar with.

SICRE: One of the courses I teach at BMCC is *Public Speaking for Social Justice*. The students' final projects are to videotape themselves delivering a speech or an original spoken word. Their work is placed online to evoke social change. While studying feminism for the first time, an Afro-Latino student of mine wrote and performed a spoken word piece about a young man being physically abused by a woman. He wanted a public forum where he could address this issue, and spoken word became that creative outlet. He was fascinated with the notion of equality for all when looking at feminism, and the fact that feminism is not only specific to women. He wanted to talk about men who have been emotionally or physically abused by women, and how their voice is completely silenced because it is socially unacceptable. Adding his own Hip Hop soundtrack, he created a completely original Hip Hop piece focused on social change.

JOHNSON: In my course, students start writing their spoken word pieces halfway through the semester. There is a certain level of trust by then because the class is known as being a safe space. I analyze drafts of students' spoken word poetry in search of truths hidden in flowery language and embedded in false platitudes. My thinking is, if you bring it up, if it is lurking in the shadows, and if I can see it, we have got to deal with it. Once completed, the results are liberating, but the writing process can be challenging. I remember one of my students, a young Black woman who did not recognize her own strength, struggled to write about her feelings of abandonment and rejection while her family suffered through a divorce. Afraid and unsure of the process, she relied heavily on the positive affirmations and encouragement from her peers, eventually realizing she needed to find courage from within and be brave enough to say the things she was afraid to. Once she discovered the power of performing the piece, she experienced an emotional catharsis and never looked back, even declaring a major in theatre. If my students are brave enough, angry enough or passionate enough about whatever it is that they have to say, spoken word poetry can transform them. I always remind them, even though they are sharing their own personal story, they are most likely telling someone else's story as well. In this way, their spoken word becomes more than a performance assignment; it is a portal of connection where students and audience access the universal through the personal. In teaching this approach, if the delivery is safe, and the message surfaces, the audience may clap politely, but it is not going to emotionally move anyone. However, if they speak from a place of authenticity, their words will resonate with their audience and their message will truly be a gift of shared understanding and validation.

JOHNSON, SICRE: It does not matter to us if our students are novices or if they are accomplished performers. Over the years, we have devised accessible assignments allowing anyone to access our course material at a comfortable entry point, and have invited them to apply themselves and ultimately reap the rewards, based on the work they put into it.

JOHNSON: Both Sicre and I start the semester by having our students read Danny Hoch's "Hip Hop Manifesto"[7] as a way of providing history, insight and context for our ongoing conversation about HHT. In my course, in terms of performance assignments, we begin by remixing the traditional monologue assignment with Hip Hop. The result is the 'ol' skool' tribute assignment, in which students are assigned a classic Hip Hop artist's rap song, and taught how to do lite impersonation while researching the artist's dance moves and gestures. The end result is an a capella performance of the song as their Hip Hop artist. Another remixed assignment is "The Class Anthem," where a traditional group choral poem or recitation is reinvented. I ask all students to memorize and deliver the same rap song exactly as the Hip Hop artist performed it. Over the course of the semester, the song returns as a pop quiz or memorized text I use to teach other performance

elements like moving on stage, vocal projection and engaging the audience. By the end of the semester, the assignment develops into a musical ensemble number that the class performs. I like to select songs that have an invaluable message, such as *I Love Myself* by Kendrick Lamar, *Lost Ones* by Lauryn Hill and *Hip Hop* by Mos Def, among others.

JOHNSON, SICRE: Another common source we both use is a short documentary film series that speaks to the notion of appropriation as human tradition, called "Everything is a Remix"[8] by Kirby Ferguson. This film suggests that everything that has come before influences what will come next, based on the things that are picked and chosen to inspire and make an impact; refashioned and reformed into something new. In this way, the remix is acceptable as long as you make it your own. In the same way Hip Hop asks culture to perpetually reinvent itself, we ask the same of our students.

Hip Hop Theatre of the Oppressed—the Black student remix

SICRE: I trained with Augusto Boal in Brazil where I learned Theatre of the Oppressed (TO) directly from him and his Jokers.[9] TO provides tools and games for anyone to explore their history, look at their present circumstance and then rehearse a possible future through theatre. Because Boal wanted others to not only replicate his practices but also adapt them to the community they are working in, adapting and remixing his work with Hip Hop Theatre is a natural progression. Thus, I use his methodologies and remix them with HHT aesthetics. For example, traditionally in "Newspaper Theatre,"[10] students bring in current event articles and recreate the images of them. In my remixed assignment I have students read specific articles about the #BlackLivesMatter movement, and ask them to recreate these articles as frozen images set to Hip Hop songs, such as *Fight the Power* by Public Enemy or *Police State* by Dead Prez.[11] In 2014, my students selected stories about Ferguson, Eric Garner and Michael Brown and created images of protest and arrest and performed them to *Police State*. The songs and the images sparked a dialogue with the audience, as Black students initiated a discourse on social issues.

JOHNSON, SICRE: We are teaching material that already exists but we are blending these practices to fit the needs of students in our classrooms. Johnson calls this "collaging." We are quilting or weaving several teaching styles to create new approaches. Echoing the creative endeavors of our students, we have developed teaching styles based on tradition and proven innovation, and just like a collage, we fill in the empty spaces with creative elements added by the students. Thus old methodologies merge with new, leading to our cutting-edge approach to pedagogy.

Creating safe spaces

As instructors deliberately designing our classrooms to be safe spaces, we provide students the opportunity to self explore in the context of their peers and, eventually, an audience. When they share their truths in front of others, they make self-discoveries, and shatter preconceived notions of themselves. In order to create a safe space, we use a similar approach by starting each class in a circle formation. The practice of gathering together in a circle echoes African traditions where the circle represents being whole, one and communal. For students engaging in theatre for the first time, the awakening starts as they actually move the tables and desks to create the circle. The circle requires everyone to be present and ready to participate, because everyone can be seen.

JOHNSON: Students taking my class for the first time do not recognize this non-traditional approach to class formation and are often intimidated, "You want us to do what?" is often heard after they are told that they have to get in a circle, say their name and share something about themselves. Instead of playing the traditional name game, I teach students a brief rap song involving call and response called "Step Up, Step Back" introducing themselves in rhyme:

CLASS: STEP UP, STEP BACK, INTRODUCE YOURSELF!
STUDENT: My name is... (Student says their name.)
CLASS: YEAH!
STUDENT: And I like to eat! (Students choose anything they like to do, e.g., play, write, cook.)
CLASS: YEAH!
STUDENT: If you don't like it
CLASS: YEAH!
STUDENT: Then have a seat! (Come up with a line that rhymes with what the student likes to do.)
CLASS: OH YEAH!

After the exercise, students are compelled to talk, asking questions like "What's your name again? How do you say your name? What does your name mean?" Dialogue that rarely happens early on in a traditional classroom starts to immediately develop, encouraging comfort zones to increase and barriers to come down.

SICRE: In my classes, I bring in a small globe and ask the following question in a communal circle: "If you could change the world, what would you do? If you had all the money in the world, and resources were not a problem, what would you do?" And then, students begin to share after they say their name. For example, someone might say, "Homelessness,"

prompting me to ask, "How would you end homelessness?" or "Do you know someone who is homeless?" They might not have any answers at this point in the discussion, but by just being in the circle and having people listening and sharing, a communal bond starts to emerge. Students begin to realize that there are others in the room feeling the same way and that they are not alone. Thus, one simple activity, which only takes 10–15 minutes out of your first/second day of classes, can create class cohesion. I also lead variations of the exercise known as "the spectrum" or "crossing the line" or, as I like to call it, "big wind blows," where students are asked to cross the room or circle when they agree or disagree with a statement I present. Through the simple action of walking from one side of the circle to the other, the class becomes more unified, as students are able to silently express their preferences, reveal information about themselves and identify with other like-minded peers.

JOHNSON, SICRE: Activities like these create safe spaces at the beginning of the semester because no one is talking or judging. People are just listening and connecting with each other according to their own life experiences. Some argue that today's youth are so attached to technology and social media that they seem to have forgotten how to connect with each other on a personal level. Therefore, this practice of communal gathering, of being present in a circle, of call and response to learn people's names, of talking about our community and what's going on in the world, and what they would change, compels the students to interact in the moment.

JOHNSON: Creating a safe space and a classroom community does not stop here. During my MFA training, I was introduced to the concept of "checking-in," a simple exercise where each student is asked to "say what they need to say" instead of focusing on issues and other concerns outside class—to leave the concerns of their world "at the door" so to speak. I guide check-ins with abstract prompts like "If you were a color right here, right now, in this moment, what would it be and why? Why is this like you right now?" Once I feel everyone has reached a certain level of comfort, I invite them to share whatever they want in a check-in. By empowering students to own their feelings, each class presents a new opportunity for students to share a part of themselves as they continue to build ensemble.

Current events and campus climate influence the way I may lead a check-in. I like to choose material that provokes self-reflection and promotes conversation. Sometimes I select an evocative rap lyric like "Even though you fed up, you gotta keep your head up" by Tupac, or a single phrase like "I can't breathe," and ask students to connect the dots to their own life. It is imperative that I am keenly aware of the frustrations Black students may experience due to racial incidents on campus or instances of

rampant injustice of police brutality nationwide. In these moments, the check-in functions as a pressure-release where I can encourage my students to speak their truth and articulate the thoughts and feelings they are perpetually asked to swallow and ignore, in order to keep going. Consequently, these "check-ins" are a key component in creating a safe classroom space and have become a part of my class ritual.

SICRE: Similarly, I have two "semester check-ins" where I dedicate an entire class period to discussing where "we"[12] are. My students sit in a circle, similar to community gatherings, and I ask them to share frustrations they may be having with the material or assignments as well as successes. Because of the community-building activities done at the beginning of the semester, students feel comfortable sharing.

JOHNSON: Another culturally relevant technique that I employ is playing Hip Hop music as students enter the class. Music affects everyone differently, and it is enjoyable to watch students make dramatic entrances dancing to the music, or rocking with an appreciative head nod. Entering this atmosphere prompts conversation, group dancing, singing, laughter and, ultimately fosters an environment of trust. Without fail, students will ask to add their favorite song to the playlist, make requests or take over DJing duties, playing their favorite Hip Hop tracks directly from their laptop or smartphone. Through the simple act of playing Hip Hop songs at the start of class, I establish an unspoken, intergenerational connection between students and myself, all the while subtly reinforcing the notion that this class is a safe space, and uniquely theirs. While I do not censor this playlist and will include unedited rap songs, I do control the quality and integrity of the songs played because this pre-class music party is another valuable opportunity to introduce students to "gems" in the Hip Hop canon—seminal rap songs they should know, but probably do not. I also like to play instrumental versions of rap songs, inviting students to assemble in rhyme cyphers and initiate dance battles, all before the start of class.

SICRE: Another idea I like to use when teaching TO is Boal's quote that, "Perhaps the theatre is not revolutionary in itself; but have no doubt, it is a rehearsal of revolution!"[13] Boal created safe spaces as places to rehearse what one might do next in life. This quote relates perfectly to my social justice courses because students' performances are a rehearsal. The classroom is a safe space for students to talk, feel confident, start writing, critiquing each other/themselves and performing material that works for them. For instance, I have been recently remixing this idea by specifically focusing on the #BlackLivesMatter movement and protest. We have been using stories from the movement to explore scenarios that promote change.

JOHNSON, SICRE: Two to three weeks after the beginning of the semester, we witness students giving hugs, kisses, handshakes, and engaging in genuine

conversation. Neither of us prompts our students to do this; it just happens. We believe this occurs because we place ourselves "presently" in the room with our students. Most university courses are taught from the notion that the professor is the classroom authority. Yes, we know professors are "technically" in charge since we are the ones giving a grade, but that does not mean we know more than everyone else in the room. Building on Freire's ideas that no one is a blank slate, we utilize our communal classroom communities to resolve problems together. If a student raises a problem, we will ask if anyone else is experiencing or has encountered the same problem. Usually other students will share that they have experienced the same problem, but more than that, they will share how they faced it and what solutions they used to address it. Over time, collective learning empowers students as they begin to realize they can make changes, they do have the answers and they can solve their own problems.

Creating safe spaces and collective learning environments are extremely important to enable students to engage in constructive criticism of their peers' performances. Students can find it difficult to provide feedback to their peers for any number of reasons: from the desire not to hurt someone's feelings by saying something negative, to simply being shy about voicing an opinion. Teaching students how to give an effective critique can be challenging, but we believe the answer lies first in validation, followed by the reflection of one's own work through the evaluation of their peers, as opposed to only the professor giving feedback. When peers are able to validate and empower one another, the focus becomes about how to make the work better. The critique becomes about reflection and not personal attack. The answer then lies in the general perspective of an audience member. Because ultimately, what is a performance piece without an audience? We believe we empower our students through critical engagement, paving the way for strong final performances. There is no greater reward than witnessing our students' realizations about how much they have grown from their initial feelings of nervousness and uncertainty as they performed their first pieces, to the grounded and liberated feelings they experience when they present their final performances.

A push for social change

There is a huge need for social justice advocacy and social change. Our classes reflect the need and ground the pedagogical impulses of our artistry. We strive to successfully take our students on an inward journey of self-discovery to an outward engagement with social justice issues for others.

SICRE: I teach two very different social justice classes. One is *The Arts and Social Justice* at Marymount and the other is *Advanced Public Speaking for*

Social Justice at BMCC. In both courses, students must engage in creating a final performance piece. As a call to arms, most students opt to create a digital performance but in order to create these pieces students must have a foundation. Students in my *Advanced Public Speaking for Social Justice* class at BMCC start the semester by engaging in conversations about Isms.[14] Starting with feminism, ageism and racism, they look at social and economic differences in society and inequality. Students then consider these topics in the context of oppression and the affect these things have on their own lives, ultimately determining how they can create a change with their performance pieces. At Marymount, my *Arts and Social Justice* class begins with an introduction to Hip Hop, spoken word, graffiti, Theatre of the Oppressed and arts in the prisons. I expose them to art and artists engaging in social change, and topics of feminism and racism emerge from the conversations. They are not only introduced to who is doing the work, and what methodologies are being used, but they are also charged with selecting a topic and choosing a Hip Hop approach to create a piece. Sometimes, students opt to create live pieces. The first year I taught the course at Marymount, a young Black woman created a live, silent monologue piece about #BringBackOurGirls. The monologue began with her sitting on a chair facing the back wall. As she turned around we could see that her mouth was covered with duct tape and she had been visibly crying, as mascara marked her face. She then pulled note cards, the first one reading, #BringBackOurGirls. She was portraying a young girl in Nigeria who had been kidnapped by Boko Haram.[15] With each card, she informed us how she was kidnapped, and sold into marriage against her will. By the end, the audience experienced an emotional journey that left them talking about her piece and reviving the now almost forgotten hashtag.

JOHNSON: In *Act Like You Know*, I plant the seeds of social justice very early in the semester through check-ins and select performance assignments. As a professor, I understand my responsibilities as a teacher but I am also keenly aware of the conversations that must take place and take precedence over coursework when difficult subjects arise, such as Trayvon Martin's untimely death or after a racially charged incident occurs on campus. These conversations allow Black students to express and validate their feelings and let non–Black students develop new sensitivities as they become aware of how racism affects not only their Black classmates but Black people in general. By the time students get to the spoken word project, mid-way through the semester, they are prepared to tackle concerns that hit close to home in their creative writing. Depending on the student, themes may coalesce, or revolve around two or three topics; regardless, I am always deeply moved by what they share.

SICRE: After the death of Michael Brown, Marymount organized bus rides to the citywide marches in demonstration against his death, and encouraged

all students to join the protest. Interestingly, BMCC did not organize bus rides or encourage students to participate in the protest. Then one of the days my class was held at Marymount, four of my Black students were not present because they asked if they could go march. As a professor teaching social justice, I had to ask myself, "How am I supposed to say no, you better be in class?" I could not. I had to say, "Yes, go march. Absolutely." Then I had to ask: How do I continue with a regular lesson for the students who did not go march when a national issue has taken precedence? I decided to cancel my planned lesson and substituted it for a conversation with the remaining students about Michael Brown. Although I could not march that day because my contract prohibited me from cancelling class, I did accompany several students to other marches that did not occur during classroom hours.

JOHNSON: Throughout the semester I intersperse course material with timely, topical conversations about current events that students are hashtagging, tweeting and regularly streaming on their social media newsfeeds. From there, they wrestle with these issues in various ways, including writing, memorizing and performing "a hot 16" rap verse or doing a free-write exercise on the topic at hand. I continually assess the balance between engaging students in social justice issues against the nuts and bolts of how I teach the course and material that needs to be covered. Through critical analysis and dialogue, students engage in rich conversations, which often inspire them to revamp final project ideas to reflect these prevalent issues. Fortunately, when time runs out during class, digital media and social networking platforms are available to continue the conversation.

Digital media

We both make sure our work reaches beyond the classroom. We have documented our pedagogy by recording our students' work to create digital archives that will serve as powerful resources for future generations of students. We create private Facebook groups to provide a forum for 24-hour classroom discussions. If our students do not have Facebook, we create generic accounts for students so they can log in, post and connect with class activity. This way, when students are unable to finish a discussion in class, they can continue the conversation after class, online. Additionally, we are able to post relevant links and articles to further supplement student learning. We both agree that Facebook is a more powerful platform than Blackboard (the online classroom software provided by our universities) because Facebook has the visuals that students crave.

JOHNSON: I created a Tumblr page[16] to archive my student-devised play *gener8-tion Txt* and I have a YouTube channel dedicated to *Act Like You Know* performances, rehearsals and promotional spots.

SICRE: In my case, I have crafted playlists of videos showcasing examples of spoken word pieces that I can add to and use over and over again on Blackboard. Second, I created a YouTube channel specifically for my *Advanced Public Speaking for Social Justice* course. This way they have a channel to post their work. Current students can see the canon of powerful messages other students have previously created, making it easier to write something on a topic they feel passionate about. For example, a Black student created a mini documentary on sickle cell anemia, which predominantly affects African Americans. He wanted to educate others on ableism, and how discrimination occurs in favor of able-bodied people. His piece not only showcased the discrimination Black sickle cell students face at school, but also the lack of understanding from faculty about this disease and its side effects. Now, there is a digital archive of a performance piece that is profound, heartfelt, thought pro-voking and exposing an issue that would not have been brought up in another classroom.

JOHNSON, SICRE: The digital archive represents the level and quality of the type of work our students will aspire to create. First the class watches national and international artist performances, then they view previous classmates' work before they create their own. We are a dramaturg of sorts for the students. There is nothing like covering a topic and then all of a sudden, students are posting different perspectives about that topic through their own discovery. We continually gather these resources and share them in future semesters. This notion of a digital classroom and archiving adds to our growing catalogue of information, as we incorporate yet another way for community to join the conversa-tion, unsolicited.

SICRE: The day after a class discussion about Garner and Brown, I arrived home and logged on to see multiple student postings about them. Con-versations on social justice did not stop in the classroom, but continued in the digital realm. Allowing students to share what was posted on the page, and spread the word, enabled them to further the conversation.

JOHNSON, SICRE: In theatre, creating a digital copy of creative work is frowned upon because of copyright issues. Recording a performance for viewing later is contrary to the idea of great theatre, which is intended to be experienced by a live audience in the moment. Digital copies of this type of work have been shunned. However when one looks at the ever-growing reach of technology and the need for continually broadening exposure to social change, having a digital record can reach, impact and connect with far more people than a single live performance. With digital media, everyone has access, which is what social justice is all about: access and equality for all people. In addition, regional theatres and university theatre programs are creating digital media to promote and market upcoming shows to attract new audiences and build buzz. Early on, the

sports industry recognized the value of digital media as a means of solidi-fying its product in the mainstream culture and it is entirely possible that the arts can capitalize on the use of digital media to do the same.

Final thoughts

We are keenly aware of the challenges facing Black college students, who often feel marginalized and feel like their concerns repeatedly go unheard at PWIs. Our work helps amplify their voices and provides a safe space for them to develop and express their world. Our teaching methods engage Black stu- :
dents and empower them to speak their truths through the courageous act of performance. Students have consistently been thankful for the opportunity to have the space to declare their identities and speak their truths. In a world where we have to be reminded with a hashtag that Black Lives Matter, our courses empower students to go beyond hashtag activism. They teach stu-dents how to make their voices heard. Students recognize our teaching efforts, and perpetually express their gratitude for designing a course where they can create safely and express themselves. In addressing issues of diversity and inclusion, culturally responsive education and digital humanities is a must in today's world. Through our unique remixing we have helped elevate Black student voices that are often silenced, inviting them not only to criti-cally think about issues of identity, difference and social unrest, but to effect-ively embody such concerns, challenge misconceptions, confront injustice and proudly celebrate who they are on stage.

Notes

1 Paulo Freire, *Pedagogy of the Oppressed*, 30th ed. (New York: Bloomsbury Aca-demic, 2000).
2 Nicole Schor, "Act Like You Know Hip-Hop Class Takes the Stage for Final Per-formance," accessed March 20, 2015, http://thebrownandwhite.com/2015/04/27/act-like-you-know-hip-hop-class/.
3 Daniel Banks, *Say Word!: Voices from Hip Hop Theater* (Ann Arbor: University of Michigan Press, 2011), 19.
4 Jeff Chang, *Can't Stop, Won't Stop: A History of the Hip-Hop Generation* (New York: St. Martin's Press, 2005), 105.
5 Nelson George, *Hip Hop America* (New York: Viking, 1998), 2.
6 Stephen Acker and Michael Miller, "Campus Learning Spaces: Investing in How Students Learn," *EDUCAUSE Center for Applied Research Bulletin* 2005, no. 8 (2005): 1–11.
7 Danny Hoch, "Toward a Hip Hop Aesthetic: A Manifesto for the Hip Hop Movement," last modified September 8, 2006, www.dannyhoch.com.
8 "Everything's a Remix," YouTube video, posted by Kirby Ferguson, April 16, 2011, www.youtube.com/watch?v=NmwwjikTHxw.
9 Jokers are facilitators and teachers of Theatre of the Oppressed techniques, coined by Boal.
10 Augusto Boal, *Legislative Theatre* (New York: Routledge, 1999), 234–246.

11 "10 Hip Hop Songs in Response to Questlove's Call for Protest Music," Ranjul Punjabi, The Boombox, last modified December 17, 2014, http://theboombox.com/10-hip-hop-songs-questloves-call-for-protest-music/.

12 The entire classroom community, students and professor.

13 Augusto Boal, *Theatre of the Oppressed* (New York: Theater Communications Group, 1985), 155.

14 According to Merriam-Webster's Learner's Dictionary an *Ism* is "an oppressive and especially discriminatory attitude or belief."

15 Ishaan Tharoor, "8 Questions You Want Answered About Nigerian Missing Schoolgirls," *The Washington Post*, accessed February 17, 2016, www.washingtonpost.com/news/worldviews/wp/2014/05/06/8-questions-you-want-answered-about-nigerias-missing-schoolgirls/.

16 "Gener8-tion Txt," Tumblr, last modified March 20, 2012, www.gentxt-blog.tumblr.com.

Reflections from distinguished practitioners

Rituals, processes, methods

Judyie Al-Bilali, Tim Bond, Sheldon Epps,
Shirley Jo Finney, Nataki Garrett,
Anita Gonzalez, Paul Carter Harrison,
Robbie McCauley, Seret Scott,
Tommie "Tonea" Stewart and Talvin Wilks

Brown Paper Studio is the applied theatre process I created in 2002 while living in Cape Town, South Africa, and is now also practiced in the States. I codified my teaching, devising and directing into Brown Paper Studio basics; Be On Time, Gratitude, Safety, Circle, Breath, Eye Contact and Trust. Several of these are expressed in the opening rituals of class or rehearsal. Timeliness acknowledges respect of everyone's artistic dedication and gratitude brings spirit into the room, while physical and emotional safety establishes mutually respectful relationships.

When participating in Brown Paper Studio we stand in a circle with connected hands. The positioning of hands is significant; the right-hand faces down and the left hand faces up. This positioning provides a balanced flow of the giving and receiving of energy around the circle. While the hands are still touching we also stretch. As we stretch the company is instructed to vocally express how they feel using sounds. The sound literally and figuratively sets the tone for an atmosphere of genuine expressiveness. Breath is vital to opening the circle, and provides the foundation of fully embodied work. We send breath to release and expand tense areas of the body. Breath is the animator of the space and the more individual breath in the room the more collective inspiration is available. Once we are physically connected in the circle, activated with sound and grounded with breath, we then allow for the vulnerability of eye contact. We make eye contact with others in the room, with our hands still connected. I remind the actors that the circle always exists, even when an actor is alone on stage. And finally, cultivating trust in oneself is the key.

(Judyie Al-Bilali, University of Massachusetts/Amherst, Theatre
Department and Commonwealth Honors College, Assistant
Professor of Performance and Theatre for Social Change)

I usually cook a pot of greens and "Hoppin' John" on the night before I begin rehearsals to put my body, mind and spirit in the flow to receive inspiration from my ancestors. Sharing a meal with the cast is also very

important for me during the process. When we share food, listen to music, swap stories and hang I know the gumbo pot of ensemble and community is seasoned and stewing.

(Tim Bond, Syracuse Stage and SU Drama,
Producing Artistic Director)

On the first day in the theatre, whether that is for staging or the beginning of the tech process, I gather the acting company onstage and before we begin our work I ask them to take a look—a *real* look—out into the house. I remind them to express gratitude and respect for the space where we are working and to give thanks to all of those who have previously filled the theatre with their artistry and dynamic energy. I then ask them to take a silent moment to "bless the space" in whatever way that they feel appropriate. I find that this moment gives the actors individually and collectively a kind of ownership of the space, a connection to the history of the theatre (in the case of The Playhouse, a nearly 100-year history), and also engagement with all of the others who have left what I call "the power of their artistic spirit" in the room over the many years of being in production. This blessing of the space makes the acting company part of a continuum and imbues in them a sense of history, both about the physical space and the ongoing life of our craft and art form.

(Sheldon Epps, Pasadena Playhouse, Artistic Director)

I have spent over 40 years in the entertainment industry, first as a performer and now as a director/performer. My talents have taken me to some of the most acclaimed regional theatres, and also abroad. Most times I was the first Woman of Color some of these regional theatres had hired, and usually this was the first time actors of color were directed by a Black woman. Working with me was often their first time being introduced to a spirit-based approach to storytelling. When one has to navigate being the only person of color thrown against a White background it is difficult to break down barriers and build walls of trust that creative expression requires.

In my work, I advocate for *knowing* to take place on a cellular level, giving actors unspoken permission to just *be*. In response to what my method is when working with actors, I offer that I am a human being, a female and a person of color who directs. I can only speak from that place of truth. The stories I shepherd and "conduct" come to me. I do not choose the story. The story finds me. I have discovered in my years as an artist, both as actor/director, that stories arrive when I have lived either the situation or the circumstances, or I am in the midst of experience. My decision to midwife and guide the birth of a story comes from this sacred space. I first have to mine and excavate my own personal truth

before I can excavate and mine the text for the actors and the design team who will embark on the journey we will travel called the creative process. It is important for me to *feel*. I leave the semantics to the writer. It is the emotions that interest me. Between the lines are where the juice and nectar lives, where the spirit dwells and where one finds the life force. I first must hear the music inside the script. It is the emotional tone and language that carries the energy that drives the story: The Nommo. Story is our way home and each actor has to have the courage to show up. It is from that place that I begin my meditation.

I want my actors to feel safe, be seen and feel nurtured. I let the spirit guide this process, as we first bless the space, the rehearsal hall and the performance space. I usually lead rehearsals with the following blessing while in a circle:

> We give praise and thanks to the Creative Spirit that dwells in each and every one of us, to the Ancestors, those who came before and those who are with us now. We know that the work we do will not return void. We know that those who fill the seats have a divine appointment and will be touched by the playwright's words and story we tell.

I trust the process moment to moment letting the energy/Nommo dictate the story, with the director/conductor and performer/actor in symbiotic transformational dance.

(Shirley Jo Finney, Director)

I ask the universe and the ancestors to help me discover the answer to the question, "Why this play now?" I accept that the answers to that question are infinite.

In my rehearsal process everyone is a collaborator and we are all working together to push the limits of the world the playwright has created. The work I do tends to be provocative so it is imperative that the actors feel supported and free enough to play in a treacherous landscape. My process is more like a soup with all of the ingredients in one pot stewing together taking on each other's flavor, getting better with time—continuing to steep throughout the tech rehearsal and opening until the final day of performance.

While blocking I like to give parameters instead of directions. I ask a lot of questions about the actors' instincts and push them to follow their own impulses instead of relying on me to define how they move. I am attracted to what is intrinsic and human and I do not always believe in what makes sense or what is logical as I find those ideas to be unreliable. I seek to deliver a show that is a living thing still in the process of becoming. While the design process must end with the technical rehearsals, my

process empowers the actors to continue making discoveries about the world and their characters until closing.

(Nataki Garrett, California Institute of the Arts, Associate Dean, Co-Head, BFA Acting Program)

Training actors in sound movement, improvisation and grounding exercises from and within the African Diaspora are essential components of my rehearsal process. Listening and responding to music in a physical way is a part of my Afro-centric approach to theatre training. While some actors are able to improvise to music, encouraging the body to respond to rhythm, mood *and* the emotional quality of the sound is an acquired skill. Thus, jamming to music becomes a part of my rehearsal process because many actors have not experienced movement as a physical, improvisational response to sound.

Recently, I directed a play by a Puerto Rican playwright named Cindy Sanabria that required expertise in *parkour*, the street-based acrobatics that youth play when they challenge one another on the street. Participating in *parkour* also required that the actors learn physical connection without contact, and how to shift and dodge and turn and jump with and around one another without injury. The Midwestern actors cast in the show had a limited understanding of how to play and challenge one another. They also had never participated in Brazilian *candomble* or a Harlem stick dance. So, I found that I needed to work with the performers on skills that are basic within African Diaspora performance: grounding the body, listening and responding to music and interacting with the physical space of other performers. By grounding I mean that the actors needed to feel the force of gravity pulling them to the ground, allowing their body's energy to release into the joints, and then rebound off of the ground to execute a move. Acrobatic and clowning exercises approach this kind of agility training, but they do not emphasize rebound and directional shifts like African performance styles do. Each rehearsal we dedicated 20–30 minutes to experimentation with this style of movement.

(Anita Gonzalez, University of Michigan, School of Music, Theatre and Dance, Professor of Theatre and Drama)

As a child, the Barnum & Bailey 3-Ring Circus was my earliest encounter with the performance gestalt I refer to as *Modality: A Pathway to Ritual Improvisation*, whereas the sum of disparate actions coalesce into a singularly *whole* dramatic experience. For instance, the Ring Master, redolent of the Minstrel Interlocutor, orchestrated the simultaneous actions of dancing goliath Pachyderms that dwarfed clowns shot from cannons while acrobats flew in the air on trapezes. This spectacle was a cohesive performance mode that was dynamic and compelling.

Though I did not grow-up with any particular denominational affiliation, my pubescent curiosity led me to attend the religious practices of friends in the neighborhood, whereby I discovered the ritual practices of diverse religions. None compared to the animated embodiment of the spiritually invocative ritual of the Baptist churches where the orchestration of song, dance and drum elicited seemingly disparate spontaneous gestures within the congregation that collectively invited the spiritual "presence" of the Savior. Even more galvanic was the AME churches—where my grandmother, a Geechee from the Sea Islands of South Carolina, was a spiritual leader. The ritual gestures brought me as close to African ritual spirit evocation I could possibly experience. The one thing each of these ritual modes had in common was mystery that led to a spiritual epiphany.

I found my way into theatre practice soon after completing my graduate studies in Gestalt Psychology and Phenomenology at the New School for Social Research in New York. It was during these studies that I discovered the tendency of human behavior to organize perceived discrete phenomena into whole patterns with concrete meanings. Upon discovering the significance of how parts in the experiential field contributed to a *whole* response, I was no longer concerned with Freudian dualistic principles that atomized human behavior into *conscious vs. sub-conscious*, or one-to-one linear relationships to *cause and effect*, liberating me from theatrical expositions arrested in Realism. Even before completing my studies, I became interested in the ritual exercises of Julian Beck and Judith Malina at their Living Theatre, where they produced experimental productions. Harassed by the government for taxes, Beck and Malina went into "voluntary exile" in Europe armed with Oriental mysticism, gestalt therapy techniques and an Artaudian objective to eliminate any binary distinction between art and life. In the early 1960s, on the heels of the Living Theatre departure, I too would seek artistic refuge in Europe. As a result of being absorbed by the recondite dramatic modes of Beckett, Sartre and Albee, and the ritual stylizations of Jean Genet's *The Blacks: A Clown Show*, and Adrienne Kennedy's *Funnyhouse of a Negro*, I pursued a trail to Peter Brook's expositions on Total Theatre.

In Amsterdam, I became associated with a loose federation of artists—composers, poets, painters—who conspired to alter the conventional methodologies of theatre practice in the National Theatres of the Netherlands. Included was Peter Schat, a composer protégé of the twentieth century composer Stockhausen, Lodewijk de Boer, a violist in the Concertgebouw Orchestra, who became one of the principal contemporary playwright/directors in the Netherlands, and the incorrigible, yet popular enfant-terrible Cabarateer, Ramsus Schaffee.

Already infected by the spontaneity of happenings, we eagerly set upon Peter Brook's formulations for Total Theatre, constructing projects

that depended upon processing the independent elements of perform-
ance, music, text, movement, actors, lighting and environment, so that
the dramatic narrative came together, ritualistically, as a cohesive *whole*.
The process, while engaging—even entertaining—seemed somewhat
whimsical to me at first until I stumbled upon books on ritual exercises
of African sacred systems. It occurred to me at once that what we were
processing—and what Peter Brook had appropriated as Total Theatre—
was embedded in the traditional practices of several West African sacred
systems. I soon began to look into the rear-view mirror of my African
American cultural history for clues of African retention that were most
salient in Gospel, Blues and Jazz. Black Church, as a cultural site, clearly
became the point of return for the construction of a ritual theatre mode
inspired by African retention. I returned to the States in 1968 to teach at
Howard University with my first full-length play in tow, *Tabernacle*.

Tabernacle, a play-within-a-ritual mode set in a Black Church for 20
Black male actors, could not be produced in Amsterdam because of both
the lack of personnel and the lack of cultural intimacy. The archetypally
conceived performance elements included a Preacher as the principle
orchestrator of the mode, a Chorus of Mothers, consisting of five six-foot
tall husky men wearing oversized masks, a Coltrane Sound musical
ensemble (led by Eric Gravatt, a Philosophy student at the time), which
improvisationally moved the dramatic actions forward, and Young Men
of the community who performed a variety of roles, including Police, a
Judge and a White Female Harlem Merchant. The multi-roles performed
by all actors required that they understood the archetype of the charac-
terizations, rather than invent an individualized emotional life for the
characters. The very power of the spiritual evocation convinced me that
I was on the right track toward a ritual exercise that could capture an
audience in the manner of Black Church.

Theatre, including Shakespeare, has the capacity to become a spiritu-
alized secular event. Closer examination of the Black Church reveals a
high degree of theatricality and musicality which owes its rituals to
African traditions. Words alone do not have the capacity to arouse a
Black audience unless those words are orchestrated with all the perform-
ance forces in the environment—including audience/witnesses. It is
important to recognize here that the *event*—as opposed to the *play*—is
the *thang*, the opportunity to employ song, dance and drum to dredge
from the performance environment the rhythms of life that provide the
sensate power and vitality to focus a cosmic source of light on the
mundane (that is Realism). The *event*, then, becomes the context of
reality, a force-field of phenomena in a mode which must be ritualized.

In this way, *Modality* is a music construct, a path toward improvisation
in the ritual mode. The mode is motile, yet volatile, and vulnerable to
shifts that can corrupt as well as amplify the collective process needed to

reveal the epiphany of the dramatic context in the mode. The African American Ritual Mode, while adhering firmly to familiar narratives in a Sacred Text, is an improvisation that has the following construction:

a A Praise Environment, be it within an edifice or an open field.

b Preacher as Spiritual Leader: a spiritualist who mediates between spirit and corpus, light and shadow, manipulating all forces in the mode with proper word-force (Nommo) to construct a narrative, based upon the Bible, so as to bridge myth with reality in the process of revealing the spirit in the mode.

c Chorus/Musicians represent the Sacred Community since it has more direct access to the "ancestral" spirit.

d Congregation/Community-participating witnesses to the ritual whose aural and physical "responses" to the Preachers "call" is a necessary aspect in the incantative process of focusing the collective aspirations of the community.

e Sacred objects, images, icons, idols, and fetishes are displayed on the altar, sacred tools to summon forth the spirits or otherwise to help generate Spiritual Force in the space of worship.

f Elders, due to their proximity to spiritual wisdom, are custodians of the ritual procedures, passing judgment on the capacity of the Preacher to activate the forces in the mode required to illuminate historical and spiritual relationships that provide harmony for the community.

In the 1970s, Barbara Ann Teer utilized the spiritual evocation method of Black Church at the National Black Theatre in Harlem to train her actors to surrender themselves—psychically and spiritually—to the deliverance of "testifyin" performances of texts—the earliest example of *choreopoems*—frequently summoning spirits that were not always controllable, though the power of the event could not be denied. Testifyin' was certainly a principal aspect of Gilbert Moses's production of Amiri Baraka's *Slaveship*, a lean script of approximately seven pages, yet poetically forceful text that Moses was able to ritualize for 90 minutes with an orchestration of highly visceral body movements and spirited music that created a compelling theatrical mode.

In 1970, responding to the insistent solicitation of a vibrant group of Black students in search of guidance in the Theatre Department at California State University, Sacramento—among them being the forceful leadership of a potent young actor, Randy Martin, an uncompromising character actress who frequently appears on television, Bebe Drake Hooks and the widely sought after ritual-stylist stage director Shirley Jo Finney—I left Howard University with a collection of poems by Melvin Van Peebles and joined the faculty of Sacramento State to initiate the

conceptualization and development of the poems (along with my colleague and designer for the project, the highly acclaimed painter/sculptor/scholar Oliver Lee Jackson) into what became *Ain't Supposed to Die a Natural Death*.

Working intimately with Jackson and the students for long hours over a 15-week period, I was able to process the concept of *Modality* in a manner that went beyond the *choreopoem*, committing the students/actors to the excavation of archetypes that related to poems. We would call the theatrical format Kuntu Drama, which Jackson explains thusly in the preface to my anthology, *Kuntu Drama: Plays of the African Continuum*:

> Kuntu Drama is drama that has, as its ultimate purpose, to reveal and invoke the reality of the particular mode it has ritualized. The theater style depends on power and power invocation. It is magical in that it attempts to produce modification in behavior through a combined use of word power, dance, and music power. It is sacred theater in the sense that it seeks to fulfill a spiritual revelation. The play is the ritualized context of reality. The ritual confirms the mode: it is a living incantation that focuses power to invoke and release beneficent power to the audience … Kuntu Drama is testimonial.

At the core of my ritual pursuit, I am channeling the spirit of my aunt, the pop-composer Gladyce de Jesus, Thelonius Monk, Sun Ra and Julius Hemphill for a theatrical mode that opens a path toward revelations.

(Paul Carter Harrison, Playwright, Director and Theorist)

I direct with chunks of text woven through with guidelines and anecdotes in conversational language informed by what I consider the basic source of Black culture—jazz.

I experience directing as an exchange, a facilitation and a process full of questions. I learned to direct by doing it, and cannot imagine another way. Trust is an essential tool of the work—not necessarily trust of one another but trust of the work. Of course people should strive to be trustworthy, but trust of the work is more reliable. I have heard people describe processes such as blocking a play before meeting actors, and deciding exactly what to tell the designers. My way is to start not knowing. It is OK to start not knowing how things will end up. Be willing to invite actors to explore with you. Of course I study the script or obsess with ideas for generated works, but I cannot know what to do until I see all the actors who will do the work in the room.

Guiding principles for me as a director are based in what I have experienced as an actor. I suggest that actors be constantly aware that they are alone with others. Ensemble is a delicate condition to achieve and should not be pushed. With my cast, I begin with a deep

consideration of the material I am directing. Resistance is full of information. Welcome it from actors, and accept the challenge to chip away at it with questions. Good questions include: What are you not saying? What are you not thinking? Also remind actors that they need not answer the questions out loud or even silently, but to please listen to them. Let the actor know as much as you know. Actors have a particular intelligence. Respect it.

In terms of rituals, I find that they are best used when they emerge from the work, be it for scripted pieces or generated ones. One ritual I rely on is, at some point, to have actors talk through what is happening in the piece, sequentially, as themselves/their characters as creatively as possible. Further, we should all find elements of the African Diaspora as well as other cultural resonances in all the work that we do. I weave Black dramaturgical information in talks with all artists in the company. Everybody should know more about Black culture, no matter the play. As the venerable Vivian Robinson, founder of the AUDELCO (Black-Theatre) awards once quipped, "Othello wasn't the only Moor in Venice."

(Robbie McCauley, Actor and Professor Emerita, Emerson College)

I have a fairly fluid process when directing. I don't start blocking until several days after the read through and during that time the actors are free to move about the room/space (even during the table-read) to make it their own. In doing so I learn quite a bit about each actor's physicality. The cast usually begins to bond around the daily 20–30 minutes of actor time that is set-up before rehearsals. The cast can self-suggest improvisations and warm-ups they find useful. Their self-suggested group activities empower and promote a sense of character independence. It also gives me an opportunity to watch the cast work with each other sans script.

(Seret Scott, Director)

Directing requires vision, intuition, appreciation, understanding and inspiration. It is my personal practice to access the energy of the playwright by simply holding the script in my hand. It is not common for anyone to do this, but it is the truth of my procedure. I seek the inspiration of the writer's words and that connection becomes communal for me.

After establishing a strong connection with the play, completing common procedures, such as casting the show, and identifying the units and beats with the cast, my next step is to explore the play's zeitgeist. Together, the cast and technical staff discuss economic, social and politically sensitive concerns for the world of the play that influence our choices of lighting, costuming, etc. While developing my directorial concept, which influences how I block the actors, I like to identify or

find an element of surprise for my audience. An element of surprise occurs when the director incorporates an unexpected highlight in the directorial pattern for telling the story. Full of intuition, communalism and collaboration, my directorial process encourages sincere connection amongst all parties involved.

<div align="right">(Tommie "Tonea" Stewart, Dean and Professor, College of Visual and
Performing Arts, Alabama State University, Actor and Director)</div>

I have developed an approach to character development and storytelling that I call *Rootedness: The Griot Tradition in the Process of Devising*. Rootedness is about exploring memory, understanding the visceral, imagistic and experiential of the past as told through a collective community ritual. This process is inspired by two traditional sources. The first source is the *griot* (or *jeli*), found in West African cultures. The *griot* holds the history, language and metaphors of a community. The second source is called *talking into the moment*, an improvisational technique that I learned from Tina Shepard, a founding member of the Open Theatre with Joseph Chaikin.

Rootedness as a process uses a circular interview technique that allows an individual character or generative storyteller to formulate his or her story by answering a series of questions from the "community." In answering those questions, the character roots (imagines) his/her history or back story. It is an improvisation that evolves and develops each time the generative character steps into the circle of questioning. In a way it is a type of spiraling in for the actor that can be rooted in memory, informed by the creative imagination or sourced by actual text or observations. To this end, *Rootedness* creates a collective event and a group informed history that can then be "peopled/populated" by other characters who reinforce or challenge the story through call and response and/or reflecting or witnessing, thus developing an even greater world. This process is vital because it merges Western and African traditions that create a contemporary way of building and devising story. It recognizes and validates the importance of an Africanist approach in creating contemporary performance.

<div align="right">(Talvin Wilks, Director, Playwright and Dramaturg)</div>

Words of wisdom for actors

Talvin Wilks, Sheldon Epps, Shirley Jo Finney, Walter Dallas, Kamilah Forbes, Kym Moore, Judyie Al-Bilali, Tim Bond, Nataki Garrett, Paul Carter Harrison, Anita Gonzalez, Ron Himes and Seret Scott

Today's actors are the next generation of pioneers in understanding the idea of equity and representation on the American stage. They are the inheritors of a 2040 census projection (originally 2050) that states that there will be no recognizable majority/minority in the current way we look at demographic statistics in this country. This does not mean, however, that economic equity will be met in our society, nor that representational equity will be met on our stages.

The best way to address the challenge of representation is to be committed to telling your stories, to strive to be generative artists, even if your practice is rooted in performance. The diversity of stories being told and the voices being celebrated gets us closer to the idea of equity and representation.

Participate in the process of researching and making theatre about the repressed stories of the nineteenth and twentieth centuries. We have legends of unheralded heroines and heroes, and through their experiences we learn more about our own history and will begin to see a greater truth and more diversity on our stages.

Understand your place in a longstanding cultural lineage. You are part of an incredible history of groundbreaking artists who fought against staggering odds to have a place in an American tradition that often stereotypes, caricatures, mocks, ridicules, segregates and demeans the Black image on stage. Understand your history. Seek it out. Find your forefathers and foremothers, and celebrate them.

(Talvin Wilks, Director, Playwright and Dramaturg)

Many years ago I had the great pleasure to meet and spend some time with Lloyd Richards, a true pioneering African American director. When I asked him for words of advice he said, "Keep your eyes on the prize ... Not on the prizes!" Very wise words then and now, and incredibly valuable advice for anyone who works in the theatre. The prize is the work itself and the constant search for mastery. The trophies, awards and

recognition that may follow are much to be cherished, but not to be sought in the artistic process.

(Sheldon Epps, Pasadena Playhouse, Artistic Director)

Before you venture on into the world of "show business" you must have a foundation; a sense of self. Most actors become so busy pursuing their dream that they lose their sense of self. I have seen many Black actors lose their identity, while trying to fit to become a carbon copy of what someone else wants them to be. Learn how to navigate your career and set your own boundaries. Be clear with your vision. While the industry uses the phrase "show business," you must realize that this is a *business of show*. To the corporations, you are a commodity.

(Shirley Jo Finney, Director)

Always speak the truth. Be you. Do you. You are more than enough.

Trust your instincts and know that part of your job is to help your partners on stage succeed. Learn your history: know that many Black theatre pioneers have paved the way for you: honor them, respect them and know that these ancestors are onstage with you.

(Walter Dallas, Director, Writer, Master Teacher
and Photographer)

Embrace your whole personal lived experience in the audition room; this includes your unique voice, presence, perspectives and style. Understand that your uniqueness is your largest asset. Often times the actors entering audition rooms look and sound just like one another. However, directors need to know if you can bring a character that lives on the page to life. Your authenticity aids you in building a three-dimensional character.

(Kamilah Forbes, Director and Producing Artistic
Director of Hi-ARTs)

Life is not solely about being Black or any other label you might ascribe to your being, it *is* about being Present.

The Black/African American/Actor of Color must be well aware of the specifics of culture and how it informs the representation of any character. We have to maintain authority over what we create by crafting characters so multifaceted and layered that the viewer is unwittingly seduced into a new way of seeing. The particular vagaries of this business and the presumed dearth of Black directors makes the task of creating truthful constructions of character very challenging indeed. Some of the most highly acclaimed directors in our discipline do not see the infinite range of potential representations of *us* that exist in the world. The fact that there are Afro-Cubans who look like Black/African American people, but also speak Spanish, can be confounding to directors who rely on two dimensional

representations of character that fall short of any true expression of the human experience.

I strongly recommend viewing Marlon T Riggs's seminal documentary film, *Ethnic Notions*, which will give actors/directors a very clear depiction of how certain images of Black people have been used to advance White supremacy in the minds of billions worldwide. Many in the so-called "Black Community" suffer from a regular diet of ingested misrepresentation. So much so that people unwittingly succumb to the belief that what they are seeing is actually true or "the way it is." A vicious cycle ensues, whereby negative ideas of who we are supposed to be in the world are subconsciously ingested and serve to promote delusional beliefs about who we are as a people.

Acting is political! It always has been in the case of the Black/African American body on stage or in film. It is certainly true for other similarly marked bodies, but the bewildering power of media to continually produce distorted images of the Black body in pain points to a subconscious need to avoid dealing with the fragility of their own humanity. Taking on these negative images as the fullness of our cultural reality is abominable. Yet this act continues with many in our own community perpetrating these pervasive lies of the mind. Attending to these distortions has been a significant part of our work since the nineteenth century. Nevertheless I am encouraged by the incredible array of new representations that are flourishing in this twenty-first century, and thanks to performance artists like Issa Rae, Pharrell, and Marcus Gardley I have no doubt it will continue. Right on!

Develop self-awareness, which is altogether different from self-consciousness. All actors struggle with self-consciousness to a certain extent. To become self-aware one must take the time and space to become better acquainted with who they are as a singular human being. Self-awareness can be a lifelong process that shifts with age and experience. How can we ask the character who she is if we have no idea how to answer this question for ourselves? I wouldn't dare suggest how this is done because everyone has to find their own way. However, I do suggest reading James Baldwin's essay *The Creative Process* as a starting point.

Compassion and vulnerability are one and the same when you are acting. Compassion for the character and your ability to be vulnerable within her given circumstances requires great courage and inner strength. Paradoxically it also requires a certain degree of detachment. Compassion evolves from the awareness of the perils brought about by judgment, and the actor's vulnerability is expressed in their willingness to make space inside themselves to embrace this apparent stranger in the process.

Acting *is* about actions. What the character does given the specific set of circumstances outlined in the play or film is up to the actor in relationship to the play/text/script. The situation is defined by the given

circumstances as well as the character's relationship to her self and other characters that exist in the world of the play. Emotion will reveal itself in the process.

(Kym Moore, Brown University, Associate Professor, Department of
Theatre Arts and Performance Studies, Artistic Director,
AntiGravity Theatre Project)

Pursuing a career in acting means being a theatre-maker and being a theatre-maker is to be a cultivator of community. Cultivating community requires cooperation and collaboration rather than competition. This awareness is also rooted in the Pan-African aesthetic. Cooperation and collaboration are our way of life.

I want to affirm Black actors' magnificent role in the context of the African Diaspora; we are conduits for spirit, for the ancestors, for the forces of nature. The awareness and invocation of spirit in the creative process is our fundamental heritage as Black artists. Theatre is a magical, transformational, revelatory place. We enter into the dark together and we agree to make-believe. We agree to dream new worlds.

Self-care is vital to your success. Take care of your body, respect your instrument, eat well, rest well and exercise. Trust your body, your feelings, your voice, your impressions, your passion, your intelligence and your intuition. Trust your right to be an actor, to be an artist, to be a channel for the light. Trust yourself to realize your highest destiny.

Always look for the best in the work of your fellow artists. Be generous with your praise.

Training and expanding your skills are lifelong commitments. Visit art galleries and museums. Read widely and research deeply. Travel whenever possible.

Allow yourself the freedom to make mistakes, to make a mess and to fall down and get up again. This is your right as a creative human being.

(Judyie Al-Bilali, University of Massachusetts/Amherst, Theatre
Department and Commonwealth Honors College, Assistant
Professor of Performance and Theatre for Social Change)

Honor your ancestors by studying our history.

As you stand on the shoulders of those who have paved the way for you to tell our stories *be fearless*!

Don't limit yourself and don't be daunted by the limitations others may try to place on you.

Prepare yourself so when the door is open you are prepared to walk through it.

(Tim Bond, Syracuse Stage and SU Drama,
Producing Artistic Director)

Do everything! Act! Produce! Write! Direct! Be a leader! Do everything so that you can make opportunities for those coming behind you, and so that you do not have to rely on others to make sure our stories get told.

The world will marginalize you so you must always play outside of the lines. This type of exploration beyond someone else's boundaries pushes the margins back as you expand. You are bigger than any perceived idea about you.

(Nataki Garrett, California Institute of the Arts, Associate Dean, Co-Head, BFA Acting Program)

Do not become seduced into what I call "performing Blackness." This type of performance involves superficial responses to the surfaces of African American speech, body movement and "attitude" that lead toward stereotypic portrayals of Black life. There is a vast difference between stereotype and archetype. The archetypal portrayal is rooted in reliable constructions of African American social history and culture. Revisiting and rediscovering that archetypal cultural sensibility is greatly recommended.

(Paul Carter Harrison, Playwright, Director and Theorist)

Love yourself and do not lose connections to your cultural heritage as you strive to become a part of the professional stage.

Students of all ethnicities need to read and perform diverse cultural plays as often as possible. Today's plays are written in a variety of acting genres—post modernism, musicals, fantasy, magic realism— and relevant theatre training demands that students experience performance works that advance the canon and comment upon the world as it is now.

Request that multicultural shows be produced in your training grounds. These multicultural shows are the building blocks for the new American theatre. Each year, at least one African American or Latin(x) student in my undergraduate BFA acting program comes to my office in tears. After three or four years training in American realism and Shakespeare they realize that their artistic future may not be in playing European roles. Their acting curriculum has created neither space nor opportunity for them to learn about diverse cultural plays and how to perform them. "How" they ask, "will I be able to be cast if I have never played a Black or Latin(x) role?" They wonder if they will be able to embody Black roles or participate in conversations about productions that emerge from diverse cultural communities. Participating in multicultural shows allows performers to present human experiences to audiences who hope to navigate through a global community.

(Anita Gonzalez, University of Michigan, School of Music, Theatre and Dance, Professor of Theatre and Drama)

We have an aesthetic that is rooted in our Black heritage and culture. It is important that you understand that and that you immerse yourself in it. That is the literature, music, dance, history and politics … we must look at the world through an African American lens.

(Ron Himes, St. Louis Black Repertory Theatre Company, Founder/Producing Director)

As a Black stage actor in the 1960s, there were no expectations of starting at the top. The people I knew in the business were grateful for the opportunity to work at their craft. Theatre was their passion; they were devoted to it even as some held full-time day jobs. Along with the need to tell *our* stories, Black theatres were founded in part to give steady work to Black performers. We worked where we could. What we didn't know was that many industry people were attending the extremely creative, underfunded productions in our Black theatres. As the industry began to recognize our talent, work in various venues became more accessible and Black stories began to be produced in traditionally White theatre seasons. Today young and new actors often have agents, managers and other forms of assistance from the outset of their careers. Young actors often tell me that they are advised to "hold-out" for larger, more visible projects than those in regional theatres. I advise them that those larger projects may or may not come along. What perhaps will come along is a regional production that offers a ton of work experience and exposure.

(Seret Scott, Director)

Appendix

Recommendations for acting/ performance programs that seek to provide equitable training

Curriculum and performance opportunities

1 Acting teachers should explore and participate in acting methods rooted with(in) African lineage, for Africans are the first to engage in performance, and we all sprang from them.
2 Dialect training should include U.S. Black accents, such as New York, New Orleans, and Southern, and global Black accents, such as Jamaican and various ethnic African dialects.
3 Consider starting your theatre history with ancient African ritual performance, and then turning towards the Greeks.
4 Reflect upon and address the alienation enacted with the term "classical acting." Classical acting often includes histories and styles of White people during the Greek, Elizabethan, and Restoration eras. But where are the Black people and people of other ethnicities in "all" of these periods? Imagine how alienating these courses are for non-White actors.
5 Creating dramatic forms must not be exclusive to those deemed "playwrights." Artists are writers too. With this in mind, programs that teach Black actors must have courses where actors can generate their own material, solo and ensemble.
6 Programs must have designated space for students to perform their own work and ensemble work for an audience, be it devising, traditional playwriting, etc.
7 Reflect on how you are selecting racial and cultural diversity in your season. Are you only choosing non-White plays and playwrights that have been vetted by White theatre practitioners and foundations?
8 Make sure your actors have access to culturally diverse performance material.

Faculty and cultural awareness

1 Hire culturally Black faculty. Several.
2 Hire Black faculty to direct all types of plays in the season.
3 Do not assume that Black students are happy or content with your season or their existence in your programming. Listen and respond to your

students' concerns in regards to your season, extracurricular opportunities for growth, and racial and cultural climate in your studio.

4 If you feel culturally inept teaching acting to any student, don't suffer in silence; seek help.
5 Engage in race-based and culture-based conversations on a regular basis with your students and department members. Hire facilitators who specialize in these types of discussions.
6 End colorblind casting.
7 Employ integrated casting[1] and/or color-conscious casting.[2]
8 Culturally diversifying and providing equitable training for all students should be a shared responsibility among all faculty.
9 Attend and/or join historically Black theatre groups, such as the Black Theatre Network (BTN), the Black Theatre Association at the Association for Theatre in Higher Education (ATHE), the National Black Theatre Festival (NBTF), and the Atlanta Black Theatre Festival (ABTF).[3]

Notes

1 Daniel Banks, "The Welcome Table: Casting for an Integrated Society," *Theatre Topics* 23, no. 1 (2013): 1–18.
2 Teresa Eyring, "Standing up for Playwrights and Against 'Colorblind' Casting," *American Theatre*, January 7, 2016, www.americantheatre.org/2016/01/07/standing-up-for-playwrights-and-against-colorblind-casting/.
3 www.blacktheatrenetwork.org, www.athe.org/group/bta, www.nbtf.org, www.atlantabtf.org

Index

Page numbers in *italics* denote tables.

education *see* culturally relevant
 pedagogy; performing arts education
Edwards, Gus 129
Ekong, Archie 162
Elam, Harry 3–4, 6
Elements of Composition 156–7
Ellington, Justin 10, 19, 34
emcees 143, 146, 188
Emeka, Justin 11, 89–105
Emerson College 211
emotion, as a component of African
 American culture 6
Emotional Availability (principle of
 "SoulWork") 46–7
Ensemble Theatre 41
environment 130
Epps, Sheldon 13, 204, 213–14
Eric B 155
Ethnic Notions (Riggs) 215
European texts 11
Everlasting Arms (Rice) 78
"Everything is a Remix" (Ferguson)
 190
EVIDENCE (Brown) 19, 32
Experimental Theatre Wing (ETW),
 NYU 41–2
expressive individualism 6

Facebook 196
Federal Theatre Project 92
feedback 194
feminism 188, 195
Fences (Wilson) 185, 186
Ferguson 190
Ferguson, Kirby 190
field songs 48; *see also* Negro Spirituals
Fight the Power (Public Enemy) 190
Finney, Shirley Jo 13, 204–5, 209, 214
Flask of the Spirit (Thompson) 103
Flow (Power) 162, 178
Flyin' West (Cleage) 185
Foley, Fiona 171
Fonda, Jane 19, 28
*For Black Boys Who Have Considered
 Homicide When the Streets Were Too
 Much* (Simone and Mason) 129
*For colored girls who have considered suicide/
 when the rainbow is enuf* (Shange)
 106–7, 108, 118–19, 174, 182
Forbes, Kamilah 13, 150, 214
"forgotten people", the 77
Foster, Gloria 93
Foster, John Shévin 14

Fountain, Eli 105n21
"fourth wall" 111
Franklin, Aretha 82–3
Freddie Hendricks Youth Ensemble of
 Atlanta (YEA) 8, 9, 19–36; *see also*
 Youth Ensemble of Atlanta
Freeman, Brian 57
Freeman, Morgan 93
Freire, Paulo 184, 194
From Tel Aviv to Ramallah (Lane) 162
Frost, Anthony 73
Frye, Andrea 34
Fugees 155
Funnyhouse of a Negro (Kennedy) 207

gaines, reg e 150
Gant, Jerry 150
Gantt, Denise Kumani 80
Garner, Eric 190, 197
Garrett, Nataki 13, 205–6, 217
Gates, Henry Louis 125
Gaunt, Kyra 164n2
Gavin, Ellen 57
Gaye, Marvin 55
gender queerness 166n23
gener8-tion Txt (Johnson) 196
Genet, John 207
gentrification 182
Georgia State University (GSU) 10
Ghana 118–19, 140, 147–9
Ghartey-Tagoe, Amma 165n7
Gilkes, Cheryl Townsend 130–1
Goddess City (Abrams and Grant) 162
Goddess, Rha 150, 164
Golden, Ebony Noelle 128, 133
Gonzalez, Anita 13, 206, 217
Goodman, Benny 92
Goodwin, Idris 130, 164
Gordy, Berry 177
Gore, Tipper 148
Gossett, Lou 93
graffiti arts 188
Grant, Antoy 162, 164
Grant, Micki 10
Gravatt, Eric 208
Greek culture 1, 7, 109, 111, 112–13
griot/griotte 27, 128–9; emcees as 143;
 *Rootedness: The Griot Tradition in the
 Process of Devising* (Wilks) 212
Guga S'thebe community center,
 Capetown, South Africa 151
Gurira, Danai 129
Guyton, Tyree 180, 181